GW00994386

Birds

of the

World

To Bertrand Eliotout,
who lived every day of his life among birds,
till the very end.

Birds

of the

World

365 DAYS

BY PHILIPPE J. DUBOIS

ABRAMS, NEW YORK

FOREWORD.

With a little effort, you can live every day of your life in contact with birds. All you have to do is look around you, or watch the sky. Whether in the depths of a tropical forest or in the center of the city, birds keep us company. The fellowship they offer is often silent and shy, but can also be noisy and overwhelming. The presence of birds, whether they are colorful or drab, is always a pleasure.

For every day, there is a bird. From January 1 to December 31, we can attune our senses to the feathered flock that surrounds us. They are everywhere: pigeons pecking at crumbs in the city streets, a falcon or seagull gliding overhead, a titmouse doing acrobatics at the end of a branch.

Birds are an integral part of my life. They have accompanied me since earliest childhood and have become my passion; I have traveled all over the world in their pursuit. The fascinating thing about birds is that they permit us to leave the beaten path, abandoning the usual tourist destinations for encounters of unbelievable beauty. From the Arctic to the Antarctic, from the Himalayas to the Gobi Desert, in tropical jungles or right in my backyard, I have met hundreds of species, and I get to know the birds a little better every day.

This book, then, is an invitation to take a voyage—without leaving your chair. In the course of these pages, through the passing days, you, too, will depart on a journey into the world of birds and come to know them better and better. The first days of the year are an ideal time to explore the common species around us. Then, as the weeks go by, we will venture forth to meet the birds where they live, going a little farther afield each day, and gladly finding ourselves always at their side. One never lives with birds; one lives near them. We must be discreet and attentive witnesses to read

the hieroglyphs that they draw in the trees and the air. We must also remember that birds are living their lives for their own fulfillment, and not for ours. For this reason, bird-watching is a valuable lesson in patience. It also underscores the limitations of human sight and hearing, which are weak compared to those of most animals. But, of course, you must know something well to see or hear it well. In the woods, when I ask the uninitiated how many birdsongs or calls they hear at a time, their answer might be five, while I hear at least nine. Which goes to show that everything can be learned, even how to sharpen our senses.

Each encounter with a bird is its own particular story. In the course of these pages, I have enjoyed sharing some of the individual stories that together describe how I became an ornithologist. In reading them yourself, you will no doubt recall your own interactions with birds. Inside each one of us is a slumbering bird-watcher. To awaken ourselves to this practice is to open ourselves to nature, to better comprehend it and, in the process, better perceive our surroundings—and their evolution—in a respectful and responsible way. For birds are, among other things, marvelous vectors of biodiversity, and they serve as an excellent mirror of the health of our planet.

For every page, there is a bird. Open this book and read it as you like: enjoying one page a day for 365 days, or pecking here and there like a bird at the feeder. The text will teach you a great deal about the avian world, and the photos are there to inspire your dreams. But for now, put down the book and, with binoculars in hand, head out into the world to find some birds of your own.

Great tit

Birds do not celebrate the new year. In the gardens of the city, it is as silent as in the country. People are sleeping late today, still lost in dreams. Lively and discreet, a great tit inspects the thuja trees that separate the house from its neighbors. This bird will no doubt find a few tiny invertebrates there that, like itself, have braved the frigid temperatures of the winter night. Then, with a slightly jerky flight, it approaches the bird feeder on the terrace to peck at the grain and suet that some charitable soul—and bird lover—left out the previous day. Just then, if we push open the shutters, this might be the first bird that we see in the new year.

The great tit has many things going for it: its commonness, its simple song, its colorful feathers, and its outgoing temperament. It is cheeky, talkative, a true companion to humans, always on the lookout for what we leave for it. It is also an opportunist whose ancestors left the forests where they originated to inhabit the parks and gardens of the city. In sum, the great tit is a modern bird in tune with its times.

The great tit, *Parus major*, is one of the most common birds. It lives in Europe and Asia, where it is for the most part sedentary. It can also be spotted in sub-desert zones, though only at high altitude, or on the tiny islands of the Mediterranean. The birds of the most northerly regions (notably Siberia) do migrate toward temperate lands in winter.

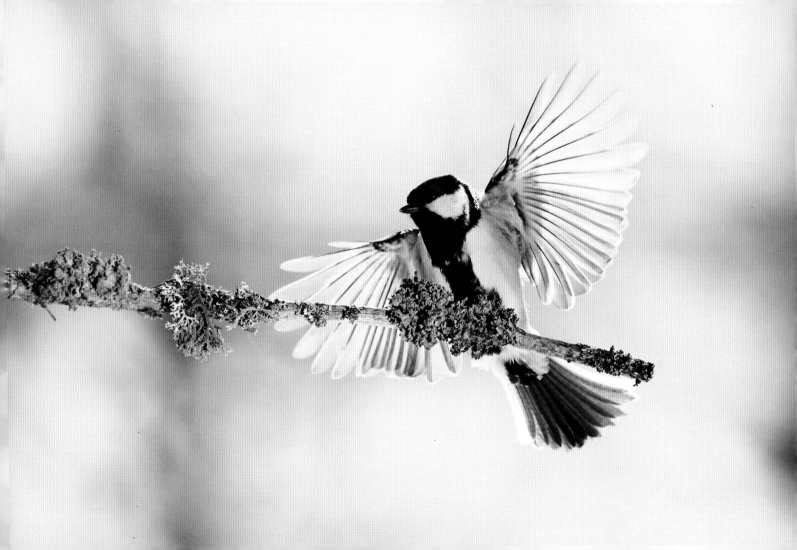

Tawny owl

The owl is the symbol of cold winter nights. Starting in December, the male makes his strange and sonorous cry: *Hooooooo… hoohoohoohoohooooooo!* A big urban park, a wooded border in the country, or, even better, a forest at night is an excellent place to hear his song. What a sudden contrast between, on one hand, the icy, motionless winter night and, on the other, the tawny owl's love song, a portent of beautiful weather, a brood of fledglings, buds on the trees. It is almost like an incantation to lengthen the days and raise the temperature.

The tawny owl is most often a dark and furtive mass glimpsed at night in the headlights of a car, surging out of the blackness alongside the road. For to find the owl in broad daylight requires perseverance. In the spring, after a long search in the forest, we may finally track one down. Claws clamped tight, high on the trunk of an old tree, eyes half-closed, it regards us, half absentminded, half on its guard. We move a few steps closer and it takes flight, a gray shadow escaping us once more against a background of spring leaves.

The tawny owl, *Strix aluco*, is the most common nocturnal bird of prey in Europe. Closely linked to the forests and big trees, the species is strictly sedentary. These owls hardly move from the place where the adults raise their young. They begin singing very early in the year, in the middle of winter, and reproduce by the end of the season. In the spring and early summer, you can often hear their young, as they strike out a little farther in search of their own territory.

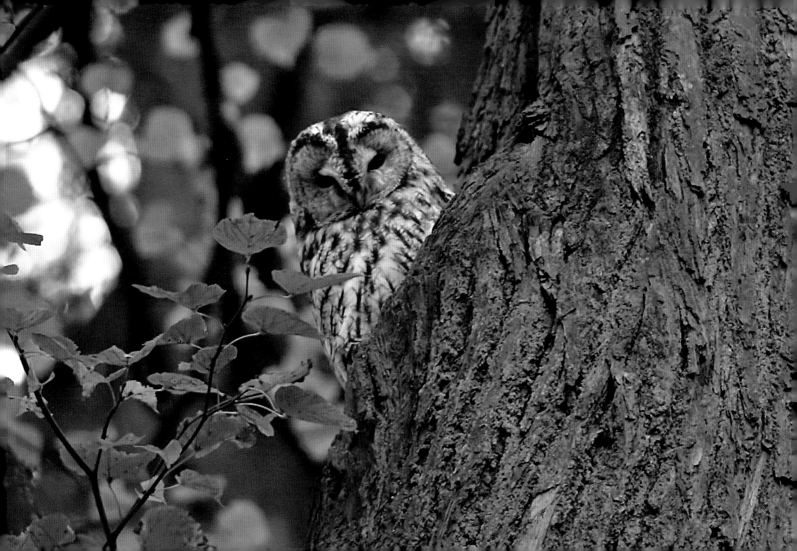

Greater white-fronted goose

At the bend in the road around the polder, the murmur swells. We first hear distant sounds, like those of a crowd in a stadium, then, as we approach, a high-pitched clamor that grows, a moment later, into the sound of a vast quacking multitude. Suddenly, barely a few hundred yards away, below the dike, there they are: thousands of white-fronted geese, grazing in a meadow. Clustered together, their beaks nibbling the short winter grass, the geese bustle about as the ambient temperature flirts with zero. Here and there, birds crane their necks to scan their surroundings for danger. But the only threat here, in the Netherlands, is that we will edge too close, prompting a mass takeoff. If that happens, the air will be filled with the din of thousands of cries. Long lines of birds will form above the string of poplars lining the meadow, and the geese will drop down into another polder, hidden by trees and invisible to our eyes.

The Netherlands is the best place to see the greater white-fronted goose. Tens of thousands of the birds winter there each year, in tranquillity. If a cold snap comes, France, especially the northern region, may be visited by a few dozen or hundred geese. But they are often frightened by the shots of hunters and tend not to linger, soon flying back home again.

The greater white-fronted goose, *Anser albifrons*, is distinguished from other geese by the white circle at the base of its beak and the black stripes on its gray belly. It nests in the tundra of the Siberian and Canadian High Arctic and winters in central Europe, as well as along the western coast of North America and in eastern Asia. It is a great migrator.

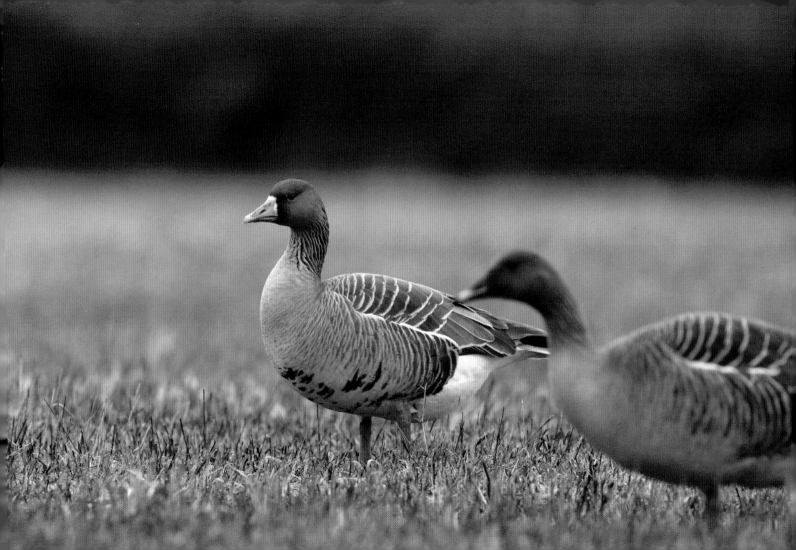

Common buzzard

It is very cold, but the sky is blue. The ground is covered with frost, and it must have been a harsh night for the animals. Though it is nearly noon, the sun seems reluctant to climb to its zenith. Above the barren wood, a pair of buzzards circle in concert. From time to time, one of the birds gives the characteristic mewing cry of the species. Is it the beginning of a mating ritual or simply a sedentary couple patrolling the neighborhood?

During the winter, large numbers of buzzards from Scandinavia or Eastern Europe are attracted to milder climates, especially if it has been unusually cold in the north. You can see the birds perched, unmoving, in trees or on posts. You may also observe the buzzard soaring above the highway, attentive to all that passes on the ground, ready to swoop down on an imprudent field mouse or vole.

The buzzard varies in its plumage. Some birds are very dark, while others are nearly pure white. Because of its varied plumage this common bird may often be confused with similarly arrayed birds of other species.

Of all the European birds of prey, the common buzzard, *Buteo buteo*, is indeed the most common. From northern Scandinavia to the Spanish sierras, from Ireland to the Ural Mountains, the buzzard can occupy any number of habitats, as long as there are trees in which to nest. While those that live in temperate Europe are principally sedentary, buzzards in the north of the continent migrate twice a year between their nesting grounds and the European south.

JANUARY

4

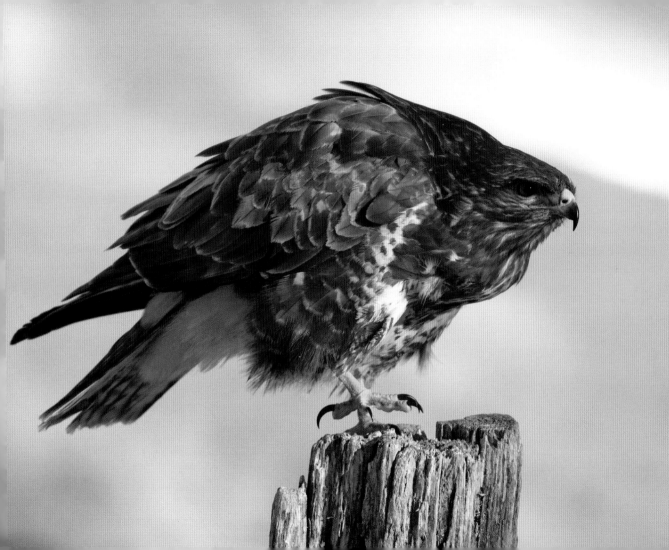

European starling

The starling, known for its brazen ways, is often the first to stuff itself with grain or suet at the bird feeder. With a gawky gait, it comes to search for its provender, using its size to push past titmice and even greenfinches, as long as the grain or suet lasts. The starling is a scrapper, often seen quarreling with its companions over a bit of food.

In winter, starlings can form roosts of hundreds of thousands—sometimes even millions—and their flight at dusk makes superb arabesques in the darkening sky. The sight is not so pleasant for the farmer who sees these hordes land in his trees, and is even less pleasing to city dwellers when the birds target the trees lining a peaceful street. The parked cars covered with droppings the next morning are a less than delightful sight.

The starling is commonly rebuked for this offense, and even treated as something of a pest. But in the countries of Eastern Europe and in Russia, its annual return is greeted with as much pleasure as that of the swallow in the West. There, the starlings are considered a sign of spring's return, and children in school build them birdhouses.

JANUARY

5

A devilish opportunist, the European starling, *Sturnus vulgaris*, can be found everywhere in Europe, in northern Africa (during the winter), and all the way to Central Asia. It has also crossed the Atlantic as a stowaway and has now spread throughout North America. Today, however, certain populations are on the decline in Western Europe as well as in England, as nutritional resources have diminished. In winter, these areas receive massive contingents of competing birds from the east.

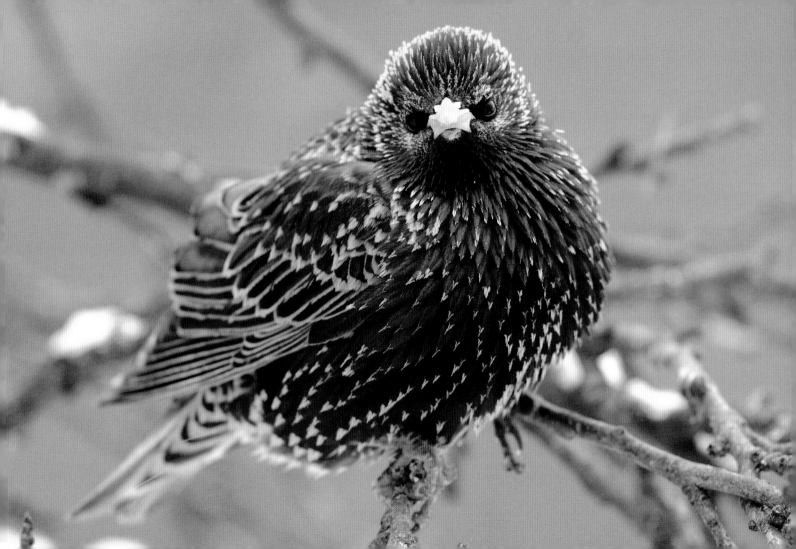

Griffon vulture

My first memories of the griffon vulture go back to the mid-1970s when, as a young ornithologist, I spotted some of these raptors in a Spanish sierra. At the time, the French population was quite sparse, and confined solely to the Pyrenees range. Today, the species has been successfully reintroduced in the Cévennes and the Alps, and the birds, with their great flying wings, can be seen gliding majestically in the sky in those regions. In fact, the vulture is known, first and foremost, for its flight: as a large brown rectangle gliding above gorges or cliffs and, without beating its wings, soaring to the greatest of heights. Along with other raptors, it is perhaps the most beautiful living illustration of the verb "fly."

In winter, vultures can also be seen perched on a rocky peak, banded close together, their heads slightly hunched into their shoulders, waiting. Waiting for what? In this cold, gray season, there are no thermal drafts on which to fly. The raptors' wings are deprived of their best ally: heat. These earthbound vultures resemble a team of Icaruses, their wings burnt by the sun of a long-ago summer.

Vultures are scavengers who are essential to the pastoral ecosystem. The true garbage collectors of nature, they help relieve it of domestic (or wild) animals who die in the mountain pastures of summer. The vulture's shape and appearance have long made it a sinister animal in the eyes of humans, but it remains an indispensable ally. In Asia, the poisonous residue of an anti-inflammatory drug used in livestock has, in the space of just a few years, reduced the continent's vulture population nearly to zero.

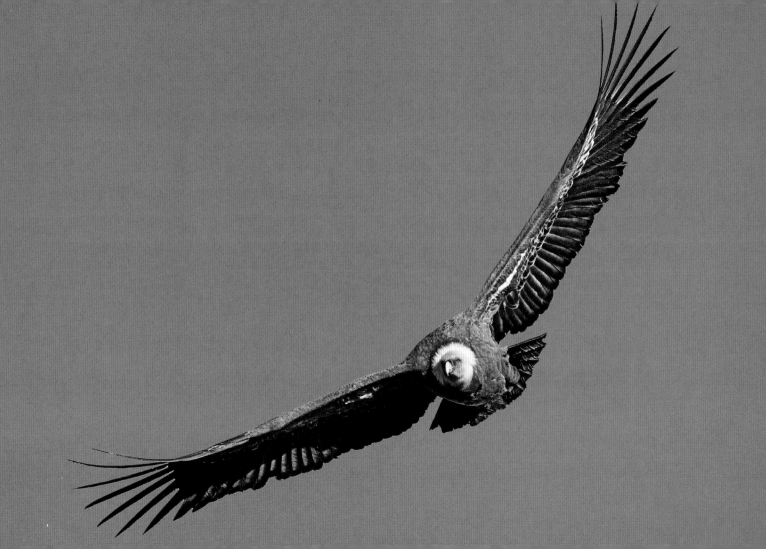

Eurasian blackbird

On this cold winter's day, it is one of the only creatures visible. In the dormant garden, the inky silhouette of the blackbird, despite its color, brings life to the trees where the bird perches and issues its reproachful cries. The cat, below, winds through the garden as well, its steps muffled by grass bleached by nighttime frost. Leaping from branch to branch, the blackbird follows the cat's progress, punctuating it with *tuk-tuk-tuks* of alarm.

The Eurasian, or common, blackbird is not known for its discretion. Always on the alert, easily alarmed and full of chatter, the male begins to sing in January, announcing the courting season amid the falling night. Perched well in view, in a tree or on a satellite dish, he sings—and happily, his song is melodious, fluting, and musical. To these briefest of days where the darkness lingers, he brings a whiff of gaiety and optimism.

Aside from the period when it broods and raises its hatchlings, there is hardly a moment when the blackbird is quiet. When its fledglings are old enough to fly, the blackbird raises its voice once more, sounding the alarm in every direction as its clumsy young ones navigate the trees and ground. Blackbird, chatty bird …

Scattered throughout Europe and into Asia but absent in the Americas, the Eurasian blackbird, *Turdus merula*, is a very common species. Over time, it has learned to love living among humans, and it does not hesitate to nest in even the smallest gardens in the heart of large cities. Most birds are resident, though those nesting in the far north are obliged to leave these places in winter and head south.

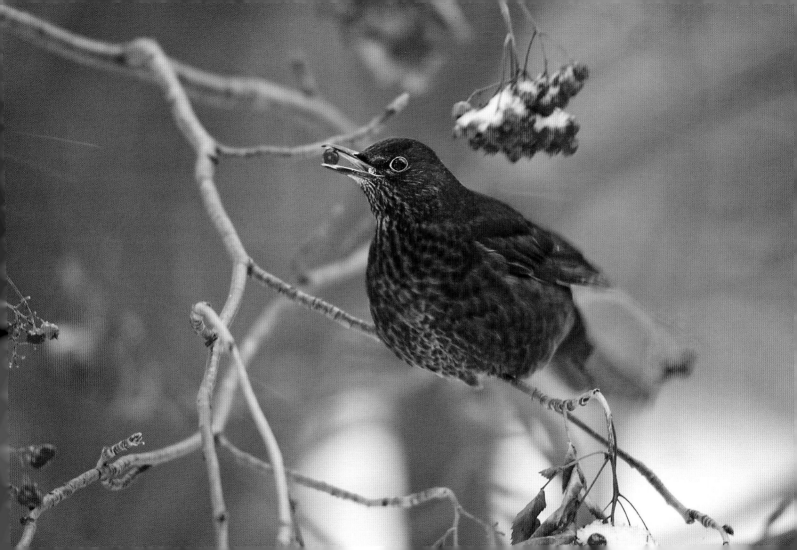

Northern pintail duck

At the shore of the Gulf of Morbihan in Brittany, it is low tide. Ducks splash in the sludge that extends nearly to the horizon. The males have a long tail, a pale gray body, a white neck, and a brown-black head. These are pintail ducks, who have flown from the Russian tundra to pass the winter here. They mingle with wigeons and teals, two other varieties of duck. The winged mass riffles with flaps, quacks, hisses, takeoffs, and landings. The majority of pintails, however, will spend the winter much farther south—in Africa—at the edges of the Sahelian grasslands, in Mali's Inner Niger Delta, or along the Senegal River.

In the first days of March, the African birds return. They quickly pass through France before continuing on their route to the north. The lower part of their bodies is tinged red: their plumage still bears traces of red laterite dust, evidence of their weeks in Africa. In a pool of water, the males parade around the females. A swallow glides along the water's surface. For the pintails, spring is in the air.

A great migrator, the northern pintail duck, *Anas acuta*, travels thousands of miles between the areas where it breeds (Scandinavia, Siberia) and those where it typically spends the winter (sub-Saharan Africa). A fraction of the population, however, stays closer to home, spending the winter on the Atlantic coasts of Europe and on the Mediterranean. The species also nests in the Great Plains of North America, passing the winter months particularly on the Texas Gulf Coast.

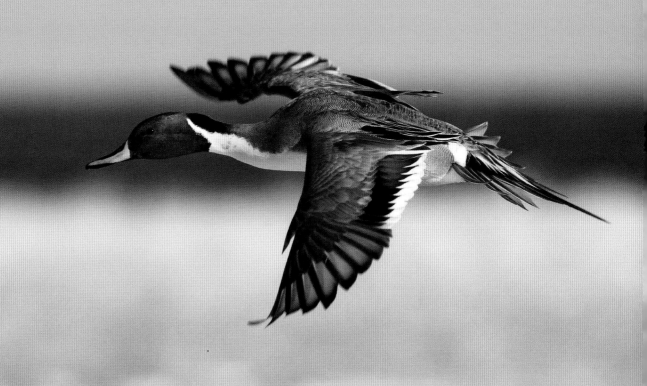

European greenfinch

I would readily place the greenfinch among the simplest and most modest of birds. Its plumage is modest, first of all—not bright green or yellow, but a grayish yellow-green. Its song is a simple one, a mix of gentle trills and squeaky cries. Finally, it lives in ordinary places: in gardens, in city parks, out in the country where little groves of trees may be speckled with green—the green of the greenfinch. In winter, it joins up with other birds such as the goldfinch or the chaffinch, who lend a little color to the group. But you can also spot greenfinches at the bird feeder where, ordinary as they are, they refuse to give up their share, making an aggressive bid for their sunflower seeds.

Nevertheless, slowly but surely and for reasons still little known, the ordinary greenfinch is seeing a dwindling of its numbers. Is this an effect of climate change, or of some transformation in its habitat? The greenfinch tells us nothing, and it is up to us to find out.

JANUARY

9

The European greenfinch, *Carduelis chloris*, belongs to the finch family, as do goldfinches, chaffinches, linnets, siskins, crossbills, and bullfinches. Scattered throughout Europe, the greenfinch frequents the countryside and suburban habitats, and is quite well acclimated to both.

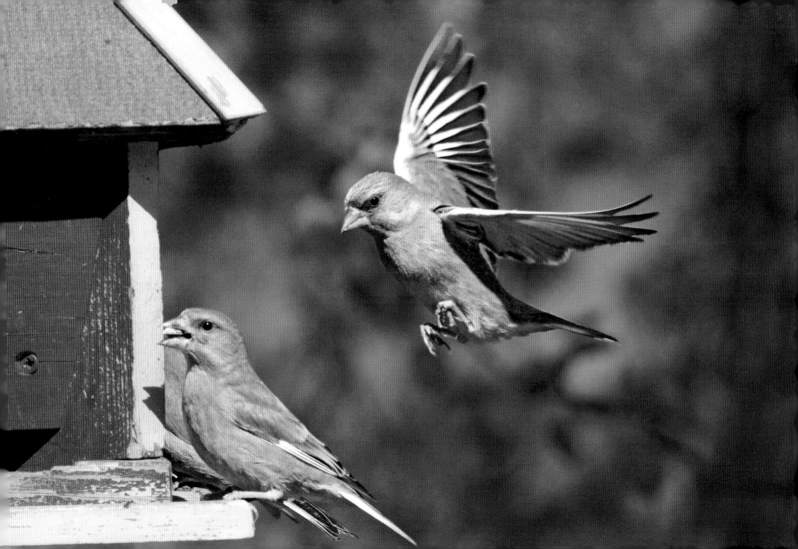

Eurasian collared dove

Although this bird is known in North America as the Eurasian collared dove (or simply the collared dove), it is known as the Turkish dove in most of Europe. Why? Until around sixty years ago, the bird's habitat was limited to the Middle East and Eastern Europe. Starting then, for unknown reasons, this dove began a vast migration toward the west, gradually colonizing all of Europe, then North Africa, and even a part of North America. Acclimating easily to the new habitats it encountered, in France as elsewhere in temperate Europe, the dove settled down in cities and villages, perfectly content to live among humans. It has always felt odd to come across this bird in its original habitat, on some acacia bristling with thorns at the edge of the desert, as I recently did in Oman. How strange that this was the same species that would soon greet me back in my yard in France.

In Western Europe, the Eurasian, or "Turkish," collared dove, *Streptopelia decaocto*, is more or less resident, even if movements of the birds are seen at some migratory sites. It is found from sea level to higher altitudes (nearly 4500 feet [1372 meters] in the eastern Pyrenees), and from nearly as far north as the polar circle all the way south to the oases of North Africa. It provides one of the most striking examples of a "conflict-free" colonization, since the dove's presence seems to have had no negative impact on other species.

JANUARY

IO

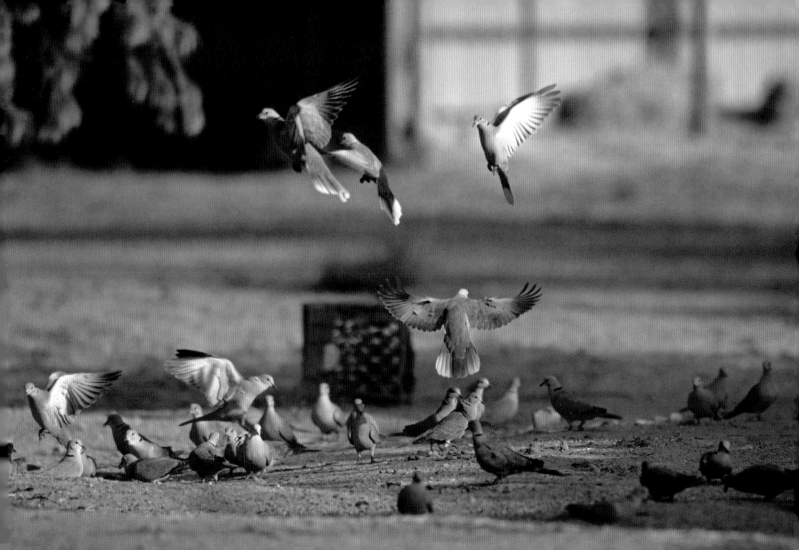

Arctic loon

On a cold and hazy winter's day, the surface of the lake is smooth as a mirror. A coot navigates near the bank, leaving ripples in the water. Farther offshore, a substantial gray silhouette floats amid the gray water and sky. This ghostly bird is an Arctic loon. It has come to spend the winter inland, far from its native tundra. It has taken the opportunity to exchange its breeding plumage, dominated by black, white, and gray, for a temporary coat of gray and white, as if to pass unseen through the drab wintry world. Slowly it swims, and slowly it dives underwater, leaving only a few rings at the surface. The Arctic loon is a highly skilled diver. It can stay underwater for more than a minute, hunting for small fish. Here it is resurfacing: just its head reemerges, followed a few seconds later by the rest of its body. It comes up farther away, one eye on its observer. The loon is the most restrained of birds: no great beatings of wings, noisy displays, or brightly colored plumes. Above all, the Arctic loon seems to want to melt into its winter environment and become invisible.

The Arctic loon, *Gavia arctica*, nests in the European and Siberian Arctic. A related species, the Pacific loon, or *Gavia pacifica*, reproduces in eastern Siberia and North America. All these birds leave the high latitudes at the end of the summer to winter in the temperate regions of the Atlantic and the Pacific, most often at sea, but also on the great interior plains.

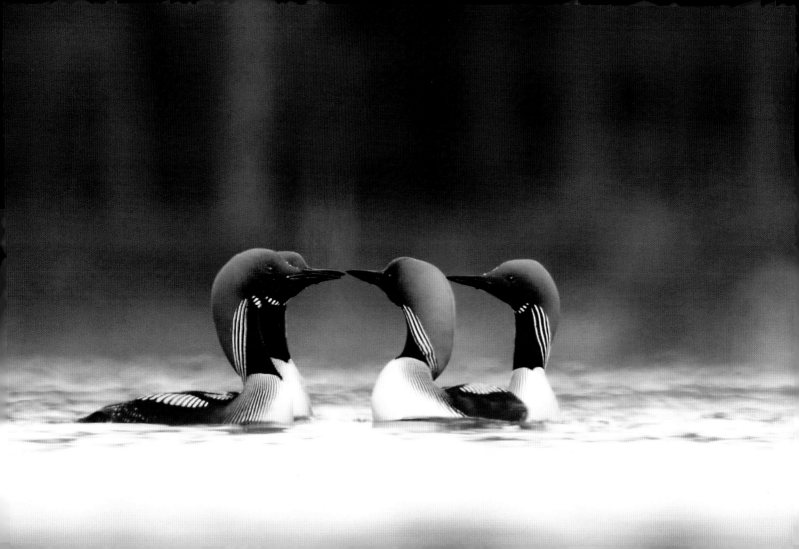

European magpie

The garden is dormant—or almost so. At the top of a pine tree, the magpie chatters ceaselessly. And to whom? The blackbird, perched a few yards away? The hedge sparrow rummaging in the flowerbeds? The wary tits, who fear the magpie? Or perhaps a person indoors in his study, who has overheard her shrill, rasping cries? It hardly matters. More chatterbox than thief, the magpie reminds us of its presence throughout the year. It chatters because the cat is walking along the path; it chatters again because the letter carrier has dropped the mail into the mailbox; it chatters when it arrives at the bird feeder, a conquering emperor, sweeping away the sparrows, greenfinches, and other small birds who until that moment were devouring the seed left for them.

In a few days, the male and female magpie will begin to build their spring nest. Before other birds, the magpie alerts us that the time has come to start thinking about the next generation. And all this while chattering away at any provocation.

The European magpie, *Pica pica*, is a resident species; the birds do not travel far from their place of birth. With a vast distribution around the world, the species ranges from Europe to northern Asia, and also includes North America and, to some extent, northern Africa. The magpie is fairly omnivorous and sometimes attacks young birds of other species.

Cape petrel

The place to look for the cape petrel is the Southern Ocean. In fact, "look for" is hardly the right term. You need to take a boat and maneuver through the Drake Passage, that famous body of water separating the South American continent from the Antarctic Peninsula. It takes a strong stomach not to simply stay in bed. When I awoke—after what one might call an agitated night—I remember seeing dozens of birds gliding behind the boat in perfectly choreographed formation, soaring up on the wind then coasting the length of the ship's rail. The flock approached very near, then sailed up and out as if to leave us, but soon circled back to the ship's stern, ready to ascend again.

The cape petrel is a superb species, beautifully patterned in brown-black and white. For this reason, it is also called a "pintado," or painted, petrel. Along with the albatross, it accompanies those sailors crazy enough to venture forth through these waters constantly roiled by violent winds.

Limited in its habitat to the Antarctic and sub-Antarctic oceans, the cape petrel, *Daption capense*, nests mostly around the Antarctic Peninsula and the islands of the Scotia Sea. Cape petrels nest in cliffside colonies. After reproducing, the birds range freely over the Southern Ocean, over the course of the winter, and head as far north as Angola, Australia, and the Galápagos.

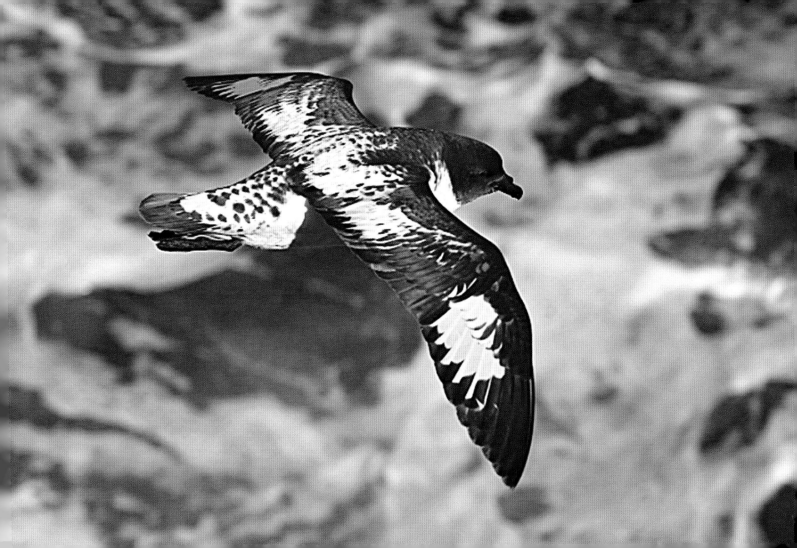

House sparrow

W hole volumes could be written about the house sparrow. For those who observe the life around them, the sparrow appears everywhere, every day. Mischievous, curious, cheeky, quarrelsome, adaptable, loudmouthed, flirtatious, aggressive: all these qualities, and many more, are the sparrow's in spades. Modest in its livery and its vocalization, the house sparrow nevertheless leaves no one indifferent—if only because it has, in places, become very rare. It has nearly disappeared from London and other European cities, as a result of pollution, the disappearance of insects, and, no doubt, other factors yet to be clarified.

The sparrow can be found in farmyards and playgrounds, in subway stations, in supermarkets (in the fruit and vegetable aisle, or near the grains), on sidewalks or chimneys, on the shrubs in a hedgerow, and even on boats. It chirps, flutters, quarrels, always in motion. It is a little brown and gray flea that leaps for the tiniest crumb of a sandwich. To observe the sparrow is to see the liveliest side of life.

Now omnipresent, the house sparrow, *Passer domesticus*, is found in Europe, Asia, and Africa. And it was introduced in the Americas with such success that it has now spread worldwide. The male is characterized by a brown back, a gray cap, and a black throat, while the female is drabber, with brown striations.

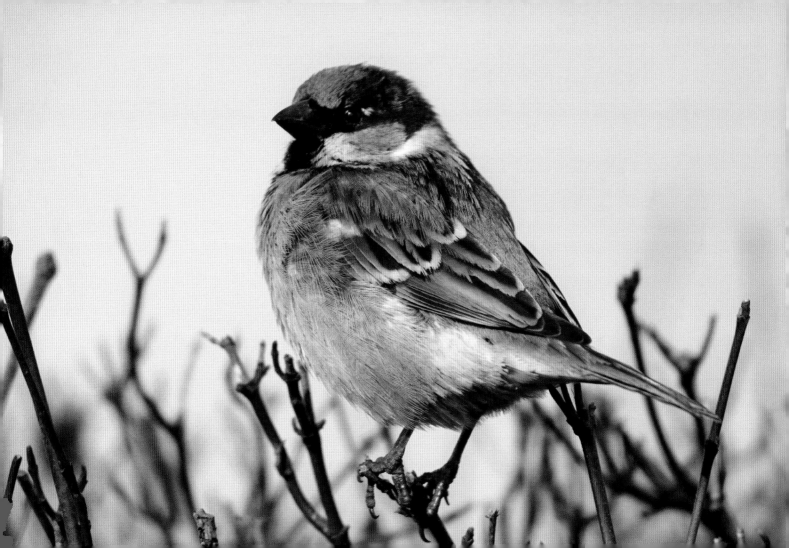

Water rail

In winter, there are markedly fewer bird species to be seen in temperate zones. Many species head for warmer territory. Those that remain can be seen more easily, and may often be discovered by bird-watching beginners for the first time.

At the edge of the frozen pond, among the jumble of reeds flattened with ice or, instead, stiffened into an *I*, the water rail trots, beak outstretched, always on the alert, shaking its slightly raised tail with each step. What the observer sees is most often a furtive shadow, quick to conceal itself. Only patience and discretion allows us finally to spot the water rail, always so skittish and attentive to every gesture, sauntering along the edge of the reeds. At the smallest alarm, it will slip quickly into the vegetation and refuse to come back out.

Such is the life of the water rail, a discreet and fearful dweller at the edges of swamps and ponds. You may hear its cry, which resembles the grunting of a pig, more often than you see the bird.

The water rail, *Rallus aquaticus*, is for the most part sedentary. Nevertheless, the temperate regions of Europe receive a contingent of water rails each winter from the north. The birds spend the harsh weather in humid places. Their cries, which sound like high-pitched grunting, can be heard both night and day. Similar species can be found in North America.

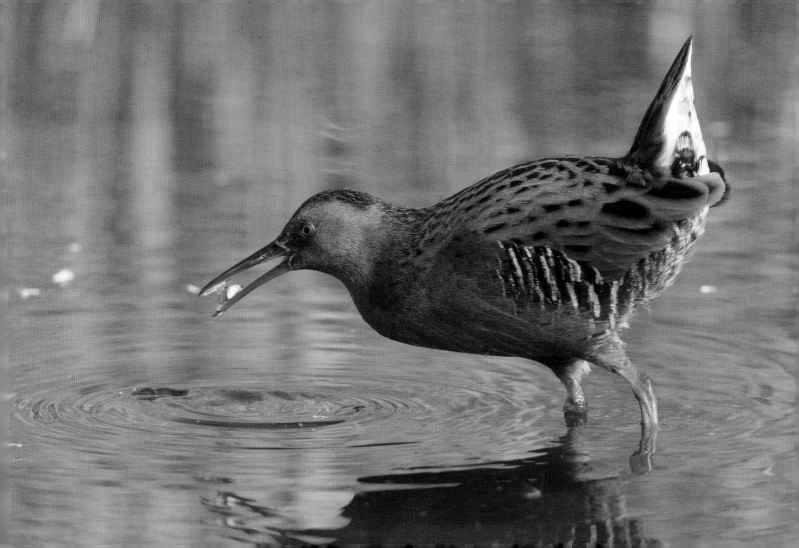

Ross's goose

In Europe, the majority of geese are gray. This is not the case in America, where there are two white species: the snow goose and Ross's goose. Ross's goose, which is relatively small, flies south from the great Canadian northwest each winter, and spends the season primarily on the West Coast of the United States. It was in the Sacramento Valley, east of San Francisco, that I spotted one. In a huge field of corn stubble, the Ross's goose was sharing its sustenance with its larger cousin, the snow goose, and the sandhill crane. There were thousands of birds. Their hubbub could be heard from several hundred yards away. And the noise reached still farther until, suddenly and for some unknown reason, a part of the gaggle swirled up into the air for an instant, then, like a shower of snow, fell in separate flakes back to the field. As soon as they landed, the birds resumed their frenetic honking. Some of them, extending their necks, never took their eyes off the observers marveling at the spectacle they created.

Ross's goose, *Anser rossii*, is a snow goose in miniature. It nests in the Canadian Arctic and winters all along the West Coast of the United States, and farther east in the state of Texas. Threatened with extinction more than fifty years ago, the species has rebounded beautifully, thanks to an effective policy of protection focused on its migration sites and winter habitats.

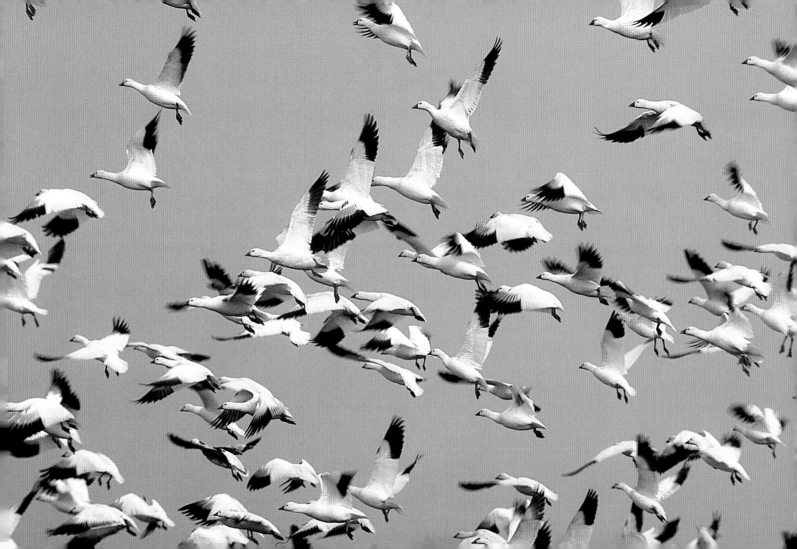

RAIN FOREST BIRD-WATCHING

When the cold and gray weather settles in over Europe, it is a good time to seek out the heat and sun of the tropics. Having left Europe shivering behind us, we find ourselves newly disembarked in a warmer land. Our first steps into the rain forest are terrifying. Besides the heat and moisture, the trees are enormous and the undergrowth is dense. The birds, calling to each other with their myriad cries and songs, are invisible in the foliage. We are plagued by frustration. We can see nothing, identify nothing. So why have we come here? Our eyes search in vain for a brown shape eclipsed by leaves, while one hand slaps at mosquitoes and the other tries to prise an enterprising leech from a foot. All this in clothes dripping with sweat…

It takes several days for our bodies and senses to grow accustomed to the environment. As we get our bearings, what was once forbidding becomes almost familiar, and observing birds becomes easier. We are not yet (tropical) Robin Hoods, but, little by little and with increasing pleasure, we begin to explore this habitat blessed with the greatest biodiversity on the planet.

Ornithology in the rain forest requires patience, a constant alertness of the senses, and a certain coolheadedness. After a period of fumbling and doubt, you become familiar fairly quickly with the dark forests, taking care not to break branches or crunch leaves while walking. Soon, you move like a wild animal in search of your prey: birds that offer the observer a procession of phenomenal colors and astonishing shapes.

Black-headed gull

The Seine is gray and the sky heavy this morning. The trees on the quays are bleak, their branches bare. A long barge crawls slowly toward the sea. But a few bundles of white feathers twirl and whine above the flow of water. The black-headed gulls are the river's flames of life. Each fall, they return from central and northern Europe, and they stay here until the following March. They sustain themselves with what they find on the water; some even embolden themselves to bicker over bread with sparrows and pigeons. Paris would not be what it is without its river and the gulls that give it life.

When evening comes, you see streams of birds returning swiftly to some roost on the outskirts of town. Silently, they melt into the blackness of twilight. They will reach their resting spot at night, caught like a flurry of bats in the moonlight, casting their reflections on the pond where they sleep.

In the winter, the black-headed gull, *Larus ridibundus*, has a white head, with a small black mark behind the eye. In the spring, the species assumes its breeding plumage, characterized by a chocolate-brown crown that covers the head. The black-headed gull makes its nest on big inland ponds and lakes, and many spend the winter on the European coasts.

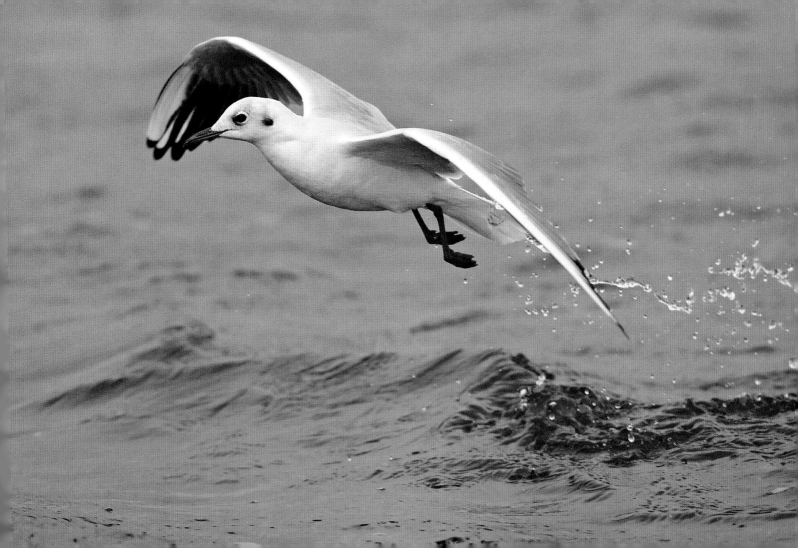

Common goldeneye

As with many ducks, the male of the common goldeneye has a superb plumage, while the female's feathers are gray and brown. As a young naturalist, I remember spending long moments admiring photos of this species, which nests in the Scandinavian tundra. And when I spotted some goldeneyes for the first time, on Lake Geneva, I was powerfully moved. There they were at last, within sight of my binoculars! On this cold winter day, the males were already making their display, dancing around the females, abruptly throwing back their heads. The females, indifferent to this masculine outpouring, continued diving for food without interruption. Later, I saw the goldeneye again on a Scottish loch, in the month of June; on another occasion, I spotted them on a Norwegian tundra. The male is always beautiful, and does indeed have golden eyes. This species leaves no observer indifferent— no doubt because the exotic ornamentation of its black-and-white plumage contrasts so strikingly with the austere habitats that the bird frequents all year.

The common goldeneye, *Bucephala clangula,* can be found all over Eurasia as well as in North America. Nesting in the highest latitudes, the bird flies south in winter toward temperate zones, choosing either coastal waters (notably sheltered bays) or big lakes as a habitat for the months of October through March, or sometimes later.

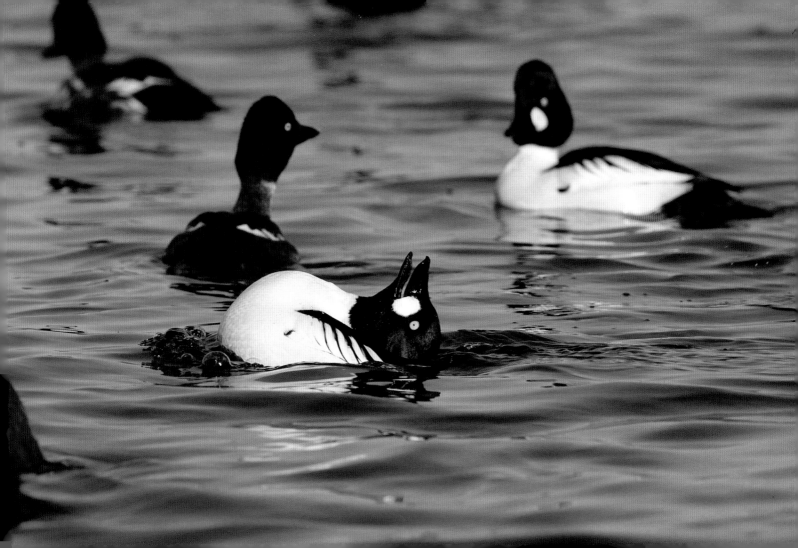

Gentoo penguin

When you land at Port Lockroy, on the Antarctic Peninsula, you are immediately struck by the swarming of the colony of penguins—and by its smell. You might think you were in a fishing village, so redolent is the air with the odor of raw fish. Thousands of penguins are nesting here, clustered tightly together.

The male has carefully made a semblance of a nest. That is to say, he has brought his companion a host of small pebbles, which she has arranged into an attractive circle and sat upon in order to lay one or two eggs. But both sexes take part in the incubation, and the changing of the guard is accompanied by a boisterously noisy display, as the penguins extend their necks and beat their wings. The birds are not very shy, since humans are unfamiliar to them as predators, but they will not allow visitors to approach close enough to touch. They always keep strangers at a prudent distance, for some minimal security. Their worst enemy remains the leopard seal, which is never too far off, stationed on an ice floe and ready to pounce on the first careless penguin.

The gentoo penguin, *Pygoscelis papua*, nests in colonies in the Antarctic as well as in the Falkland Islands. A little clumsy on land, with a waddling gait, it is fast underwater, attaining speeds up to 22 miles (35 kilometers) an hour. Like other species of penguins, it may eventually suffer the effects of climate change as temperatures trend upward.

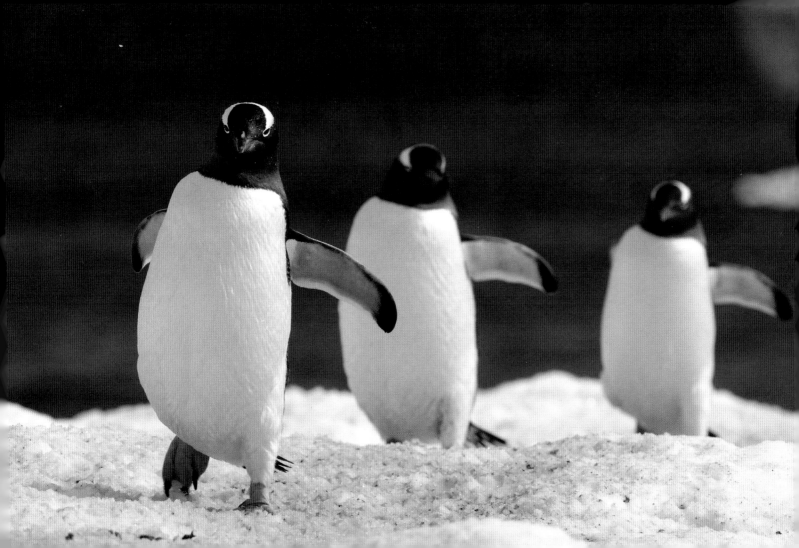

Ivory gull

The ivory gull lives in the very high Arctic. It rarely ventures beyond the line that separates its native ice fields from open water. When an ivory gull happens to wander as far as the European or American coast, it is hailed as a true event by bird-watchers.

So it was in January 2009, when a young bird arrived in the Arcachon Bay of France, after some fierce storms. A considerable number of bird-watchers traveled to the bay to catch a glimpse of this mythic species. After all, it's not every day that you can make it up to Spitsbergen or Greenland to admire the ivory gull at home. To these observers, it was odd to see the gull there, in the full sun, surrounded by utterly ordinary species. The ivory gull stayed more than a month and then, one day, flew off again. It must have flown back toward the cold of the north, for it was spotted again, a few days later, in the Irish village of Baltimore.

An inhabitant of the High Arctic, the ivory gull, *Pagophila eburnea*, has become rare. The melting of the polar ice caps, a consequence of global warming, has been calamitous for the species, which lives only on ice. In addition, the apparently elevated residual pesticides rates in this region seem to be having a negative effect on the gull's reproduction. The ivory gull is to birds as the polar bear is to mammals: a species in great danger of extinction.

Yellowhammer

The little road to the next village on this plateau in Auvergne, France, is bordered by old hedges. Behind them, the fields and the pastures, frosted with ice, offer little to see. However, just after a bend in the road, my brisk steps cause a little flock of birds to peel off into the air. Quickly, they position themselves on top of the bushes, shaking their tails nervously and giving soft *tics*. I have surprised a winter flock of yellowhammers, presumably while they were searching for seeds in the adjacent field. The males sport their beautiful colors of yellow and red-brown, while the females and this year's juveniles wear a drabber plumage, striped with brown and black. One by one, the birds fly back down to the neighboring field as peace returns, their observer remaining stopped in his tracks. There they can be seen hopping through the grass, feverishly seeking their food. In the distance a buzzard passes on its way to its perch for the night. It is cool, with night already falling though it is not yet five o'clock. Suddenly, with a chorus of sharp little cries, the whole flock of yellowhammers takes off for their roost, where they will spend the night huddled together until morning.

Among the European buntings, the yellowhammer, *Emberiza citrinella*, is one of the most common. It is primarily sedentary in temperate Europe, but the northern birds spend the winter on the shores of the Mediterranean. In winter, yellowhammers may join into flocks with finches (greenfinches, chaffinches, siskins) and sparrows.

Green woodpecker

Who is more loyal to tree trunks than the woodpecker? Photos or illustrations always show the woodpecker in the act of scrambling up a trunk to knock its beak into the bark to flush out tiny invertebrates. The green woodpecker, however, is an exception. In a big city park, on a walk in search of some wintering passerines, you are always surprised when a green woodpecker bursts up from the lawn. You may well know that this woodpecker likes to seek out insects on the ground, but there is always a fraction of a second in which you wonder what this big greenish bird who has just taken flight could possibly be.

The green woodpecker is a regular in the gardens and big parks of the city. But it can also be found in the forest, where its behavior is more discreet than in urban areas. Unlike other woodpeckers, it does not drum on tree trunks, but it can be recognized by the shrill cry that it makes in flight. It is the famous woodpecker "laugh"—very similar to Woody Woodpecker's, in fact, except that the green woodpecker is European, and Woody, obviously, is American!

The green woodpecker, *Picus viridis*, can be recognized by his plumage: a slightly dull green on the back (except for the greenish-yellow rump) and a gray-beige underside. The male and the female have a black "mask" around the eyes and a red crown, while the male has a red "mustache" that on the female is black. The species is very sedentary.

Gray heron

While closing the shutters of the house to the already darkened sky, I hear a low *quack!* from the sky. The slow silhouette of a gray heron flies over the roof, as the bird makes its way to a nearby body of water to spend the night—a mysterious shadow that soon disappears into the black clouds. By day, you can see the heron on the bank of the river, standing on one foot, its head hunched into its shoulders. Is it asleep? Is the heron dreaming, or, rather, is it waiting for a fish to pass within reach of its beak? If one does, with a sudden release of its neck, the heron will harpoon the unsuspecting fish in a flash. When the heron walks, it is slowly, with measured steps. It stops to inspect its surroundings, then moves on with equal solemnity.

The heron maintains its discretion throughout the year. In the spring, when several dozen couples nest in the big trees around the pond, one can hardly spot the comings and goings of the birds as they leave or return to their nests. But surely they know that among humans, at least, they have only admirers.

The gray heron, *Ardea cinerea*, is present on all the continents except for the Americas, where it is replaced by the great blue heron, *Ardea herodias*. As with other species, the gray herons of temperate regions are resident while those who dwell in the north are migratory, fleeing the harshness of winter to take refuge at the seashore or along rivers that do not freeze.

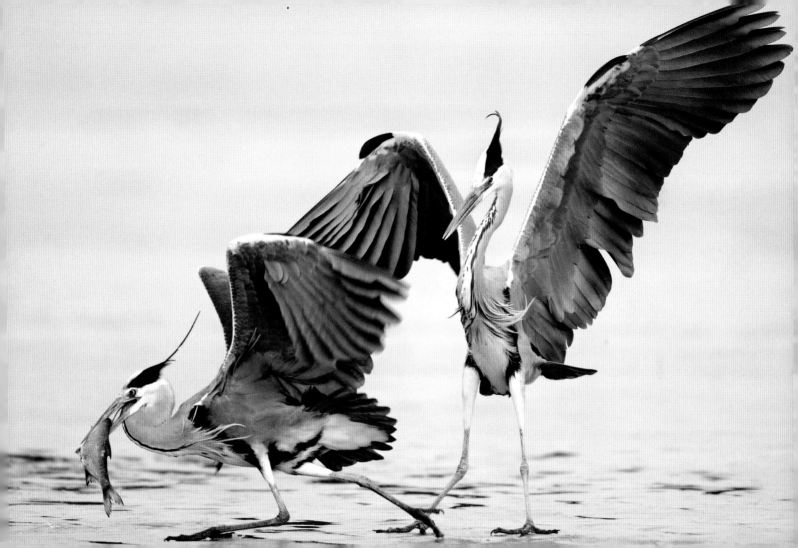

Eurasian nuthatch

On my daily walk through the little public park on my way to work, I despair at the morning silence. In winter, the only birdsong to be heard is the little shouts of contact between the tits, or the blackbird's sonorous call of alarm. This morning brings something new: the nuthatch has decided to put an end to the winter and to announce, to the world at large, that it is time for spring. To this end, it gives a musical series of *tui…tui…tui…tui…tui!* There it is on the trunk of a tree, head facing down toward the ground. Having spied me, it darts out of sight to the other side of the trunk. I soon locate it again: a good fifty yards higher up, it flies out to lay claim to a thick vertical branch. It pauses an instant, gives its insistent call, and, joyously, flies off again. Lively and impudent, the nuthatch is one creature who will never be cold.

Sedentary within most of its reproductive territory, the Eurasian nuthatch, *Sitta europaea,* can be found from Europe to eastern Asia. It nests in tree cavities, whose entry it narrows with mortar. After the breeding season, it may form flocks with other birds, such as tits, to search for food.

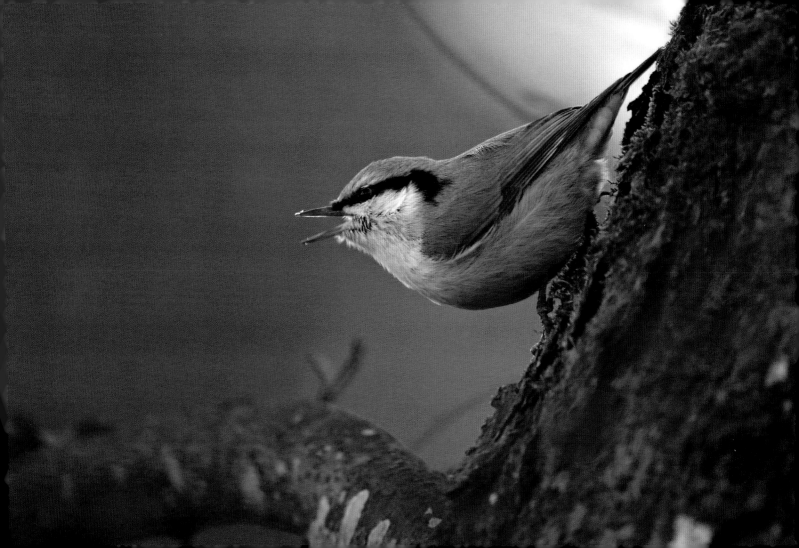

Red-breasted goose

Among the geese that visit Europe, the red-breasted goose is legendary. First, it is the most colorful goose, standing out spectacularly among the brown or grayish feathers of other species. Second, this species comes from the distant lands of the Taimyr Peninsula or the Novaya Zemlya archipelago, Arctic territories far beyond our reach. Finally, it is rare, an endangered species, and it winters in Europe only around the delta of the Danube River.

That is where I went to see it, in the company of some ornithologist friends. I was eager to observe some groups of this species, since I had only ever seen a red-breasted goose by itself. When we arrived in Northern Dobruja, despite the cold and gray weather, we all opened our eyes wide. Soon, we spotted a gaggle of geese in a field: more than two thousand of them, mostly greater white-fronted geese. But among the birds were around fifty red-breasted geese, displaying their red, black, and white plumage. There they were! Our hearts beating quickly, we drove closer to admire them. Too close, apparently: the flock took off like a single bird, in a chorus of honking and beating wings. It hardly mattered, for there we were, in the land of the red-breasted goose.

Long hunted, and threatened by the reduction of the tundra (where it nests) and progression of the boreal forest as a result of the changing climate, the red-breasted goose, *Branta ruficollis*, faces a future that is far from rosy. In addition to these threats, a large part of the population winters only between the Danube delta, in Romania, and the Bulgarian border. In the latter country, despite its protection under international law, the red-breasted goose remains a target for poachers.

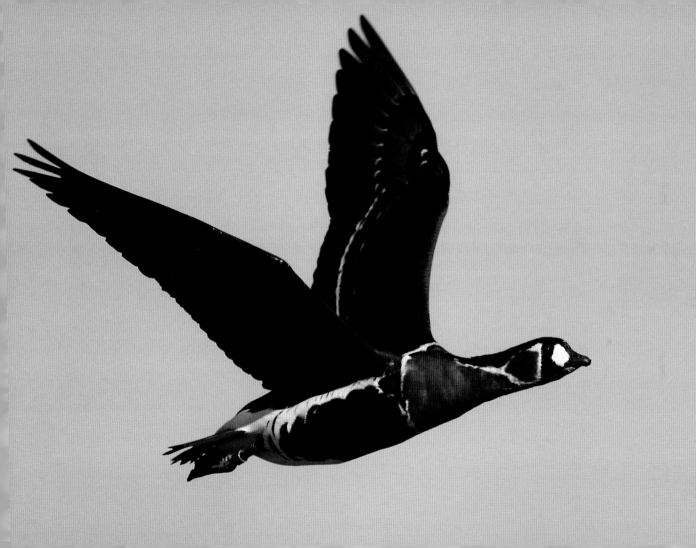

White wagtail

A t the edge of a large fountain in a city park, a bird trots along, energetically shaking its tail. A white wagtail is searching for the few small invertebrates reckless enough to brave the vicissitudes of winter. With a quick gesture, hardly pausing, the bird captures one, then continues its rapid steps around the pool's perimeter. In winter, white wagtails do not hesitate to venture into the heart of the city to search for food. Some even nest in these urban areas, as long as there is water, especially a stream or river. In metropolitan areas such as the large coastal cities of France or Great Britain, when evening comes, the wagtails form roosts of up to several hundred birds. There, you may find them perched on the roof of a train station or on the deck of boats at harbor, preparing to spend the night.

With a flap of the wings, the white wagtail takes flight, disturbed by the children playing around the pool. There it goes, winging off to another spot, its flight punctuated with resonant cries of *tsilip!*

27

The white wagtail, *Motacilla alba*, migrates from northern Europe to tropical Africa, while the birds of temperate Europe are content with shorter journeys that lead them to the ports of the Mediterranean. This is known as "leapfrog migration," with the birds of the northern territories "leaping over" the territory of the southern population.

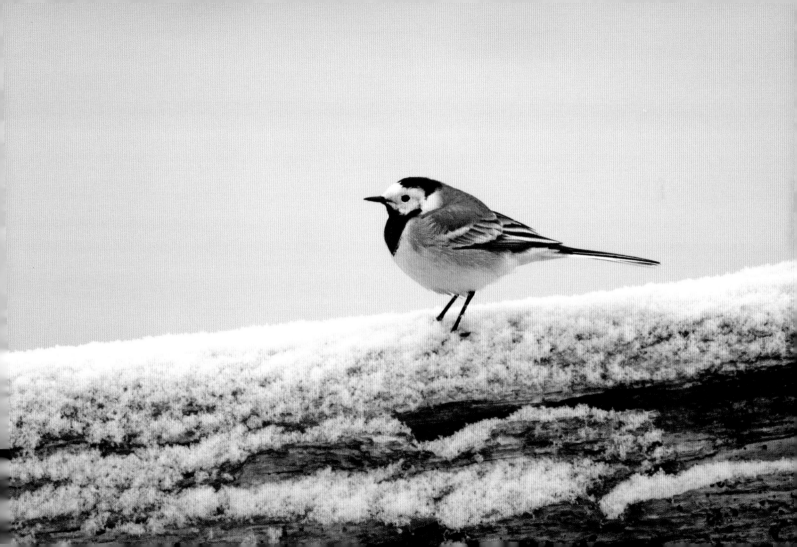

Eurasian oystercatcher

Gusts of wind make the sand dance along the bay, where the horizon fades into the incoming sea. Near the Banc de l'Illette, the birds begin to hasten to spots with the highest elevation. The tide is rising in the Bay of Somme. Plovers, sandpipers, and godwits mingle with curlews, who tower over them by several heads. Next to them, compact clumps of black and white feathers capped with a long red-orange beak signal the presence of the oystercatcher, the most gregarious of the bunch. At each arrival of a new group of small shorebirds or of a particularly strong wave, the oystercatchers take off in a chorus of high, fluting calls: *kluip…kluip…kluip!*

Later, at low tide, they can be seen striding up and down the beaches and mudflats in search of the mollusks they find so delicious. Their long straight beaks probe the sludge, from which they pull shellfish at regular intervals. They know better than anyone how to crack open the shells to gorge themselves on the salty flesh inside.

If it gets cold enough, the oystercatchers are forced to fly farther south, to find gentler weather conditions that allow them to feed themselves.

The Eurasian oystercatcher, *Haematopus ostralegus*, nests all over Europe, from Iceland and Scandinavia to the shores of the Mediterranean, but also farther east, in central Asia, eastern Siberia, China, and as far away as New Zealand. Many northern birds spend the winter on the Atlantic coasts of the British Isles and in France, from the Bay of Somme to the Arcachon Basin.

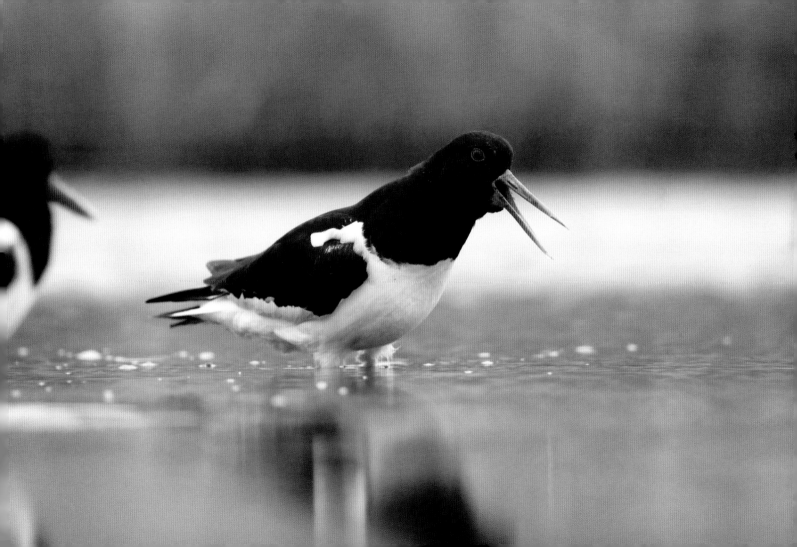

Wallcreeper

It was on the Grandval Dam, in the Cantal department of France, that I first saw the wallcreeper. On the concrete of the structure, nearly as dark as the basalt next to it, the bird hunted for its minuscule prey in the moss growing vertically out of the rock wall. It made its way with little leaps, like a climber rappelling down a rock face. From time to time, it took flight to travel a little farther. It transformed the gray of the rock where it stood into the likeness of a superb butterfly, as it spread its wings with their bright red markings.

There is something about the wallcreeper that captures the imagination. In the summer, it lives on the darkest mountain cliff faces. In winter, however, some birds descend to lower altitudes and even to the plains. During this season, you can find the wallcreeper on a dam, a church, a castle, a cliff, or even on the Panthéon in Paris, as in the case of a bird I spotted in the winter of 2004. This fleeting Parisian visitor had attracted a crowd of ornithologists, as well as some curious amateurs who were surprised to see a bird so foreign to the city.

It is not easy to spot the wallcreeper, *Tichodroma muraria*. When it is perched on the rocky wall of a cliff, it camouflages itself perfectly, all the more so because it explores each crag so minutely. It can thus disappear from sight for long moments, hidden behind an outcropping or within a crevice of the rock. It lives primarily in the mountains of Europe and the Middle East.

JANUARY

29

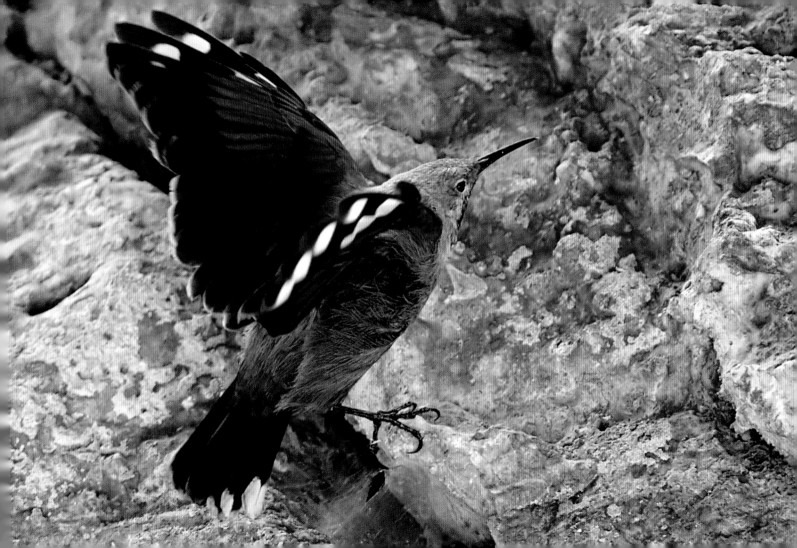

European eagle-owl

Night is about to fall. In the twilight, the cliff before us stands like an immense statue, its top dissolving into the dark clouds above. It is cold, and there will surely be frost tomorrow morning. It is in these conditions, however, requiring multiple layers of clothing, that the eagle-owl announces its intention to breed. With its call, it adds to the lugubrious atmosphere a song that makes a shiver run down your spine: a *hoo…ho!*, solemn and cavernous, echoing against the walls of the cliff and into the nearby valley. A slight wind riffles the bushes below our observatory, while we scan the rocks, as well as we can, for his silhouette. There he is! At the summit of the highest peak, he stands, stock-still, against the smoky sky where the moon struggles to break through. He has surely spotted us long ago, but given the distance that separates us, he knows he has nothing to fear.

Another deep *hoo…ho!* And then nothing. The great bird has flown off, melting into the night.

Threatened with near-disappearance in Europe around the 1970s, when it was still unprotected, the European eagle-owl, *Bubo bubo*, has since seen a resurgence in its numbers that puts it out of danger. It lives primarily in cliffs, deep valleys, and screes of rock, but the northern European populations dwell in the forests instead. It is a very sedentary species.

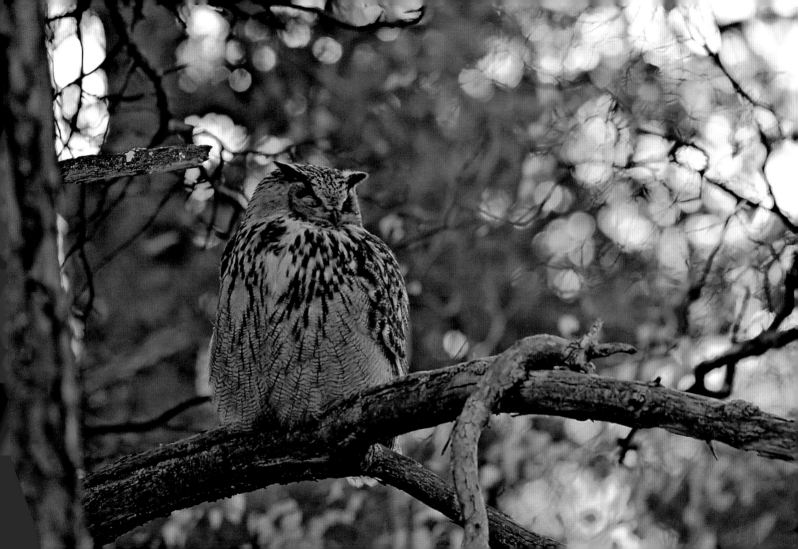

Blue tit

There is no bird more shameless than the blue tit. A regular at bird feeders, it is never the last to raid the seed scattered in the morning for small, feathered creatures frozen with cold. Quick and vivacious, it lands for a fraction of a second on the bird feeder's wooden perch, then flies off again immediately, a sunflower seed in its beak. It alights on a branch to strip off the shell, taking shelter from a magpie who succeeded earlier in stealing its food. Smaller than the finch, greenfinch, and starling, quicker than the great tit to claim its seeds, the blue tit is a little blue arrow shot through the gray of winter.

Outside the garden, the blue tit keeps itself just as busy. You can spot it in city parks or the wetlands at the edge of ponds, pecking at seeds that remain in the tufts of reeds.

But it is at the end of summer that I most love to see the blue tit, when the nesting birds merge back into a large flock. In that season, you can see one of these flocks, sometimes dozens of birds strong, crossing the yard while giving little high-pitched cries. So they pass, wandering, not knowing exactly where they're going, guided only by their search for food.

JANUARY

31

Present all over Europe and in part of Asia, the blue tit, *Parus caeruleus*, is one of the most common passerines seen in gardens, woods, and fields. The birds of the north migrate, but only irregularly, without any drive to relocate except after a good reproductive season and when seed becomes scarce in their nesting sites.

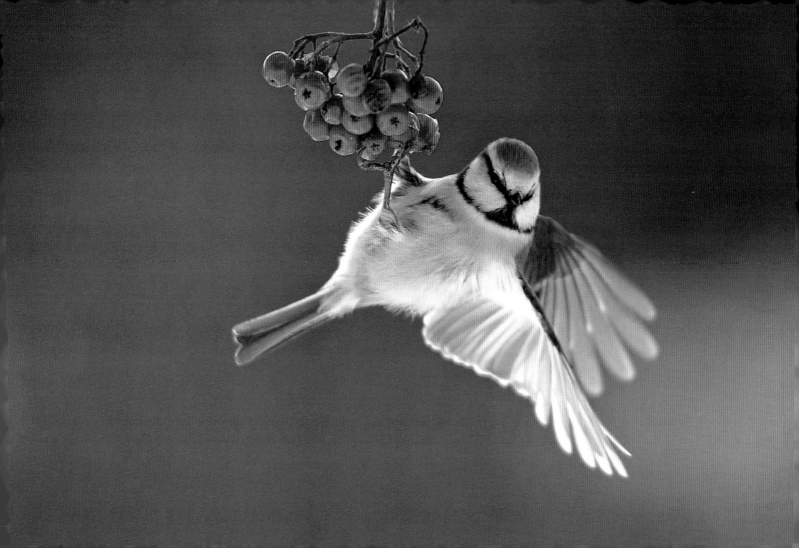

Green heron

The green heron is well hidden amid the green vegetation. Like many large wading birds, it is a perfect mimic, extending its neck toward the sky and holding itself as narrow and straight as possible. It practically looks like a reed itself. In any case, it can unexpectedly disappear amid the plants of the marsh. Very often, one may startle it into flight inadvertently. On sluggish wings, it moves off, giving a feeble, rasping cry, and assumes a position a little farther off in the reeds. Even if you know exactly where it landed, it's no easy matter to spot it again. But if you're lucky, you can sometimes watch it sunbathing at the edge of the reed bed. The heron may then show itself to be less skittish, while still maintaining what it feels is a safe distance.

Using its fine-pointed beak like a dagger, the green heron brings a quick demise to adventurous fish. Suddenly extending its neck, it catches and swallows the fish in one bite.

There are many subspecies of the green heron, *Butorides virescens*, spread throughout North and Central America. Its close cousin, the striated heron (*B. striatus*), found in South America as well as in Africa and Asia, was at one time closely attached as well, but evolution has since rendered it a full-fledged separate species.

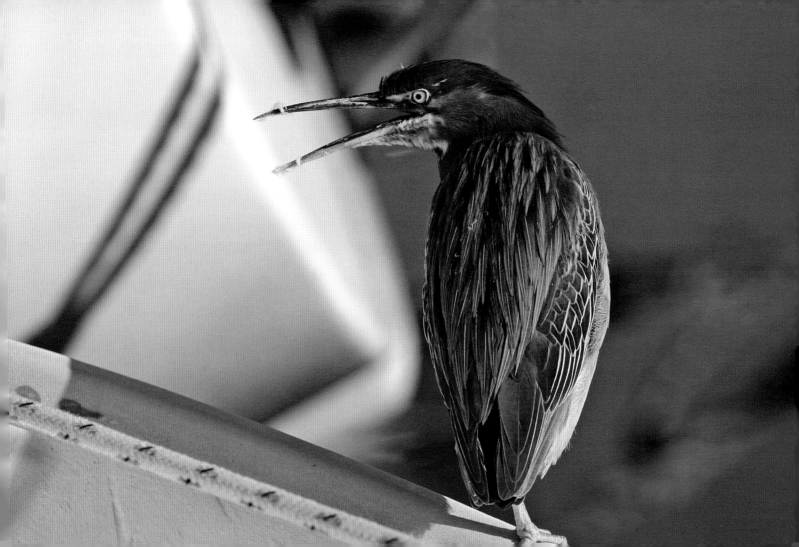

Tufted duck

On the Geneva waterfront, pedestrians stroll along the edge of the lake, and some toss bread to the birds. Dozens of coots and mute swans crowd around in response, while a noisy white army of black-headed gulls wheels above, all attracted by the food. Among these birds, some small ducks paddle at the center of the throng. The males wear a sober black-and-white plumage, while the females are chocolate brown. Each bears a small crest on the back of its head, and the irises of their eyes are a beautiful golden yellow. They have come from far away: from northern and eastern Europe, and even from western Siberia. There, the lakes and ponds are frozen for long months, while here, there is open water and no lack of food.

Farther away, outside the city, one can see big flocks of tufted ducks, heads under their wings, sleeping close to the shore. They are often accompanied by their relative, the common pochard, but also by great crested grebes and other waterbirds.

The majority of tufted ducks (*Aythya fuligula*) who spend the winter in western Europe come from very far away. But the species also nests in growing numbers in France, where there are now 1000 to 1500 breeding couples. It is one of the species of duck that reproduces latest in the season, with the females still caring for unfledged young as late as August.

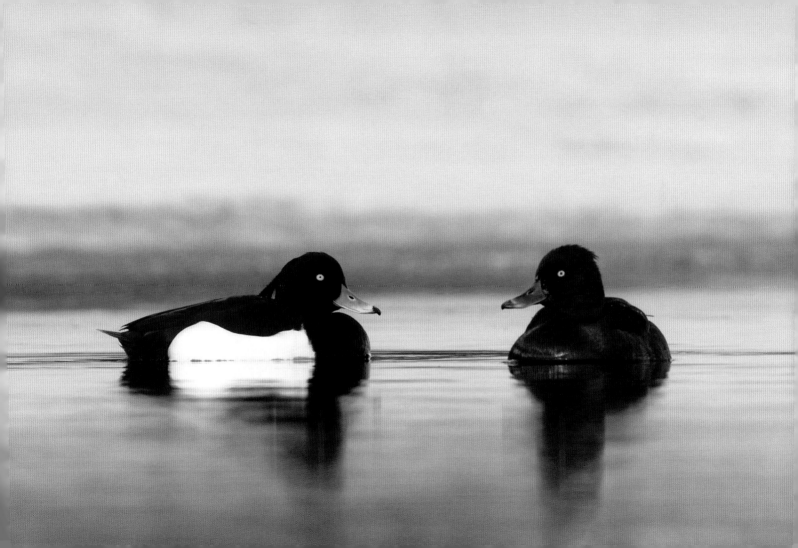

Gray wagtail

You usually hear it before you see it. *Tsip…tissip!* goes the gray wagtail's high, resonant cry. It has spotted us first. A moment earlier, it must have been trotting at the edge of the canal or along the riverbank, in search of a few microorganisms. There it is soaring off, with an undulating flight, thanks to its endless tail.

I have always been surprised by the extent to which the gray wagtail, whose belly is bright yellow, blends in with the ground it stands on, stone in particular. The gray color of its back and head permits it to go easily unseen. Quite often, even in Paris, I have heard it before being able to spot it. It walks with a rapid pace on the quay, at the very edge of the water, skimming the waves and pecking energetically at all that passes, unconcerned with the noise of the cars and their horns. In this small, disorienting instant, I suddenly recall the gray wagtails I have seen in summer, on the edge of a rushing stream high in the mountains.

Eclectic in its tastes, the gray wagtail, *Motacilla cinerea*, can be found in flatlands as well as high in the mountains. What is vital is that it be close to running water, where it builds its nest, well hidden among the stones of the riverbank. In winter, the mountain-dwelling birds leave these places before the cold and frost to join the contingent of birds on the plains, which in France are also visited by the birds from the northern territories. The gray wagtail nests in Europe and Asia.

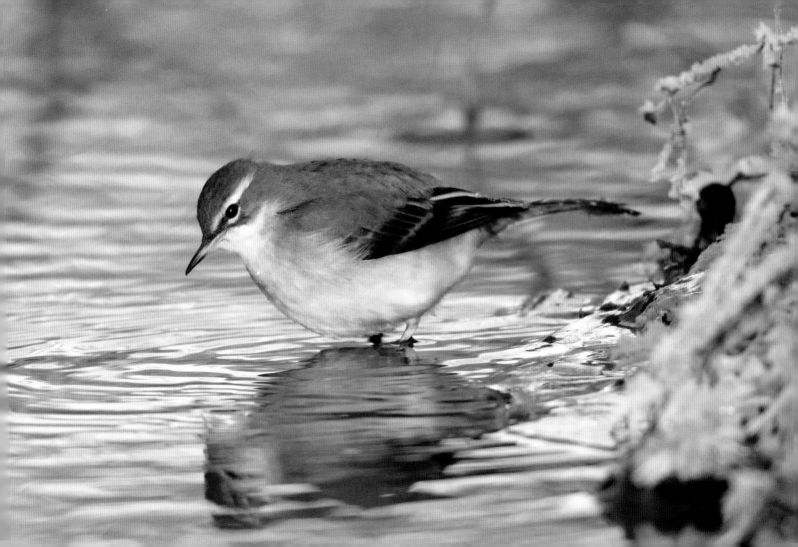

Macaws

Macaws are fantastic birds, big parrots glowing with vibrant colors who inhabit the emerald forests of the American tropics. Here, a group of bright blue and yellow macaws crosses the Orinoco at the close of day, noisily returning to a roost in the heart of the forest. Their powerful, raucous cries momentarily freeze the natural world around them. These large birds bear within them all the symbols of the first peoples of the Amazon: members of those tribes, and their gods as well, adorned themselves with the macaws' multicolored feathers. Like rainbows trailing with fronds, the macaws glide above canoes with a direct, rapid flight, leaving only a flash of memory in the fading sky. They are the most visible, and also among the most telling, modern ambassadors of tropical biodiversity—which today, in all its exuberance and color, is threatened with imminent disappearance.

The sight of a macaw in captivity, in a cage at the zoo, is a brutal testimony to our daily violation of this natural world.

Several species of macaws are endangered, extinct, or, like Spix's macaw and Lear's macaw, in critical danger of extinction. At the beginning of the twentieth century, macaws were hunted for their plumes to the point where their population was severely affected. Nowadays, however, it is the unchecked deforestation of the Amazon that poses the greatest danger to these birds.

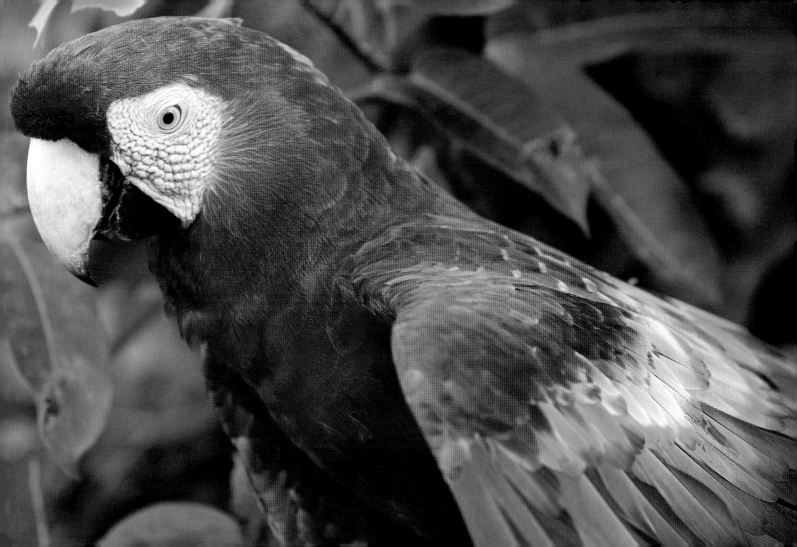

Great spotted woodpecker

In the woods, if you listen attentively, you may be surprised by the sound of a regular tapping on a trunk. Your eyes scan the surrounding trees, and soon you discover a great spotted woodpecker, perfectly still, except for its head tapping frenetically on the bark of an old oak tree. The bird is searching there for larvae or other small invertebrates.

It is the perfect season to observe woodpeckers in general, and the great spotted woodpecker in particular. As soon as the temperature inches up or the sky turns blue, the woodpeckers begin their nuptial display. As with neighboring species, the male great spotted woodpecker is distinctive in that, in place of classical birdsong, he substitutes a much more original form of vocalization, or "drumming." To call to a female, he hammers on a tree trunk with his beak, so rapidly that it sounds like someone shaking a tambourine. The relationship of the woodpecker to the tree is, you might say, a visceral one. For it is also in the tree trunk that the woodpecker digs a nesting hole in which to raise its young.

The great spotted woodpecker, *Dendrocopos major*, is clearly resident at the temperate latitudes of Europe and Asia. Farther north, the birds may migrate, depending on the available food resources. The species dwells primarily in the forest, but it is also found in urban parks and gardens, and in the flatlands as well as in the mountains.

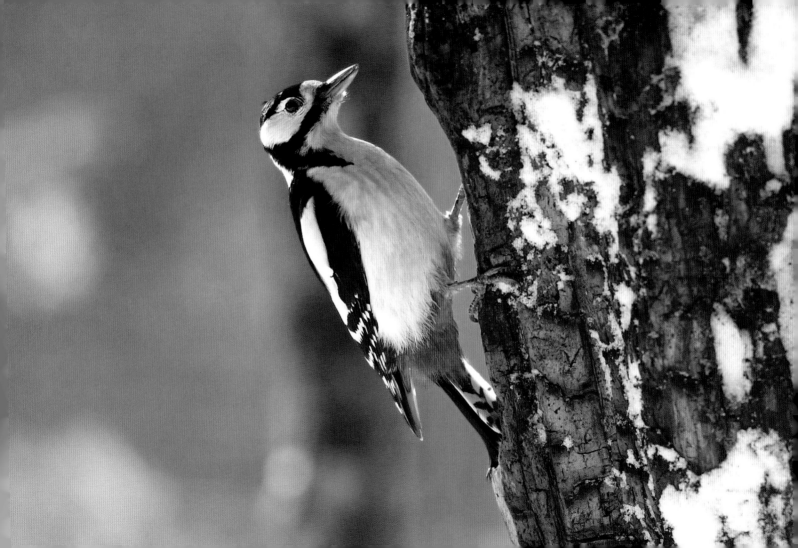

Dunnock

The dunnock is also called a hedge accentor, but in truth this bird provides little visual accent to the garden hedges where it most likes to live. It is more likely to remind you of a mouse. Always on the ground, it seems to scurry rather than hop. Its drab gray-brown plumage and unobtrusive behavior make it a double for the little domestic rodent, and the resemblance is further reinforced by its short, high, thin cries. However, the dunnock's distinctive song, which is heard starting in winter, is sprightly and fairly musical.

In fact, as we all know, clothes do not make the man, and the dunnock is actually a rascal. It leads a riotous sexual life. The female is a great seducer of males, and the male an equally great collector of female conquests. And all this under the guise of being stable, united couples. The ornithologists who have studied the behavior of the bird still have trouble believing it. But then it seems that in a great majority of animal species, monogamy is no more than a decoy.

The accentors are an Old World species, and the hedge accentor or dunnock, *Prunella modularis*, is no exception. Many species of accentors live in the mountains; the dunnock is certainly the one with the greatest spectrum of possible habitats. It is the only accentor, in any case, to live even in the gardens of the suburbs and cities. The dunnock is also the most common accentor and the one with the widest geographic distribution.

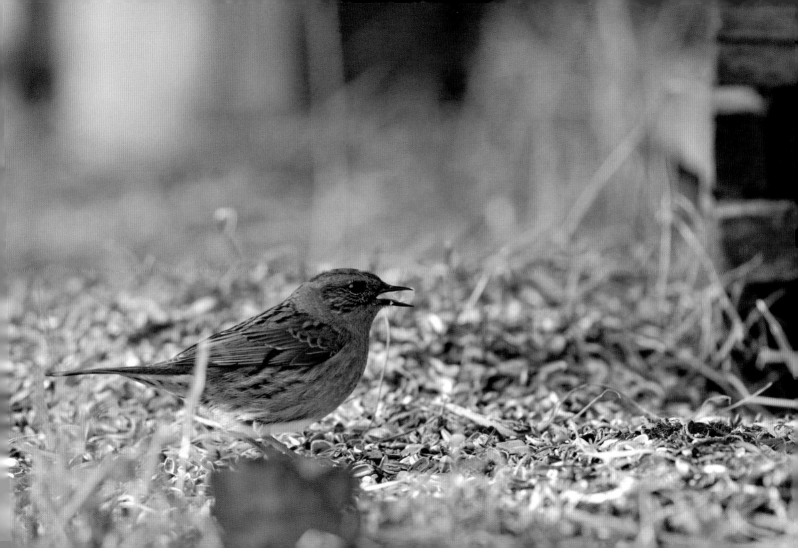

Cream-colored courser

To the south of the Atlas Mountains in Morocco, the steppe spreads out to the horizon. Here and there, trails lead off into the distance. Our car is driving on one of these. Tufts of mugwort sprout from the sandy, gravelly ground, giving off an intoxicating scent. Everything is camouflaged here, even the birds, which blend invisibly into the beige sand. A lark, a wheatear … and then, two birds who trot along at our left, not far from the path, with long legs and hunched necks. These are coursers—which, as their name suggests, chart high-speed courses through the desert steppes. By the time we cut the motor they already are far away, walking at high speed and then stopping dead in their tracks to watch us. They step off again nimbly, sprint twenty yards, and stop again. These graceful little sand waders are cautious by nature. Their silhouettes are lost in the shimmering heat, blurring rapidly into the distance. They will soon be swallowed by the horizon, like a mirage.

The cream-colored courser, *Cursorius cursor*, lives in the deserts and steppes of North Africa and the Middle East. A sedentary species, the birds hardly range at all unless food becomes scarce. Their color is a pale fawn; in flight, they reveal the completely black underside of their wings. The courser's short beak is slightly curved. It has a slender silhouette similar to the plover's.

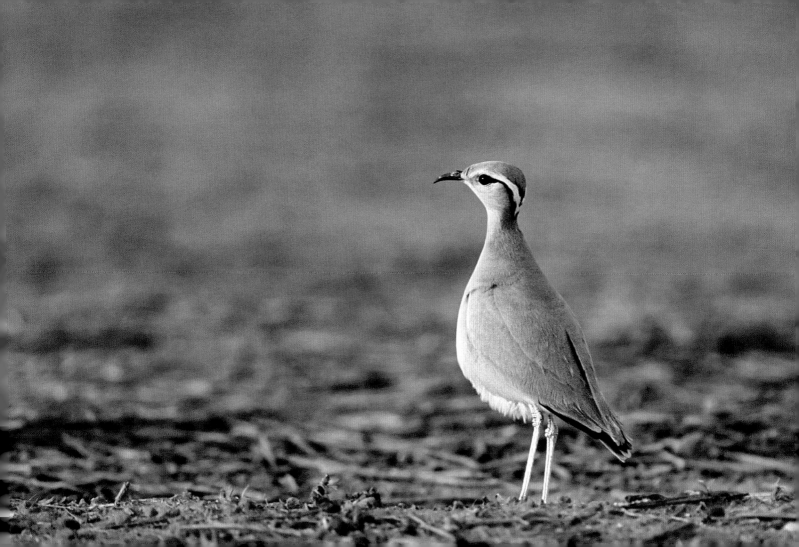

Cirl bunting

It is not yet spring in the south of Spain, but for certain birds, it is no longer completely winter. For migratory birds, it is a time of transition. It is a moment between seasons, in which nature slowly wakes, propelled by temperatures that, often briefly, rise and cause the birds to sing. Here, along the hedge that borders the great river, you must listen closely to hear the low trill, lightly rolling and metallic, of the cirl bunting: *ssississississississi!*

With binoculars you can spot it quickly, perched at the top of a bush a little taller than the others. The male sings, unmoving, his head raised and beak wide open. His pale yellow undercarriage contrasts brightly with his reddish-brown back. The black mask that he wears at his throat, eyes, and crown sets off the pale yellow-green of his breast and cheeks. Not far away, on the ground, two brown and whitish females hop along searching for seed. Behind the hedge, a lark belts out a song over the field.

FEBRUARY

8

Primarily limited to the Mediterranean, Atlantic, and other very temperate regions, the cirl bunting, *Emberiza cirlus*, seems nevertheless to be spreading toward the north. No doubt global warming is helping it to conquer new territory.

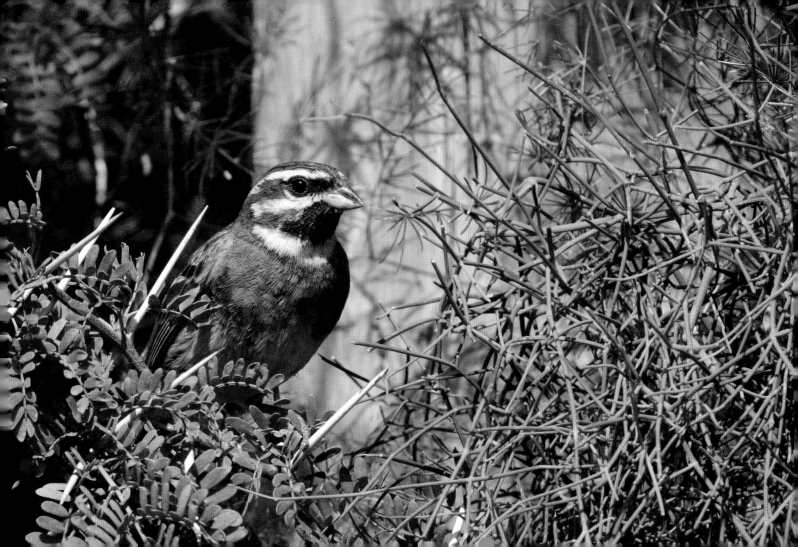

Great hornbill

In this early February evening, this forest in Cambodia is truly one of the last places where one can find at least a hint of cool air. Silent and immobile since the middle of the morning, the birds are beginning to revive, and, here and there, a few cries or an isolated song can be heard. All of a sudden, there is a noise from the tree branches in front of us, a commotion of leaves, and a big bird, followed by another, then yet another noisily takes off. It is difficult to follow them among the trees, but a gap in the foliage offers a momentary glimpse of these big hornbills, with their slow flight and black-and-white-striped wings. And that beak! An enormous yellow carapace, topped with a horny outgrowth, or casque. This is why they are called "hornbills." Watching them, I wonder how they can fly with such an appendage. But as I will soon learn, the beak is nearly as light as balsa. The birds fly away, but not before gratifying us with a deep and resonant honk that echoes all through the forest.

A few days later, I was lucky enough to see a hornbill perched at the top of a tree, attentive to the little people walking below, but not visibly disconcerted by our presence. It flew off nevertheless, in a rush of rumpled feathers. It looked almost like a swan.

The male great hornbill, *Buceros bicornis*, can weigh up to eight pounds and has a wingspan of up to 70 inches (178 centimeters). The horned casque on top of its beak serves as a sound box for its powerful cry. The species lives in the forests of Southeast Asia.

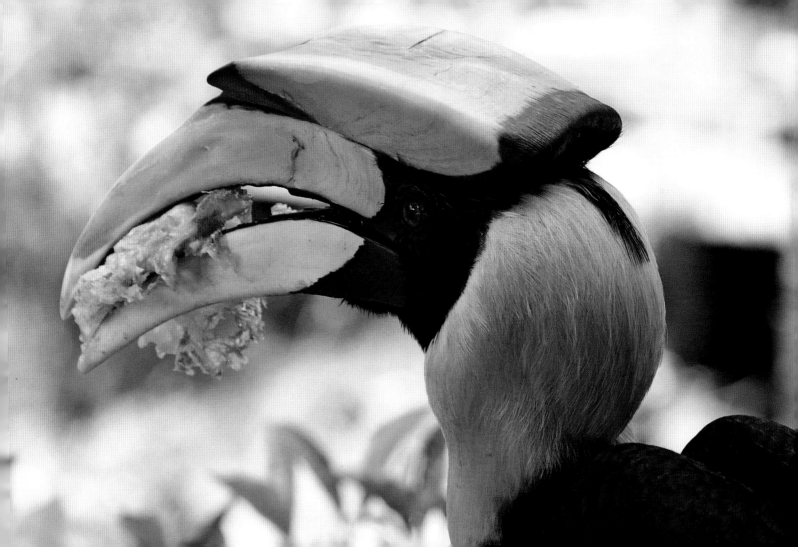

Barnacle goose

You are most likely to spot the barnacle goose in Belgium, Luxembourg, or, especially, the Netherlands. French bird-watchers are unused to seeing geese in winter, but in the Netherlands they will see tens of thousands of these and other geese on the polders of Zeeland or Friesland. In winter, the barnacle goose is one of the most common of these wild geese. The birds hail primarily from the Far North, including Spitsbergen, where the barnacle goose nests on the cliffs. Here in the Netherlands, hundreds, even thousands, of barnacle geese energetically paddle in the water. In French, they are called "nonnettes," or "little nuns," since their black, gray, and white plumage makes them resemble a troop of nuns.

Often seen in association with other gray geese, such as the greater white-fronted goose, barnacle geese regularly fill the air with their take-offs and raucous caws. All it takes is a bird of prey passing through their territory or a door slamming too loudly for the group to lift off and then, fairly quickly, settle back into the same field, slightly farther away.

The barnacle goose, *Branta leucopsis*, nests in the Far North. For several decades, however, populations have been settling farther to the south, in the Baltic Sea and even in the North Sea, as far as the Netherlands, where they are joined in winter by the northern population. In France, they appear rarely and in small numbers, except in the case of severe cold weather, when several hundred birds may visit.

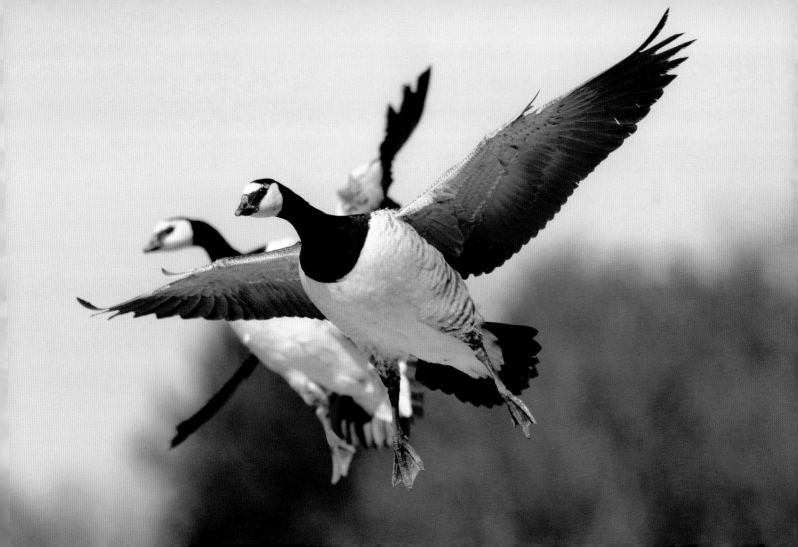

Crested lark

Some years ago, here and there in the region around Paris, I often saw crested larks in supermarket parking lots. You had to come early in the morning to spot one or two of the birds, trotting between the first few cars parked there. At the time, I found this an incongruous environment for such a bird, but it is indeed said to nest on wide, flat, graveled roofs. Today, the species has almost completely disappeared from the Parisian area. And to think that in the nineteenth century, writers reported observing the species right inside the city, where it fed on insects that it found in horse manure! Quite another era for this close cousin of the skylark. Today, you must look for the crested lark at the edge of the Mediterranean, where it is still fairly common—but for how much longer?

The crested lark has always seemed to me to be overlooked in concerns over species conservation. It survives here and there, north of the Loire and notably in Calais. It is always a pleasure to see the bird ambling along the beach, its little crest buffeted by the ocean wind.

A member of the lark family, the crested lark, *Galerida cristata,* often lives not far from people. It frequently subsists on insects found near livestock or in village farms. In southern Europe, it is commonly found in vineyards and scrubland. In northern Africa and the Middle East, it can be spotted in arid and desertlike areas. It is resident wherever it lives.

FEBRUARY

II

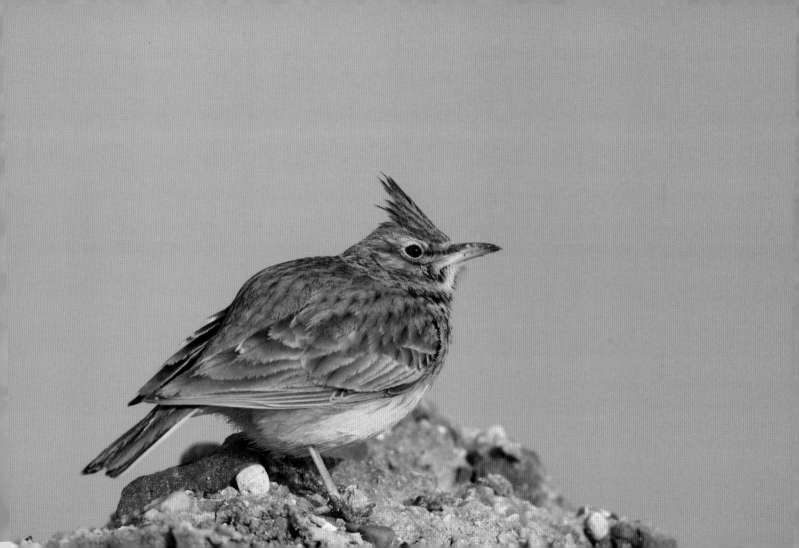

Blue peacock

Everyone knows the peacock: the male who spreads his enormous tail for the female, while she suddenly appears minuscule by contrast. It is the male, too, that is known for his deafening cry of *lay-onh … lay-onh!* There are peacocks in every zoo, and that is where you most often see them.

I have a very particular memory of a peacock. It was February, and I was walking in the jungle of Chitwan National Park, in Nepal. I was going along a little trail, with a fellow ornithologist following behind me, when a female peacock suddenly took off in front of us, in a commotion of feathers and reproachful cries. Even a pheasant, back at home in Europe, taking flight at our feet would have made us jump, but in this case a peacock, five times as large, made us leap practically to the tops of the trees!

My heart beating wildly, I turned back toward my companion, who was pale with shock. With a small movement of his chin, he signaled me to look back ahead of me. Fifty yards in front of us, a splendid panther stared us down. We had just made him lose his prey.

The blue peacock or Indian peafowl, *Pavo cristatus*, is a galliform of the Asian forest, from the same family as pheasants. It was introduced in Europe many years ago, certainly a number of centuries before our era, by the Greeks. Like the swan, it has always been linked to rulers as an ornamental bird, although, during the Roman era, it was eaten as well.

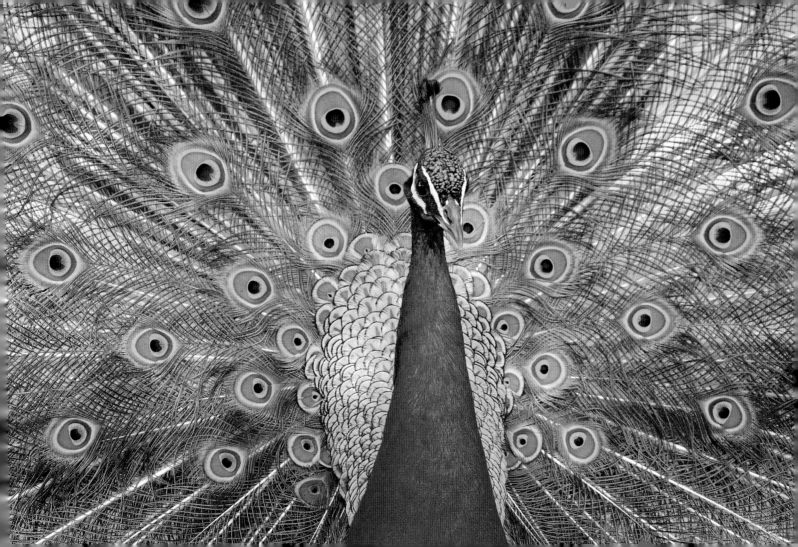

A WINTER LANDSCAPE

It has snowed during the night. In the morning, the half-gray, half-blue sky tries to make way for a timid ray of sun. A wind from the northwest rustles the branches of the ash trees that border the meadow, in front of the house. As I go outside, my steps crunch in the fresh snow. Warmly dressed, binoculars around my neck, I go out to listen to what the birds have to say. In truth, they are not saying much of anything this morning. Chilled by the icy night, they are little balls of feathers huddled against a tree trunk or deep inside a bush. The only stirring comes from a yellowhammer I startle into flight, who salutes me with a sleepy *tic.* On the path, I see the tracks of a fox. He must have been out chasing field mice at dawn, for I see the prints of his four paws suddenly come together in the snow. A crow flies in the distance, hurrying back to a tree. A buzzard is perched on a fence post. What is it waiting for? An unlikely vole? An adventurous, careless tit? It is a beautiful landscape, but an empty one. Certainly the altitude has something to do with it. So I return to the house and sit by the fire to watch, through the window, the incessant ballet of the tits coming to look for seed at the bird feeder. A pale ray of sun sketches fragile little shadows on the ground.

Bald eagle

If I say the words *pygargue à tête blanche*, they will probably mean nothing to you; even to the average French person they are unfamiliar. The English name for this bird, the "bald eagle," may be equally obscure to many people who are not American. But this powerful raptor, with its white head and legs, is the American national bird, seen in the Great Seal of the United States and on the official communications of the president. Images come to mind, even for a European—of eagles perched in trees in Alaska, waiting for grizzly bears to finish their feast of spawning salmon. A beautiful symbol of the richness of nature, this real-life American symbol nevertheless nearly disappeared for a time under the dual assault of hunting and pesticides.

Today, thanks to effective protection, the bald eagle has returned in force. In my memory are unforgettable images of birds perched on a rocky outcropping over the sea, somewhere in the Aleutian Islands. There, the bald eagle showed itself in all its wild majesty.

A fishing bird, the bald eagle, *Haliaeetus leucocepahlus*, lives in North America, from the continental United States up to northern Alaska. Some birds migrate south in winter, but the bird is a "partial" migrator, which is to say that its seasonal movements remain relatively bounded (within a range of a few hundred miles).

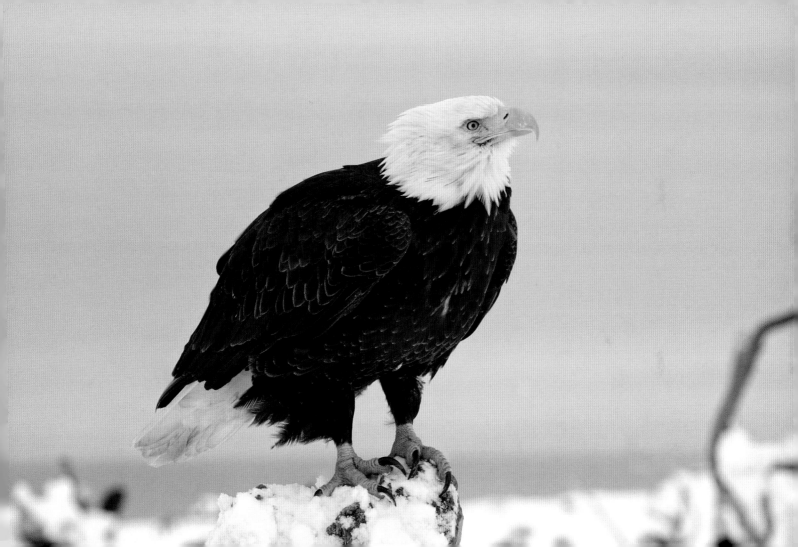

Slender-billed curlew

In the early twenty-first century, few birds have inspired as much discussion as the slender-billed curlew. This species has the sad distinction of being undoubtedly the rarest in Europe and in the whole western Palearctic region (a biogeographical zone that encompasses not only Europe but also North Africa and the Middle East). In truth, we are not even sure whether the species still exists. Once common, it wintered particularly in Morocco and nested somewhere in the wilds of central Siberia. But hunting, habitat loss, and, certainly, the fact that it is a very specialized species have meant that, over time, it has become extremely rare. Indeed, when the red alert went up warning of its imminent extinction, it was probably already too late. The last sighting of the bird was in Hungary in 2001. Since then, bird-watchers have been seeking it frantically—often in vain.

The image opposite is a historic one. It is not only one of the best photographs of the slender-billed curlew, *Numenius tenui-rostris*, but it was taken in France in 1968 and represents the last slender-billed curlew whose sighting in that country was officially recorded. It once lived in swampy parts of central Siberia and spent the winter in the coastal wetlands from Morocco to Iran.

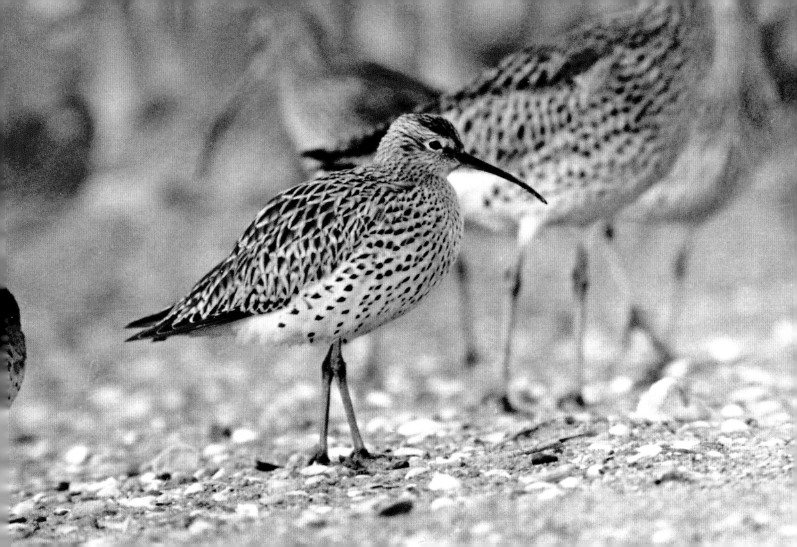

Common shelduck

When I was young, I was an avid reader of a magazine whose title in English would be *Animals and Nature*. In one issue, there was an article about a big, multicolored duck that I was astonished to see lived in Europe, its colors made it look so much like a tropical species. It was the common shelduck.

Later, I learned that this large duck, fairly similar to a goose, lived on the European seashore and that it was, as its name suggests, quite common. I first saw the bird in person in the Bay of Somme, where I watched thousands of shelducks paddle. Since then, it has followed me everywhere in Europe—along the coasts, but also farther east, to the edge of the saltwater lakes on the Central Asian steppes.

The shelduck has a curious habit that, in some languages, has earned it the nickname "rabbit duck": it likes to nest in rabbit burrows, and will go so far as to drive out the rabbits in order to lay and incubate its eggs.

FEBRUARY

16

The male common shelduck, *Tadorna tadorna*, has a big red wattle on its beak, like the mute swan. It lives all over the western Palearctic. The northern birds spend the winter on the Atlantic and Mediterranean coasts of Europe. They are protected by law, and have become more and more widespread.

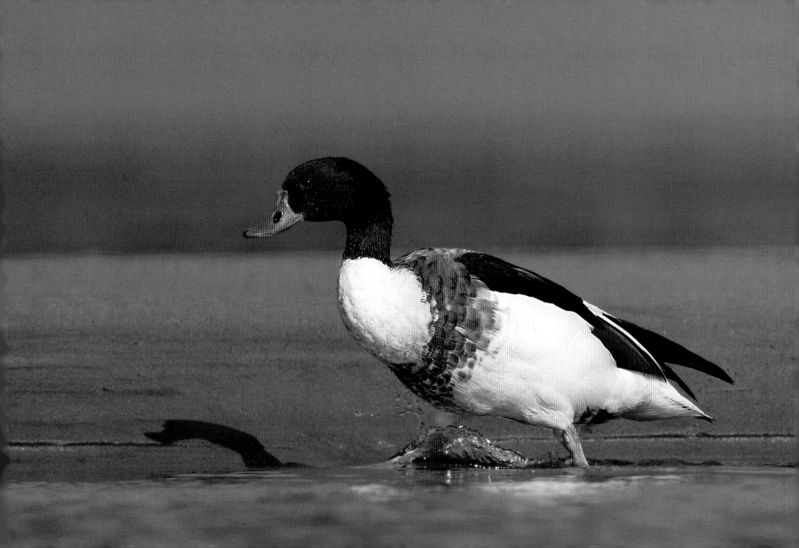

Black woodpecker

Kluuuu…Kluuuu! In the forest of beech trees bare of leaves, a powerful cry tears the silence of this misty morning. Footsteps crunch through the dead leaves of last autumn. The black woodpecker is not far off …*Kluuuu!* Hidden behind a tree trunk, I search for the calling bird. I spot it in flight, as it passes from one trunk to another. This large woodpecker, black, as its name indicates, and the size of a jackdaw, pins himself against a beech tree not far from me, after having reached the target of his undulating flight. This individual has a beautiful, complete red crown; it is a male, since the female has none. There it is tapping energetically on the trunk then taking off again, this time giving a resonant *krukrukrukru!* that echoes in the forest cathedral. Then nothing more. A few minutes later, I hear his cry again, but it is already far off.

The black woodpecker was, several decades ago, a true rarity, limited to large eastern forests. It has now colonized all of France, or nearly all, thanks notably to the expanding forests where it makes its home.

The black woodpecker, *Dryocopus martius*, is the largest woodpecker in Europe. Fairly shy, it can be observed quite well right at the beginning of the spring, when the birds make their mating display and are fairly talkative. It has colonized a large part of Europe, but it has yet to set foot in the British Isles.

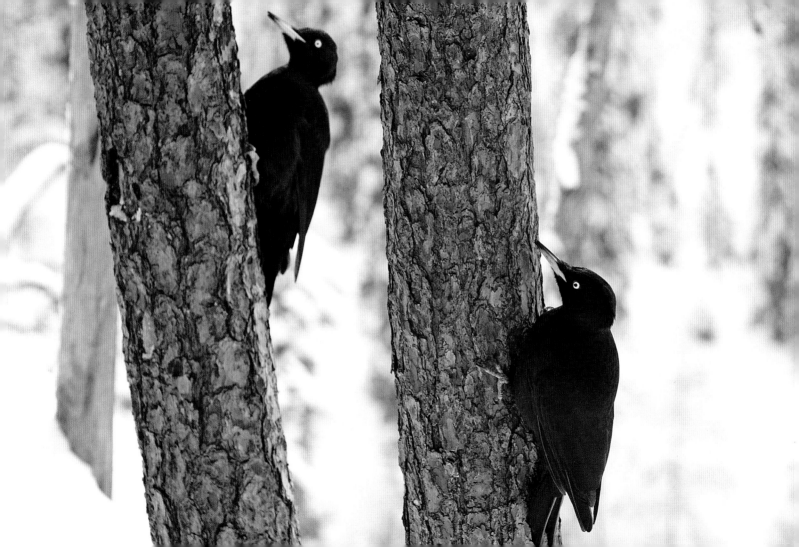

Iceland gull

When the Atlantic storms grow particularly severe at the end of winter, the ornithologists of the western coast of France—and of all of Western Europe—ready themselves for battle. These violent depressions that rapidly cross the ocean bring with them gulls that normally winter between Iceland, Greenland, and the eastern coast of Canada. Among these is the Iceland gull. In the 1980s, the species was extremely rare, and I remember a pilgrimage of ornithologists to see a bird that reached the port of Le Havre one February morning.

Since then, and without doubt partly because of the climate change that has led to an increase in winter depressions over the Atlantic, there is practically no winter that goes by without someone spotting one or several Iceland gulls between Brittany and the Netherlands. Sometimes there are even dozens, as in the course of winter 2009, as a result of the European windstorm Klaus.

This immaculate white gull of the Arctic brings with it all the mysteries of those cold highlands, where most of us will never visit.

It is especially the young Iceland gulls, *Larus glaucoides*, who succeed in flying to the European shores in winter. On the other side of the Atlantic, the species commonly winters in Canada, and much more rarely in the United States. The species nests in the Canadian High Arctic.

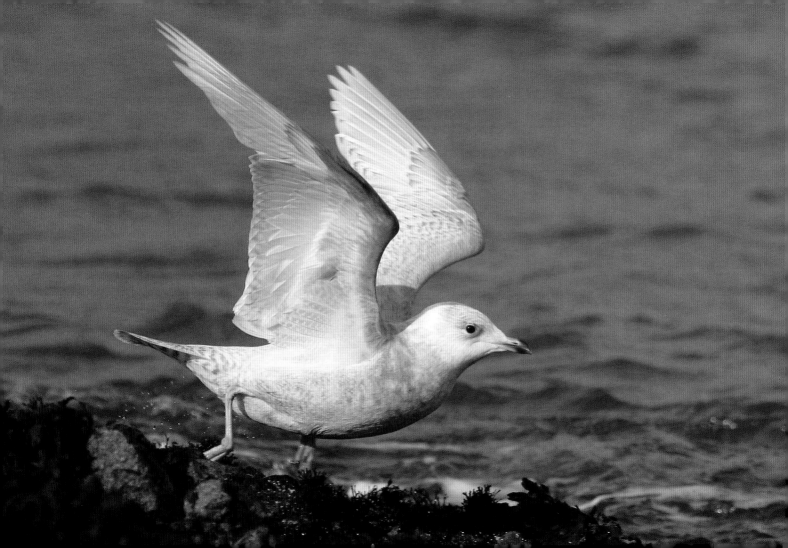

Giant ibis

We left before daybreak, in a remote region in the north of Cambodia. Here, in the tropical hardwood forest—what is called a dipterocarp forest—the leaves fall all year long, without any marked seasonality. As we put down our feet, we take care to make the least noise possible. We are going to witness the waking of the giant ibis—the largest of its tribe, but also the rarest.

Some 150 yards away from us, three ghostly shapes, perched at the top of a dead tree, separate slightly from the dark blue sky. With regular blasts, a resonant trumpet blow rips through the predawn silence. Little by little, the silhouettes grow clearer: the birds are shaking themselves. Holding our breath, we stay as silent as possible. The sky lightens, then becomes a dark gray-blue. It will be hot today. The birds trumpet once again, craning their necks, then, without warning, suddenly take flight to disappear behind the trees, leaving us alone in this magical scene.

Only 45 years ago, it was thought that the giant ibis, *Pseudibis gigantea*, had disappeared. But then it was found here, in the deepest part of the former Indochina. There are no more than two hundred giant ibises remaining in the world, and the species is currently considered in critical danger of extinction. It is on the border between Cambodia and Laos that you can still see the species.

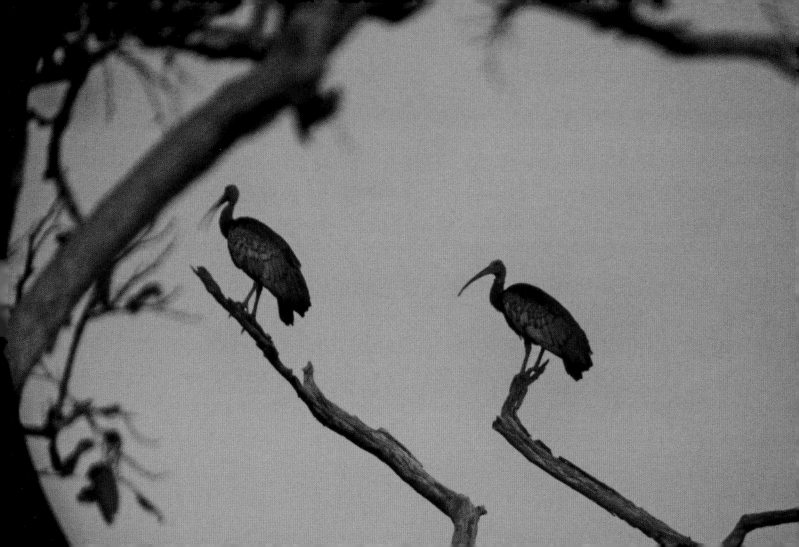

Smew

It was during my first trip to the Netherlands, in the middle of winter. Several fellow ornithologists and I had decided to go observe the geese and ducks that spent the winter by the tens of thousands along the great dikes of Zeeland and near Amsterdam. It was on the polder of Flevoland that I spotted the first group of smews. In France, you may see the occasional individual smew, unless the cold is truly fierce. But here, there were hundreds, huddled against one another to form a sort of floating raft, their black-and-white plumage standing out against the dark, gray waters. The flock progressed along the length of the dike, moving a little farther away when we approached, only to return and protect themselves against the wall when we got back into the car. What caught the eye, of course, were the males all in their shades of black and white, like little water ermines.

In January 1979, Western Europe was swept by a powerful cold front that chased the smews from the North Sea. For French ornithologists, it was a chance to observe flocks of these birds in an unaccustomed place.

The smew, *Mergellus albellus*, reproduces on the lakes of the Eurasian High Arctic tundra. Most birds spend the winter in the North Sea and Baltic Sea. In France, their numbers rarely exceed a hundred during the winter, unless a cold front temporarily transforms the country into a Dutch outpost.

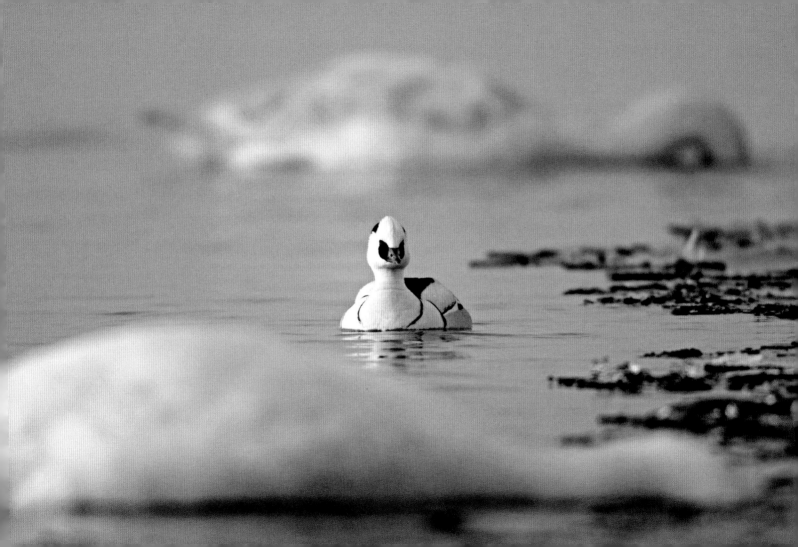

Indian vultures

Some years ago, any traveler crossing India would have been struck by the number of vultures to be found there, even in the middle of cities. These garbage collectors of nature, profoundly respected by the Hindu people, do the considerable work of perfectly cleaning all the animal cadavers scattered across the country. The Zoroastrians in India—and also, earlier, in Iran—even constructed "towers of silence" where they exposed the bodies of the dead. The bodies were picked clean by the vultures, seen as sacred birds, and thus were prevented from defiling the earth. The Tibetans in the high mountains do the same.

Or rather "did the same," for in the space of just a few years, the population of Asian vultures has plummeted by more than 95 percent, changing them from common birds to a bird population threatened with extinction. The culprit is a powerful anti-inflammatory drug given to livestock, which the birds ingest along with the flesh of the dead animals. This has led to a slow death for most of these unfortunate vultures. Today, it is unusual to see more than fifty Asian vultures in one location.

The three or four species of Asian vultures are all threatened with extinction, following the ingestion of the anti-inflammatory drug Diclofenac. Now forbidden in Asia, the drug is still used in Africa, and beginning to affect the vulture populations of that continent. In the meantime, we can only try to safeguard the last Asian vultures that survive.

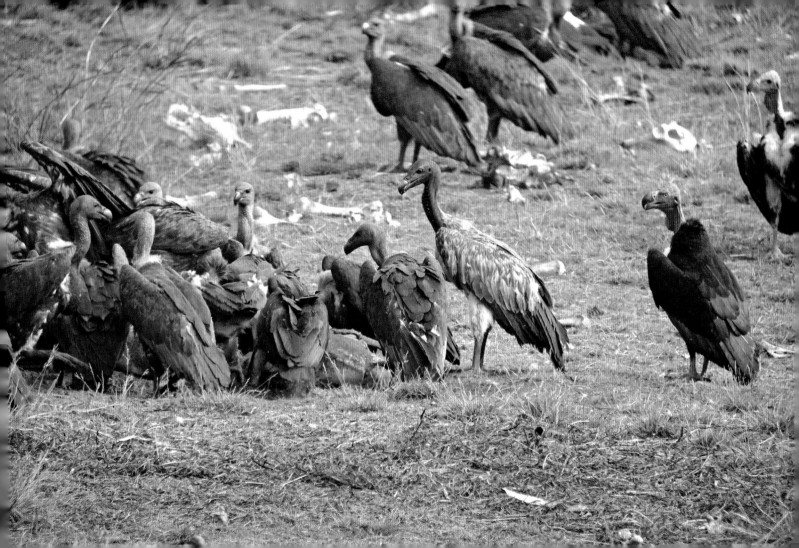

Song thrush

Like the blackbird, the song thrush is a precocious singer. Along with the nightingale and the blackcap warbler, it is one of our finest soloists. For if its plumage remains fairly modest—a brown back, an underside dotted with black—its song is superb. The song is a motif repeated several times, but each motif is different. One might almost imagine that the song thrush is reciting a poem. You can listen to it, in the early morning or at the day's end, as it sings out its stanzas, perched at the top of a tree. Unmoving, its head high, the male claims its territory. There is hardly any bird besides the blackbird who, at this time of year, is a vocal match for the song thrush. When the night is already fallen, the thrush continues to sing, invisible to the eye.

At the same time of year, in the countryside, you see migrators quietly heading back north. But it is actually later on, in the fall, when the migration of song thrushes is the most spectacular. One cool early October morning, dozens of birds, having flown all night, will alight in the hedges or trees of towns and fields, giving a faint call of *tic!* The soloist of February seems far off indeed.

22

The song thrush, *Turdus philomelos*, one of four common thrushes in Europe, is by far the best singer. It is also the most common in the temperate regions. The bird is a partial migrator that winters primarily in southern Europe and at the edge of the Mediterranean. It migrates in the fall, generally in the month of October, and in the spring, in February and March.

Greater hoopoe-lark

Early in the morning, while the nocturnal cold still lingers, we walk in the Tunisian *reg*, or stony desert, dotted with fragrant mugwort and other scented plants. A magnificent song rings out: one whistled note, sometimes trilled, rising gradually in a slow crescendo to end shockingly high up the scale. Is the singer far away? Is it close? Impossible to tell, for the sound seems to come out of nowhere, borne by the wind of the desert and simply passing before us. We scan for it with our binoculars. Nothing … And then all of a sudden, a tan shape rises in the sky, spreads its wings, and reveals great black-and-white patterns like a butterfly's, before letting itself drop like a rock. The bird was, in fact, much closer than we imagined. It pauses at the top of a bush and watches us. As we slowly approach, the bird comes to rest on the ground, and, neck extended, head to one side, it moves off in rapid steps without taking its eyes off us. With its large feet, it moves quickly. It is useless to follow the bird; it has already crossed the little hill in front of us.

We retrace our steps. The silent morning air is once again broken by the hoopoe-lark's ethereal song.

A member of the lark family, the greater hoopoe-lark, *Alaemon alaudipes*, is a major species of the deserts of northern Africa and Asia Minor. A sedentary species, the hoopoe-lark never strays far from these semidesert steppes covered with mugwort and from even harsher habitats, where only a few wizened plants grow among the dry wadis.

Graylag goose

In closing the shutters this evening, I heard the cries of a gaggle of graylag geese heading north, despite the noise pollution of the city. The mild weather of these last few days had heralded a possible migration. For some time, ornithologists had been reporting groups of them, both day and night. The beautiful quacking birds were returning from the west of France, even the south of Spain in some cases. Sure of themselves, they flew straight toward the Netherlands, Denmark, or Sweden, where they would nest. The hunting season was over, so there was no risk of being shot.

They passed very quickly. Already, their calls were diluted by the city noise. I could see nothing, obviously: it was a black night. But I closed my window again with a tender thought for these migrators—stopped by nothing, not night, not wind, not rain, so pressed are they to carry out their mission and perpetuate the species in some remote corner of Scandinavia. And I thought again of the geese in *The Wonderful Adventures of Nils*, by Swedish author Selma Lagerlöf, a book that so inspired me as a boy.

FEBRUARY

24

The graylag goose, *Anser anser*, nests in Northern Europe, primarily, and in Western Europe as well, but also in the east as far as Siberia and in Central Asia. For some years, the species has been in spatial progression. These geese now settle in France to nest, in small numbers. And they also come there to winter, doubtless thanks to the less severe weather that no longer pushes them farther south to Spain.

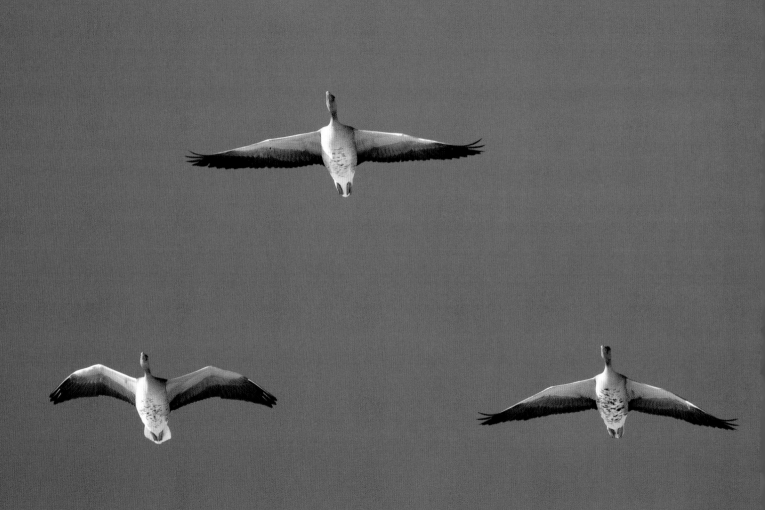

Common chiffchaff

How eagerly we ornithologists await the first song of the chiff-chaff. At our latitude, its refrain is one of the most tangible signs that winter has gone. The winter over, even though it is only late February? For nature, spring does not arrive on the 21st of March, nor on the 24th of February. Spring is here when the temperatures climb again, the first butterflies flutter, the buds appear on the trees…and the chiffchaff sings.

Often, the seasoned observer will already have spotted one or two, a few days earlier. But they stay silent and furtive. It is still too cold. Then comes a beautiful day at the end of winter, a little warmer, and there it is singing at top volume, gratifying us with its simple song: *tyip-tyep…tyip-tyep…tyip-tyip…tyip-tyep!* It is a little monotonous (the chiffchaff is sometimes called "the penny counter"), but full of joy. The bird, between two stanzas, runs the length of the still barren branch of a tree in search of the first tiny insects. Spring is here!

Sedentary in part of Europe (the south), the common chiffchaff, *Phylloscopus collybita*, is a partial migrator in all the temperate areas. The birds along the Atlantic shore do not travel far, but those inland clearly leave their summer home. The birds from northern Europe migrate much farther, reaching as far as tropical Africa. The chiffchaff is a precocious migrator and returns starting in February.

FEBRUARY

25

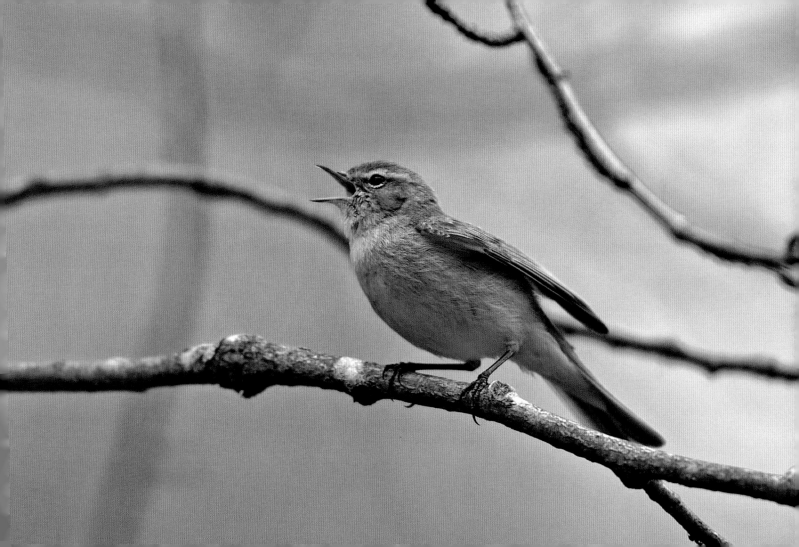

Short-eared owl

We have arrived before the end of day at the small butte overlooking the swamp. Despite the paralyzing cold, we keep our eyes peeled. It is the hour when the short-eared owls begin to hunt. And here is one now, followed by another and then yet another. Like gigantic butterflies flying in slow-motion, the owls fly over the swamp in every direction, in search of voles or field mice. There are a dozen owls now, gliding soundlessly, close to the ground. Suddenly, one owl lands and we see, through our telescopes, its round head turning 180 degrees and its yellow eyes staring at us.

A rare diurnal bird among nocturnal raptors, the short-eared owl is quite exceptional. You can see it in broad daylight, hunting like a buzzard or a foxhound.

As night falls and the cold forces us to pack up camp, the elegant birds continue their hushed flight. In the distance, the first lights of the village light up the hill from the other side of the swamp.

FEBRUARY

26

The short-eared owl, *Asio flammeus*, ranges principally from Northern Europe to eastern Siberia, but also may be found in North America and in the southern half of South America. The northern populations are migratory, and in winter the temperate regions receive birds from the north, but the species is never common.

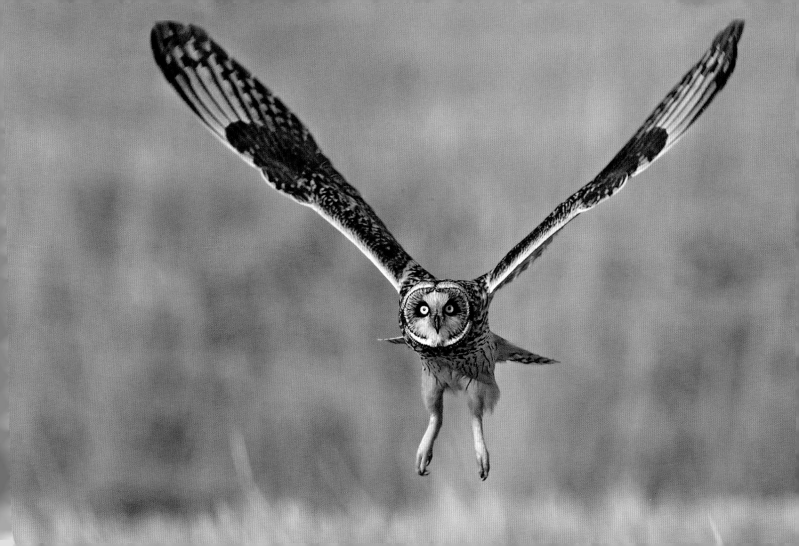

Barbet

Tou-ke-rouk...Tou-ke-rouk...Tou-ke-rouk...Tou-ke-rouk...Tou-ke-rouk! Endlessly, a bird makes its singsong cry amid the immense fronds of a forest in Southeast Asia. It is a barbet, a species related to the European woodpeckers. The barbet's singular song is a symbol of all the tropical rain forests of Asia. Everywhere in the tropics, from the plain to the mountain, from India to Indonesia, its song may be heard. Catching sight of the singer is another matter, so dense is the foliage and so tall are the trees. Your only opportunity may come when a bird happens to sing atop a dead tree silhouetted against the sky. With rare exceptions, barbets are green, which, given their habitat, makes them masters of camouflage.

Farther away, the small coppersmith barbet is also loquacious, but less musical: *touk...touk...touk...touk...touk...touk!* But, at least, these barbets manage to make themselves heard. They have to compete with the chorus of insects, its sound so metallic that you would think you were at a rock concert. All of this in a hot, humid atmosphere, where you must constantly step carefully to avoid hungry leeches. The ornithologist's life is never easy!

There exist dozens of barbet species, especially in tropical Asia, but in Africa as well. Most belong to the Megalaima family. Like many tropical species, they are sedentary birds.

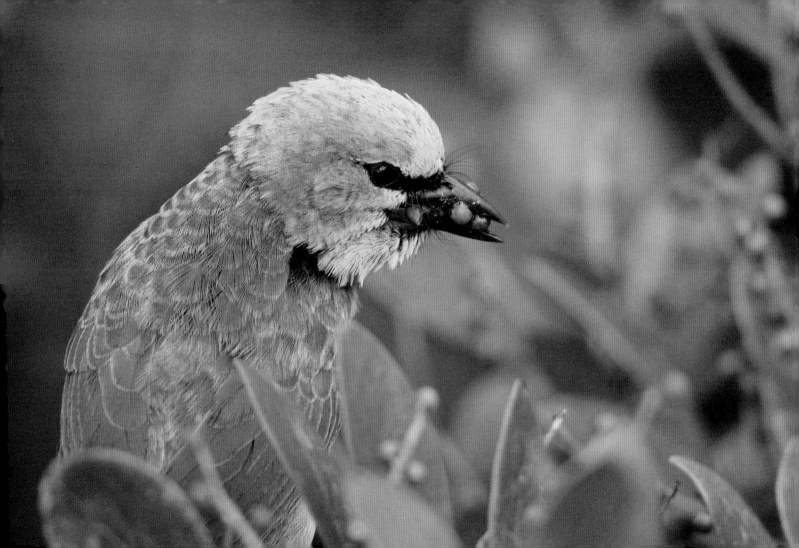

Winter wren

The winter wren is the imp of the garden. Lively as a mouse, curious about everything, the wren is here one instant and over there the next. Minuscule, with short wings and legs, its tail constantly held at a 90-degree angle, it sidles between two piles of wood, under a stack of logs, behind an old watering can. With the blackbird, the hedge sparrow, and the robin, it forms a garden quartet. When all seems dead in winter, the wren dances with activity between two rows of frozen plants. It is the wren, too, who makes its song heard in the month of January, as strident and forceful as the bird is small. This little garden gnome sings all year long, or nearly so.

It is in the countryside of Brittany that I have seen the largest number of wrens. There seemed to be one at the base of every gorse bush. In any case, the wren likes to make its nest in the heart of this thorny plant. You would have to be clever indeed to dislodge it.

Among the smallest birds of Europe, the winter wren, *Troglodytes troglodytes*, is also one of the most common. It is nevertheless the only species of its family in the Old World. In the Americas, by contrast, there exist a number of species, including the large cactus wren. No doubt it was there that the wren family originated.

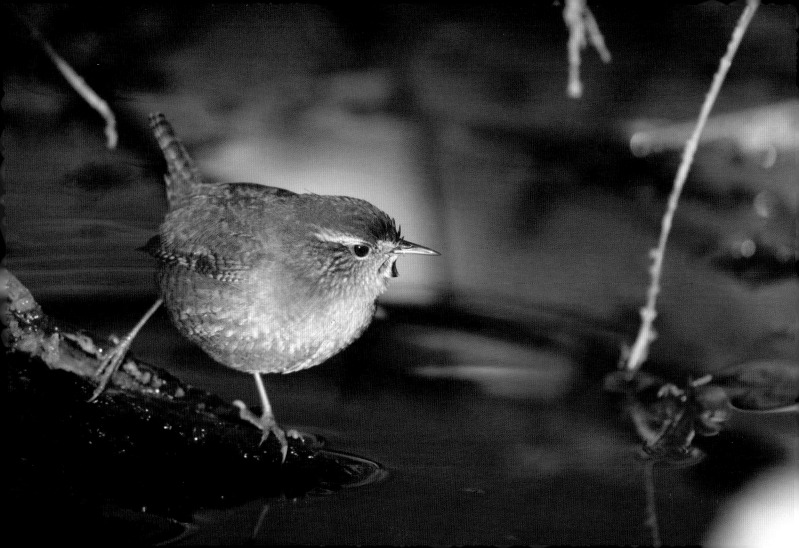

Garganey

It was near the beginning of my career as an ornithologist. I was bicycling from Versailles to the Saint Quentin Pond, an important ornithological site in the western suburbs of Paris. At the beginning of March, I knew that they were about to come back, and I hastened to welcome them. Them? The garganeys, of course.

Their mere name is rich with promise: beautiful days, long evenings, mild weather. The Eurasian teal seen in winter, a close relative of the garganey, will soon give way to its summer cousin. These garganeys have returned from sub-Saharan Africa after a long journey over the desert and across the Mediterranean. And the garganeys that I glimpse among other dabbling, or surface-feeding, ducks have still farther to go. Doubtless the ones there will nest somewhere in Siberia. For the moment, the males circle around the females, making their distinctive rattling noise. Tomorrow, the garganeys will be gone. The route is long, and the stopover in France must be a short one. They are travelers hurrying to head back north toward the lands where snow still covers the ground. As if to prove to me even more convincingly that spring has arrived, a solitary swallow glides above the surface of the pond.

The garganey, *Anas querquedula*, is one of the Old World ducks that migrates the farthest. The birds who nest in central Siberia winter in the lands between Sudan and Senegal, making an extremely long trip. In the spring, they make the reverse journey. The species nests in swamps and ponds rich in vegetation.

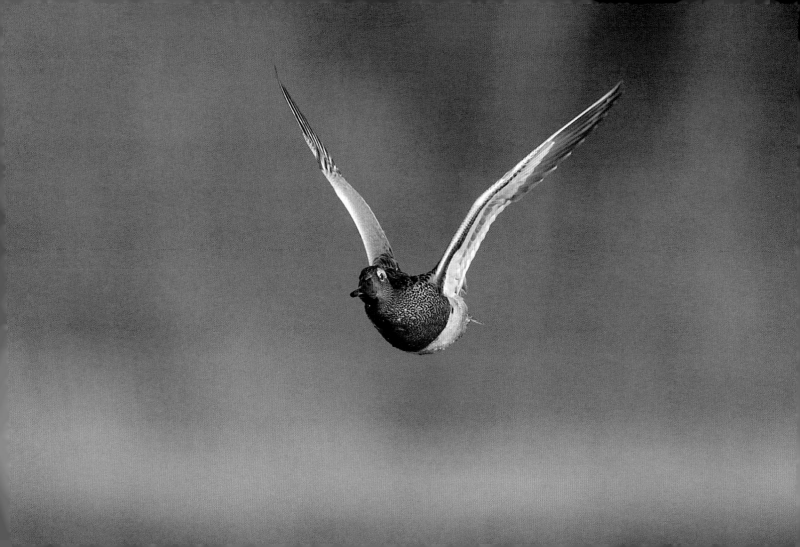

Desert sparrow

To reach the fort of Ksar Ghilane, in the south of Tunisia, you must take a sandy trail worthy of an auto rally. There, lost in the whitecaps of the dunes, stands a fort dating from Roman times, a particular attraction for fans of offroading. Nevertheless, in dugouts in the walls hides the desert sparrow. "Hides" is truly the word, for the birds, who are few, are also quite shy. The female is the same color as the earth from which the fort is built. The male, dressed in gray and white, has only a pretty black bib to enhance the sobriety of his suit. These birds are legendary among ornithologists, for they are loyal solely to difficult, hot, and remote places. Thus finding the desert sparrow is an exercise that demands patience and endurance.

We don't know very much about this species, except that it is fairly erratic: one year it is here, another year somewhere else. Nowhere are its numbers significant, and these numbers seem to be declining dangerously even in its Asian bastion. Despite environmentally difficult conditions, these sparrows know where to find the smallest speck of an insect sheltered in a hole in the wall or under a bush.

The territory of the desert sparrow, *Passer simplex*, spreads from the desert lands of the Maghreb to Sudan, while a small relict population survives in central Asia (in Turkmenistan in particular). The species is not migratory, but it does move based on the availability of food resources.

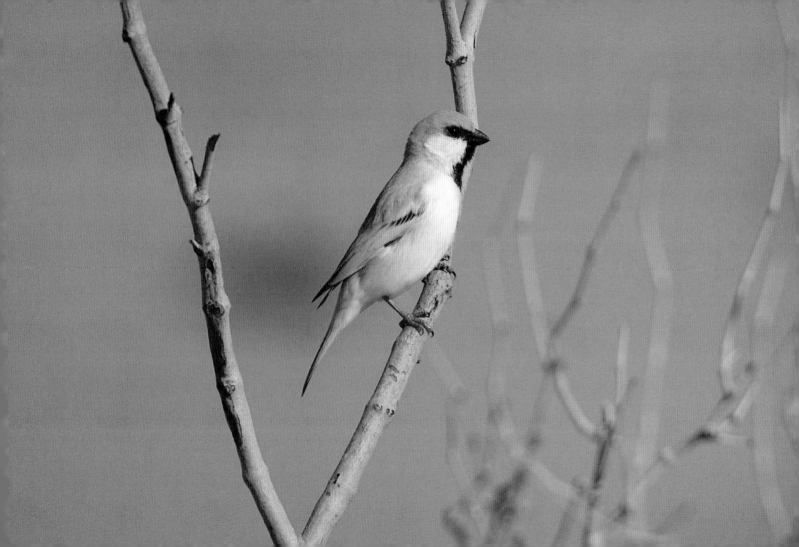

Sociable lapwing

There is a list of bird species that, for Western ornithologists, inhabit the domain of myth. The sociable lapwing is on the list. Because it comes from the immense Kazakh steppes and has become very rare, people long for an encounter with this bird.

Fortunately, if you do not go to the sociable lapwing, the sociable lapwing might yet come to you. These are words to remember, for this bird occasionally makes an erratic visit to Western Europe. You may look for it amid great flocks of northern lapwings, its European cousin, when they are on the move in the course of their migrations. That is to say, in October and the beginning of November, and then in the beginning of March, when the birds head back toward the north and east. The latter season is the ideal time to spot the sociable lapwing. In this season, unlike in the fall, the bird will have regained its breeding plumage, all in shades of tan and brown. While on the ground it blends in amazingly well with the clods of earth; when it spreads its wings in flight it suddenly unveils their patterns of black and white.

The sociable lapwing, *Vanellus gregarius*, nests in the great steppes of Central Asia. Once common in these vast territories, it has become very rare. It is pushed back by humans when they overpasture livestock on the steppes. It is also pushed back when people abandon these areas and leave them to become high grassland, which does not suit the sociable lapwing's reproductive needs. The sociable lapwig is a species that typically inhabits a narrow ecological spectrum.

MARCH

3

Canada goose

The large Canada goose can be found on both sides of the Atlantic. On the western side, in North America, the goose is at home, but not a stay-at-home. At the beginning of March, you see migrating flocks flying over the New York region, departing in search of the colder temperatures on the far side of the Canadian border. Some thousands of miles farther west, the birds do the same; they abandon the sites where they winter in California or Oregon, as they are awaited in their summer home of Alaska.

On the European side, things are a bit different. The species was introduced here in the course of the twentieth century and has become very invasive in certain countries, including Sweden, Belgium, the Netherlands, Luxembourg, Germany, Great Britain, and more recently, France. Here, it is hardly migratory at all.

On both sides of the ocean, however, it is regarded mainly as a nuisance. It basks on the lakes of city parks and recreation areas, cheerfully covering the lawn with its droppings—to the great displeasure of bathers, when warm weather returns. Which goes to show that just because you're at home doesn't mean you're welcome everywhere.

The Canada goose, *Branta canadensis*, is a large goose with brown, black, and white plumage. In North America, where it originates, there are more than a dozen different subspecies. They are so different, in fact, that the species has recently been split into two distinct species: large and small.

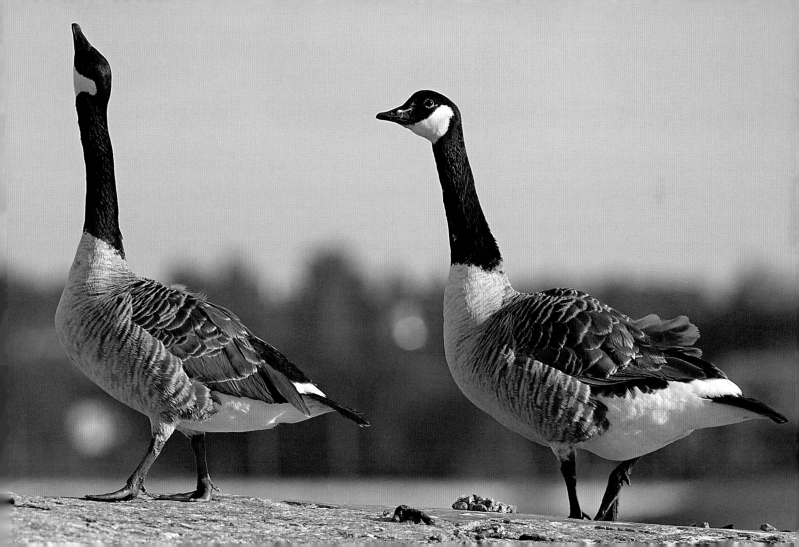

Eurasian treecreeper

There is still snow on the ground, and the forest remains a fairly somber place. For the most part, the leaves are no more than buds, especially here in the mountains. From the distance comes the faint sound of a great tit practicing its springtime call.

There is nevertheless a bird here that, with utter discretion, has already begun its breeding period. It is the Eurasian treecreeper, a small ball of white and brown feathers busily searching for minuscule arthropods on the trunks of trees. It progresses by fits and starts, creeping along as if climbing up the immense face of a mountain. With its curved beak it extracts the tiny creatures hidden beneath the bark. It has seen us, and slips over to the other side of the trunk. Showing itself again, a good dozen yards higher, it gratifies us with a high-pitched *siiiiiie!*, its song as subtle as the singer. It soon flies off and begins its game again on a neighboring trunk.

The Eurasian treecreeper, *Certhia familiaris*, is found in temperate Europe from the Scandinavian forests to the Spanish sierras. It is a mostly mountain-dwelling species there, except in the British Isles, where it is present throughout. Other closely related species live in Asia and North America.

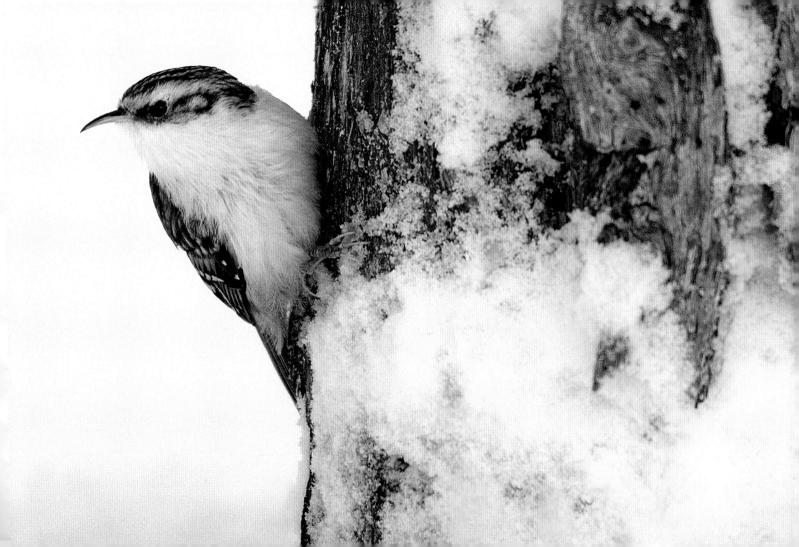

California condor

Some years ago, it appeared that the condor would never again fly the skies of California. Its story is one of a successful rescue—at least, so we hope. Once dwelling in the Californian mountains, but also in the Grand Canyon and in Baja California in Mexico, this splendid raptor was persecuted during the nineteenth and twentieth centuries—directly, through hunting, and indirectly, as a victim of the poisoning or destruction of its habitat. Its trials were so significant that by 1987, no more than 22 birds survived in the wild. It was decided to capture them all and give them a chance to reproduce in captivity. The effort was a success, and in 1991, the first birds were released back into nature. Since then more condors have been bred and released, although very few have yet reproduced in the wild.

The road is long, very long, for the condor to again become established as a nesting bird in the wild. Some die every year, electrocuted by high-tension power lines or—still—poisoned. But success surely lies ahead. That was how I felt when I saw bird number 68, perched at the top of a giant sequoia in Pfeiffer Big Sur State Park.

As of this writing, there remain no more than 322 California condors, *Gymnogyps californicus*, of which 172 have been released back into the wild. This bird, which can live up to fifty years, remains one of the most threatened in the world. Its rescue is the most onerous conservation program that the United States government has undertaken.

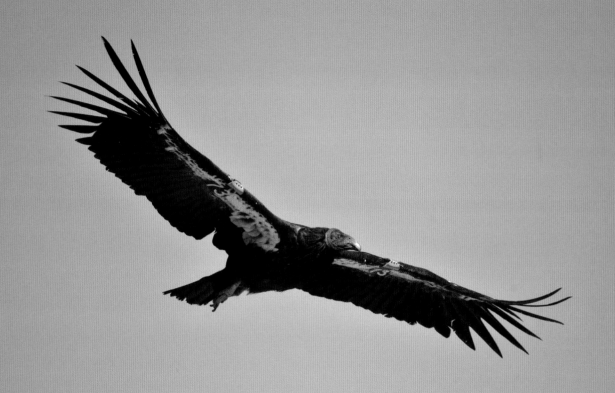

Tailorbird

There is nothing extraordinary about the tailorbird to look at it, except for its long tail. Greenish and white, it blends perfectly with its wooded environment. This small passerine bird lives in the rain forests of Asia and, amid the great spectacle offered by the biodiversity of these latitudes, it is far from the most likely to catch the ornithologist's eye. However, the tailorbird's name fits it well, for it is a past master of the art of couture. Indeed, it builds its nest by sewing together big leaves with plant fibers. More precisely, *he* builds the nest—because it is the males who are the tailors, piercing holes with their beaks and using the fibers to tie everything together. Once the outer shell is finished, the nest will be lined with the necessary materials for the eggs to be deposited.

The nests are well hidden in the tree foliage, and I have never been able to find one, despite observing the adults sounding alarms around me in the Thai forest.

There exist some 15 species of the tailorbird, or *Orthotomus*, living primarily in eastern Asia. Tailorbirds are part of the Sylviidae family, along with the warblers, leaf-warblers, and chiffchaffs of Europe. Their closest European cousin is the zitting cisticola. Tailorbirds are sedentary; they do not migrate.

Siberian crane

Today, the Siberian crane is among the world's living crane species in grave danger of extinction. At the Indian site where you could spot the Siberian crane at the end of the 1990s, in Bharatpur, not far from Delhi, it has now disappeared. In 2000, I had the good fortune to see seven birds together, in the north of Iran. This remote place was closely guarded from hunters, who considered these birds a true relic of the past. The cranes were standing on a *damgah*, an area specially maintained to attract ducks, which are captured at night in nets. The cranes, wading through the water, moved slowly as they sought their food, their plumage entirely white except for a mask as red as their legs. But they were far away from us and, for some unclear reason, we had been forbidden to bring our telescopes.

Since then, I have learned that the Siberian crane no longer comes to Iran. Here and there, they are still spotted in the delta of the Volga or in Kazakhstan, while the bulk of the flocks spend the winter around Lake Poyang, in eastern China. The Siberian crane is still a threatened species and risks disappearing by the end of the century.

Worldwide, there remain no more than 3200 Siberian cranes, or *Grus leucogeranus*. The bird nests in the eastern tundra of Siberia, as its name indicates, and winters in China. It is among the more than one thousand species of birds, out of around ten thousand, that are threatened with extinction.

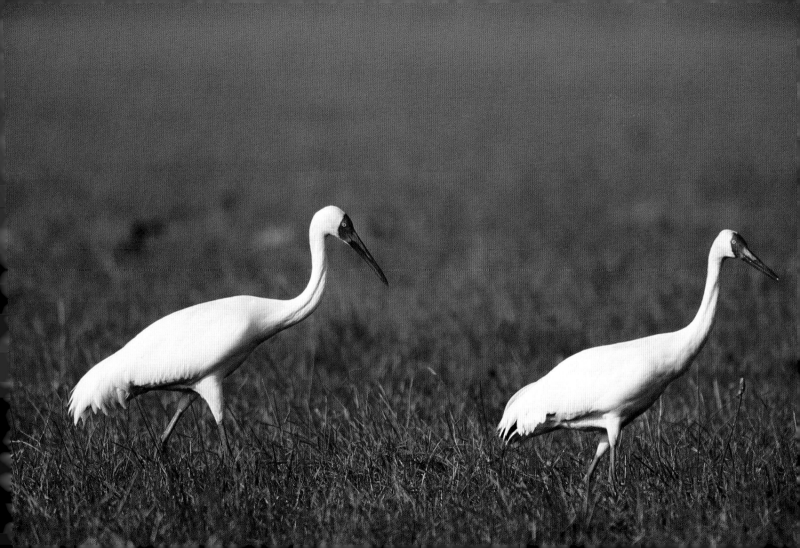

Black redstart

In the constant bustle of the city, you must have an ornithologist's keen ear to catch the song of the black redstart. It is not so much a song as a series of rasping, scraping notes—like the noise of crumpled paper—that ends with a faint *itui-tuituitui!* In short, it's a sound that can hardly be transcribed. For evident reasons, then, it is often drowned out by motors, horns, and the other noises of city life. Moreover, the black redstart sings only for his beloved—though also, to the benefit of the passing ornithologist.

Nevertheless, in some circumstances, this same song, without being any more melodious, can be heard marvelously well. In a mountain arena, for example, somewhere in the Alps, it stands out in astonishing relief, echoing back along the cliffs. For the black redstart is a mountain dweller who has acclimated little by little to the plains, first to the country and then to the city.

In the fall, you may see the black redstart traveling along the coasts. It will perch on a rock at the seashore, its orange tail seized with a regular nervous trembling, while it keeps the rest of its body stock-still and its eye trained on the observer.

The black redstart, *Phoenicurus ochruros*, is found from Europe to the foothills of the Himalayas. It is a bird of the rocks, whether perched in a mountain scree, on a seaside cliff, or atop a large city building. That is its domain. Only those from the most northern parts of Europe leave in the fall, and they do not go far, preferring the area around the Mediterranean.

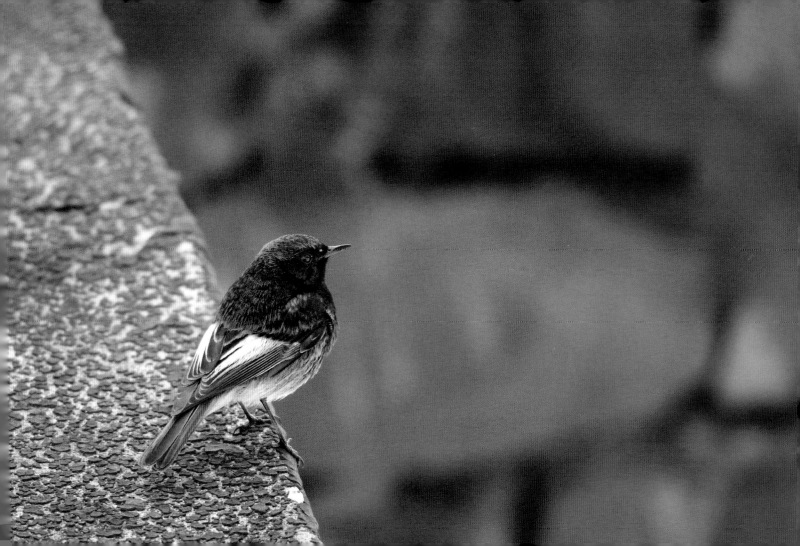

Baikal teal

The Baikal teal is assuredly an Asian bird. Until recently, it was considered rare and endangered. And then a site in South Korea was discovered where more than 600,000 birds were spending the winter. This was truly a happy surprise, but no one knows exactly what part of Siberia these birds come from. What an extraordinary spectacle to witness, at sunset, tens of thousands of these birds taking flight, swirling above the lakes bordering the Geum River! They look almost like swarms of insects, mayflies in the evening sky. To a westerner, their choreography recalls that of the starlings returning to their roosts. The arabesques that these ducks draw in the orange sky are more reminiscent of Arabic writing than of Korean characters.

But you must go as far as Korea, during the winter period, to see this teal in great numbers. Curiously, it is not easy to spot in its summer home in Siberia, where it is dispersed over a wide habitat. Occasionally, it strays into Europe or to North America, and thus it is possible that you might see it there as well.

The male Baikal teal, *Anas formosa*, displays a complex pattern of black, white, and green marks on his head. The female, meanwhile, is brownish and very drab, like other females of the *Anas* genus (which are among the dabbling, or surface-feeding, ducks).

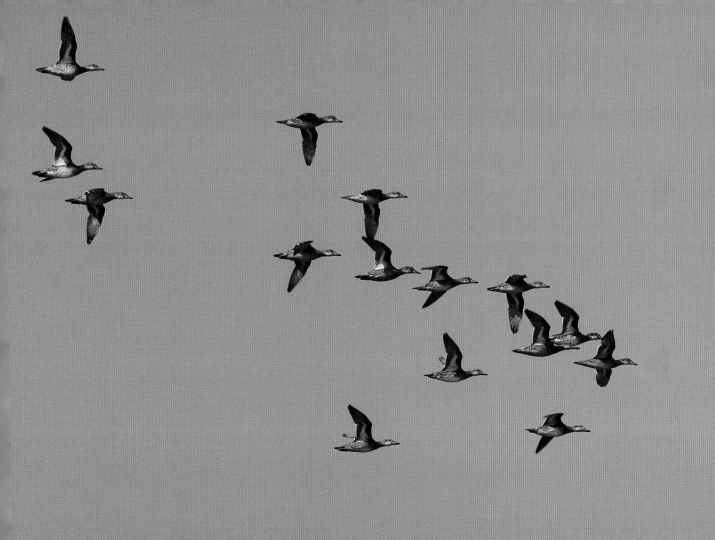

European serin

Those who are not familiar with the birds of Europe are always surprised to learn that a serin, of the same family as the caged canary, lives in our temperate regions. Moreover, like the true wild canary—found in the Canary Islands—the European serin is not totally yellow, as some domesticated birds may be. Only the head and the rump are lemon yellow. The European serin lacks the vocal capacity of its indoor cousin, but it has a joyous chatter of its own. The notes it sings are so rapid and garnished with trills, a bit like those sometimes made by its domestic relative, that it sounds as if the bird is in a hurry to reel off its message.

Leaving his perch, the male flies, slowly beating his wings and continuing his chatter. This nuptial flight seems to please the female, who, discreet in her drab greenish habit, has not moved from the branch where she is perched.

In summer, when the birds seem crushed under the heat, the European serin grows quiet. We already miss its optimistic song.

The European serin, *Serinus serinus*, belongs to the finch family, like the chaffinch or bullfinch. In the fall, many birds migrate toward the south, to the shore of the Mediterranean. They frequently mingle with linnets, greenfinches, and other finches. As the climate warms, however, the birds tend to stay farther north.

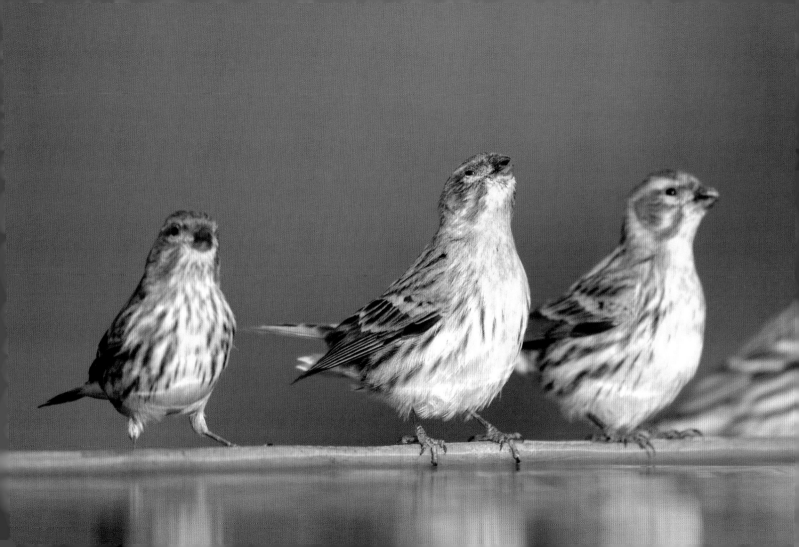

Northern shoveler

On this Mediterranean swamp not far from the coast, several dozen northern shovelers have stopped to rest. With their great spatula-like beaks, they probe the water in search of food. They swim energetically in every direction. From time to time, some birds take off and land again; three males pursue a female. Between destinations, with only a short break to grab some food, these three still somehow find the energy for courtship. Like many migrators en route to the north, the shovelers keep their stopovers brief. Tomorrow, these birds will perhaps be gone, replaced by others that arrived in the night. Many shovelers will spend the winter in tropical Africa and thus travel thousands of miles. But not all: a number of birds spend the winter in temperate Europe, particularly in the marshes of the western part of the continent. However, they are sensitive to the cold, and when it freezes, the shovelers desert the ponds and flee farther to the south.

Later in the season, one may see a male, neck extended, attentive to the least sign of disturbance. No doubt a female is nesting on a small pond nearby.

The northern shoveler, *Anas clypeata*, is a species widely dispersed from North America to Asia. The birds that nest in the northern regions migrate toward the south. They spend the winter in warm regions such as California, Texas, the Mediterranean perimeter, the Middle East, and even tropical Africa and Central America.

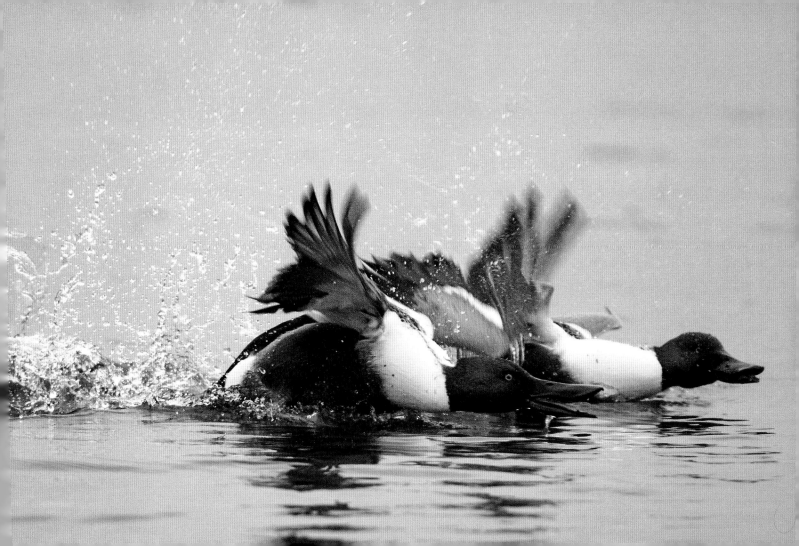

Water pipit

The water pipit, despite its name, is a bird of the mountains. At least it is a mountain bird in summer, when it nests at high altitudes, in mountain pastures. When fall comes, it leaves the heights to spend the winter on the plains, notably on the coasts, in the swamps, or at the edges of ponds.

It is in springtime, when the birds return to the regions where they reproduce, that they are the most beautiful. The bottoms of their bodies, especially their breasts, are tinted pink, and the caps on their heads are gray. Around that time you may find a small flock here or there that has stopped to rest in a coastal wetland. Like all pipits, the birds are past masters at the art of dissimulation and at ferreting through the tall grasses. But with patience, you may finally see one abandon its cover.

Later in the season, you can observe the water pipit at higher elevations. The males sing as they fly and then parachute back down, still singing, to assume a prominent stance on a rock.

Intimately linked to the mountains in summer, the water pipit, *Anthus spinoletta*, is found in all the mountain ranges of Europe, and across the Middle East to central Asia and Mongolia. The European birds may spend the winter in North Africa.

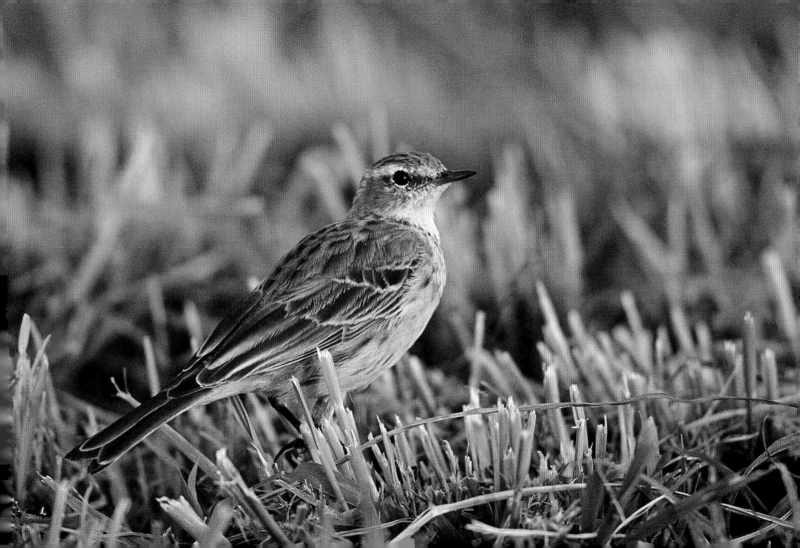

Barn owl

All too often, our first glimpse of the barn owl is in the form of a flattened pancake on the side of the road. This owl has the sad reputation of being one of the most frequent victims of highway traffic.

When night comes, the barn owl covers the breadth of the countryside without a sound, in its slow and velvety flight. This "white lady" can hear a field mouse at a distance, in the darkest night, and pounce, seizing its prey in its talons. To catch it up close, you must find a bell tower or abandoned shed where it is raising its fledglings. Otherwise, you must content yourself with a fleeting midnight vision of a bird hunting at the edge of the road, illuminated for a moment in the headlights of a car. A ghost that quickly vanishes into the dark, it leaves behind only a fugitive memory, like the trail of a shooting star. The barn owl is a mysterious animal, long the object of superstitious beliefs. The bird has maintained an ambiguous relationship with humankind: close enough to nest amid our dwellings, but absent when we are awake, as if we can never meet face-to-face.

Primarily sedentary, the barn owl, *Tyto alba*, is found in Europe as well as in India, in Southeast Asia, and in a large part of Africa. Its facial mask, in the shape of a heart, acts like a receiver dish and directs sound toward its ears, which helps explain the barn owl's remarkable hearing.

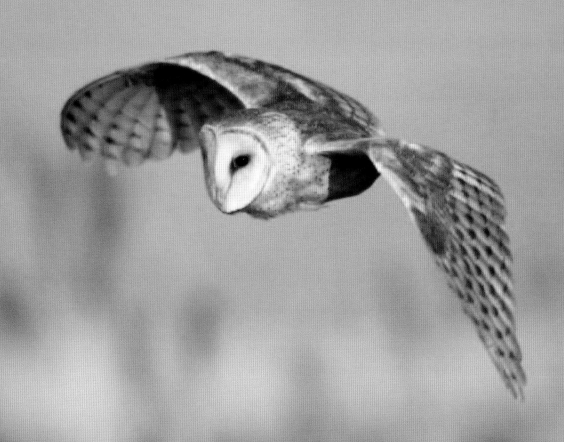

Barn swallow

The first swallow of spring! You may capture only a fleeting vision of this migrator in a rush to the north, but in that brief moment the rush of adrenaline makes your heart pound. After long weeks spent in the company of winter, with its lands deserted by birds and its cold, gray weather, the first swallow fills the ornithologist with happiness and plenitude.

"A swallow doesn't mean it's spring," as a French adage says, but, for me, it certainly contributes to that feeling. And this bird, briefly spotted above a pool of water, hunting insects before it continues on its route, gives rise to optimism. It may well rain tomorrow or even freeze or snow again, but a new and irreversible stage has been reached in our progress toward the long days of summer.

The courageous swallow, returned from Africa, has braved the Sahara, then crossed the Mediterranean. At present, it is flying back to northern lands still benumbed by cold, and these will not spare the swallow their storms, frost, or rain.

From North America to Europe and Asia, the barn swallow, *Hirundo rustica*, nests in temperate regions. It then migrates toward the tropical regions of Asia, South America, and Africa. Here and there, some individual birds are left behind in the intervening regions, and farther and farther to the north as the climate warms.

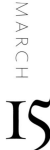

MARCH

15

Turaco

Turacos are unquestionably among the most beautiful birds of the African forest. Often green in color—but not always—they blend in admirably with the foliage. The birds are quite shy, and you hear them more than you see them. They are not, however, great singers, and their cries are not the most graceful. They are far from stingy with their noisy, rasping cry of *kok-kok-kok-kok!*, especially at dawn, when it echoes through the forest clearings and becomes an intimate part of the aural atmosphere of the vast African forest.

When you finally have the chance to observe a turaco, you see its plumage in all its subtle beauty. Though the color green dominates in most species, it is always embellished by subtle hues ranging from red to violet to orange, set off by a spot of white. Its head is ornamented with a crest, comb, or tuft of feathers, and it appears to be wearing red and white eye shadow. The violet turaco and Ross's turaco, meanwhile, are quite another color: a dark violet-blue. The violet turaco has a yellow face and a sort of red pom-pom on top of its head, which is beautiful.

The 23 species of turaco all live in sub-Saharan Africa. These birds make up the Musophagidae family and are fairly closely related to parrots, without the powerful beaks but with the same lovely colors. They live all year in the forest and are especially active at sunrise.

Egyptian goose

At the edge of a large African lake, notable visitors include crocodiles, zebras, a passing lion, antelopes, or even a herd of elephants who have come to quench their thirst. Your gaze may be less drawn to the birds that always populate the banks of a body of water. Among them, however, the Egyptian goose cuts a figure impossible to ignore. This member of the Anatidae family, its size halfway between that of a goose and a duck, is particularly common in tropical Africa. Despite its name, the bird is rare in Egypt, and you do not see it except on the shores of Lake Nasser, in the southernmost part of the country, and particularly around the Abu Simbel temples. The Egyptian goose must once have been more common there.

But the bird can also be seen in Belgium, the Netherlands, Great Britain, and other European countries. Introduced into parks and gardens for its slightly exotic plumage, the goose rapidly took wing, so to speak, and has now established wild populations in many regions of the continent. Which is not necessarily so pleasing to the local avian life. The Egyptian goose, given its size, is a dominant bird that knows how to make room for itself.

The Egyptian goose, *Alopochen aegyptiacus*, is common in tropical Africa. In temperate Europe, it has been settling into the wild more and more, and is presently considered an invasive species. It has a low tolerance for other species of waterbirds.

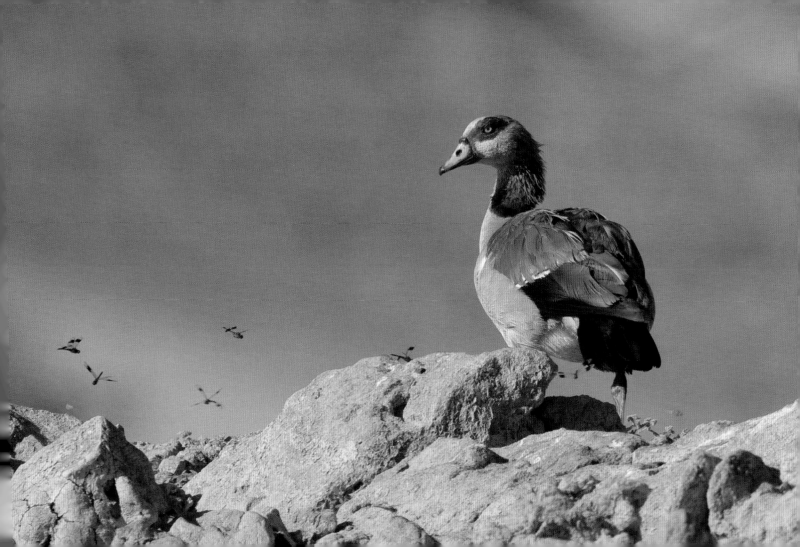

Eurasian woodcock

W e are warmly dressed this evening to head into the forest. The Rambouillet Forest, to the west of Paris, is a lovely place to see the Eurasian woodcock. Starting at dusk, if the weather is calm, the males emerge from the underbrush and fly over the forest, giving a high, thin cry: *tic!* This display is called "roding," and the month of March is the right time to witness it. Against the darkening sky, the shy silhouette of the woodcock traces complicated arabesques. From time to time, the male punctuates his gentle cry with a raucous and guttural call that makes for a sharp contrast. The females are invisible, likely crouched on the cushion of dead leaves at the foot of an oak.

In their own discreet matter, the woodcocks, like other birds, signal that they have begun the process of reproduction.

In the fall, around the first of November, the woodcocks of the coastal woods on the northern seashore are flushed out. Each bird is a fat brown mass that takes off laboriously and looks to find somewhere to land as quickly as possible, as the hunters of the area are on alert.

The Eurasian woodcock, *Scolopax rusticola*, nests all over Europe. The northern birds arrive in the fall en masse in the woods of the temperate regions. But the species remains discreet. It is better known to hunters than to hikers or even to naturalists.

Fieldfare

In the prairie where the farmer is pasturing his cows, a flock of fieldfares has made a stop. Several dozen of them search for food in the new grass. By turns, they hop, deftly peck the ground for food, and stand still to cast a watchful eye on their surroundings. They advance briskly and will soon finish their systematic inspection of the field. But then a hen harrier on the hunt makes the whole group take flight, with an indignant chorus of *chac…chac…chac!* Soon, the birds alight back in the pasture—but this time a little farther from the car of a bird-watcher stopped by the wayside.

These fieldfares are running late, for most of these birds have already departed. Since the thaw, the fieldfares are leaving us, and their migrations seem earlier nowadays than in the past—a result, no doubt, of milder winters.

Unless we travel to northern Europe during their nesting period, we will have to wait for October to see the fieldfares land here again. If a cold snap arrives a little later in the season, they may come to visit in large flocks.

The fieldfare, *Turdus pilaris*, is often present in the highest latitudes of Europe. It is there that it reproduces, in the boreal forest as well as in large parks in the middle of cities. Though it also nests in small numbers in the northeast of France, it is most often seen during the winter, when it comes to stay for the season all over the country.

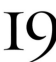

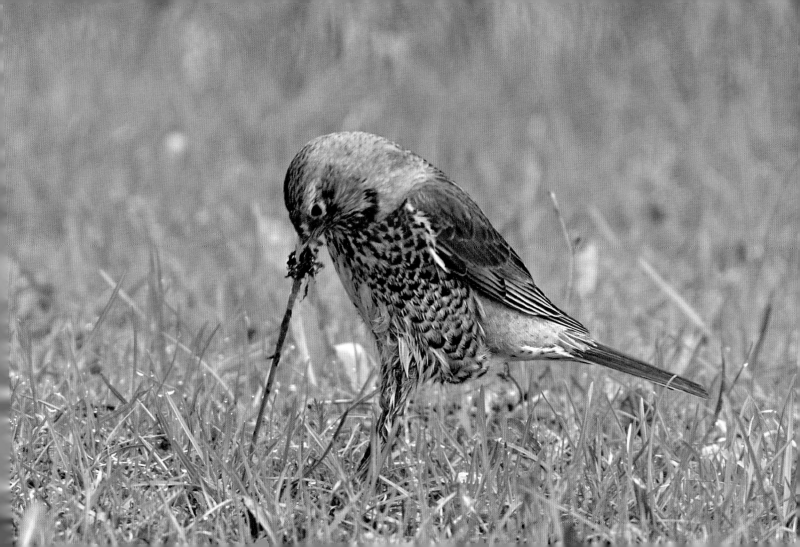

Common moorhen

Cautiously, always on the lookout, the common moorhen paces along the edge of a small urban pond. At each stride, the whole back of its body seems seized with a jerky trembling. It looks as nervous as a mouse crossing a courtyard where the barn cat dozes with eyes half-closed.

But here there is nothing much to fear, and the moorhen remains quite well fed on the crumbs dropped by walkers in the park. This winter, the bird could be seen walking on the frozen surface of the lake, among seagulls and coots. But at the slightest alarm, it would plunge deep into the nearest bank of reeds to hide.

On returning a few days later, I witnessed a fairly violent conflict between two males, no doubt over a scrap of turf. No question here of any shyness or anxiety. Facing off, the two birds rushed at each other like two roosters at a cockfight. Appearances can indeed be deceptive.

MARCH

20

Plentiful all over the world, the common moorhen or waterhen, *Gallinula chloropus*, is equally at home on ponds and lakes in the wilderness or on a minuscule body of water in the middle of a city park. It is the moorhen's opportunism, no doubt, that allows it to colonize such a wide range of watery habitats.

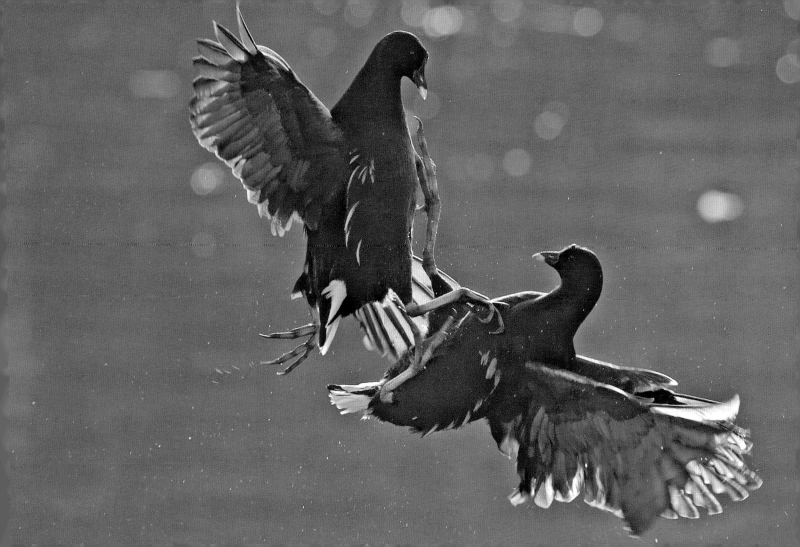

Song sparrow

The song sparrow is perhaps most likely to be cast in the role of "anonymous bird." It would be hard to be more sober in plumage than the sparrow, with its brown back and underside of mottled blackish stripes on a white background. Its only adornment is its white, or occasionally gray, eyebrows.

The song sparrow is extraordinarily common in North America, at every season and in nearly every place. I remember seeing dozens of these migrators striding along the headlands at Point Reyes, north of San Francisco, while the fog began to roll back over earth and sea. The birds might have been heading back toward the boreal region or, more simply, a few tens or hundreds of miles north.

This modest bird nevertheless has a pretty song, fairly musical, though brief. Not far from Saint-Laurent, in Montreal, it sang in March even as ice floes floated along the river. I was struck by the constancy and determination of this male bird who defied the endless Quebec winter.

Very common in all of North America, the song sparrow, *Melospiza melodia*, is resident in most of the United States, but migratory particularly in Canada. In the southeast of the continent, it is seen principally in winter. There are numerous subspecies, distinguished only by subtle differences in plumage.

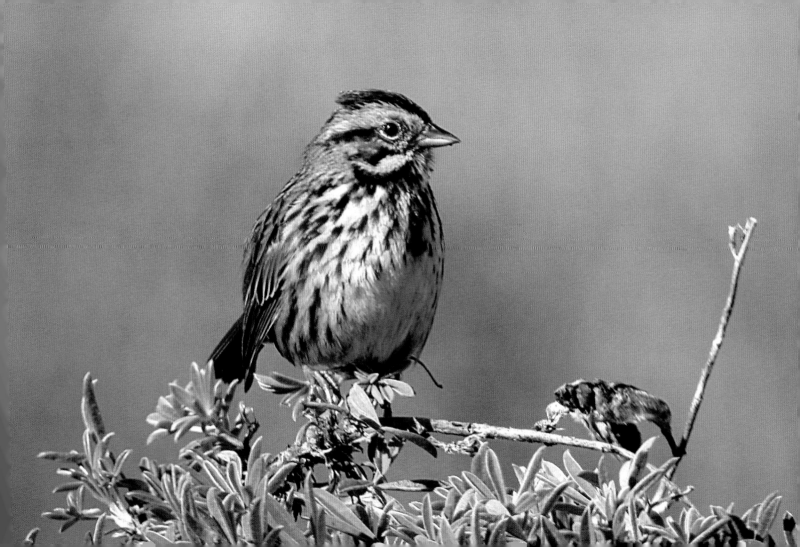

Carrion crow

Those interested in animal behavior are always certain of finding something to marvel at in the carrion crow. All one has to do is sit down in a public garden and wait. The crows are rarely far away. Compelled by curiosity, if not by hunger, they come to inspect the place, to snitch from the pigeons, to observe as much as they are observed.

To say that carrion crows are intelligent is an understatement. They know how to use tools (stones, twigs) to seek out food in unreachable places. They are even said to be capable of learning several dozen words. They are remarkable opportunists, who live as happily in the forest as in the middle of major cities, always finding a nesting spot and a place to find food. The carrion crow is distinct from the raven, its close cousin. Less sociable than the raven, it is much better adapted to living alongside people.

With its intelligence and powers of adaptation, the carrion crow seems fitted to survive anything! One could predict that if these birds were ever wiped out, humans would surely follow soon after.

Present all over Europe and in part of Asia, the carrion crow, *Corvus corone*, has other cousins who live elsewhere, notably in North America. The species is very sedentary and remains loyal to its territory for life, whatever the climate conditions.

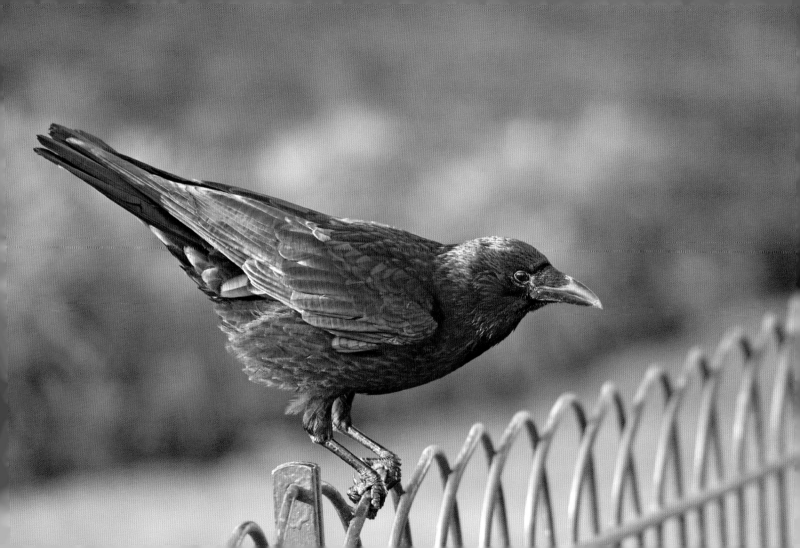

California quail

It is along the Californian coast, in rocky or bushy terrain, that I have seen the largest number of quail. These birds, which are similar to partridges, are fairly timid; they are always on guard. You often see them in small groups. There is no question of approaching them with a decisive step: they will vanish immediately into the vegetation. Instead, you must watch them without moving. With cautious steps, the birds inspect the ground, searching it for seeds. Like a knight with a plumed helmet, the male bears a black crest on top of his head.

Sometimes, you may spot the birds perched at a good height in the trees. But more often you will only hear the sound of the male bird singing. In the morning, when the air is still pure and sound carries far, the males sing out and respond to one another in the still-sleeping countryside.

This American species, *Callipepla californica,* is found on the West Coast of North America, as far south as Baja California. The California quail was introduced here and there in Europe for hunting purposes, but without real success.

Black-tailed godwit

The communal marshland of Lairoux-Curzon, in the Vendée department of France, is covered with tens of thousands of white buttercups. The immense pasture is partly submerged in water, which shimmers in the spring sunshine. In the distance, the Curzon church raises its clock tower against the blue and white sky. A flock of birds has taken off from the other end of the marsh and several hundred rise into the air, giving resonant cries of *grutto…grutto… grutto!* These black-tailed godwits, returning from Senegal, Mali, or perhaps the south of Spain, have paused here for a few hours to nourish themselves before leaving for their next and last stop: the Netherlands. A few dozen fly due north: they are full. But most of them touch back down and rejoin the thousands of birds frenetically probing the ground for small invertebrates. Each minute, each second counts for these birds, who must ingest as much food as possible, so as to store up the considerable energy they need for their journey.

In a few days, only two or three hundred birds will be left here. Their rest stops are brief, for reproduction will not wait.

MARCH

24

The black-tailed godwit, *Limosa limosa*, nests from Iceland to Siberia, but the populations that pass through Western Europe in the course of migration nest primarily in the Netherlands and Germany. Their numbers have diminished considerably in these last years, both because of the loss of prairieland and because of haymaking earlier in the season, which destroys the birds' nests.

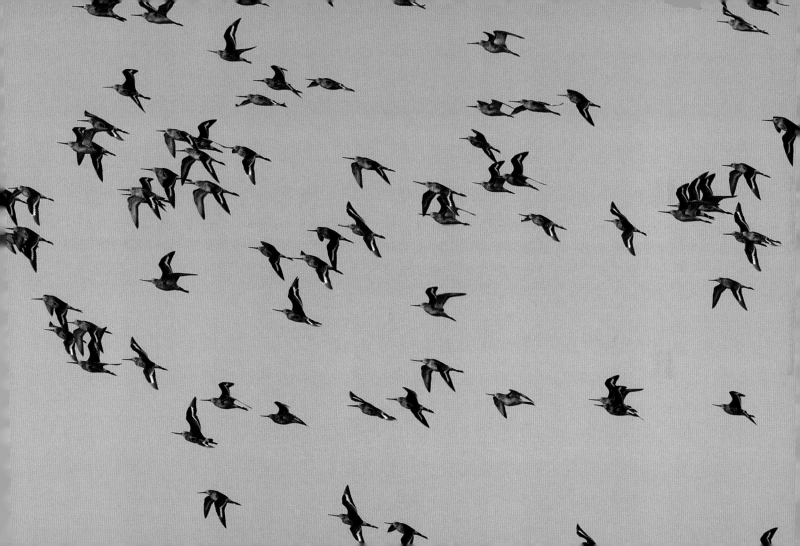

Woodlark

On the volcanic plateau known as the Planèze de Saint-Flour, spring tarries before truly arriving. A group of chaffinches accompanied by some bramblings search for food on the little road winding between the prairies, which are still bordered by hedges and big stones. A red kite glides nonchalantly overhead. A small voice is heard in the air: *lulululu…duduli!* It is not flamboyant, as calls go, but it is cheerful. The woodlark does what it can to be noticed; in any case, the male does, with an eye to attracting his future companion. There it is, in flight against the gray sky, its large wings and short tail differentiating it easily from the larger skylark. It soon lands at the top of a sylvester pine and continues its song. It has no crest, or hardly any, and a distinctive little black-and-white mark on the edge of its wings.

The woodlark is a discreet bird all year long. When a little group of these migrators flies south, some early October morning, it will require a good ear (and practice) to distinguish their soft cry, which recalls the melody of their song.

The Latin name of the European woodlark, *Lullula arborea*, reflects the liquid notes of its song. Partial migrators, the birds generally travel hundreds of miles to reach warmer regions—but certain populations are sedentary.

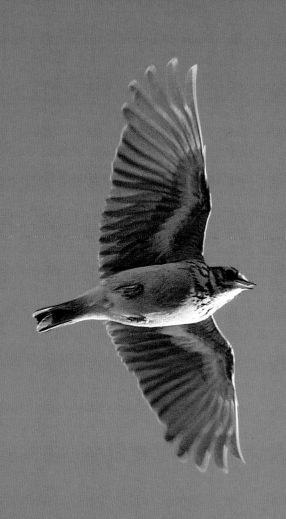

Ring-billed gull

In North America, where it originates, the ring-billed gull is, to my eyes, a city bird. Even if my association is subjective, and only accurate in part, it is in New York, Boston, and Montreal that I have seen the greatest number of these birds. On the banks of the Hudson, in winter, you can observe ring-billed gulls of all ages, lined up single file on the railings of the embankment. An excellent way to study the plumage of the species! In Montreal, in summer, I have seen thousands of birds around the Ile de la Couvée, where the species nests in great numbers. From east to west, the ring-billed gull never hesitates to gorge itself on bread tossed by passersby.

On the other side of the Atlantic, in Europe, I have seen the ring-billed gull more than twenty times. Here is a species perfectly able to cross the ocean, if in small numbers, often propelled by winter storms. It is always a surprise to spot one of these birds in some little port of Brittany.

Nesting all over North America, the ring-billed gull, *Larus delawarensis*, makes only short migrations in winter, when a great number of birds settle in the southern part of the continent. The bird is also regularly seen in winter on the European coasts. That is, perhaps, a result both of its growing numbers and of the crosswinds of winter storms, which move birds toward the east.

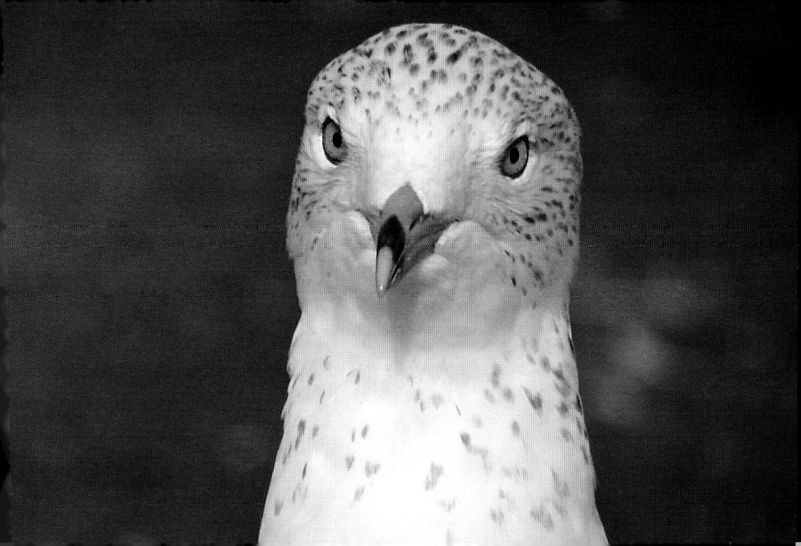

Common cuckoo

If you took a random poll and asked each person to imitate the song of the cuckoo, I would guess that three-quarters of the results would be convincing. On the other hand, how many of those people would actually have seen the common cuckoo? Very few, in fact, other than naturalists. I remember my grandmother, who loved birds, lamenting at the age of 96 that she had never seen a cuckoo in her life.

However, the common cuckoo is not that difficult to see. It is just extremely inconspicuous. A forest dweller, it never strays far from cover, and most often sings while well hidden amid the vegetation. It can be spotted most easily in flight. But it somewhat resembles a sparrowhawk: it has the same general color of gray, the same boldly striped underside, the same longish tail. Only their flight distinguishes the two birds: direct and fairly slow for the cuckoo; undulating, quick, and often low to the ground for the hunting sparrowhawk.

The cuckoo is not uniquely Swiss, and is not there just to tell us what time it is. (Perhaps it prefers to sing at a certain time of day?) If it tells us anything, it is that spring is truly here and that it is time to head out into the natural world.

A long-distance migrator, the common cuckoo, *Cuculus canorus*, lives all over Asia and Europe. It migrates in the fall toward the warm regions of subequatorial Africa, India, and Southeast Asia. The cuckoo is a brood parasite: the female lays an egg in the nest of another species, and the chick is then raised by its hosts.

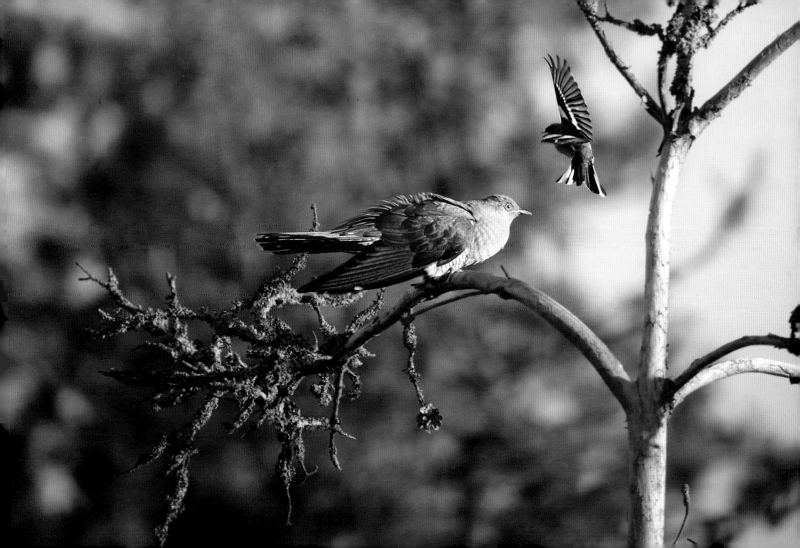

Penduline tit

Even if you're an ornithologist, you need a good ear to hear the cry of the penduline tit, when two or three of the birds travel through the great reed bed that borders the marsh. Their cries of *ssii… siii… sii!* are so thin that they easily pass unnoticed. Then, once you do hear them, it takes a bit of patience to find the birds. Here is one, perched at the top of a cattail, dissecting the downy seeds that grow there. As it works away busily with its little pointed beak, it looks so much like a true tit that you can understand why it got its name, despite not being a member of the *Parus* genus. With a hesitant flight, it heads over to visit another reed, all the while giving its shrill cry. With its black Zorro mask, the penduline tit is irresistible.

The birds have stopped for a few days in this Atlantic marshland, but soon they will continue on their way toward some other reed bed in Eastern Europe. They will leave as discreetly as they arrived.

MARCH

28

The penduline tit, *Remiz pendulinus*, nests in Europe and in western Asia. Certain populations are migratory and winter in small numbers in the south and the west of France. In the spring, the male constructs a nest in the form of a downy ball, made mostly of soft willow catkins, which it suspends from a branch.

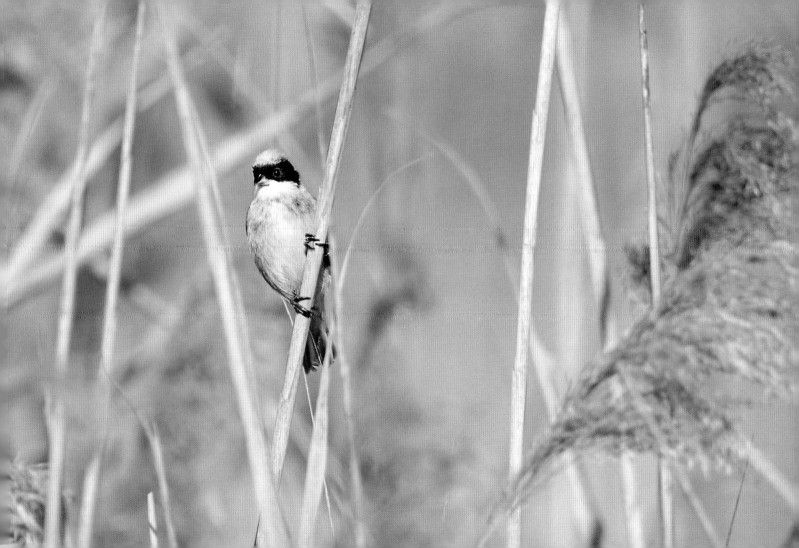

White-headed duck

At the end of the 1970s, the white-headed duck had become an extremely rare bird in Europe. The few surviving individuals could be seen on lagoons in the wilds of Andalusia. But their exact location was a carefully kept secret—you practically had to wear a blindfold to get the vigilant guardians of the spot to take you there. The humpbacked birds, their tails raised, the males sporting a bright blue beak, are quite strange-looking—which only added to the aura of mystery when they suddenly sprung up one day in the sights of our binoculars.

Today, the species, without being common, has been much restored in Europe. It is the populations in Central Asia and in the Middle East, numerous but little known years ago, that suffer from diminishing numbers, in the face of hunting and the loss of their habitat.

The odd-looking white-headed duck is decidedly a bird with a hard life, whose path, as this century unfolds, is particularly fraught with pitfalls.

In Europe, the territory of the white-headed duck, *Oxyura leucocephala*, has been reduced to particular locations in Spain and, more broadly, in Romania. It is found in greater numbers in Central Asia, where its populations winter, especially toward the Middle East and in Turkey. It is a species threatened by disappearance on a global scale.

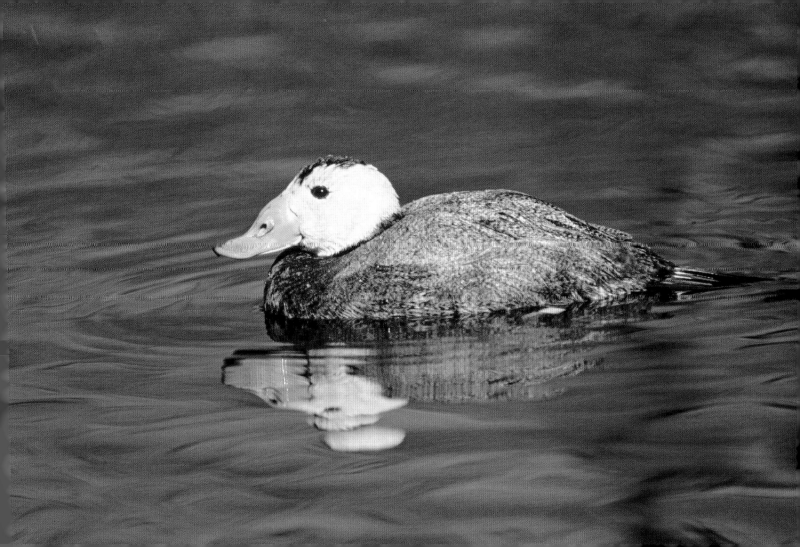

IMPRESSIONS OF THE SOUTH

To escape the cold and wet of the north at this time of year, we must head for the Mediterranean. It is the time of year to welcome the migrators returning our way from Africa. These valiant birds have braved the burning Sahara, then crossed the Mediterranean, in a season where the sea is not necessarily at its calmest and most blue. There are certain places that I love to visit during this period, when the springtime is certainly winning the game but winter can still make a sneak attack. There is the delta of the Guadalquivir River, in southernmost Spain, where one has the impression that it is already the month of May. In France, there is the Camargue, flooded with water and birds; the island of Porquerolles, an enchanted garden where thousands of birds rest, exhausted from their maritime crossing; and the green and flourishing backcountry scrubland, bursting with flowers and still empty of the throbbing song of the cicadas.

It is a moment of rebirth for nature in general and the birds in particular. There is not a moment to lose: put down this book and go outside.

MARCH

30

Common bulbul

After a night arrival at the Marrakech airport, we wake up early, so eager are we to go observe the birds. In the hotel garden, a song issues forth from the first glimmer of daylight. You might think it was a blackbird, but the notes are louder, more resonant, and more detached, with a faster rhythm. Who is the singer belting out his song so early in the day?

Gently pushing open the shutters, my eyes still drowsy, I scan for the bird in question. Finally I spot it, drinking from a visible leak in a garden hose. It is brown and fairly unobtrusive in appearance. It is the common bulbul. Bulbul: a name of Persian origin, but embraced by speakers of Arabic, in a fairly accurate onomatopoeic evocation of the bird's song.

In the palm groves of Marrakech, as in those of the Draa River valley or the Tafilalt oasis, bulbuls are omnipresent. They are never far from humankind and yet never exactly familiar with people, either. They are observers of domestic work, but always on their guard. In the stifling air of midday, the bird makes its song heard, well hidden among the leaves of a date palm.

MARCH

31

Several dozen species of bulbuls live in Asia and Africa. The common bulbul, *Pycnonotus barbatus*, is surely the most northern of these, with a territory stretching as far as North Africa. They are a sedentary species, and have a similar song, made up of resonant, liquid, leaping notes.

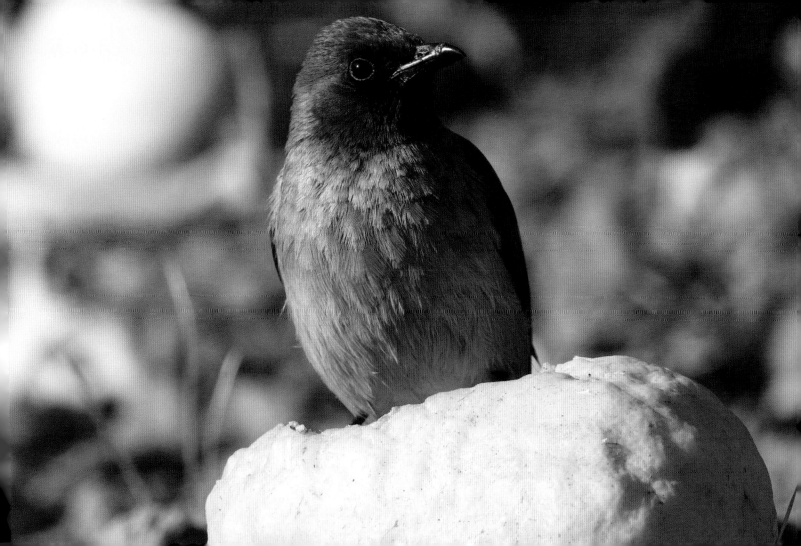

Zebra finch

April Fools' Day is a time for pranks—among ornithologists as well as everyone else. On April 1, it has become a tradition for people to announce, on the Web or in discussion forums, the discovery somewhere of an extraordinary bird. Obviously, no one believes them. But sometimes there can be a remarkable sighting … even on the first of April.

I remember one morning on April 1 when a friend of mine claimed to have discovered a zebra finch in his garden. I wasn't even sure what this bird looked like—it is not listed in European or North American bird guides. In that light, my friend's supposed scoop seemed like a fairly ridiculous joke. Until I paid him a visit that afternoon and saw, among the sparrows that always frequented his garden, a small colorful bird, with a bright orange cheek. Of course, it had escaped from some cage, because the species lives in Australia. But it was a real pleasure to observe this April Fools' joke come to life, prettily stealing seeds with the rest of the birds.

Originating on the Australian continent, the zebra finch, *Taeniopygia guttata* is a species of the Estrildidae family, small, colorful passerines that are commonly seen in pet stores. Because it reproduces well in captivity, this species has been widely used by geneticists to study various aspects of avian life and of living creatures in general.

APRIL

I

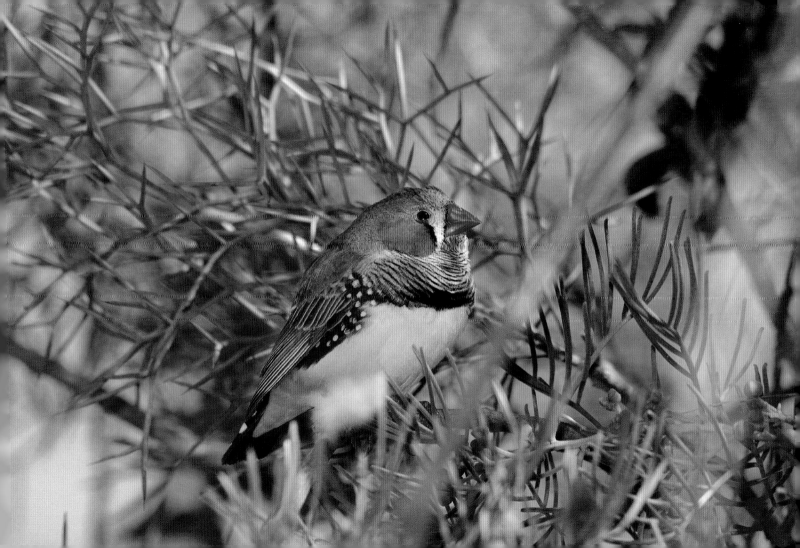

Western capercaillie

Christian had had us spend the night outdoors, our tent surrounded by snow. It was a terrible night, at an altitude of nearly 3000 feet (914 meters) in the massif of the Vosges range. But the spectacle before us that morning swept away the hard night. We were there to witness the parade of the western capercaillies, which takes place in a courting ground specially designated for its display. The males, seeking to seduce their beloveds, return to this spot year after year. Despite the fierce cold of the early morning, we were rewarded with the sight of a superb male, excited and majestic, who came to visit the lek (the name for this courting ground, which is usually a clearing in the forest) for some long minutes. Spreading his tail like a peacock, he sang for the unseen females. And "sing" is not the right word. For his "song" is in fact a mix of odd noises: the sound of a cue ball bouncing on hollow ground, followed by the "pop" of an uncorked bottle, and ending with the scraping of a knife being sharpened. For us, shivering but fascinated by the bird, it was not the sweetness of the song that was the most important thing, but the unique beauty of the moment.

The western capercaillie, or *Tetrao urogallus*, also known as the wood grouse, lives in Europe. Fairly common in the boreal forests of Scandinavia, the western capercaillie has become very rare in temperate Europe, where it survives only in the mountains (the Alps, the Pyrenees, the Cantabrian Mountains of Scotland). A victim of hunting and especially of the human encroachment associated with mountain sports, it unfortunately seems to face a grim future.

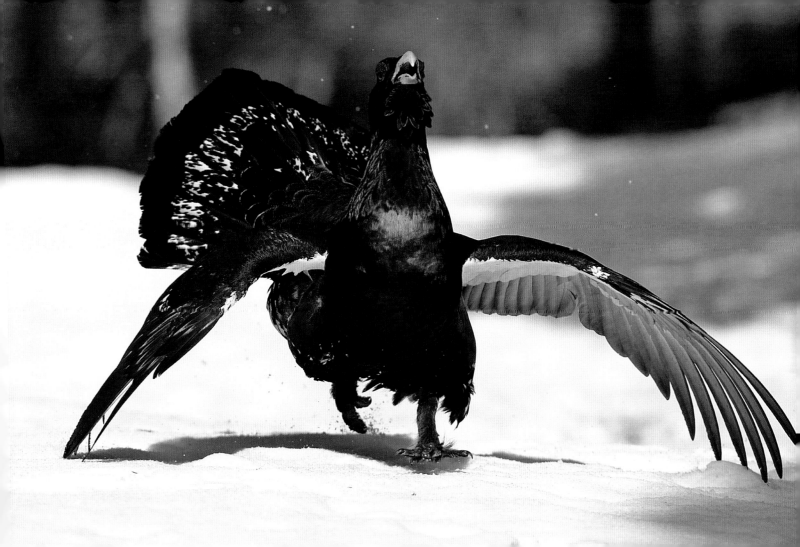

European scops-owl

It is the first warm night on the island of Porquerolles after a brisk northern wind dies down. In the sleeping pine forest echoes the tireless, fluting note of the scops-owl: *tiu!* repeated every three or four seconds. The scops-owl has returned. The smallest nocturnal raptor of Europe is also the greatest migrator among owls; most of Europe's scops-owls spend the winter in Africa. Strange behavior in an owl, since most members of that family are considered to be quite sedentary. Imitating its solitary note, without moving, my body glued against the trunk of a maritime pine, I try to spot the bird, which, thinking it has a rival to contend with, has come closer. Perched high among the intermingled branches of the conifers, the scops-owl is hard to make out. With a little patience, however, I finally detect its silhouette, barely differentiated from the nighttime blue of the sky. Its little aigrettes look like two ears.

I leave, then, so as not to disturb it. As the owl fades into the distance, I hear its slightly melancholy *tiu!*, like the heartbeat of the night.

The European scops-owl, *Otus scops*, can be found in North Africa and the Middle East, as well as in southern Europe. It returns from tropical Africa, where it spends the winter, starting in the month of March. This owl lives primarily on insects and frequents pine or oak forests.

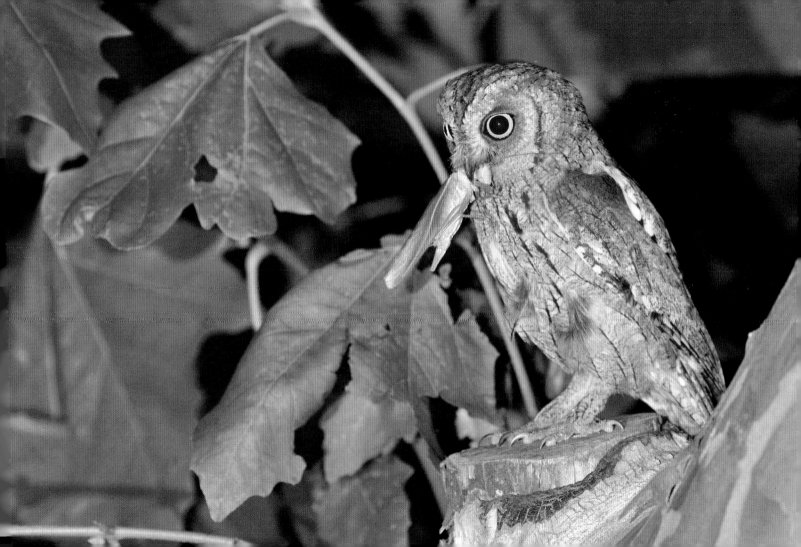

Bluethroat

A soft, cool wind rustles the hawthorn hedges. The sky, studded with white clouds, is full of spring sunlight. No question, winter is far away. All along the path, in this swamp in the Vendée, a well hidden singer makes his melody heard, sometimes intermingled with more grinding notes and imitations of other bird species. I stop and wait. Soon, the bird reveals itself at the top of a branch a bit higher than the others. This male bluethroat, freshly returned from Africa, is announcing his territory. It exhibits the bright blue throat that gives the species its name, bordered beautifully in red, while the center of its bib is ornamented with a small white ocellus, or eyespot. It looks very much like the French flag.

In the distance, a flock of black-tailed godwits give their clear calls, and the cows in the neighboring fields raise their heads. Have they noticed my presence or, like me, are they listening to this powerful soloist who so beautifully proclaims the return of fine weather? Though I can't at first say why, the bluethroat is to me a symbol of optimism. No doubt because of its lively, joyous song.

APRIL

4

The bluethroat, *Luscinia svecica*, ranges from the Atlantic coast of Europe (excluding the British Isles) to Scandinavia and across a large part of Siberia and Central Asia. It migrates to Asia and tropical Africa, although certain birds remain in place for the winter, in the south of Europe, for example.

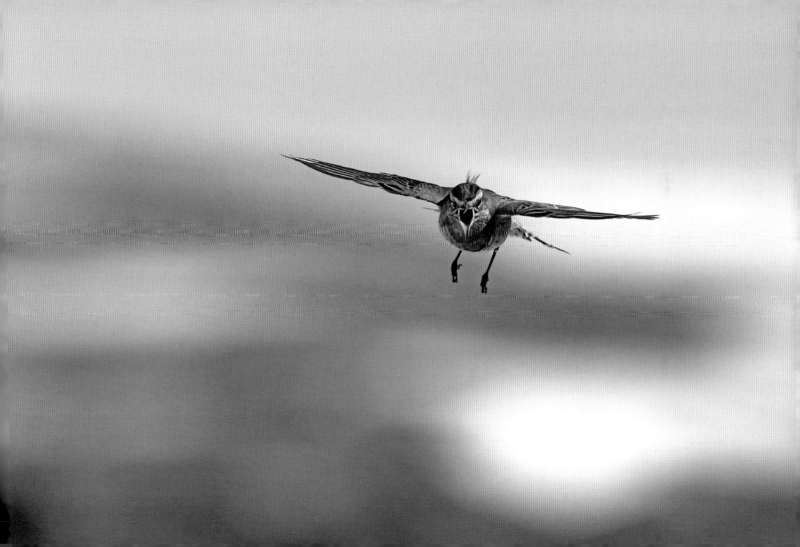

Hazel grouse

The hazel grouse is truly a paradoxical species: so difficult to observe in temperate Europe, but so abundant in the great taiga that runs from Scandinavia to eastern Siberia.

In our territory, it requires not only patience but also a keen knowledge of the terrain and biology of the species to be able to observe it under good conditions. In the boreal forest, though you won't exactly stumble on it, the hazel grouse is not really hard to spot at all. It is, of course, a question of density. And also of tranquillity. In the forests of temperate Europe, the hazel grouse is constantly disturbed by people.

At this time of year, it is the hazel grouse's characteristic song that allows us to locate it. This song consists of an extremely high-pitched chirping, which carries quite far. Once you hear it, that's the moment to look for the bird. However, it may be on the ground, and vanish before you have a good chance to spot it, or it may be perched in a tree, blending in perfectly if the forest is a dense one.

So, then, is the hazel grouse impossible to see? The best way to find out is to put down this book and go look for it.

Nesting all over Europe, the hazel grouse, *Bonasa bonasia*, is well distributed across the northern region. It is absent in North America, where relatively close species can be found. In France, it is found mostly in the Alps and in the Franche-Comté region.

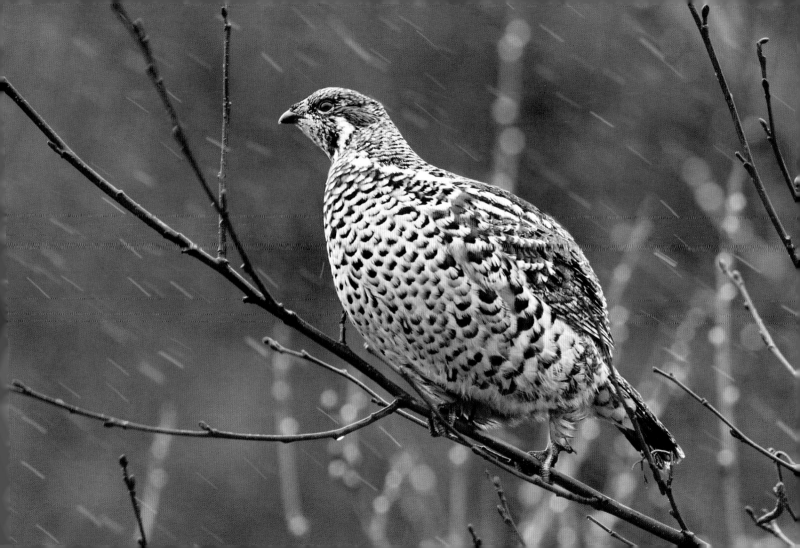

Barrow's goldeneye

Along the banks of the northern Saint Lawrence, near Pointe-au-Pic, in Quebec, it is not yet really spring. Snow is still on the ground, and the river, in places, is piled with ice floes. In the areas where the water runs freely, small flocks of ducks are looking for food. Right here is a group of Barrow's goldeneyes that have spent the winter on the river. The males parade busily around the females, making their display. They extend their necks, suddenly throwing their heads back. Sometimes, you hear their low, grunting cries resonate out over the river ice. A female takes off, quickly followed by two or three eager males. Rare are the birds who think of food. The only thing on their minds is the reproductive season, necessarily short in the high northern latitudes. There is no time to lose before the birds must return to the Canadian Great North.

The American who would like to see this superb Canadian duck must, at the very least, cross a good part of the Atlantic, to meet the breeding birds that populate Iceland.

Confined to northern North America and to Iceland, Barrow's goldeneye, *Bucephala islandica*, is found especially in the western part of Canada, up to Alaska. It hibernates all along the Pacific coast, and the small eastern population winters from Quebec to the extreme northeast of the United States. The Icelandic birds are resident.

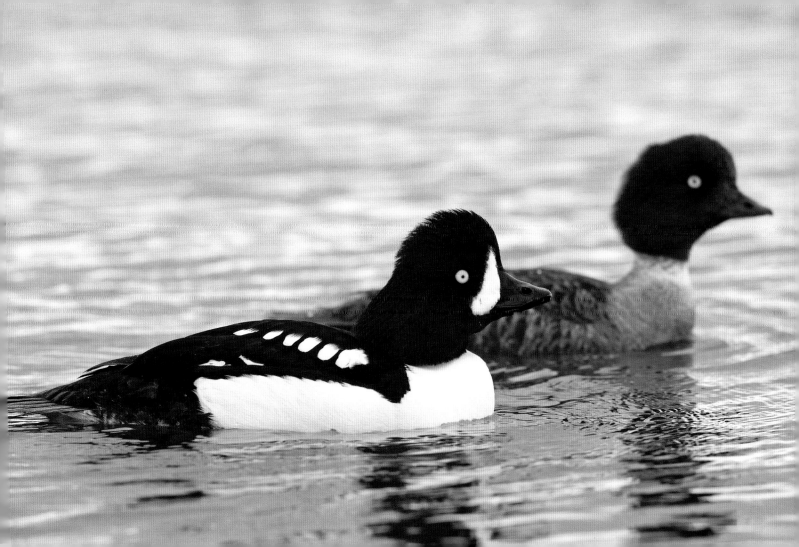

Western rock nuthatch

With our binoculars, we scan the craggy face of a great cliff in eastern Turkey. Above us glides a golden eagle, indifferent to the small human dots below. For a few minutes, we have noticed a series of high, strident calls of *huitt…huitt…huitt!*, ending in a sort of trill. The bird sings, but remains invisible: it is the western rock nuthatch, which lives on rocky cliffs. It's a strange place to be seeking out such a bird. Most nuthatches are forest dwellers, and one generally expects to see them in the woods.

"I see it!" one of us exclaims. We make a laborious survey of the crevice where the bird is perched. The cliff is huge, and it takes time to trace the path our binoculars must follow to reach the tiny ball of gray and white feathers. It is a male that is singing, at the peak of a little outcropping. Ultimately, it takes a telescope to see it properly. Luckily, the bird is more interested in singing than it is in skedaddling, which wins us enough time for a fine view.

Intimately linked to rocky habitats, the rock nuthatch, *Sitta neumayer*, is found from Greece to western Asia. Though often invisible on large rock faces, it is, fortunately, a talkative bird, and we are thus able to spot it among the rocks that camouflage it so well.

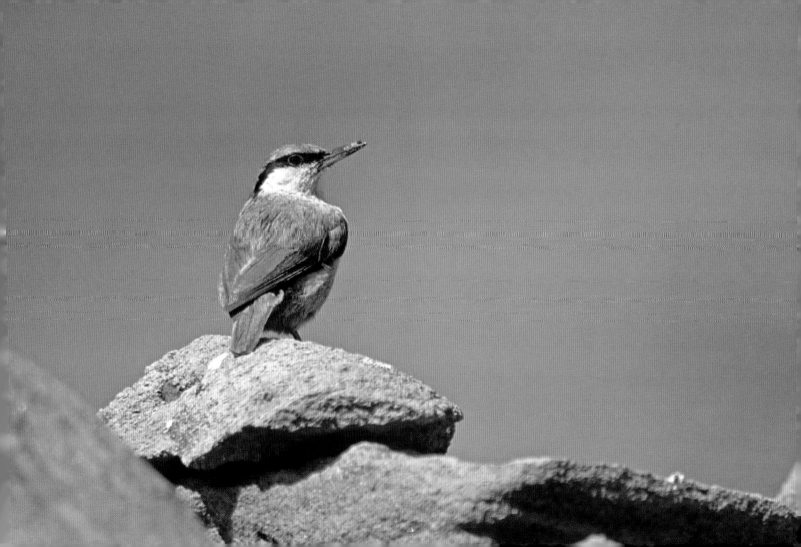

Toucan

Walking through the rain forest is no simple affair, especially when you are there to observe birds. You are faced with a constant choice between keeping your eyes glued to your feet, so as not to step on some terrible beast, and keeping your nose in the air to look for birds, which tend to sport colors that blend invisibly into the foliage.

The toucan is easier to spot than some, since it is a big bird with an enormous beak. The beak is as light as it is huge, for inside are struts filled with spongy tissue. To compare it to wood, it looks like teak but is really more like balsa. It's amazing to see the grace and precision with which the birds retrieve the fruit they eat. Because of its beak, armed with little teeth designed to grasp these fruits, the toucan was long thought to be a carnivore!

No, its beak is not made to kill, but to harvest. As scientists have recently shown, it also provides a sort of climate control: this big beak plays a role in the toucan's bodily thermoregulation.

And then it is the toucan's colors that are fascinating: mostly black, but always in concert with brighter hues. The toucan is a rainbow of feathers.

There are 34 species of toucans, which make up the Ramphastidae family. All are South or Central American. They are linked to the great rain forests; the greatest diversity of toucan species is found in the Amazon.

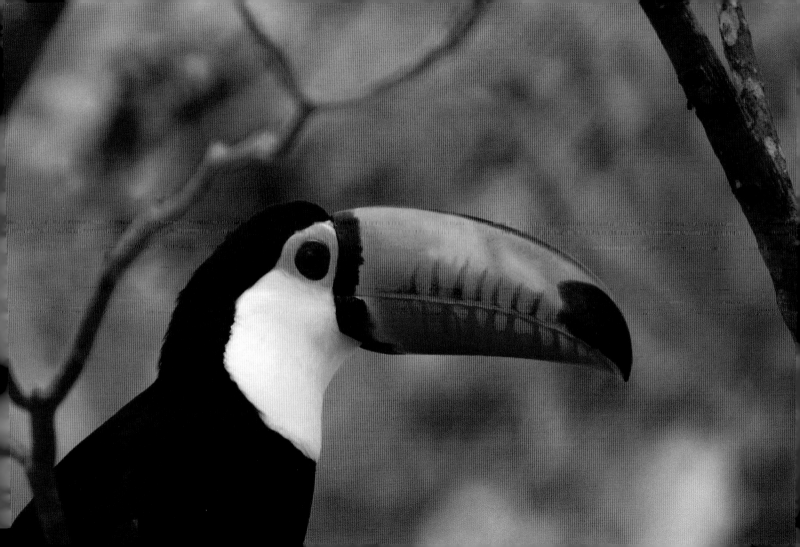

Montagu's harrier

Despite the sun shining on the limestone plateaus of the Causses, in central France, the northern wind gives the place the look of the Scandinavian tundra. Spring is there without really believing it itself. The first anemones bend in the gusts of wind, as do the taller juniper trees that must protect them. Some distant clouds hover, and with them the possibility of a shower of melting snow.

Facing into the wind and moved by some primitive instinct, a gray silhouette swoops over the ground, direction due north. It glides swiftly, like a close-hauled boat; nothing seems to stop it. It is a male Montagu's harrier, back from its winter in tropical Africa and migrating toward some grain fields, where it will nest. This bird shares features with both a sailboat and an airplane—a bit like a kite. Rejoicing in the fast-moving air, it swoops, levels out, then skims the ground again in order to avoid the gusts. It looks like a gull flying alongside a cliff. Its pale gray plumage and long wings also resemble the gull's, just as the bare limestone plateau looks, today, a little like a rough ocean.

Sometimes, the harrier rises, beats its wings vigorously a few times, then once again glides and lets itself hover, borne by an invisible wave. In the distance, a lark sings at the top of its lungs. The showers will not come this far, even if the horizon is overcast in places. Timid it may be, but spring is certainly here.

The Montagu's harrier, *Circus pygargus*, is one of the five species of harriers (diurnal raptors) that nest in Europe, Asia, and North America. It ranges principally from the Atlantic shores of Europe to central Asia, and winters in tropical Africa, crossing the Sahara. It nests in the steppes and crop fields, and the field population is heavily threatened, especially in Western Europe, as nests are destroyed more and more frequently by combine harvesters.

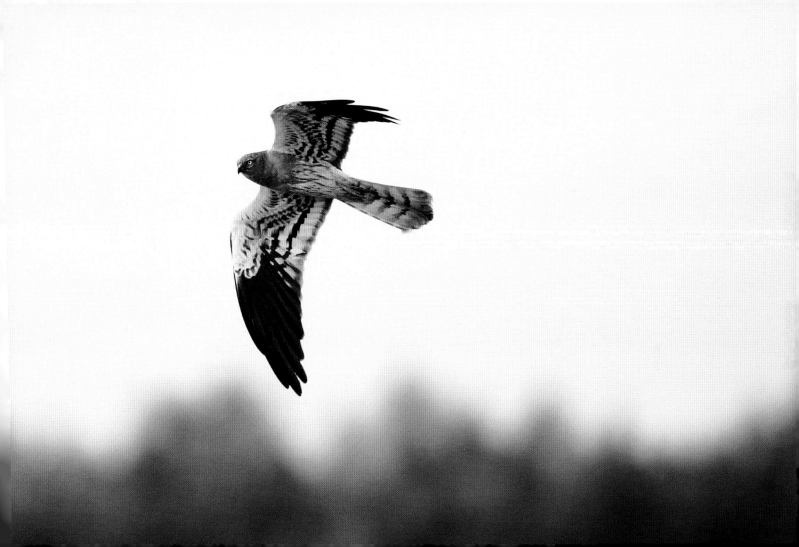

Great crested grebe

On the lake surface covered with water lilies, not far from the great reed bed, a couple of great crested grebes stand face-to-face. Two adults are making their display, very upright and a little stiff. Repeatedly, one of the two partners shakes its head no. This is the mating display of the great crested grebe. It is accompanied by ungraceful and raucous honks, trumpets, and snorts. The tableau is hardly a glamorous one—except that the birds themselves are superb. In their breeding plumage, their heads are adorned with big black and red feathers that look like a double set of ears. The rest of the plumage is drab. But ultimately, as they watch each other, and seem to say "no" while they are strongly thinking "yes," these great crested grebes are not only touching to see; they also possess a grace all their own.

Once they have raised their young, they will leave until the following fall. Then, they group themselves into flocks of dozens, or even more, on some large reservoir or along the coast. They will have a drabber winter plumage, without the ear tufts. But their long necks and their bodies sunk deep in the water make them always recognizable.

Very common all over Europe, the great crested grebe, *Podiceps cristatus*, is found as far away as Asia. In spring, it frequents all sorts of freshwater lakes and ponds; in winter, it is found either on large lakes or reservoirs, or, more often, on the sea, though never very far out from the coast. The great crested grebes of northern Europe are clearly migratory.

APRIL

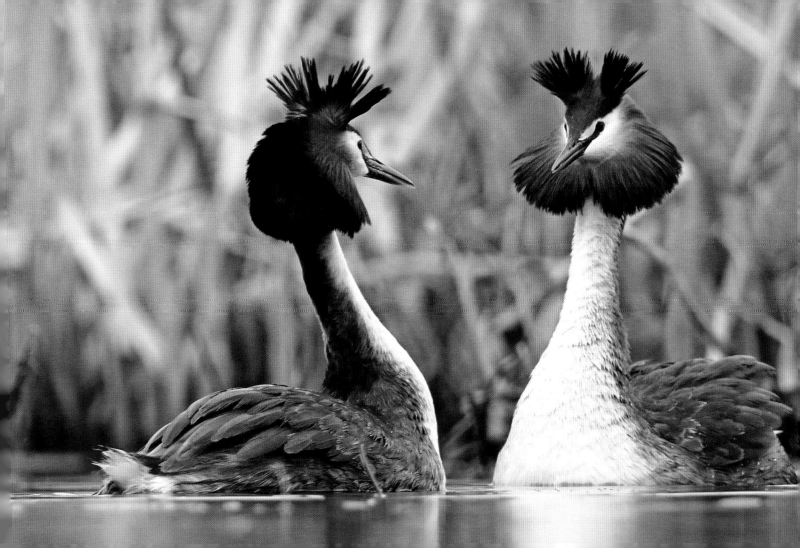

Ring ouzel

On a slightly sloping prairie, not far from Saint-Bernard-du-Touvet in Chartreuse, I saw the ring ouzel for the first time. The little flock of a dozen birds had no doubt just touched down there, and the birds had dispersed into the field. With short hops they advanced, searching for earthworms poking their noses out after a morning shower. At the time, I was truly incapable of saying whether, in view of their plumage, these were French birds returning to nest in the surrounding forests or, on the contrary, migrators on their way much farther north, to reproduce in the Scandinavian forest. Today, I know that the latter have a much blacker plumage and lack the small gray crescents borne by the French birds.

Since that first time, I have never ceased to be fascinated by the ouzel, always alert and quick to slip away, with the male sporting a beautiful crescent across his breast. For those who do not live in the mountains, the ring ouzel is typically an April migrator. Even if I have since had the pleasure of seeing them in the Alps and the Caucasus, as well as in Scandinavia, I still like to go look for them on the shorn grass around Cap Blanc-Nez in Calais each spring, when some northern birds stop for a short time to replenish their fat reserves.

Two populations of ring ouzels, *Turdus torquatus*, live in Europe. One, in the mountains of the Alps and in other peaks of temperate Europe, is more sooty in color, while the other, which dwells in the Scandinavian forest, has a plumage black as jet. Both populations spend the winter primarily in North Africa.

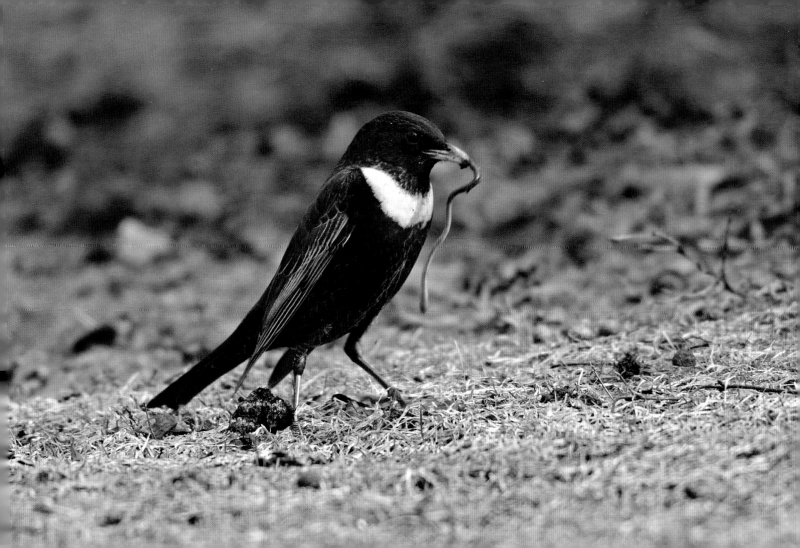

Northern bald ibis

The northern bald ibis is among the world's most endangered species. Once fairly common in North Africa, especially in Morocco, as well as in the Middle East, it has since been almost completely eradicated. A relict population on a site in Morocco, a fragile colony in Turkey, a few birds recently discovered in Syria: those are all the wild birds that remain. And to think that in the sixteenth century people spoke of seeing them all over Europe! The ibis has not coexisted easily with humankind. No doubt people have condemned it for its blackness and somewhat forbidding physique. In any case, it has now almost entirely disappeared, under the joint pressures of hunting and pesticides. So to see one bird, or a small group of them, on the Atlantic coast of Morocco or along the Euphrates in Turkey, remains a privileged moment in the life of an ornithologist.

At sunset, I saw some of these birds come to quench their thirst at a little wadi that thrusts out into the ocean, in the south of Agadir. Out of nowhere, the birds touched down, gulped a few mouthfuls, and flew back off into the desert.

Dangerously threatened with extinction, the northern bald ibis, *Geronticus eremita*, is currently the object of several conservation programs in its breeding territories. At the same time, there are attempts to reintroduce it at various sites in Europe where it existed in the past (in Austria and Spain). Fortunately, the captive population is flourishing fairly well.

Yellow wagtail

As my colleagues and ornithologist friends know, I have a weakness for the yellow wagtail. From the first days of April—and sometimes even earlier—I am on the lookout. I bike along the grain fields around the houses of Ile-de-France. More than looking for the bird, I listen attentively for its cry. It is simple: *psi!* But it is a characteristic sound, for those in the know. There is the wagtail, perched on a young rapeseed plant, yellow on yellow. Despite a little wind that bends the plants, this returning male bird clings tight, moved with the swaying of the stalk, but resisting. And he tirelessly gives his call of welcome: *psi!*

In April, numerous migrating yellow wagtails make stops here and there. To observe the species, it is best to go to the Mediterranean coast. I have seen dozens of the birds seeking their food between the hooves of horses in the Camargue, or between those of cattle in Corsica. The insects that the grazing animals flush out are rapidly gobbled up by the birds. This is also a chance to observe the extraordinary diversity of plumage seen in this species.

There are numerous tribes of yellow wagtails, *Motacilla flava*, with heads that display a variety of patterns and coloring. The bird is notable among passerine species for its diverse plumage. It nests in Eurasia as far east as Siberia, and even in Alaska on the North American continent.

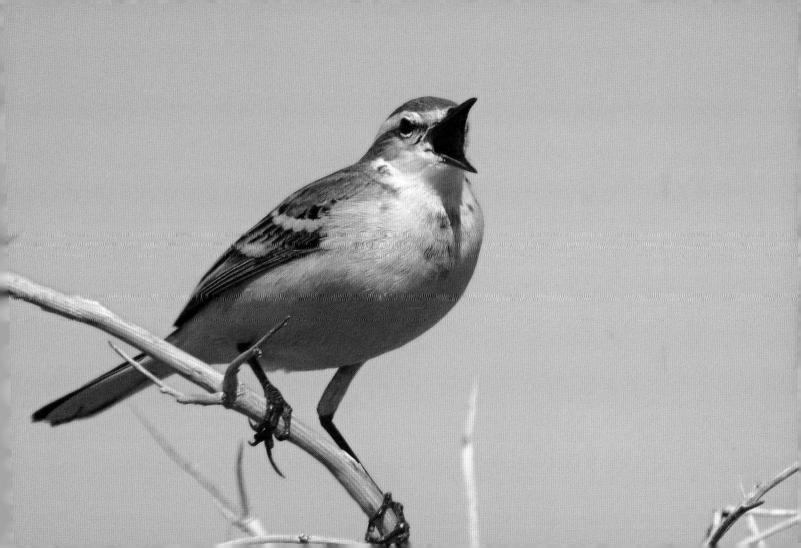

Great bustard

This is the heaviest of flying birds. You have to see a male, on the great plains of Spain, such as the Extremadura, in full display and peacocking around a group of females, to understand quite how impressive it is. With slow steps, its tail spread, it circles around them and ruffles its feathers, transforming into an enormous white ball that is visible from far away. A good thing, too, for it is not a species that lets itself be easily approached. The great bustard is a particularly shy bird. And indeed, it has long been hunted, to the point where it has today become very rare over the entirety of its distribution grounds.

While the larks sing by the hundreds in the plain not far from Talaván, this small group moves off with deliberate steps, the male twice as large as the females. Soon, the heat haze transforms the birds into silhouettes trembling on the horizon.

The adult male of the great bustard, *Otis tarda*, can weigh up to forty pounds, which makes it the heaviest flying bird in the world. Today, there are no more than small disconnected knots of the species spread across the territory from Morocco and Spain in the west and China in the east. It has nested in France since the nineteenth century, and reintroduction is currently being attempted in Great Britain.

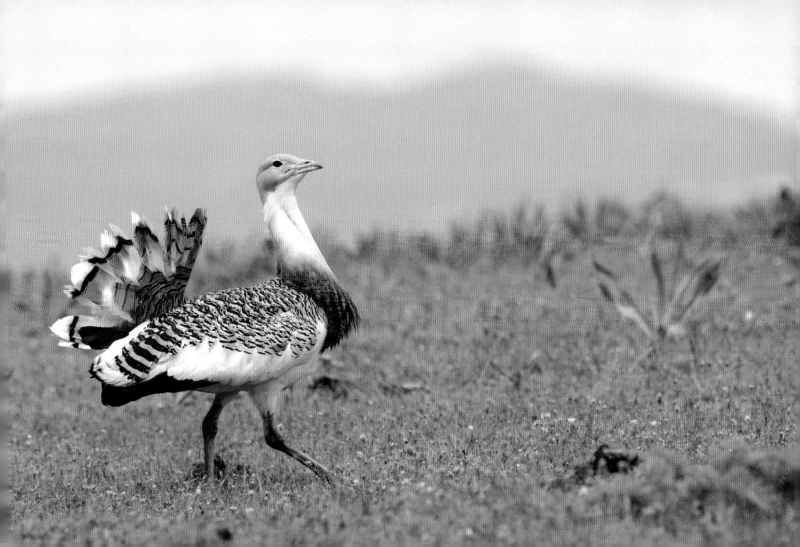

European pied flycatcher

Starting at the end of the summer, European pied flycatchers pass across France and temperate Europe to spend the winter far away in equatorial Africa. For the winter the birds acquire a fairly nondescript gray-brown and white plumage. In spring, by contrast, the males sport a striking plumage. It is made up very simply of black and white feathers, but the intricate pattern of the colors makes the pied flycatcher a gorgeous bird.

Many of the birds nest in northern Europe. In April, they stop over for a few hours or a few days, and it is particularly on the Mediterranean coast—after they have crossed the sea—that good conditions exist in which to observe them. Often exhausted by their journey, the birds more readily allow themselves to be admired. I have memories of pied flycatchers "showering" into the olive groves of Corsica or Turkey as well as into the almond orchards of Porquerolles—often, appropriately enough, after humid nights. The birds hunt from a base on a branch or a fence post, and return to the same place to devour their prey.

Common in the forests of northern Europe, the pied flycatcher, *Ficedula hypoleuca*, has become an emblematic indicator of climate change. Studies have shown that, although it always returns at the same date, it now has difficulty raising its young, because of the increasingly early hatching of insects amid rising temperatures in Europe.

Common tern

The Loire is still running high. The sandy little islands have not yet emerged, but the terns are back. With a supple flight, they fish gracefully between the city bridges. From time to time, one emits its high, slightly scraping cry. Relentlessly, they pace along the river in search of small fish. With a sharp movement, they dive into the water, submerging themselves partway and swooping out again, little fish in their beaks. But this pretty game must soon come to an end—at least temporarily. It is time for the birds to breed. To do so, the waters must recede far enough to reveal the sandbanks, and then one must pray to the patron saint of terns that a rainstorm will not come and engulf everything again.

The terns of the Loire do not have an easy life—any more than their brothers and sisters in Brittany or England, who nest on rocky little seashore islands, where rats do considerable harm to the terns' nests of eggs. But the common tern, wherever it lives, does have one advantage: when the summer ends, it leaves for six months to bask in the sun of the tropics.

With a wide geographic distribution, the common tern, *Sterna hirundo,* can be found in Europe and Asia but also in North America. It nests on the seashore as well as inland, along rivers and streams as well as large lakes and ponds. In the fall, the birds disperse over the seas, to the tropical and equatorial latitudes of the three great oceans.

Black-winged kite

I have multiple memories of the black-winged kite: in the African savannah around Mbour, in Senegal; on the high plateaus of southern Africa; here and there in the woodlands of tropical Asia; and in Spain as well as in Morocco. But also in France, most notably when the species nested for the first time in 1983 in the Landes region.

Each time, I am pleased to observe this small raptor, lively and clever. Perched at the top of a tree or a telephone pole, it always casts a malicious eye on those who would observe or photograph it. You can approach it fairly closely. A little closer yet, you think—until it takes off, with a slightly loose but rapid flight. There it is hovering, like a kestrel. It hunts and captures its prey with agility. It alternates between long moments of intense lethargy, standing nearly immobile at the summit of a tree, and other times when it uninterruptedly flies, lands, and takes off again, so deftly that following it takes all the effort in the world. The black-winged kite is the archetype of avian life.

The black-winged kite, *Elanus caeruleus*, has a large global distribution, but is concentrated mainly in the tropics. It can be found in a large part of Africa south of the equator; in India; and in Southeast Asia as far as Indonesia. In Europe, the black-winged kite nests on the Iberian Peninsula and, very recently, has been advancing into France, no doubt as a result of changing climate.

Gray plover

The tide is strong today and the sea is rushing in quickly, bringing with it groups of little wading birds that have landed in the bay to build up their strength and put on a few grams of fat. Soon, the birds will be back in their distant Arctic territory, to breed. Among them, one can distinguish a few gray plovers. First, by ear: *pii-hu-iiiii…pii-hu-iiii!* Their dragged-out, melancholy cries, easy to imitate, are unforgettable. As soon as a group of them lands, you hear it.

The birds are in the process of putting on their breeding plumage. Some of them already have their new feathers, silvery on top and black on their undercarriage, while others are still more or less in their winter costumes, dressed in pale gray. In the silt, the plovers search for their food in characteristic fashion: a few tiny, hasty steps, a sudden stop, a peck, another few rapid steps, and so on.

These are only the first contingents of migrators. Others will follow, and the spring passage will reach its peak in fifteen days or so. These birds are likely mixing with those that wintered in the area. Others in this species spend the Western European winter as far away as southern Africa.

The gray plover, *Pluvialis squatarola* (also known in North America as the black-bellied plover), nests in the tundra around the Arctic, principally in Siberia. Great migrators, the birds travel thousands of miles to winter in territory that spans from the temperate countries of Eurasia and the Americas to the tropical and southern regions of these same continents, always on the seashore.

Sooty gull

On the shore of the Indian Ocean, along the Arabian Peninsula, large sailboats return to port, their holds loaded with fish. Around the boats, a crowd of birds—terns and gulls—attempt to snatch the small fry or guts that the fishermen let drop. Among them, some beautiful gulls with gray heads and coats are the deftest at capturing food. They are completely different from our classic European or American herring gulls. In addition, their colorful beaks give them a little tropical touch that the birds of the northern regions lack.

A little farther away, at the edge of a coral reef, the gulls, accompanied by greater and lesser crested terns, stand and preen their feathers. The powerful sun reflecting off the mass of feathers makes the gulls look paler than in reality, but the deep blue of the ocean serves to enhance the bright colors of all these birds.

A light breeze from the north makes the heat more bearable. And despite its distance from France, as well as a certain exotic flavor, the place feels almost like a little port in Brittany or Ireland.

The sooty gull, *Larus* or *Ichthyaetus hemprichii*, is not a great migrator. At most, the birds that nest in colonies on little islets of the Red Sea and along the western coast of the Indian Ocean will scatter along the length of these coasts in winter.

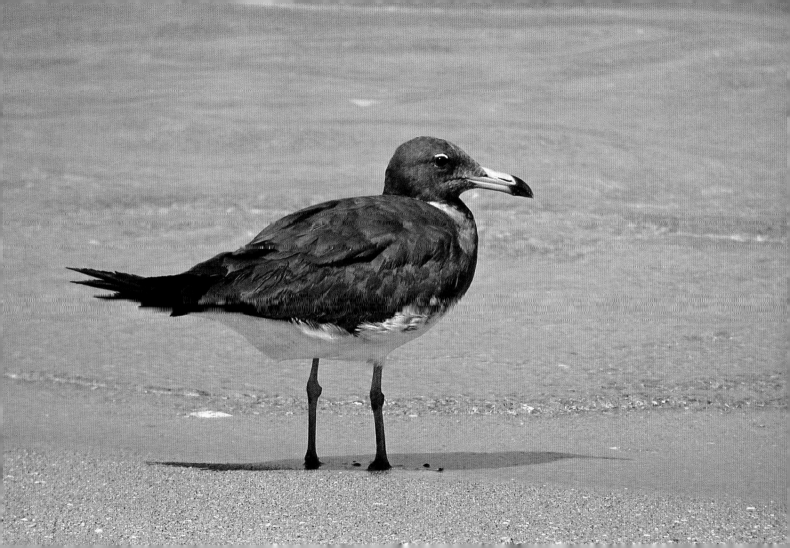

King eider

When you disembark on the peninsula of the Varangerfjord, in far northern Norwegian Lapland, you don't exactly have the impression that it's spring. Despite the direct sun, the temperature hardly ventures above freezing. The cold wind doesn't help matters. We hardly have to look for the waterfowl, huddled not far from shore and endlessly tossed in the surf, like little buoys. Amid the large flock of common eiders in front of us, we have just spotted a group of king eiders. The adult males are in perfect breeding plumage—the colorful patterns on their heads and beaks are enchanting. Despite the cold, the waves, and the ice, the males are engaged in a feverish display intended to seduce the females. The females, completely brown, are not easy to distinguish from the female common eiders, which are indeed much more common here—but their size and the shape of the beaks help to identify them.

In a few days, all these birds will depart for the Barents Sea, then doubtless travel farther north, where they will nest on the desolate tundra, far from all human beings.

Habituated to the Arctic region, the king eider, *Somateria spectabilis*, nests in the Siberian and North American tundra. The birds hardly venture south at all, remaining close to the ice fields even in winter. The species is thus very rarely seen in the temperate regions of Europe and North America.

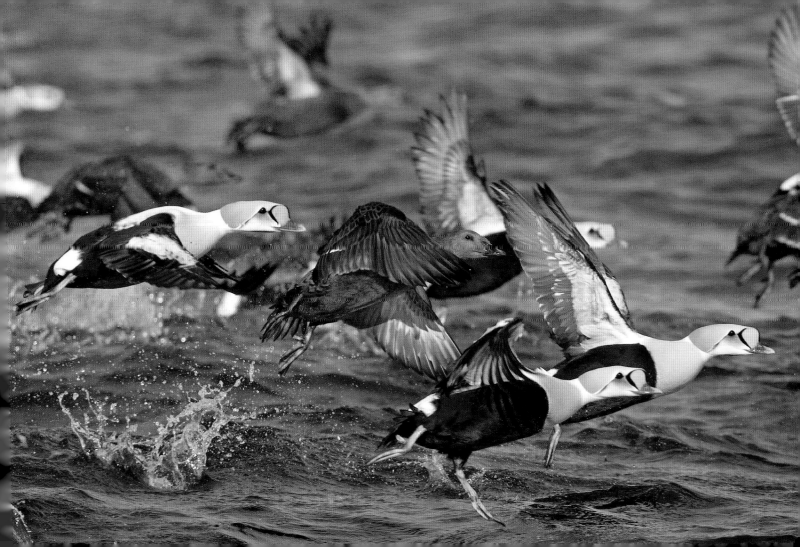

African stonechat

Agitated and nervous, the male African stonechat, perched at the top of a large thistle bush, watches us for a good moment, giving a sharp *trec … trec!* of alarm. Moving its wings and its tail, it gives us visible warning that we are on its territory. The female remains invisible; without doubt she is sitting on her eggs somewhere, perhaps in a thornbush on the nearby hillside. In the distance, a tree pipit belts out a song at the top of a tree, while the whitethroat, with its scraping call, reminds us of summer. Some swifts, flying high in the sky, sail toward the north. These days of grace around the end of April, which pass so quickly, are moments of paradise for the ornithologist. Everything is in play: the local nesting birds, like our African stonechats, are already engaged in reproduction, and the migrators are heading back to distant lands in northern Europe. We hardly know where to turn our eyes or head, so widely do the birds solicit our attention. At heart, we are as excited as the male stonechat on top of the thistle.

APRIL

21

Nesting widely over Europe, Africa, and the Middle East, the African stonechat, *Saxicola torquatus*, is found primarily in open spaces—prairies, meadows, moors, or hillsides. A good part of the European population is more or less resident, but the birds of the northern and mountainous regions spend the winter in the south of the continent and around the Mediterranean basin.

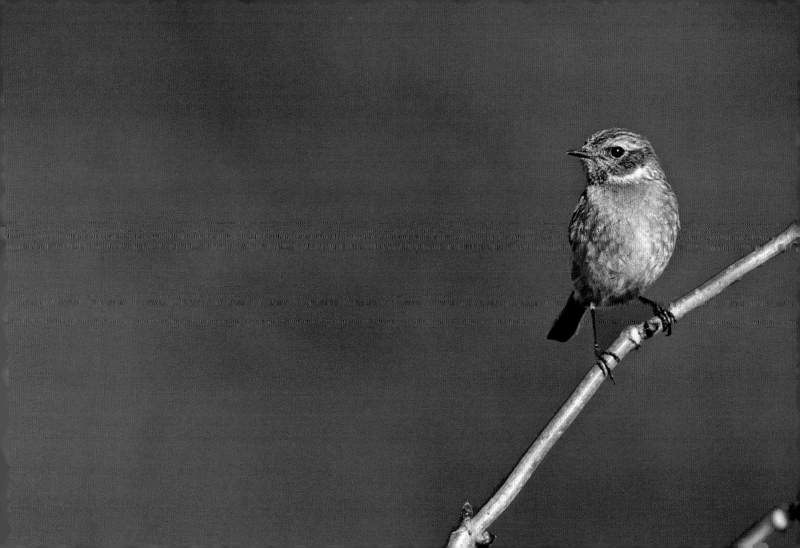

Common redshank

Tiu...tiu...tiu...tiu...tiu! Tirelessly, the male common redshank, perched on a fence post, signals to his entourage. First of all to his mate, secondly to the rivals that live with him in these prairie grasses of the Vendée wetlands, and third, no doubt, to us, who observe him from inside the car, parked several hundred yards away. Leaning slightly forward, with a watchful eye, the bird gives cries of alarm and shows us his bright red feet, which stand out against the green of the pasture. Barely a month ago, the redshanks were still on the nearby beach, feeding along with the other birds. By now, however, each has struck out on its own to nest.

A little farther on, another male makes his display. He darts from his perch and flies through the air, with rigid wings and jerky movements, tail spread, all the while making his fluting and fairly sweet song. He shows off the white marks on his wings, then comes back down again to land a little farther away in the field, no doubt near his companion, who remains hidden in the tall grass.

The common redshank, *Tringa totanus*, reproduces principally in the coastal wetlands of temperate Europe. In the north of the continent, it instead frequents the tundra and its swamps, while in Central Asia and as far away as Mongolia, it is found at the edge of water, often on the steppes. Many of the birds winter in the tropical latitudes of Africa and Asia.

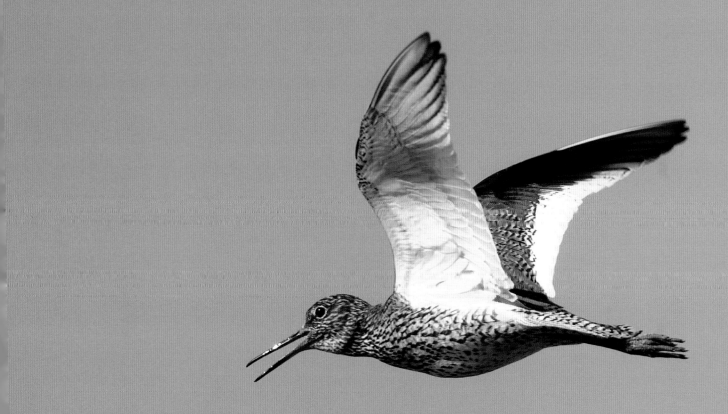

Rock ptarmigan

In the summer, you must be willing to take a long mountain journey to reach the domain of the rock ptarmigan. A shy bird, it tends to stay hidden, and if you see it at all it is often by mere chance. In the spring, when the snow cover extends fairly low on the mountains, observing a rock ptarmigan is somewhat easier. But given the white-on-white palette, it still requires an experienced eye, a well-focused telescope, and a little luck—once again—to detect a bird walking on a rock scree, between patches of snow and ground already laid bare by the thaw.

This is the case in the Alps and Pyrenees of temperate Europe. If you hesitate to climb to those heights, a good alternative is to go to Lapland. Here, in the tundra of the high plains, the rock ptarmigan is in its habitat, but there are no mountains to climb. All you have to do is walk through the tundra and look for the birds where the rocks emerge.

The ptarmigan is what is called a "glacial relict." In the time when this same tundra covered all of Europe, it lived all over, but warming has relegated it to the mountains, where it finds similar climate conditions.

Living all over the Arctic, but also in some mountains in Europe and around Baikal, the rock ptarmigan, *Lagopus muta*, has two seasonal plumages. In winter it is all white, while in summer, its head, its neck, and part of its back are adorned with brown-gray feathers.

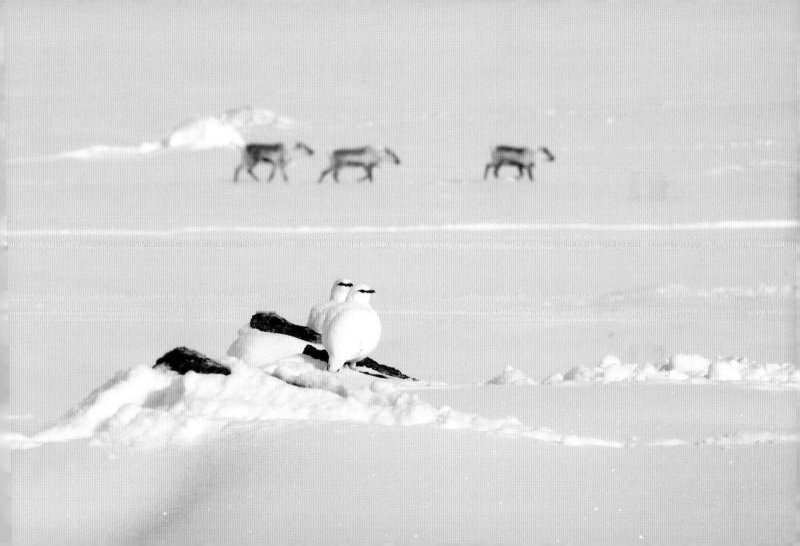

Little gull

A swarm of big black-and-white butterflies swoops down onto the lagoon at the edge of the Atlantic Ocean. The little gulls are back. Circling, they hunt along the surface of the water, in search of small insects, pecking at the surface and then continuing their erratic flight. White on top, their wings are grayish black underneath, which contrasts starkly with their backs. The heads of the adults are entirely black at this time of year. The gulls hunt, silently. There are several dozen, but sometimes there are hundreds swooping over the surface of the water, most often for just a few hours at a time.

They spend the winter offshore, far out on the sea, somewhere in the Bay of Biscay. Sometimes a sudden squall may drive the birds into shore. In that case, you can see them in the ports on ponds, tossed by the storm like wisps of fluff.

In the fall, you will see them heading south again, this time accompanied by their young, and with their heads now white in their winter plumage. In looser flocks, they seem less rushed to regain their spot on the distant ocean.

The little gull, *Larus minutus*, is, as its name suggests, the smallest of the gulls. It lives in northern and eastern Europe, as well as in Siberia. It is found in small numbers in the Great Lakes region of North America. It winters at sea, in the Bay of Biscay, but also on the Mediterranean and on the Caspian Sea.

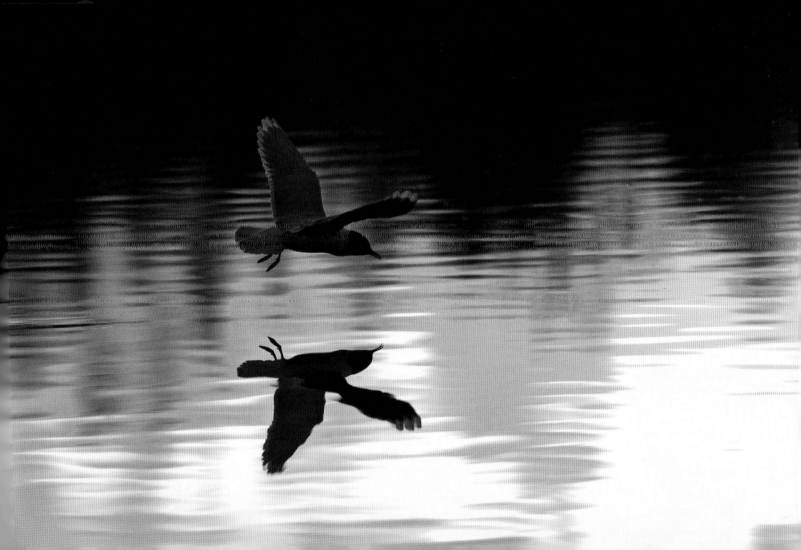

Jackdaw

There are "crows" perched on the cathedral. With an agile flight, giving high-pitched cries, they glide from one gargoyle to the other, settling for several instants at the top of the steeple, then casting themselves into the air again, where they hover. Halfway between acrobats and professional paragliders, these birds are jackdaws. In the city, one often sees them around large buildings, which they love. Outside the city, good places to look for jackdaws are mountains and seaside cliffs. In squadrons, they fly along the rock face, playing in the air. Social birds, like all in the *Corvus* genus (the crow family), they are rarely seen alone. On the plains, especially in winter, you can see them in large fields, often in the company of their bigger cousins—the crows and rooks. In this group, they look a bit runty, but they are never last in line for the seeds that remain after the harvest and plowing.

When possible, it is best to observe the jackdaw up close: its lively white eyes as well as the various shades of gray on its black feathers are superb.

Distributed widely over Europe and in Siberia, the jackdaw, *Corvus monedula*, is principally sedentary. Only the most northern and eastern birds carry out a migration that gives them some distance, during the harsh weather, from the vicissitudes of cold and frost.

Whimbrel

During the 1980s, we would go at the end of April to observe great roosts of whimbrels in the bay of Aiguillon, on the Atlantic coast. Freshly returned from tropical Africa, the birds would pause there to rest for a few hours on the surrounding polders.

Today, the birds still stop there, but in greatly reduced numbers. Is it that the spot no longer suits them? Are they, like other species, on the wane?

Later, I saw the species at its breeding grounds, on the tundras of Scandinavia and in Canada, on the shores of Churchill Bay. Furtive, quick to flight, the nesting birds could be spotted particularly by their song: a sort of soft and rolling whistle, slightly ethereal and completely strange.

Then, as if following the path of this great migrator, I found it both on the California coast, where some American birds spend the winter, and in tropical Africa, among the rice fields and palm trees. For me, the whimbrel is a fascinating species: it is the very image of the eternal voyager.

The whimbrel, *Numenius phaeopus*, nests throughout the circum-Arctic tundra. It stays there only a month and a half, long enough to raise its young, and then, very quickly, departs again toward its winter territory, which is most often tropical or subtropical. It thus travels thousands of miles every year.

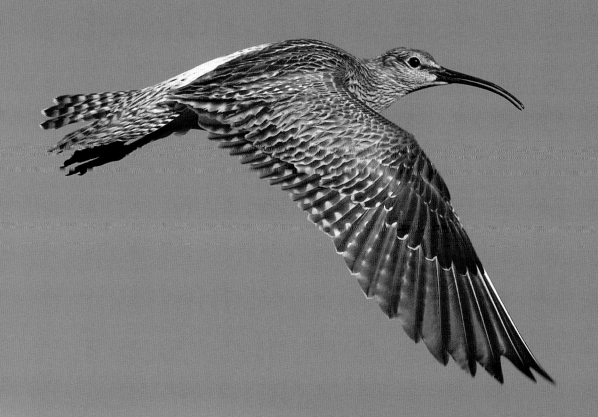

Tufted puffin

We Europeans are, like our friends on the East Coast of North America, very proud of our Atlantic puffin, with its multi-colored beak that makes it slightly resemble a parrot. But we hardly know its Pacific homologue, the tufted puffin. Larger than its Atlantic compatriot, the tufted puffin has an even more impressive beak, which is a beautiful bright orange with a paler yellow base.

I first saw this truly impressive bird along the coast of British Columbia. But my strongest memories of them are from the Aleutian Islands, where I saw the birds nesting on tiny, semi-inaccessible islets, bordered with cliffs whose tops were perpetually lost in fog. Here, the tufted puffins are at home, nesting in the burrows that they dig or else in a crevice in the middle of a scree of fallen rock. These birds look particularly strange in flight: each is totally black with an orange beak and a white mask around the eyes and on the cheeks, as well as a long pale yellow crest. They look like they came straight out of some fantastic animated movie.

The tufted puffin, *Fratercula cirrhata*, lives for the most part on the coast of the Pacific Ocean, between British Columbia to the east and the Japanese island of Hokkaido in the west. In the winter, it disperses across the high seas, here and there between the two continents.

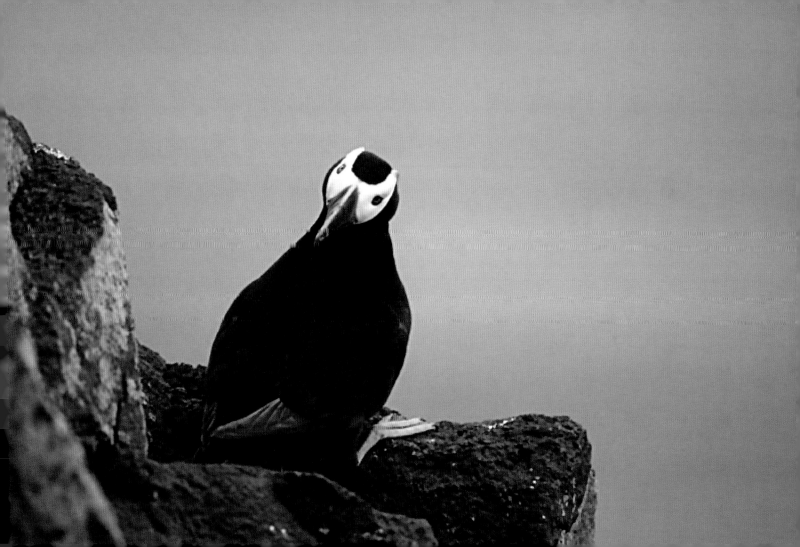

Hoopoe

Orchids line the dirt path that snakes over the limestone plateau. Nature is still coming awake. Some butterflies gather pollen, while the cirl bunting chimes out its slightly sad refrain. Before us, a hoopoe takes off. Like a great butterfly, its unfurled wings all black and white, it lands a little farther along on a low wall. The upright crest and its slightly curved beak give it a martial air. When it stands still, the bird is mostly tan in color.

As we slowly approach after having spotted it through binoculars, the hoopoe follows us with its glance. When we reach what it judges to be the minimal acceptable distance, it takes flight. This time, it flies a little farther, to the old stone wall of a sheepfold. It is no doubt there that the bird is nesting, in a crevice of the wall. As we leave it to continue our walk, we soon hear the hoopoe giving its sweet song: *houpoupoup!*

Nesting all over Europe, North Africa, and the Middle East, the majority of hoopoes, *Upupa epops*, are migratory and spend the winter in Africa. Those from the Mediterranean perimeter are more sedentary; a number of them remain in place over the winter. A species very similar to the hoopoe lives in South Africa.

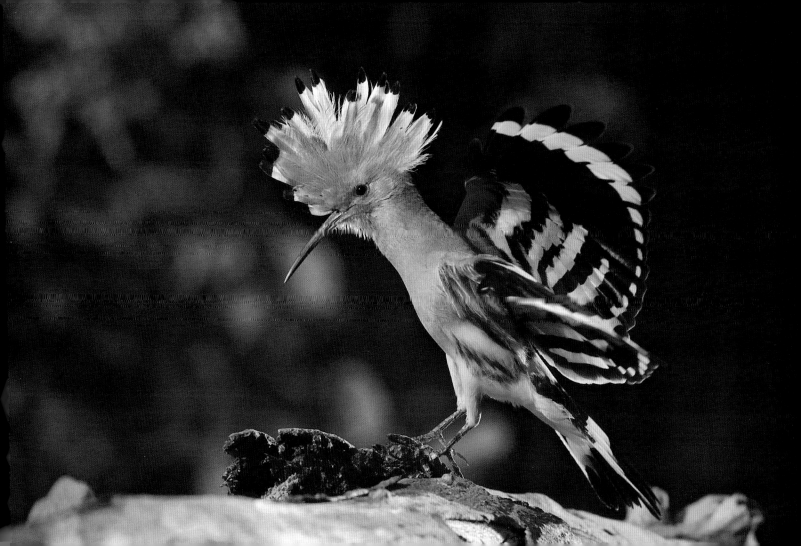

Calandra lark

It is the end of April in the plains west of Marrakech. The farmers are busy in the fields of wheat, already grown high. Everywhere around, the song of larks can be heard over the braying of donkeys and the purr of a distant tractor. Among them, fat birds flutter through the air, chirping without interruption. These are the calandra larks, the largest of the lark family. With wide wings and a short tail, they sing above the fields, flying higher and higher. The song is very similar to that of the common skylark, and thus it is mainly by their silhouettes that we can differentiate these birds.

A bird perched on top of a little hillock of stones allows us to watch it. The two large black marks that it wears on each side of its neck are typical. When it takes flight to sing, this male lark shows us the blackish underside of his wing, with its finely edged white border.

Though common here, the calandra lark has become a true rarity in France, with only around fifty pairs remaining. It was long ago when larks sang by the dozens in the countryside of the south of France.

Still relatively common on the Mediterranean coasts, the calandra lark, *Melanocorypha calandra*, is primarily a sedentary species, though it carries out movements over short distances in the fall. A victim of the changing agricultural countryside, the species has become one of the most endangered nesting species in France.

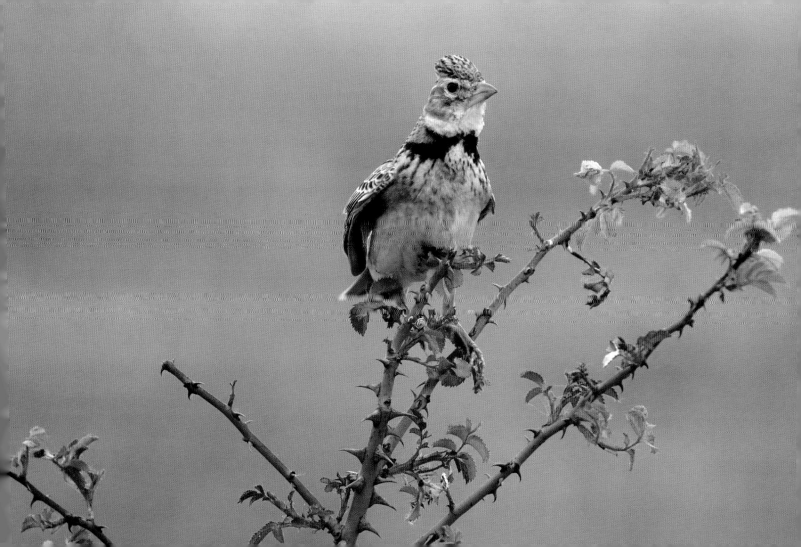

Booted eagle

I saw my first booted eagles in the Strait of Gibraltar, on the Spanish coast. In spring, as in the fall, the passage is widely used by raptors, as well as by storks, which shy away from crossing large bodies of water and seek the narrowest place to cross. There were, in fact, hundreds of the eagles. Some were black and white and some all brown, since the species exists in two different colorations.

In the gorges of the Truyère river, deep in the wilds of Cantal, I know a couple of birds that come back to more or less the same spot each year. During one breeding period, it happened that I was there to see the couple make their display, he pale and she dark, and emit a few high-pitched sounds, a rare thing for a diurnal raptor. The birds soon became more discreet, and I then saw them hardly at all before they left for tropical Africa. But before long all the birds of Western Europe would converge once again in the Strait of Gibraltar, and other marveling eyes than mine would contemplate this extraordinary spectacle of hundreds of birds of prey gliding slowly toward Africa.

APRIL

30

The booted eagle, *Aquila pennata*, nests in wide distribution across Europe, North Africa, and the Middle East, but it is not common in any of these regions. The pale variation (opposite) is clearly more common than the dark variation, which is difficult to identify, since it resembles other species of raptors.

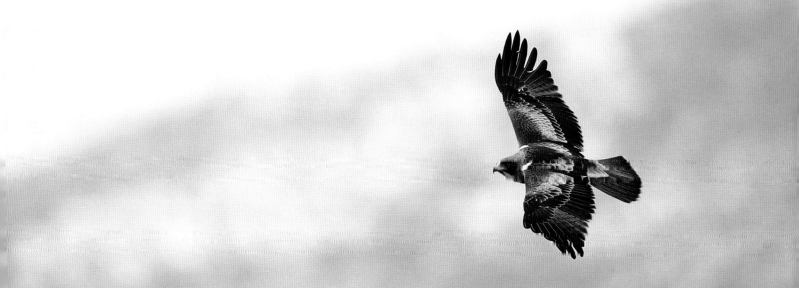

Turtle dove

At the Pointe de Grave, where the Gironde juts out into the ocean, observers follow the migrators, who are sailing toward the north and, before their eyes, will cross the few miles separating the river's south bank from the north bank.

Amid the unceasing stream of birds that fly by, we scrutinize the turtle doves. The species has been in significant decline for several years. Over the same period, it has been a victim of an unbelievable amount of poaching in the area during this part of the year, when hunting is closed. That is why, when a compact little group of birds approaches in active migration, flying above the ground and then darting over the waters, I always feel a little twinge in my heart. This flight over the estuary, though of short distance, is like a physical representation of our worries about the species. Will it even arrive at this river, to survive in a more and more hostile environment? For it is not only poachers that threaten the turtle dove. It must also brave the hazards of migration—the species winters beyond the Sahara in Africa. Then there are the hazards of the climate, with the growing dryness in its winter territory and, in its nesting grounds, a spring too rainy for good reproduction.

The plight of the turtle dove truly serves to remind us of the many threats facing bird populations today and the many questions that weigh on the future of biodiversity.

MAY

I

The turtle dove, *Streptopelia turtur*, nests from Western Europe to Central Asia. The western populations winter in sub-Saharan Africa. A longtime victim of illegal hunting in the spring (today more or less shut down), the species, beset by many challenges, is a good indicator of avian health in Europe.

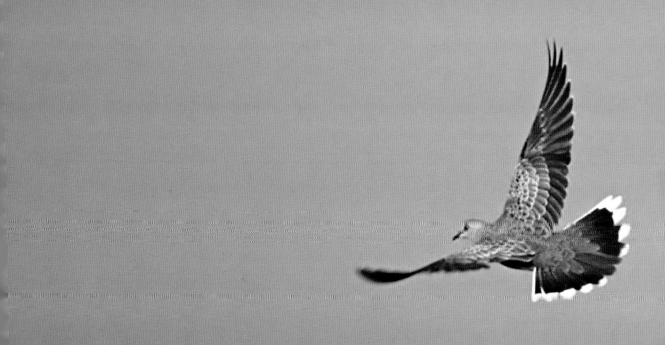

Red knot

In Delaware Bay, on the East Coast of the United States, thousands of limicoline birds (small shorebirds) jostle on the exposed mudflats. They are searching for tiny animals, and particularly for the eggs of the horseshoe crab, that curious marine arthropod that survives from prehistoric times.

Among the sandpipers, the largest are the red knots, which by this time of year have again put on their superb bright red breeding plumage. You can recognize these birds by their feathers and their imposing size amid the throng of tiny dunlins, semipalmated sandpipers, and least sandpipers. They are the biggest, certainly, but also the most endangered. The ornithologists count slightly fewer here each year; and, each spring, the number of breeding birds in the Canadian High Arctic dwindles as well. Why? There are multiple answers, but when a bird nests at such a high latitude and winters in southern South America, one can easily understand that it is exposed more than other birds to the dangers of a long journey and the constant degradation of its habitats. Such is the case with these charismatic red knots, who, unaware of the danger that threatens them, stuff themselves with larvae and microscopic eggs.

Nesting over all the circum-Arctic tundra, the red knot, *Calidris canutus*, is a long-haul migrator which, depending where it nests, will winter in South America, on the Atlantic coast of Europe, in tropical Africa, or, for the birds of eastern Siberia, as far away as Australia.

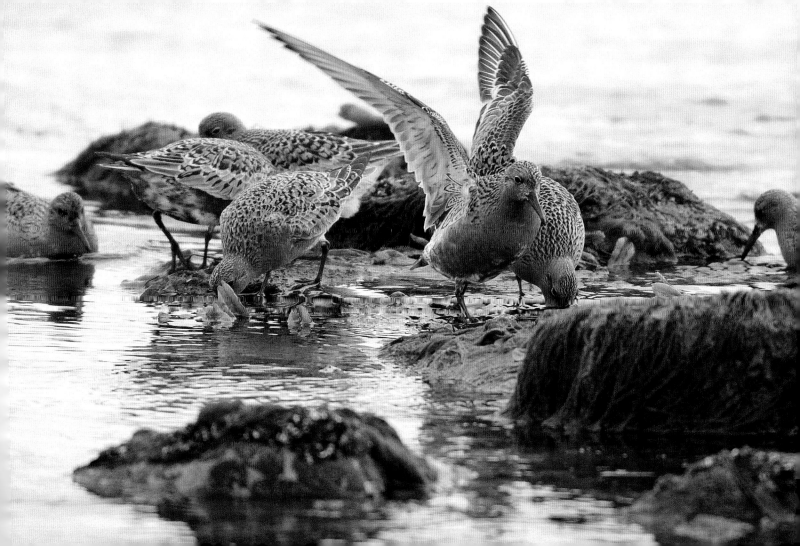

Black-headed bunting

Along the Euphrates, on the Anatolian peninsula, women in colorful clothing bustle about in the corners of fields lined by tall rows of poplars. It is a beautiful day, and the foliage is a bright green set off by the sparkling blue of the sky. The high altitude fills the air with a freshness that makes you breathe deep.

A joyous song adds to the optimistic atmosphere. The bird singing is a male black-headed bunting, perched at the end of a poplar branch. His belly is as bright yellow as the sun. Freshly returned from his migration, he loses no time in singing to attract a companion. She might not be far off, for, some hundreds of yards away, a group of migrators has touched down. There are at least thirty or so buntings pecking at seeds on a dusty little path.

In this magical instant in a remote place, far from the beaten paths of the tourists, every detail is touched with pleasure. It is a brief moment, a unique one, in which we fully experience the spring.

MAY

3

The black-headed bunting, *Emberiza melanocephala*, reproduces from eastern Italy to southern Iran. The whole population spends the winter in western India. The species is expanding slightly toward the west, and a few isolated couples are now nesting in the extreme southeast of France.

Sooty tern

In discussions of this black-feathered tern, it is often mentioned that it is a "tropical tern." This juxtaposition of words has always captured my imagination. For this tern lives along the tropical belt, and nests on little islands whose white sandy beaches are lined by coconut palms. However, the two times that I have seen this species, it was not in the Seychelles, where it is common, nor in the islands of the Caribbean, where it also reproduces. It was on the Atlantic coast of France, where from time to time a bird may stray north into uncertain latitudes not its own.

The sooty tern is at home under the tropical skies that transfix us when we see them depicted on posters in the corridors and cars of the subway. It lives among turquoise blue lagoons, cloudless skies, and white sand. Black on top, white underneath, the sooty tern nonetheless blends in beautifully amid the tropical colors. It is nothing like its cousin, the Arctic tern (see August 27), that braves the icy temperatures of the tundra to make its nest.

The sooty tern, *Onychoprion fuscata*, nests principally on the islands and islets of tropical regions of all the oceans, as far south as northern Australia. It also makes occasional appearances when it disperses into tropical waters after reproduction.

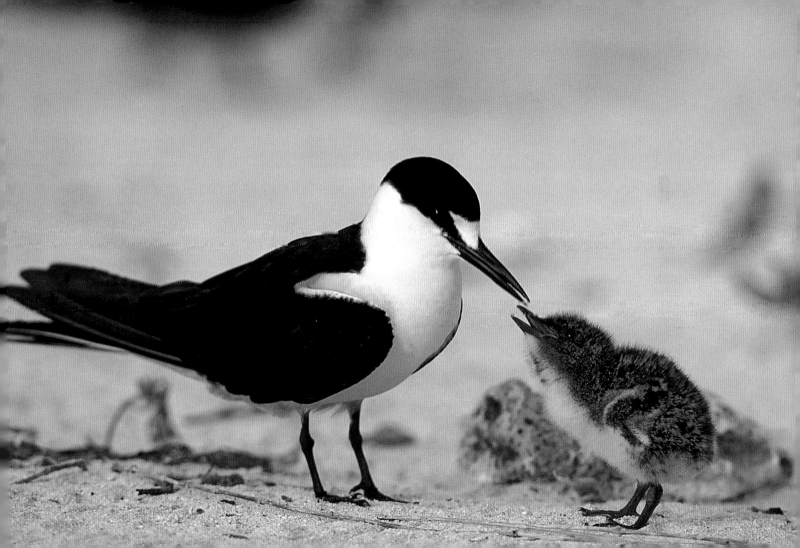

Golden oriole

I know that the bird making a resonant cry of *didelio!* in this forest is a golden oriole. I know that it's a male—because it is singing—and that it is, therefore, extremely bright yellow. But I also know that, despite its color, the golden oriole remains difficult to spot, so carefully does it stay hidden among the highest branches. The similarly bright green of the leaves does not make things any easier. One can only track the movements of the *didelio!* and hope to spot the bird when it passes from one tree to another. And so we do—but very briefly; the yellow fleck soon disappears back into the leaves.

It is during migration, when it pauses for a few hours on its northward return from the tropics, that you can most easily observe the beautiful golden oriole. If it chooses some sparse oasis to stop in—a grove of tamarisk trees, a little field of olive trees—there it cannot escape us. Perched on a branch at the top of a tree, it stares at us, ready to fly away at the least movement on our part. The fatigue of its journey works in our favor, and it hesitates to take off again—to our great delight.

A great migrator, the golden oriole, *Oriolus oriolus*, nests in Europe and beyond as far as south-central Siberia. The birds leave by August to reclaim their winter quarters, which are mainly situated south of the equator in Africa.

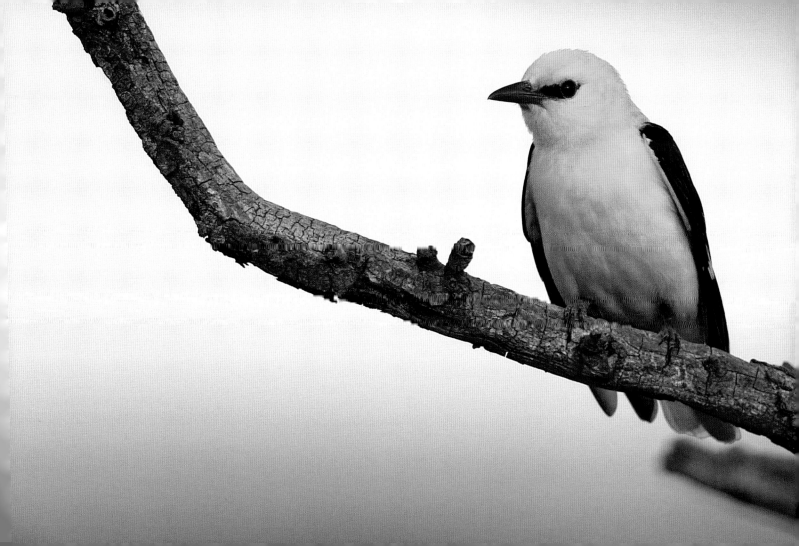

Honey buzzard

At the beginning of May, this beautiful diurnal bird of prey returns from Africa and reaches the southern coasts of Europe. The honey buzzard has three special qualities: it eats wasps and bees (hence its Latin name of *apivorus*, or bee eater); it spends the winter in Africa, which makes it a great migrator; and finally—and especially—it migrates in a group, sometimes in very large numbers.

In the spring, as well as at the end of August and beginning of fall, it is well worth finding a place along the honey buzzard's migratory path, where you can witness the sight of dozens of these birds gliding serenely through azure skies. The straits of Bosporus and Gibraltar, where the birds gather to cross the sea, are excellent spots to catch the spectacle. But in many other places as well, especially in the south of Europe, you can track the long stream of birds that sometimes forms under good weather and atmospheric conditions. In those places, in spring, you may see the honey buzzards flying in line, one after the other, toward the north. They fly fairly high in the sky, heading for the northern and eastern European forests to nest.

The honey buzzard, *Pernis apivorus*, nests all over Europe, as well as in Russia. It is especially partial to large forests. A long-haul migrator, it travels twice a year between Europe and Africa, even venturing beyond the equator.

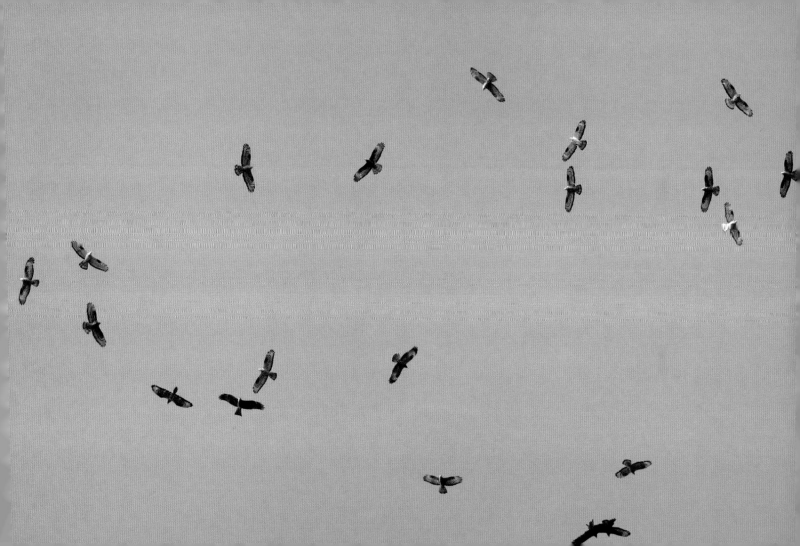

Nightingale

My first memories of the nightingale are very early. At this time of year, my parents sometimes took me to the banks of the Loire. The hawthorn bushes sparkled with white flowers. Above the Loire, which was still running high, the terns wheeled and chased each other, crying. The distant call of a cuckoo paled beside the powerful song of the nightingale. The great soloist proceeded slowly through its score, as full of ornament as the most stylized calligraphy. In the deepest part of the hawthorn bush, totally invisible, it sang slowly and for hours. And when evening came, as bats replaced the birds in the air, our nightingale continued its solo. Without cease, it sang, until total blackness fell, amid the very heart of the night. Surely it sang to celebrate the first spring warmth amid the darkness.

It was not until much later that I actually saw the shy nightingale, with a plumage as drab as his song is glorious…

The nightingale, *Luscinia megarhynchos*, ranges from Western Europe to central Siberia. A discreet bird, it is heard more often than it is seen. The bird is a nocturnal migrator that leaves fairly early in the end of summer, and spends the winter season mostly in equatorial Africa.

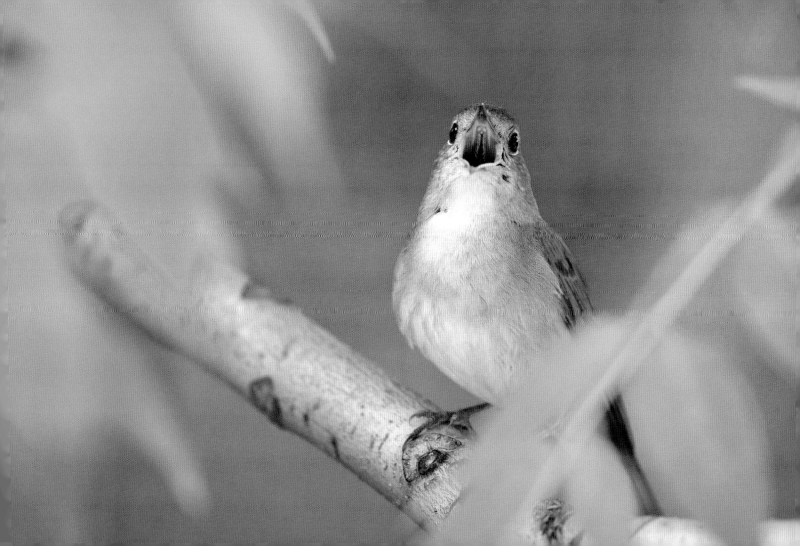

Ruff

On the polders of the island of Texel, in the Netherlands, great puddles of water dot the prairies. Flocks of ruffs jostle there, the males having regained their most beautiful finery. The old French name for the species was the *chevalier combattant*, or fighting knight. The males do indeed look like beautiful knights, with their collar of plumes, sometimes black, sometimes red, sometimes white, or even richly ornamented with all three. Here, four or five males have assembled around what is called an "arena," and the jousting has begun. This involves more visual displays and smackings of wings than real fighting. And while the males preen and exhibit their breeding plumage, the females, fairly indifferently, peck for food.

As always, it is the strongest and most enterprising who wins. Then, fairly quickly, all the males will lose their knight's plumes and abandon the site. Leaving the females to care for the young, they will begin their voyage back south to warmer territory—many with the slightly ragged uniforms of knights defeated.

The ruff, *Philomachus pugnax*, nests from northwest Europe to Siberia. The birds winter mostly in the tropical regions of Africa and India. The male is polygamous, and a great number of males do not reproduce, yielding to the dominance of a few among their number.

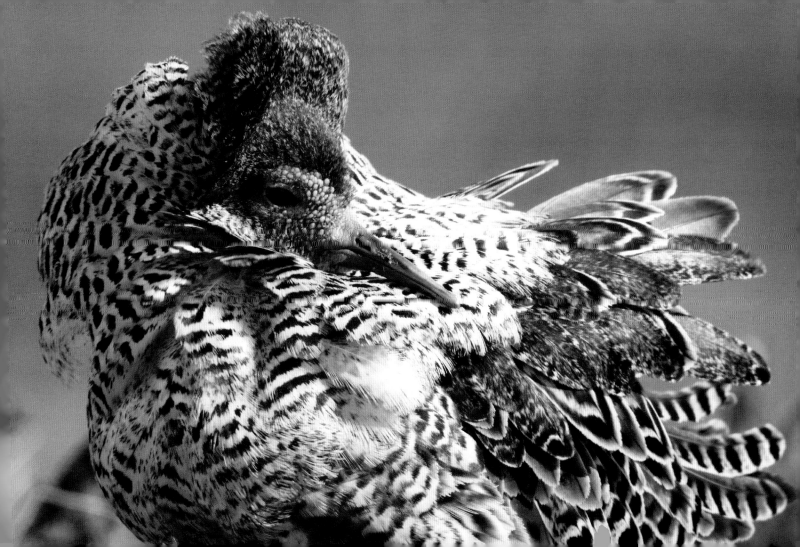

Ortolan bunting

On the exposed southern slope, the plants and bushes of the scrubland creep up the limestone ridge that dominates the valley. It is early morning, and the little world of the birds is in full voice. The Sardinian and subalpine warblers compete with their rasping, mumbling songs. In the distance, the whistling of the blue rock thrush reminds us that it is indeed in the blackbird family. Closer to us, perched at the summit of a strawberry tree, a small bird with an orange belly and yellowish mustache sings a slightly melancholy and questioning couplet. You could translate it as *beeen…beeen…beeen-tu?* Back in the land of its birth, the ortolan bunting sings, hopping from one bush to another.

The ortolan bunting, or ortolan, is well known to gastronomes. In fact, they contributed in part to the rapid decline of the species over several decades. In observing this little passerine through binoculars, you might well wonder what there is to eat of such a tiny animal … and realize that it would take a number of them to make a feast. For the moment, our solitary singer is much happier under the Provençal skies than he would be on the plate of some gourmet.

A European species, the ortolan bunting, *Emberiza hortulana*, is a migrator that winters in tropical Africa. In France, poachers still hunt for it in the fall, notably in the southwest. But its global numbers are decreasing, likely also because of the loss of its reproductive habitat and the difficult climate conditions that arise during its African winters.

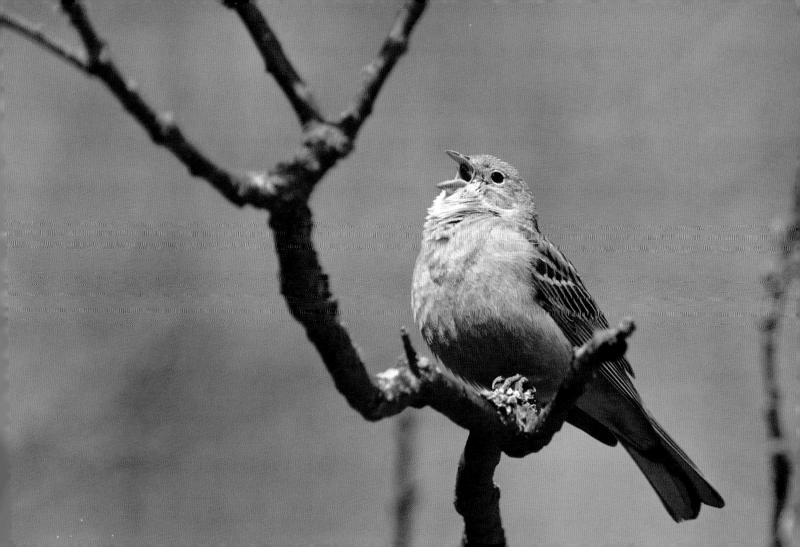

Oriental darter

The snakebird: that is the oriental darter's nickname. A darter in the water, with only its endless neck and dagger-sharp beak emerging above the surface, is a peculiar sight indeed. Then, when you see it standing, drying in the sun, its wings outstretched, it's easier to believe that this is in fact a close cousin of the cormorant. Whatever else it is, the darter is one long, narrow bird.

The oriental darter is a tropical species. I have seen it fishing among the hippopotamuses in a big park in South Africa, unfazed by these enormous beasts. On the Tonle Sap in Cambodia, flocks of darters fish in the swampy water, with only their long necks and beaks visible above the surface. They look almost like water snakes swimming at top speed. In the channels around the lake, the boat we were driving regularly startled a bird into flight. It was not easy for these birds to take off, and the long neck would shoot into the water for an instant before the bird was suddenly transformed into a sort of clumsy cormorant in the air.

Loyal to tropical regions and to large swamps, the oriental darter, *Anhinga melanogaster*, is found in Africa and in tropical Asia. The most northern colonies are found in Iraq (if those are still thriving); the species used to nest in Turkey as well. Another species of *Anhinga* lives in the Americas.

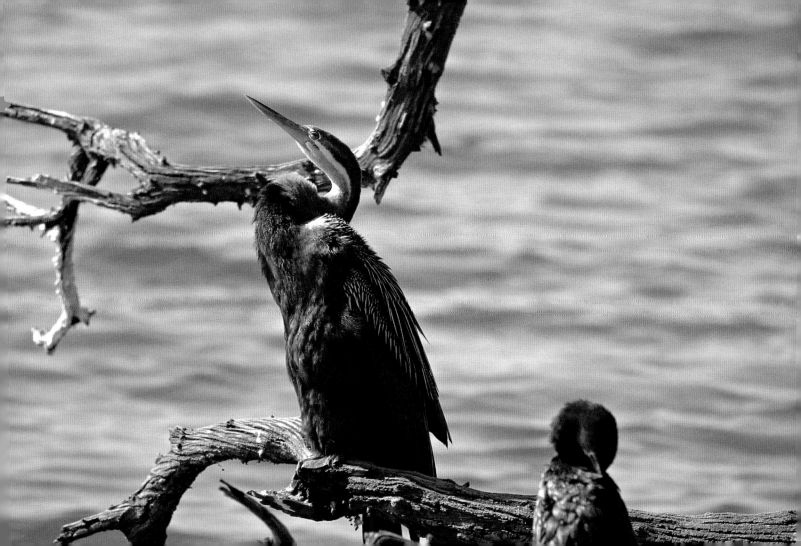

Black-winged stilt

Having long studied the species, I carry a particular affection for the black-winged stilt. With its immensely long red legs, its long fine beak, and its constant air of alertness, the black-winged stilt is not likely to pass unnoticed. Especially because it's so talkative. As soon as we enter its territory, we are sure to be greeted with a mass takeoff of birds energetically protesting our intrusion. Until we depart, they will not cease their shrill, creaking cries of *kit! kit!*, which make us feel so guilty to be there that we hasten to leave their turf. The birds will then accompany us for a long while, flying along and repeating their disagreeable cry.

The species, when it is not being disturbed, is particularly elegant, especially when it probes the shallow water with its fine beak. The stilt traps its prey at the tip of its beak with great delicacy. Its name is entirely appropriate. But why such long legs when it spends most of its time in shallow water that reaches no more than a fifth of the way up?

MAY

The black-winged stilt, *Himantopus himantopus,* is widely distributed from southern Europe to tropical Africa, as well as in the Middle East and in much of Asia. The European birds are migratory, for the most part, spending the winter in Africa. Other closely related species live in America and Australia.

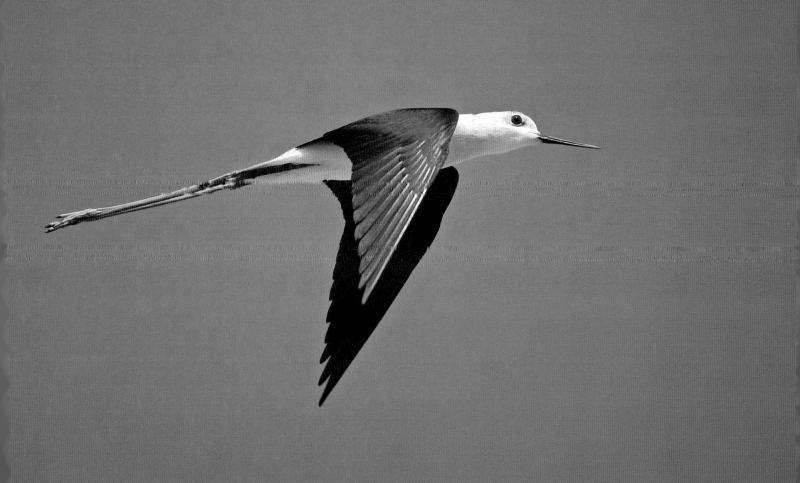

Audouin's gull

Off Cap Corse, on the island of Corsica, some little islets shelter the last nesting Audouin's gulls in France. Although the species is still very common in Spain, here there are no more than a few dozen couples. The adults are engaged in complex mating displays, incorporating head nodding, bows, staccato calls, mass takeoffs, and so on.

It is always an intense experience to observe birds initiating their nesting process when you know that only a few remain. At a time when biodiversity is so neglected, one suddenly becomes fully conscious that this intimate moment is rare, and that we must strive to lose no more of the richness of our natural inheritance. Of course, as they make their mating display before us, these Audouin's gulls know nothing of all this. Here is a male mounting his companion to mate. We can hope for only one thing: that their reproduction will be successful and that, in July, the young birds born of this union will take flight. So goes the life cycle of the Audouin's gulls of Corsica.

Threatened with disappearance a few decades ago, the Audouin's gull, *Larus audouinii*, is regaining strength, at least in its Spanish bastion. Elsewhere along the Mediterranean, it nests fairly sparsely. After reproduction, the majority of the population leave the Mediterranean basin via the Strait of Gibraltar and spread out along the African coasts, from Morocco to Senegal.

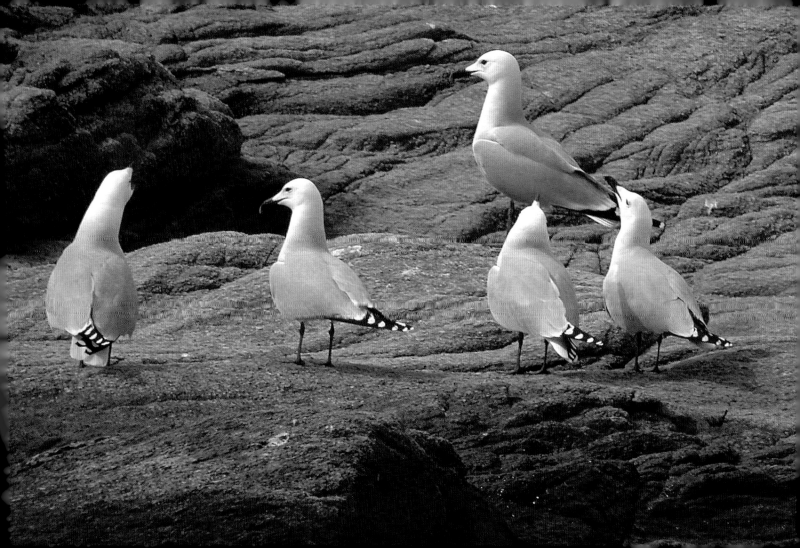

Wood warbler

In the 1990s, a walk in some beautiful beech grove in Western Europe during the month of May meant that you were sure to hear and see the wood warbler. Its climbing, accelerating trill sounded a little like a glass marble dropping on a tiled floor.

Why the past tense? Because suddenly, in the space of a few years, the wood warbler has become rare, nearly disappearing, in many of Europe's vast forests. To this day, no study has been attempted to discover the cause of this catastrophic decline in numbers. However, the wood warbler is a great migrator, traveling beyond the equator in Africa to spend the winter. As is the case with the European pied flycatcher (see April 15), the delicate balance of factors that contribute to its survival has probably been disrupted by climate change. In particular, the wood warbler has not managed to make its reproductive period coincide with the advancing hatching period of the insects that it eats.

This is why today, many of the great forests through which I walk in the spring seem suddenly empty, deprived of the wood warbler's fluting call.

The wood warbler, *Phylloscopus sibilatrix*, nests in all of temperate and northern Europe, and as far away as Siberia. A great migrator, it spends the winter season in the southern portion of Africa. One can only hope that the wood warbler will be able to adapt to the new challenges posed by the warming climate, rather than becoming one of its first victims.

Hummingbird

When I saw a hummingbird for the first time, it was in North America, not far from New York. I already knew much about this bird, of course, but I was completely astonished when I caught sight of its flight pattern. At first, I took it to be a large insect, perhaps a bumblebee pollinating flowers. But no, this animal that hovered in place, moving forward, back, from low to high, was not an insect at all. Once it landed, though it was always for only a second, you could easily see its feathers and beak: it was a bird! As soon as it took off again, zooming on its wings, you thought again of an insect.

At another time, when I was in Arizona, I saw dozens of humming-birds come to drink nectar prepared specially for them, out of a kind of upside-down bottle, several of which were suspended from the branches of a tree. Dozens of the birds came to feed, and this time, you might have thought you were watching a whole swarm of bees. I finally understood why uninformed Europeans regularly claim that they have seen a hummingbird in their yard. They are confusing the bird with a butterfly that closely resembles it, known as the hummingbird hawk-moth. Clearly, nature likes to play tricks on us.

MAY

14

There are nearly 330 species of humming-birds in the world. All live in the Americas, primarily in Central and South America, although one species is found as far north as Alaska. They are the smallest of birds (about .06 ounce for the bee hummingbird), and their wings beat the fastest, in some cases as many as 200 beats per second.

Yellow-breasted bunting

In a dry rice paddy in the north of Thailand, hundreds of yellow-breasted buntings converge toward a roost, far ahead of us. We see them pass in groups, flying fairly high in the already dark blue of the sky, while here and there, birds peck for fallen grain on the ground. Their breeding plumage, with its yellow and drab brown colors, is nothing much to look at, especially in the case of the males. In Siberia I saw a yellow-breasted bunting again, this time more beautifully dressed. Its simple but melodious song, like that of many buntings, led us to locate the bird, by the side of a little river bordered by osier and alder trees. The male who was singing was perched at the top of a young tree, showing his black head and his yellow belly, as well as the large white mark that he wore on his shoulder.

Today, Asian ornithologists describe a significant dwindling of the species in winter. The illegal capture of birds has been cited, but it is possible that the discharge of pesticides into the rice paddies is also not conducive to their life and health.

MAY

15

The yellow-breasted bunting, *Emberiza aureola*, is concentrated in Siberia during its reproductive period. Until very recently, it nested as far west as Finland, but it has since disappeared from that area. In the fall, this great migrator heads southeast and returns to its winter territory in tropical Asia.

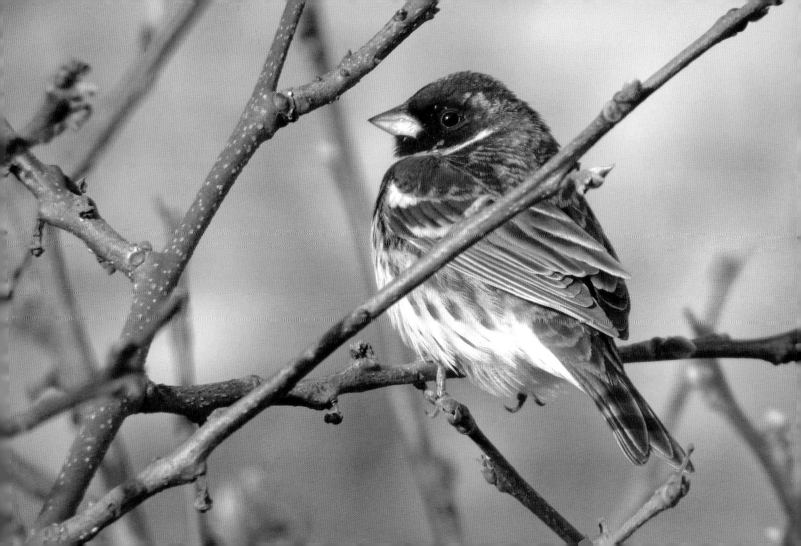

Red-backed shrike

The little road that crosses the Planèze de Saint-Flour, in the upper Auvergne, was once bordered by thick hedges of blackthorn and hawthorn. The fields and prairies were separated by old stone walls. Today, barbed wire fences have replaced many of these walls where the wall lizard loved to bask and where, starting in the month of May, the red-backed shrike came to make his nest and survey his territory with rasping cries.

Despite these disruptions to its landscape, however, the shrike is still there. One might even say that it has not declined—or, in any case, not everywhere. Amid a chorus of alarming news for birds, this is indeed a good thing.

The males return first and choose a hedge (there still are some here) from which they will more or less refuse to budge until their young take flight—except for short swoops to capture a large insect, even a small lizard. Always on the watch, with its large raptor's beak, the shrike is known for impaling its prey on the thorns of bushes (or, today, on the barbed wire, which works in much the same way); these serve it as a larder of sorts.

The red-backed shrike, *Lanius collurio*, can be found from Western Europe (except the British Isles) to western Siberia. It is a migrator that, unlike most other European species, heads southeast, rather than southwest, in the fall. It winters in the eastern part of tropical Africa.

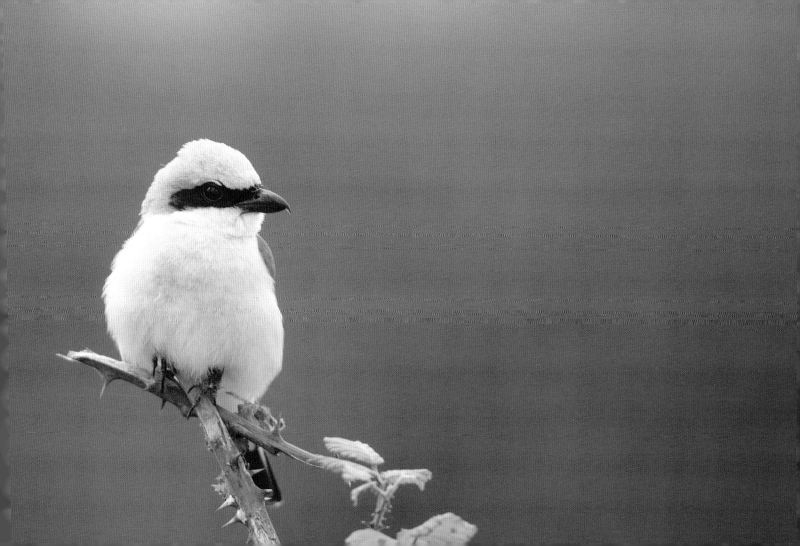

Mute swan

Majestically, a family of swans sails across the pool of the castle. The male, which can be recognized by the thick red wattle on its beak, leads the way, followed by a string of cygnets. The female brings up the rear of the group, which proceeds in single file. Then the family reaches the banks and climbs up onto firm ground. Now their majesty takes a blow, so clumsy are they when they walk. They waddle, advancing by little steps. For all that, it is unwise to approach them too closely. The male, inflating his plumage, can become very aggressive, and even if he walks poorly, he has a powerful bite!

In the air, the grace of the swan is once again apparent. With a steady and direct flight, neck extended, it moves at a good clip, each beat of its wings accompanied by a rhythmic *whirr!* of the air in its feathers. That is nearly the only sound it makes, for, as its name suggests, the bird is almost entirely mute. Save for the occasional high-pitched or stifled groan it makes from time to time, it is totally silent. Its beauty speaks for itself.

MAY

17

From Siberia to Eastern Europe, the mute swan, *Cygnus olor*, is considered a natural nester. It has been successfully introduced farther west in Europe, as well as in North America. Its introduction in Western Europe actually dates from Roman times, and has been so complete that the birds are today considered totally wild (except for those that have been placed on urban lakes and ponds).

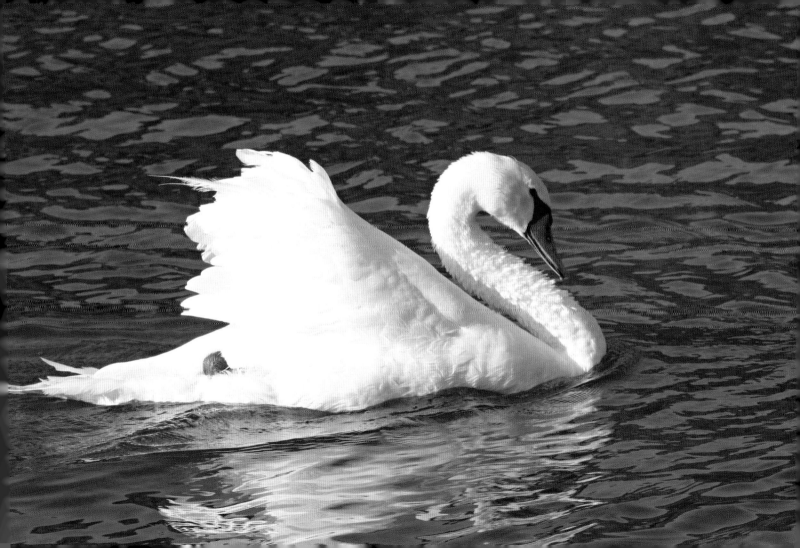

Atlantic puffin

Well before we reach the colony of seabirds on the northern shore of Scotland, the wind carries to our nostrils the smell of fish. As we move with some difficulty across the land, which is filled with holes and covered with clods of weedy earth, the distant noise of the birds begins to mingle with this ripe odor. Soon, the immense vertical face of the cliff is revealed before us, and, with it, a fabulous spectacle of the thousands of birds jostling to nest there.

At the top of the cliff, the puffins are numerous. It is there that they have their burrow, and the adults come and go. However, we are right in the middle of the brooding period and so cannot yet see the spectacle of the birds, with beaks full of sand eels, coming to feed their chicks hidden in the depths of the burrow. For the moment, despite a bad wind and a gray sky more reminiscent of winter than spring, the puffins busy themselves with reproduction. Their enormous, multicolored beaks, which have earned them the nickname of "sea parrot," stand out against the prevailing grayness. The name is fairly apt, except that the puffin's plumage, rather than being bright and colorful, is an austere black and white.

MAY

18

The Atlantic puffin, *Fratercula arctica*, nests from Arctic Siberia (Nova Zembla) in the east to the northeastern coast of North America, by way of the British Isles, Iceland, and Greenland. In France, a small relict population, 150 to 180 couples strong, still nests in Brittany. The puffin is the symbol of France's Ligue pour la Protection des Oiseaux (League for the Protection of Birds). The very large puffin population declined substantially in the 1970s and 1980s, but then began to stabilize or increase in most of its range.

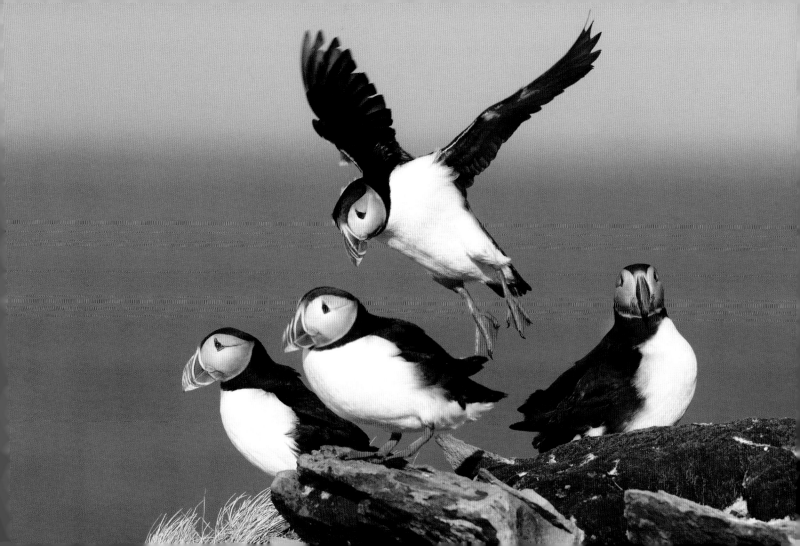

Spotted flycatcher

Tsit! In the dense tree branches, at the heart of a flamboyant chorus of singing birds, the cries of the spotted flycatcher inevitably pass unheeded. All the more so since the bird's modest song is paired with an equally modest gray plumage and a disconcerting immobility. In short, it's best not to get too excited about seeing this bird while it nests in the forest. It is during its migration that it best reveals itself, frequenting more open spots such as bushes and orchards, even perching right in sight on a fence post.

In the spring, the migration monitoring sites of southern Europe permit you to see the bird every day. This is the case along the northern shore of the Mediterranean. In early morning, the birds, who are nocturnal migrators, finish their sea crossing and finally land on a cape, a point, or an island. Exhausted by the journey, and having to regain their strength for the rest of their peregrinations, they allow themselves to be admired. One can admire, as well, how skilled this bird is at catching flies and midges. With a nimble beat of the wings, it takes off from its post to capture the imprudent insect, then returns to the same spot to eat it. So goes the flycatching of the spotted flycatcher …

The spotted flycatcher, *Muscicapa striata*, has a vast distribution that, during the spring, extends from Western Europe and North Africa to deepest Siberia. The bird is a long-distance migrator that spends the winter beyond the African equator. It returns in spring, late in the season.

MAY

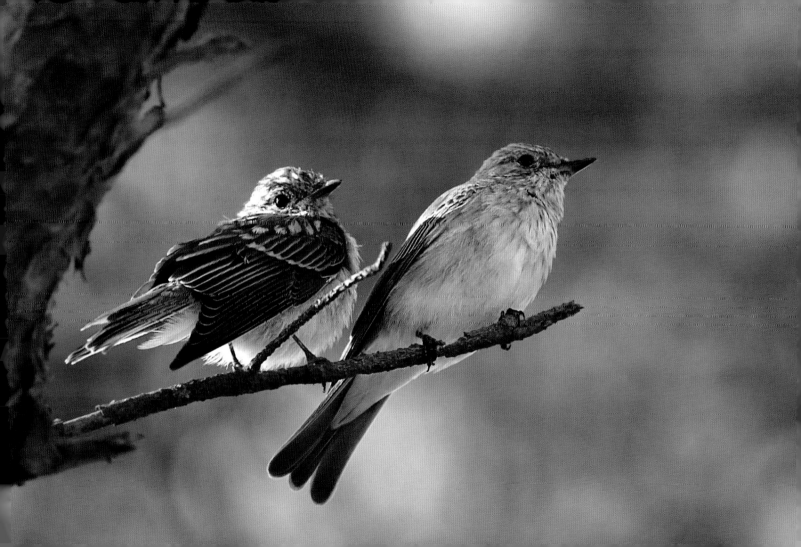

Ural owl

We are spending part of the night above the village, somewhere in the Carpathian Mountains. Everything betrays the eerie presence of brown bears: droppings, prints, scratch marks. For the moment, however, it is not the bear we have come looking for, but the Ural owl.

This larger cousin of the tawny owl will soon sing: it makes a deep, muffled bark, which echoes in the valley and makes the place seem even eerier. When you hear it, how can you avoid thinking of the prowling bears? But this evening, the Ural owl has decided to drive us crazy. A song, in the near distance, causes us to move toward the source of the sound. When we arrive at the place where we thought we could better hear (or see!) the singer, there is total silence. In the distance, we hear barking dogs, but nothing that could be our owl. We wait for a good hour, little by little invaded by the chill of the high altitude. The owl will not sing again. Perhaps we have come a little too late in the season.

Tomorrow, the shapes and voices of the forest will be manifest again. With a little luck, we will see a bear, or even several. The birds will sing. But, hidden at the top of a tree, silent, the Ural owl will simply watch us pass below.

The Ural owl, *Strix uralensis*, reproduces in the mountain forests of Eastern Europe and from the Scandinavian plains to eastern Siberia. Sedentary, the birds remain all year in their reproductive territory, but are not heard except in the beginning of the nesting season, starting at the end of winter.

MAY

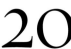

20

White-browed tit-warbler

Everything about the white-browed tit-warbler is unusual. First, there is the place where it lives: high in the Tian Shan Mountains or the Himalayas, among the stunted vegetation of rhododendrons and junipers. Second, there is its behavior: it nearly always stays under cover and is as ready and quick to hide as a mouse, never allowing the ornithologist to observe it for more than a fraction of a second. Finally, there is its plumage. Amid the monochromatic rocks and bushes of the high mountains, the appearance of a small bird, in shades of pink, blue, beige, cream, burgundy, periwinkle, and lilac, seems almost miraculous. To catch it in your binoculars even for a second creates an unforgettable moment of grace. In truth, we may well have equally beautiful birds in our backyards. But the magical setting of these remote mountains, the rarity of the species, and the difficulty of getting to its reproductive territory lend the white-browed tit-warbler a mythical dimension. Perhaps it would be otherwise if they came by the dozens to our bird feeders.

Limited to the Tian Shan range and the Himalayas, the white-browed tit-warbler, *Leptopoecile sophiae,* travels very little. In the fall, it descends only slightly in altitude. In the summer, it can be found as high up as 12,000 feet (3658 meters). This species is related to the wrens as well as to the warbler family.

MAY

21

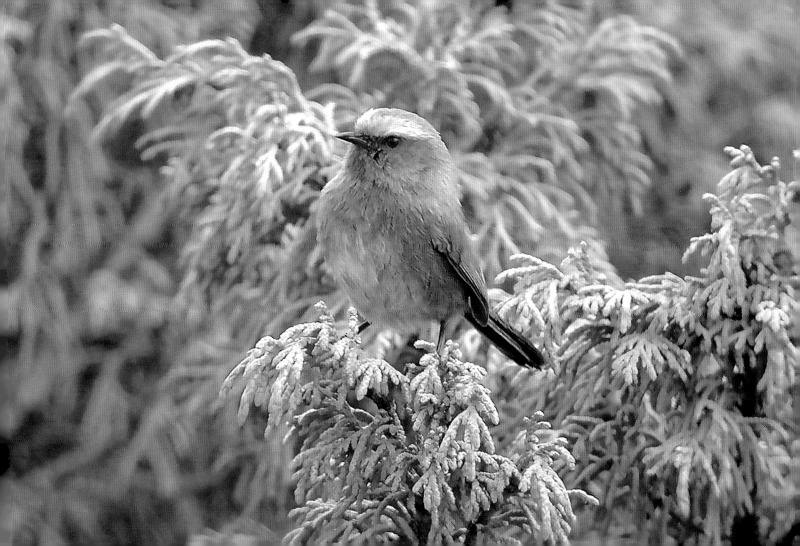

Great white pelican

On the ground, the great white pelican is not a paragon of beauty. On the water, it's not much more impressive. In flight, however, the majesty of the species is fully apparent. It is a remarkable thing to see a flock of them take off from a lake in the Danube Delta and open up into great rising orbs, keeping the beating of their wings to a bare minimum. With a black-and-white underside reminiscent of the white stork's, the pelican stands out marvelously well against the blue of the sky. Its beak is enormous, as is its wingspan. You have only to see it fly in the company of storks to realize just how big it is. Compared to the great white pelican, the stork is Lilliputian.

At present, the flock has gained altitude, and without an extra beat of their wings, the birds will fly this way for miles, until they reach a new pond with a fresh supply of fish. That crop on its beak exists because the pelican is a great fisherman. The frenzy that seizes the birds when they come upon a shoal of fish is a sight to behold: the scene looks like a scrum in a rugby match. Of all the birds in the world, the great white pelican has the build for it.

MAY

22

The great white pelican, *Pelecanus onocrotalus*, is found from Eastern Europe to Mongolia, including on the shores of the Caspian Sea. These populations are migratory, wintering in Africa and in the north of the Indian subcontinent. Other populations nest in tropical Africa, and some of those are resident.

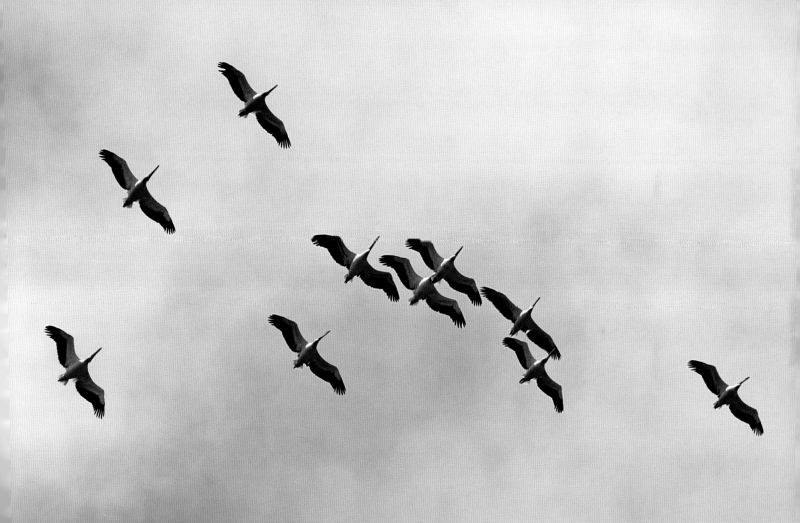

Red-footed falcon

May is the month of the red-footed falcon. Whether on the Hungarian *puszta* (plain), or along the Danube valley in Romania, or in southeast France, the sight of this species, when it returns from its African quarters, is enchanting. The male is beautifully clad in silver gray, with his "knickers," legs, and the cere of his beak all orange-red. The female is equally beautiful, finely dappled with red and gray.

During migration season on Cap Corse, you may sometimes see birds proceeding rather haltingly—stopping in flight to hunt insects, wheeling, even moving backward or landing on the ground for short instants—before taking up their route again toward the north. In the fall, in Eastern Europe, one may stumble on much larger flocks hunting together, hovering in place like kestrels. What is striking, in this bird of prey, is that the extreme looseness of its wing movements makes the bird seem somehow nonchalant. Its movements are smooth. It seems powerfully calm. And it is calming, in turn, to those humans who observe it.

The red-footed falcon, *Falco vespertinus*, reproduces from Estonia and Hungary across all of central Asia and Siberia and as far as the extreme northwest of China. It winters principally in southern Africa. In the spring, especially, small flocks may stop in France, slightly to the west of its main migration routes.

MAY

23

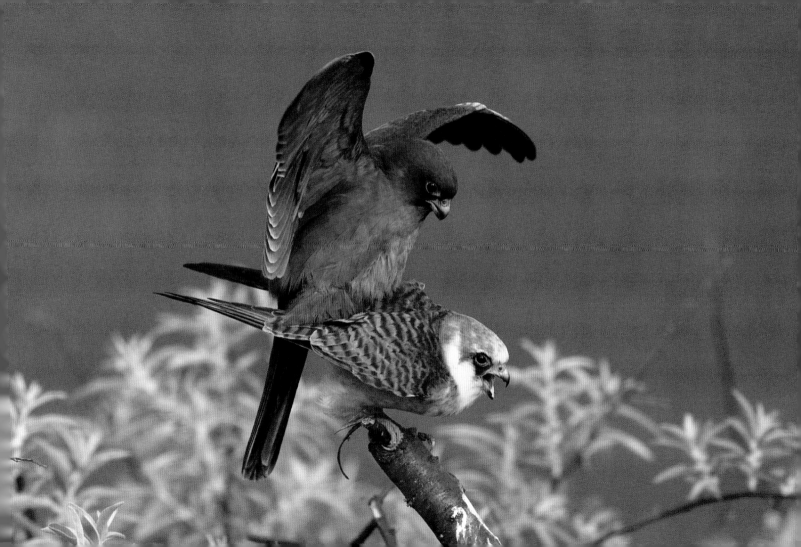

Black lark

Because it is almost never seen in Europe, and lives very far away, in the steppes of Central Asia, the black lark occupies a central place in the mythology of European ornithologists.

I first saw the black lark in the steppes of northern Kazakhstan. It was the mating flight of the species that seemed most remarkable to me. The male, all clad in black, soared into the air, looking suddenly like a big diurnal bat as, with fluttering wings, he flew over the endless steppe, singing. Then, suddenly, the bird dropped like a stone and came to rest on a bush. Here and there in the distance, you could see these black specks in motion, while the brownish females remained perfectly invisible.

Long ago, when the steppe spread farther to the west, it is said that flocks of black larks came as far as the gates of Europe, particularly on occasions of severe cold. Today, this sort of vagabondage seems to have ended. It is this history, no doubt, that gives the bird its mythical quality.

MAY

24

Nesting in central Asia, the black lark, *Melanocorypha yeltoniensis*, is found principally in the south-central Siberia and Kazakhstan. The females and the young leave the nesting grounds, but the males stay there and, banding together, brave the cold and snow as a group.

Great rosefinch

The birds of the high mountains have this in common: since they are by their very essence difficult to reach, they are always a source of pleasure for the persevering ornithologist who has made the effort to find them. Once you reach their habitat, you still need a bit of luck to pinpoint their location amid the vastness of the rocks, screes, cliffs, and high mountain pastures. Especially if the birds are passerines and thus of modest size.

The great rosefinch is one of these sought-after birds. And it is a superb species. High in the Caucasus Mountains, I spotted the great rosefinch, while the snow was still breaking up and flowers inundated the alpine meadows, too hurried to wait for spring. Three or four birds searched for seeds in the pasture among the stones. A male, his dark red plumage flecked with white, landed on a larger pebble and struck up his slightly sad song. At nearly 9000 feet (2743 meters), the air was exceptionally thin, and the notes of his simple song took on a particular fullness. You might have thought he was singing into a microphone. Even as he sang, the bird watched us from the corner of his eyes, but we did not dare to move, fascinated by the melody of this unknown voice. Then the birds abruptly took off, putting an end to this state of grace.

MAY

25

The great rosefinch, *Carpodacus rubicilla*, has a fairly limited geographic distribution. It is found in the high summits of the Caucasus, and then quite far to the east, in the Tian Shan Mountains, in the Altai Mountains of Russia and Mongolia, and at the edge of the Himalayas. The species migrates only to a lower altitude, in response to winter climate conditions.

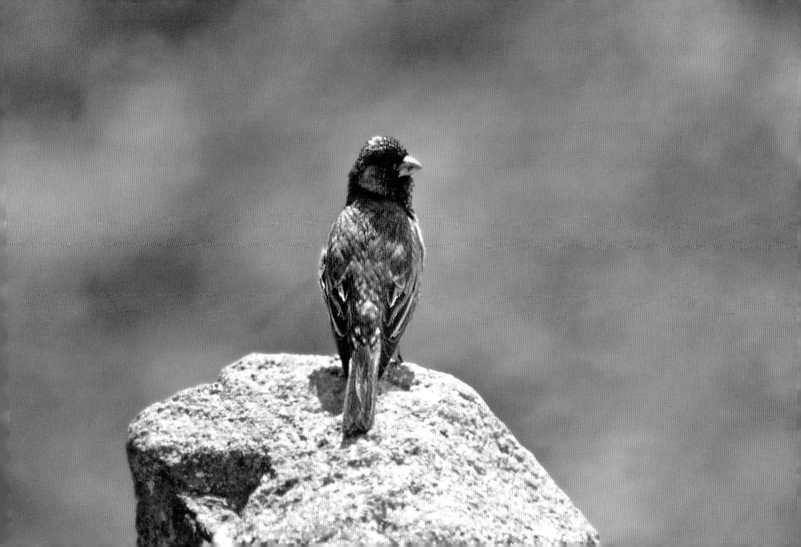

White-throated robin

To see the white-throated robin, you must go to eastern Turkey, and to Anatolia in particular. This species of the Muscicapidae family (like the nightingale, the black redstart, or the European robin) lives in mountainous regions, in areas somewhat reminiscent of Mediterranean scrubland. I had to wait a long time, well hidden across from a stunted but dense juniper, before I saw the male who was singing in the deepest part of the bush.

After performing his liquid, resonant, and fairly rapid song, the bird moved around within the dense foliage of the bush. I could see only his silhouette, as if in a shadow play, which was somewhat frustrating. And then, all of a sudden—after what seemed an infinite wait—there he was. He emerged and made several quick steps, his tail raised at 90 degrees. Gray-blue and orange were the dominant colors of his plumage. His white breast and black cheek, set off by a white eyebrow, provided the most contrast. Quickly, the male robin returned to his bush. And that was the last we saw of him. He had no doubt slipped out the back, as his other cousins in the Muscicapidae family know how to do so well.

MAY

26

The white-throated robin, *Irania gutturalis*, is found only from Turkey to the Caucasus Mountains, and then in Iran and as far as the mountains of central Asia. The birds spend the winter in the Arabian Peninsula and in northeast Africa.

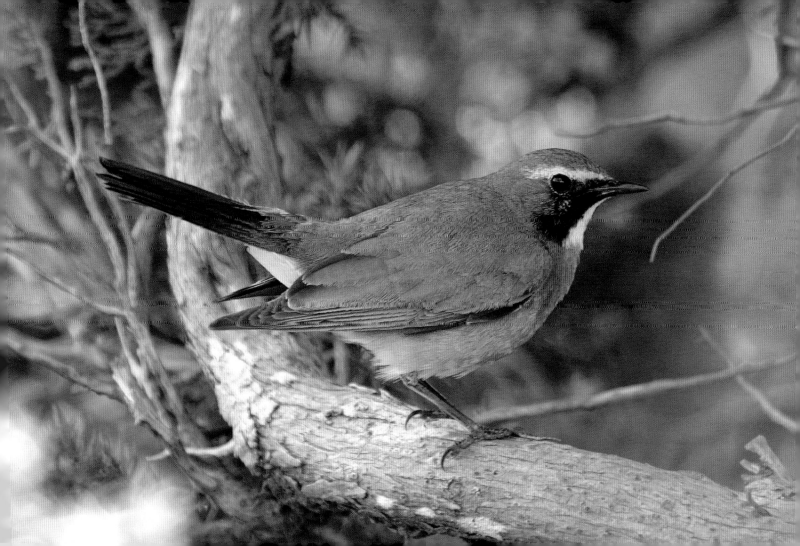

Little bustard

In the Spanish sierra, it is only the end of May, but we must go out early in the morning to avoid the heat that silences the birds. At the first hours of the day, we stride along the dusty roads bordered by fields of grain, in search of the little bustard. The little bustard is a curious bird, resembling at once a small ostrich, a large chicken, a short-necked crane, and a giant partridge. The wheat, which is still green, is already high. If we are to find a bustard, then, we will have to rely on our ears. And the song of the male is the roughest of cries. It is a sort of *prett!*—slightly rolled, staccato, low, but carrying far. That is all, as far as singing goes. Fortunately, it is a characteristic sound, for otherwise finding the bustard would be a feat indeed.

Sometimes, the little bustard takes wing, and then everything changes. Then, you find yourself in the presence of a large bird with a powerful flight. When a male bird spreads its wings, the underside is white, while the top is mostly white, but black and brown as well—which makes it particularly visible in this fairly monochromatic environment of grain fields. This bird lands, but reveals himself hardly at all. Only his head sticks out of the grain, and with it the marking wrapped around his neck like a long scarf of black feathers.

MAY

27

The little bustard, *Tetrax tetrax*, is found especially in the Iberian Peninsula and the south of France in Western Europe, then toward Ukraine and the borders of the Caspian Sea in the east. The French populations may be either sedentary (the birds of the Midi) or migratory (the birds of the Atlantic coast); in the latter case, they spend the winter in Spain.

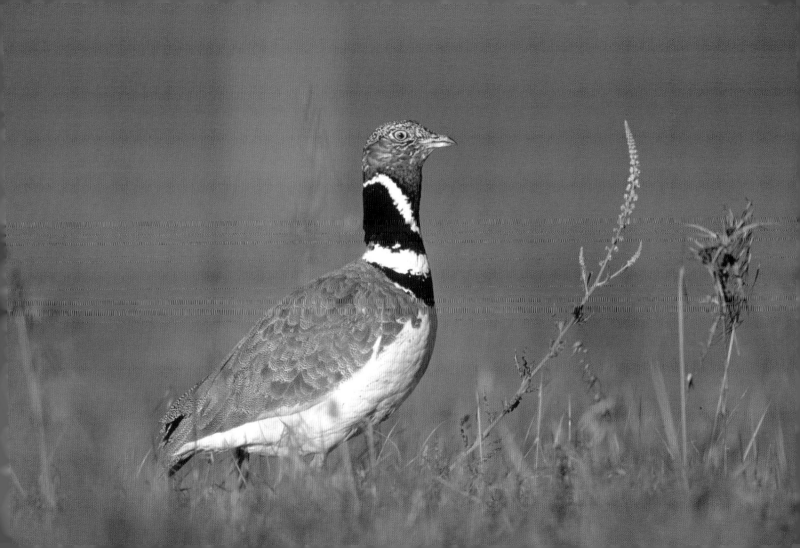

Common house martin

The colony of house martins that has taken up residence at the railroad station is again full of life. During the long months of winter, I would sometimes watch the empty nests, moored against the facade, under the roof. Like me, it was awaiting warmer days.

But now the house martins are back, actively circling, coming and going into the nests and out again, chasing each other excitedly. The nesting process is in full swing, and the birds buzz around the nests, straightening them up hastily. All this is accompanied by incessant cries of *tritt…tchiritt!*

I love this optimistic effervescence. I like to watch the house martins commit again to the public buildings, the houses, the farmyards, or the mountain cliffs. I like their long swoops followed by a rapid beating of wings as they try to raise themselves in the air while hunting insects. I also like it when they join with the swifts—which have also returned—in joyous and animated twilight sarabands. House martins are an inexhaustible source of enchantment. Too bad that, at the same time, we are so happy to destroy their nests when they are in our way.

MAY

28

The common house martin, *Delichon urbicum*, is very widely distributed throughout Europe and in the western half of Asia. By a huge majority, the birds are migratory and spend the winter in Africa. They are among the most endangered species in Western Europe, notably because of the frequent destruction of their nests in the course of renovation work.

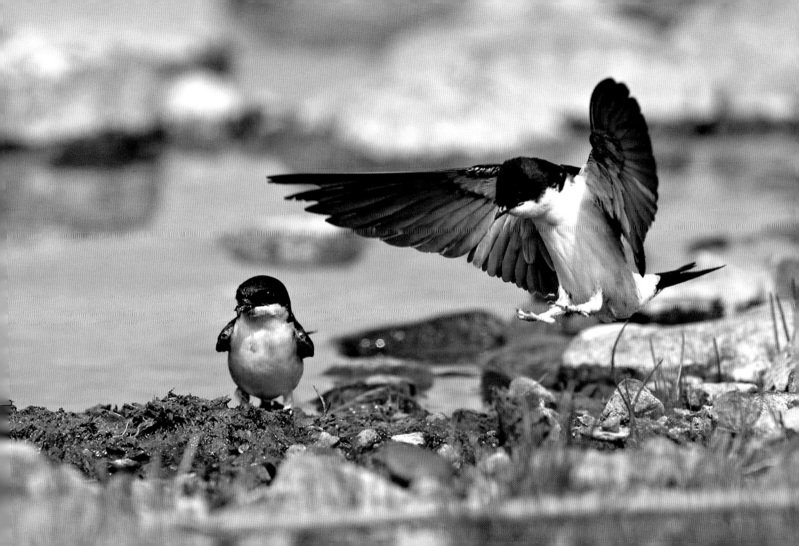

Cattle egret

I am fascinated by the history of the cattle egret. You may know this little white heron as the one often seen in the African savannah, accompanying a herd of elephants or standing near the gnus and zebras as they drink at the river.

This heron, of tropical origin, colonized areas near the Mediterranean little by little over the course of the twentieth century, and then, after braving the great sea, settled in France. First it found a home in the Camargue, having exchanged elephants and antelopes for the horses and bulls it found there. Then, growing tougher, it arrived on the southern fringes of the Atlantic, benefiting, no doubt, from the warming climate (even if, with each cold snap, their numbers melted away, victims of the bad weather).

Into the early years of the twenty-first century the species has pursued its path toward the north. The cattle egret can now be found in the north of France, and it has reached Great Britain and the Netherlands as well. The cattle egret has even taken a boat and set up shop in America.

If there is one species that indicates that the climate is warming, it is surely the cattle egret.

Widely spread through the tropical world, the cattle egret, *Bulbucus ibis*, is found in Asia, in Africa, and in America. It also nests in southern and western Europe. Before long it may have colonized Eastern Europe and a good part of Russia.

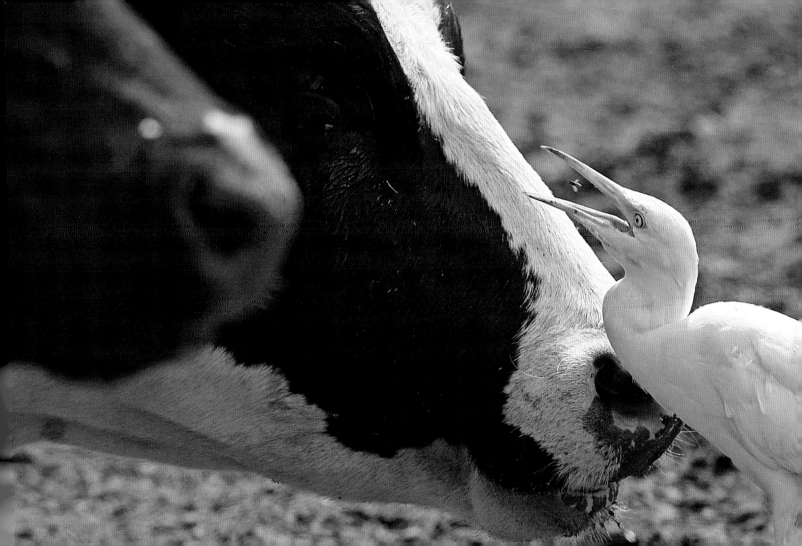

Chimney swift

Near Montreal, houses alternate with tall apartment buildings. In the evening, the chimney swifts begin their chase. With their tapered bodies and long sharp wings, they are built like airships. Their long high-pitched trill echoes in the sky at the end of this day, which, finally, smells like spring. Their English name—"chimney swift"—describes fairly well where they live. The industrial development at the beginning of the twentieth century prompted a growth in populations of these birds. Having originally nested in the cavities of trees, they went on to install themselves in the many new factory chimneys. But times have changed since then, and the number of chimney swifts has greatly diminished along with the factory chimneys. So much so that today, this species is gravely endangered in North America.

Sometimes, during the fall migrations, birds that fly along the western edge of the Atlantic to reach South America are caught in violent storms. As a result, chimney swifts may be found as far afield as the Azores and beyond, in the British Isles and even in France on a small island in the Finistère department.

MAY

30

The chimney swift, *Chaetura pelagica*, reproduces mainly in the southeast quadrant of North America. The birds, which are long-distance migrators, spend the winter in South America.

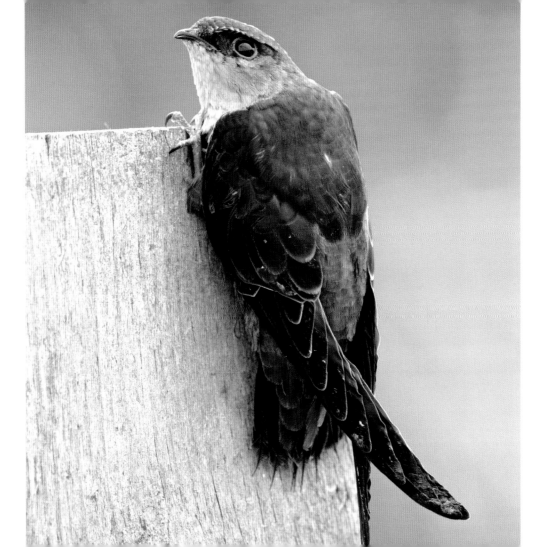

Corn bunting

The great agricultural plain is not especially interesting, but it has several little roads that appeal to an ornithologist and bicyclist like me. While coasting along past fields of ripening wheat, future corn, and rapeseed, I may hear the cascading trill of the corn bunting. It is not what you would call a colorful bird. A motley brown, it can pass completely unremarked. It is easily confused with a female sparrow, if you fail to note its plumpness and the slight vibration of its direct flight. This bunting is intimately linked to agriculture. Given only an electrical line or an isolated bush in a field, the male will perch there and deliver his perky song to the gallery. In sum, the bird blends seamlessly into the rural landscape.

Scientists, however, are concerned about the corn bunting. In many regions, it is declining in number, no doubt a victim of an agricultural system with little care for biodiversity. In Great Britain, the plight of the corn bunting is nearly a national cause. If we are not more careful, this bird, like its neighbors the skylark and the gray partridge, may well disappear, and the monotony of the plains will no longer be enlivened by its joyous song.

MAY

31

The corn bunting, *Emberiza calandra,* can be found in all of Europe, North Africa, and the Middle East, with an easternmost population in Kazakhstan. It is not a great migrator, and the species makes only limited movements, mainly among those populations farthest to the north.

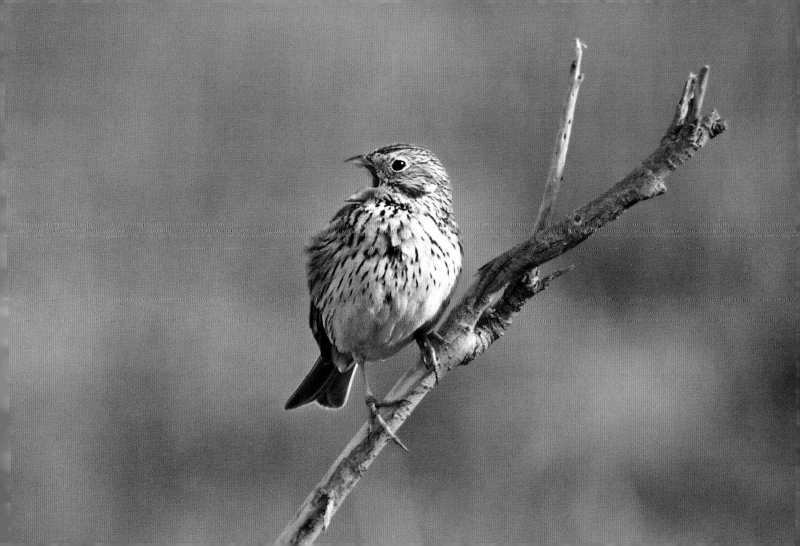

Snowcock

Few birds are so difficult to see as the snowcocks, which are related to pheasants, grouse, and partridges. The five existing species live in the Asian mountains known as the roof of the world, high in the rocks, well beyond 7500 feet (2300 meters) above sea level and the timberline. To reach their territory, you must often walk a long way on hazardous trails and endure highly changeable weather conditions. And you have to sustain an unshakable patience. You will need a sharp ear to pinpoint the snowcocks' song and a lynx's eye to spot the birds, since they blend in remarkably with the rocks. To crown it all, snowcocks are shy birds. As soon as they see you—the poor fool who has come all this way to get a look at them and now stands just a few hundred yards down the slope—they step off rapidly toward the heights, silent and well camouflaged.

In a great valley of the Himalayas, and on the rocky escarpments of the Altai Mountains, I have managed to track down the snowcock through its song. The song is similar to that of the Eurasian curlew, and it is strange to hear a sound in this environment that so recalls the distant coastal waters and the beach. It still takes a patient search through my binoculars to finally catch sight of the birds pecking for seed, far up the mountain. But after all, to see a snowcock is always something of a small miracle.

There are five species of snowcock, *Tetraogallus,* in the world, all of which dwell only in high mountain regions. They are found in the Caucasus Mountains, the Altai Mountains, and the Himalayas, and on the tall peaks of Turkey and Iran, as well as in the Ruby Mountains of Nevada, where they were introduced in recent decades. The birds live at 9000 feet (2750 meters) or higher, and descend only slightly in the coldest part of the winter to find places where food is more accessible, notably in the forest. They are almost entirely sedentary.

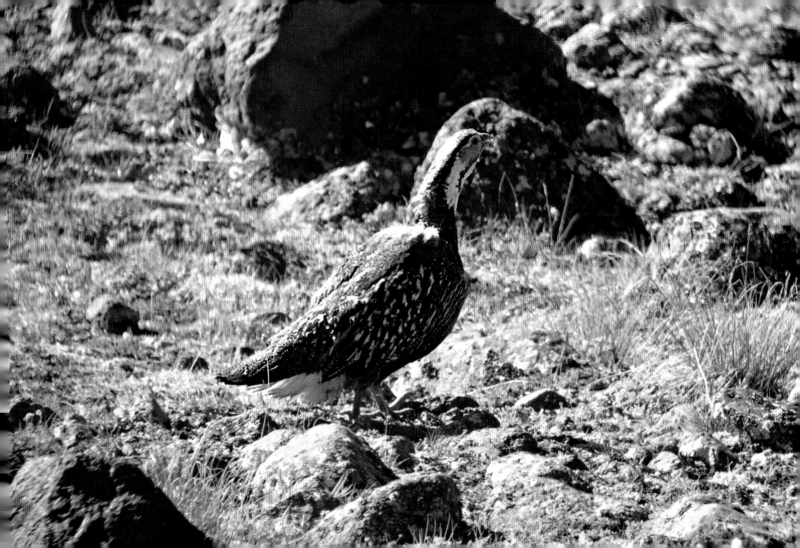

Common yellowthroat

My first encounter with the common yellowthroat was on Long Island, outside New York City. The black band that this bird wears over its eyes immediately made me think of Zorro. With this mask, its white eyebrows, and a bright yellow belly, the little brown bird moved nervously and unceasingly in the low branches of a bush. I could barely follow it with my binoculars, and it most often appeared to me in sections: sometimes the head, sometimes the belly, sometimes just the legs … After this first introduction, I saw many yellowthroats, on both the east and west coasts of the United States. I much enjoyed their song, too, which is short, noisy, and explosive: *witchiti… witchiti… witchiti!*

As common as it is, the yellowthroat will do anything it can to conceal itself when you try to observe it. It likes to stay deep undercover, often near the water; that is where it's most at home. To flush it out, without actually shaking the bush, you must remain patient.

JUNE

2

The common yellowthroat, *Geothlypis trichas,* is found in nearly all of North America, with the exception of Alaska and of boreal and Arctic Canada. The vast majority of these birds migrate, wintering anywhere from Florida down into Central and South America.

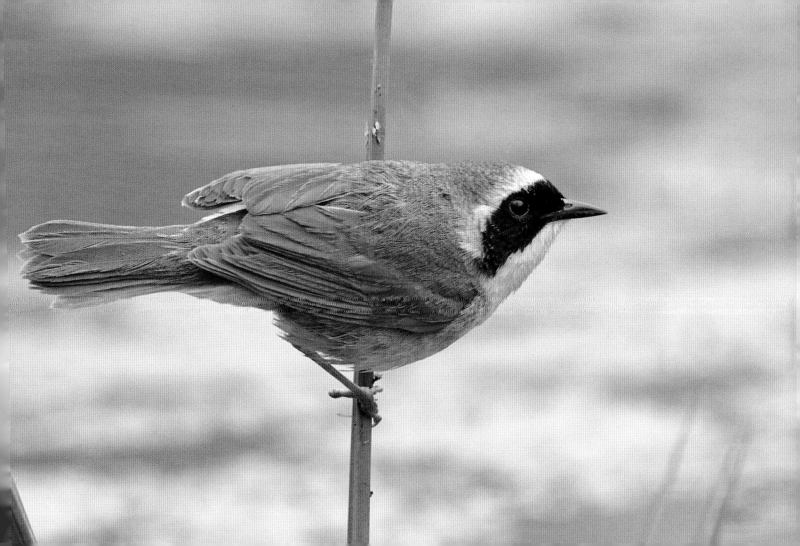

European pygmy owl

After a warm evening in the beech and pine forest of the Jura Mountains, nighttime comes, and with it the cooler air. This is the moment to go out, without a flashlight, and walk through the moonlight to seek out the European pygmy owl.

The tiny pygmy owl haunts these tall, age-old timber forests. I got my closest sight of the owl in the company of a true connoisseur of the species. Without him, by all evidence, I would have wandered the forest in vain. But he knew the nesting birds, and was able to tell me where to go to see this little owl with golden eyes. This part of the great forest, with good exposure and very old trees, suits the bird's preferences perfectly.

At the top of a spruce, in near darkness, there is the owl: a ghostly shadow that must surely be watching us back, with its piercing gaze. All we see is a silhouette taking off against the deep blue night sky. Well, close-up observation will have to await another day. But to know it is there, so near to us, visible yet difficult to discern, makes it seem all the more mysterious. Like all nocturnal raptors, the pygmy owl keeps its share of secrets from diurnal humans like ourselves.

The European pygmy owl, *Glaucicium passerinum,* is the smallest nocturnal raptor in Europe, no larger than a starling. It lives in mixed forests of beeches and conifers, often at high altitude. A sedentary species, it remains closely tied to its nesting place.

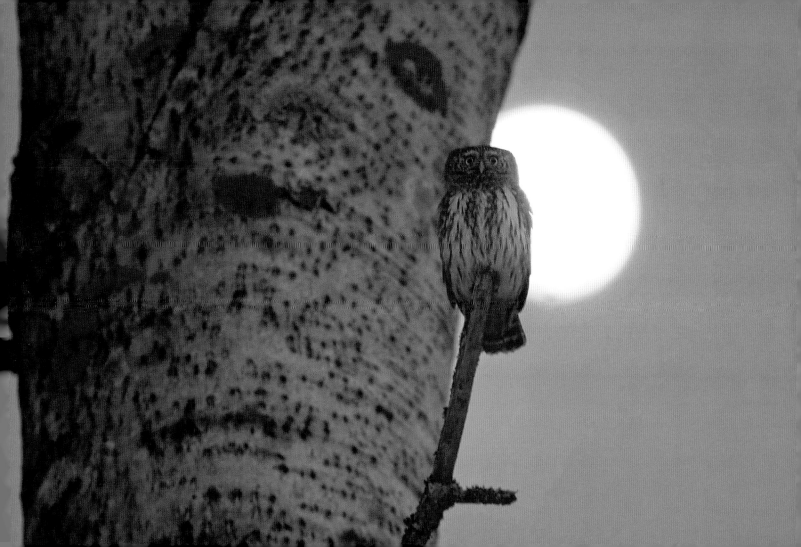

Little tern

On the narrow band of pebbles at the end of the beach, there is great animation these days. Dozens of little terns have invaded the place to build their nests. The birds come and go in an unending dance. They leave for the sea and return with a little fish in their beaks. Some offer the fish to their partners, who are newly engaged in nesting activity, while others must feed their just-hatched young. No sooner do the terns alight than they fly off again. Regularly, at the drop of a hat, the whole colony takes off, and a deafening concert of shrill and rasping cries of *kirri-kirri!* fills the air for a few instants. But very soon, the birds settle back to earth again. It is not even clear what caused their flight in the first place.

In groups, the birds take off toward the sea and pass close to us. Their rapid and direct flight, with shallow, choppy beats of their wings, often makes me think of what it would be like if mice could fly.

JUNE

4

The little tern, *Sterna albifrons*, inhabits a large part of Europe as well as eastern Asia, West Africa, and Oceania, as far off as Australia. Several closely related species live in the Americas. The European birds are migrators and spend the winter in the coastal waters of tropical Africa.

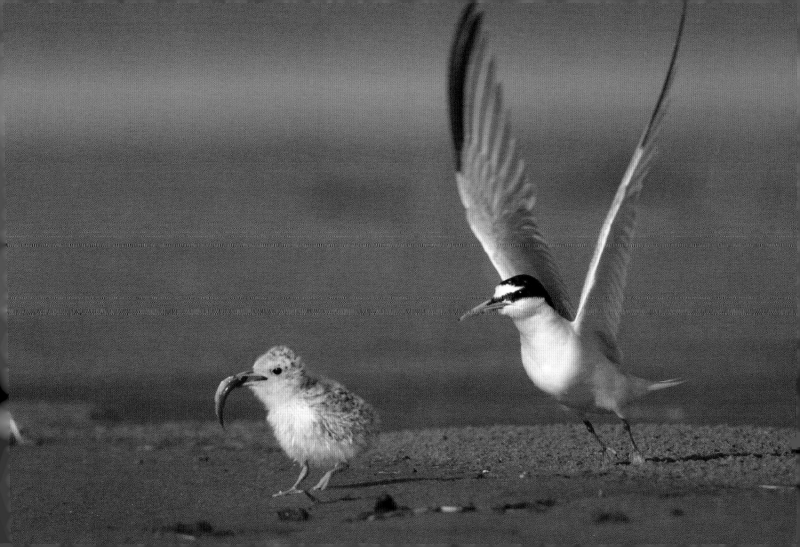

Clark's nutcracker

Rarely have I seen such nerve. In Banff National Park, in Alberta, we had stopped at a picnic area at lunchtime. As soon as I took the food out of my bag, a throng of gray birds swooped down. Without a sound, they landed near us—you might even say they encircled us—silently coming closer and closer until one bird climbed right onto our table, less than three feet (one meter) away. As we watched, other birds, no doubt encouraged by their companion's success, came to join it. One of these birds, having snatched up a little piece of bread several inches away from me, took off again with a smooth flight. I held out a scrap of food in my hand; one of the nutcrackers nimbly leaped onto my forearm, snatched up the morsel, then went and perched nearby to eat it.

Later, we learned that the nutcrackers of the park are particularly fond of picnic areas and get their food in large part from tourists. No doubt most visitors are as dumbfounded as I was by the birds' audacity.

A sedentary bird, Clark's nutcracker (*Nucifraga columbiana*) lives mostly in the Rocky Mountains, in western North America. As a species, the nutcrackers fall somewhere between jays and crows.

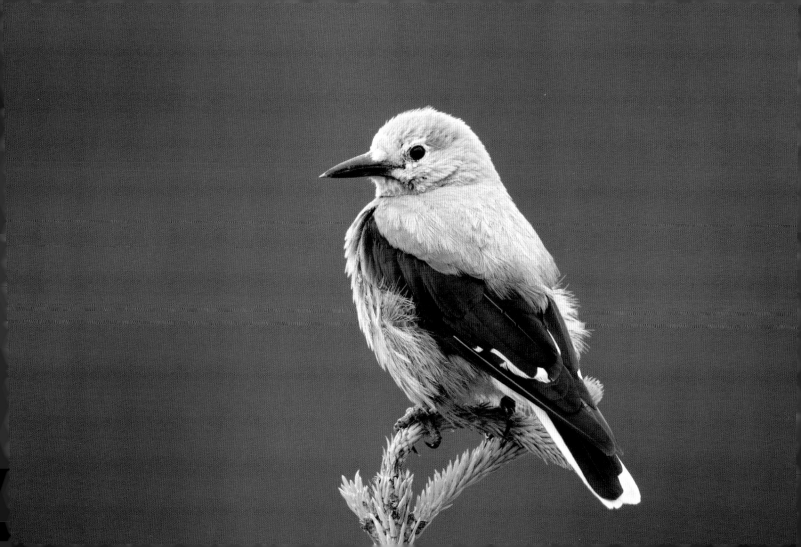

Red-headed bunting

On the semi-arid steppes of Kazakhstan, the red-headed bunting is omnipresent. Like its near cousin, the black-headed bunting (see May 3), it arrives suddenly and then, from one day to the next, the silent steppe blooms with hundreds of singing birds proclaiming their return. Despite its name, the red-headed bunting seems practically made of sunshine, so prominent is the yellow of its plumage. On its chest, its belly, and also part of its head and its lower back, it blazes with color. At least that's the case with the male; the female is drabber, wearing a dull yellowish color streaked with brown on the back.

The red-headed bunting is a species of the steppe little known to the European ornithologists, because the bird does not wander far into Western Europe except on rare occasions. To see it, you generally have to venture out to these great plains of central Asia. There, you will see it everywhere. Even so, you will never tire of its sunny plumage and bright, lively song, a fine match for the thousands of wild tulips and poppies that briefly color the endless plains of the steppe.

JUNE

6

The red-headed bunting, *Emberiza bruniceps*, nests from the Caspian Sea to western Mongolia. It is a migrator and passes the winter on the Indian subcontinent. It leaves its breeding grounds early (in August) and does not return before the end of April or, more likely, the beginning of May. By then, the previously inhospitable steppes are finally warm enough.

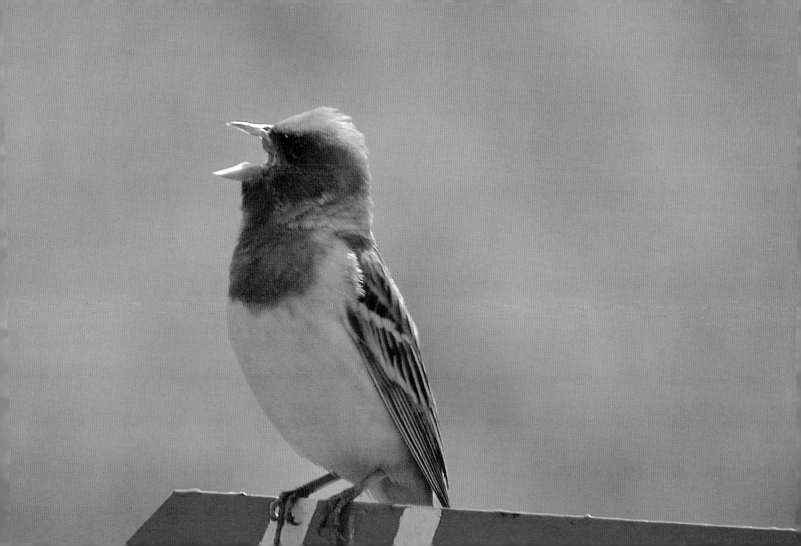

Long-tailed duck

In June, the few long-tailed ducks that winter in Western Europe have long since left for the Great North. So that is where French ornithologists must go to find them. Among the diving ducks, the long-tailed duck is doubtless one of the most beautiful species. At this time of year, the birds have put back on their breeding plumage, and the tails of the males are ornamented with long thin feathers.

In the far north of Norway, the birds are still at the seashore, and the couples have not yet dispersed over the countless little lakes of the tundra to nest. This is the moment when the males display all their talents for courtship. In a great commotion of splashing and feathers, the males give their odd cry, a slightly stifled *ah…ah…ahoua!*

Soon, this pretty scene will drift apart, and each couple will go to live on some little lake deep in the mountains that rise over the coast. This phase lasts a short period, and the female will take full charge in raising the ducklings. The males, meanwhile, will go create another beautiful tableau at the seashore and begin dressing themselves in their winter plumage, which is just as beautiful as their breeding attire.

The long-tailed duck, *Clangula hyemalis*, nests primarily on the Arctic tundra from Alaska to Siberia, by way of northern Europe. The birds leave these regions at the beginning of the fall to head back south to their winter grounds, which are at fairly high latitudes themselves. In Europe, the birds spend the winter mostly on the Baltic and North Seas.

JUNE

7

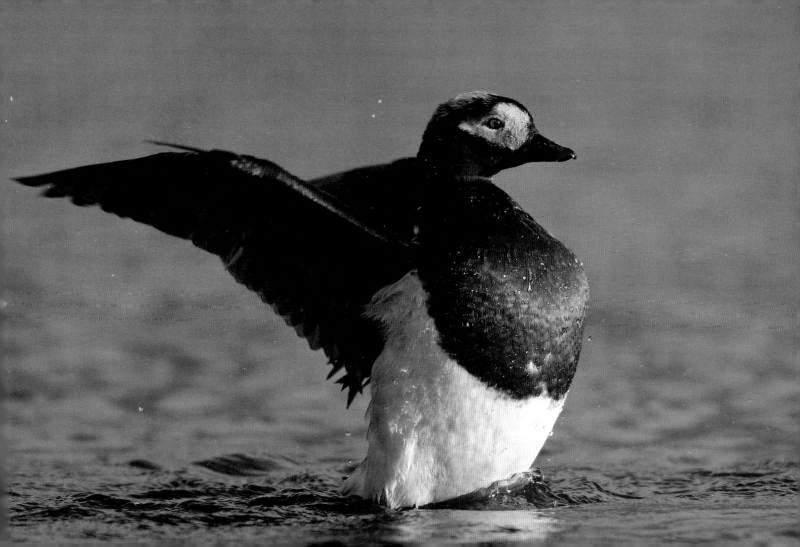

Osprey

This large Scottish loch is surrounded by a beautiful pine forest. A couple of red-throated loons swim on the water, which is smooth as a mirror. In the distance, the "drumming" noise of a snipe indicates the presence of a couple engaged in a mating display. Perched on one of the highest trees, an osprey preens. It is probably the male, while the female sits on the enormous nest that the birds have built in a large pine tree, and that they maintain from year to year. I can see it through my binoculars, or at least I see her head sticking out of the branches. She remains there, unmoving for hours as she sits on her eggs.

Later, I saw the male return with a big fish in his talons. He landed on the pile of branches and took her place. She, in turn, went off to stretch her legs and wings and to eat, on a branch not far away, the food that the male had brought her. But she returned quite rapidly to the nest, and the male then slipped away again. Given the date, the chicks must have been nearly ready to hatch.

The osprey, *Pandion haliaetus,* has an extremely wide distribution over the globe, and is present on all the continents. Eclectic in its choice of nesting site, it is equally apt to build its nest in a tree in the middle of the forest or on a scorching Saudi Arabian beach. In the temperate and boreal regions, ospreys are migratory; they are sedentary in tropical areas.

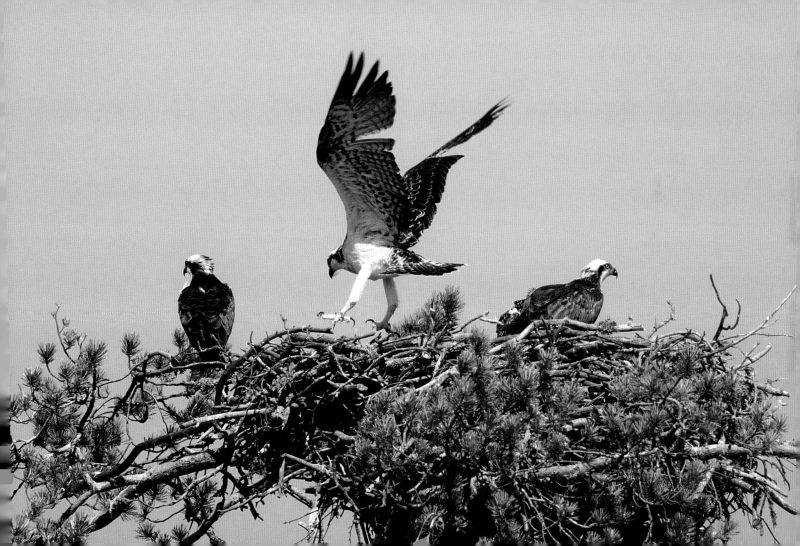

Common murre

Among the most incredible sights that birds can offer is the spectacle of an immense colony of seabirds. It is truly astonishing to see thousands of birds clinging to the cliff face, often perched on a outcropping barely an inch or two wide, sitting on their eggs shoulder to shoulder with their neighbors. And all this transpires amid a great chorus of calls, songs or, most often, sharp cries, given the many neighbors' quarrels among so many birds.

Along with the razorbill, the common murre is the least sophisticated of birds in terms of the materials of its nest. The female lays her egg right on the rock and incubates it between her legs. The egg is pear-shaped, which prevents it from rolling into the abyss.

Though the egg stays on top of the cliff, not so for the chick who hatches out of it. As soon as the baby bird reaches independence, it will throw itself from the heights of the cliff directly into the water. It does not yet know how to fly, and this is a quick way to reach the ocean water where it will spend most of its life. Inevitably, a bird sometimes misses the water and lands on the rocks at the foot of the cliff.

JUNE

9

Present in the Arctic regions, the common murre, *Uria aalge*, nests along the rocky cliffs that border the glacial oceans. Some populations nest farther to the south, as far as the British Isles and even Brittany, where the species still survives but has become very rare. As soon as reproduction is complete, the birds head back out to the open water.

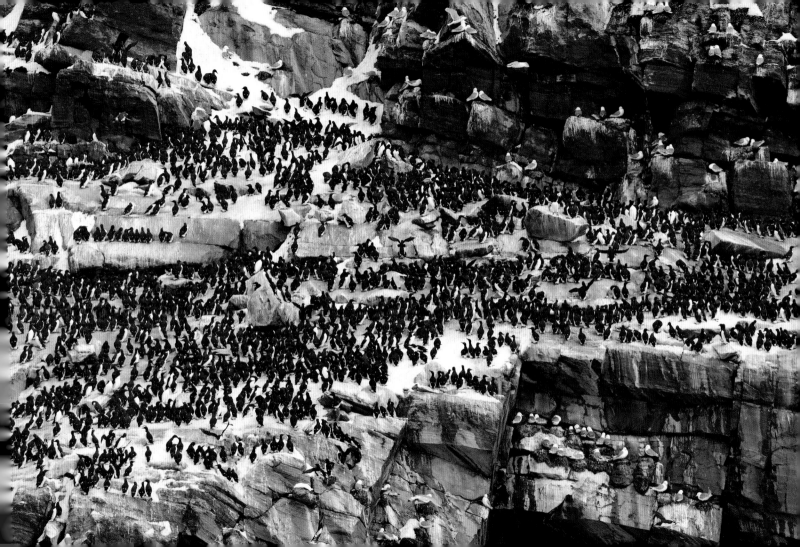

Black-crowned night heron

In closing my shutters this evening, I heard a slightly low *quack!* pierce the silence of the just fallen night. It was a night heron changing location. *Nycticorax*—literally, the night crow—is its scientific name. That word says it all. The night heron is indeed a heron with nocturnal ways. It fishes while the other birds sleep and sleeps while other herons and egrets pass their busy days in the swamp. This habit is, in the end, a fine way to attain a peaceful life.

To see the heron by day, you must go to the banks of a river or a swamp, where the tree branches lap the surface of the water. Under cover, eyes half-closed, a night heron dozes. Head shrugged into its shoulders, a little hunched up, this small heron—whose plumage is black and gray, as an adult—whiles away the hours. If it is disturbed, it will take off, giving a reproachful *quack!* The juvenile birds, with their black and gray stripes, are even more inconspicuous amid the tangle of river vegetation.

Seeing them like this, in their lethargy, one wonders what a frenetic dance they must perform by night to be so exhausted during the day.

The night heron, *Nycticorax nycticorax*, has a wide global distribution. It nests over most of the Americas, as well as in southern Europe and a large part of Asia. In Africa, it can be found nesting here and there, and the European birds also spend the winter on that continent.

JUNE

10

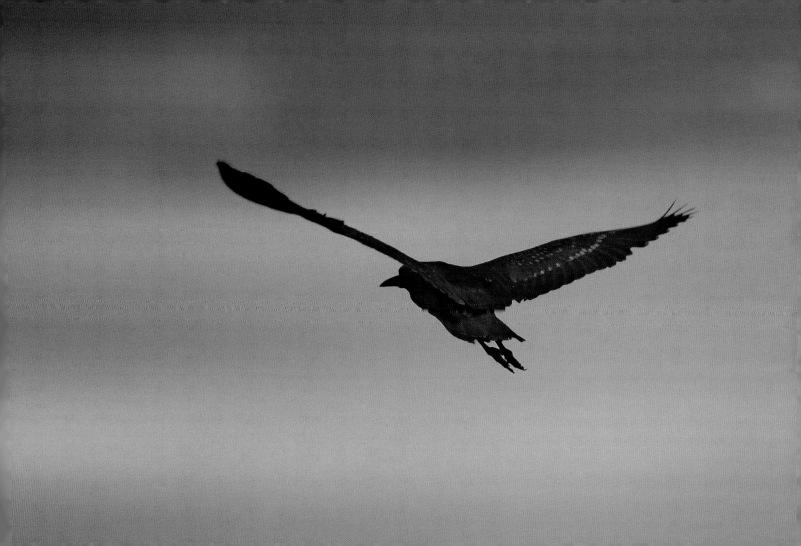

Whinchat

Some time ago, each big meadow in France's La Crau commune had its own little population of whinchats. Today, there is not one of the birds to be found here; no birds can be seen other than the corn crakes and marsh harriers that nest in the area.

Today, you may look for this little passerine migrator amid mountains of medium height. And yet here, too, the population has sharply declined. Low walls and hedges have been replaced by electric fences, which are hardly a good place to hide a nest. A migrator, the whinchat must brave the vicissitudes of long voyages. And once it does, it must endure the dryness of the Sahel in Africa and the destruction of some of its wintering sites. On top of all this, the changing climate plays a role as well. When the whinchat returns to European shores to nest, the caterpillars it normally eats have already transformed into butterflies.

No, the life of the whinchat is not a joyous one. Nevertheless, when the male, all in orange and brown, sings his heart out at the top of a blackberry bush to attract his mate, he brings great liveliness to the little mountain roads.

A very European bird, the whinchat, *Saxicola rubetra*, nests in temperate and northern Europe and spans as far to the east as western Siberia. It frequents prairie wetlands and swampy areas in the lowlands and much drier places in the mountains, with a particular fondness for meadows. It winters in tropical and equatorial Africa.

JUNE

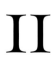

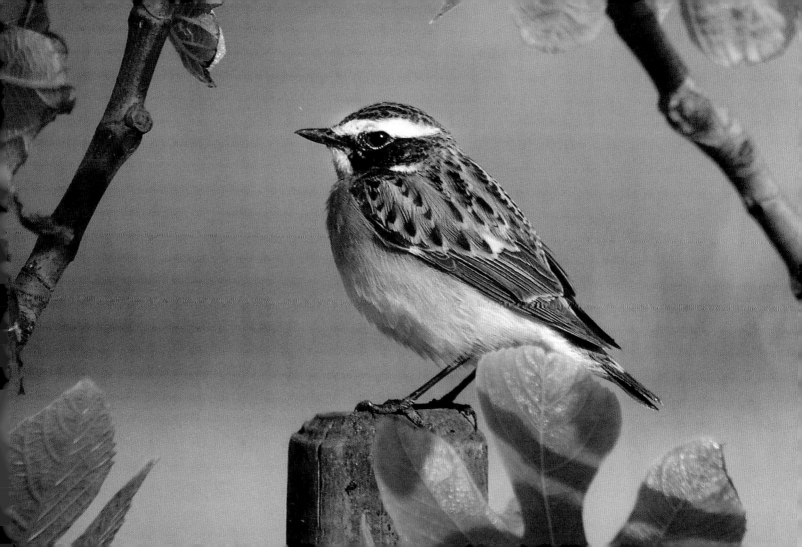

Ringed plover

At this time of year, the tundra is still clear of mosquitoes. You would be wise to seize the moment, for it will not last. Not long from now, it will be nearly impossible to walk here bareheaded without having your face swell to twice its normal size.

The ringed plovers care nothing for mosquito bites. The male has completed his little mating flight, an airborne circle in which he slowly flaps his wings and repeats his plaintive cry. Now, he comes to rest not far from the female. She remains crouched on the ground, totally still. The male bustles around her, passes on her right, on her left, spreads his wings, all while making soft calls of *pu-up!* Suddenly he mounts the female, who has not moved, and mates with her for several seconds. Then he comes down to earth again and shakes himself. The female still does not move. As if nothing has happened, the male trots back over the close-cropped ground, pecking here and there at anything that falls under his beak. I track him as he moves away, then I return to the female. She has deigned to rise and there she is, stretching her wings and legs. After shaking her feathers, she, too, departs to search for food on the vast tundra.

JUNE

12

The ringed plover, *Charadrius hiaticula,* is an occupant of the European and Siberian Arctic, where the great majority of the population nests. A small fraction nests farther to the south, around the Baltic Sea and North Seas, reaching even as far south as Brittany. Some populations winter in Europe, while others travel as far as South Africa.

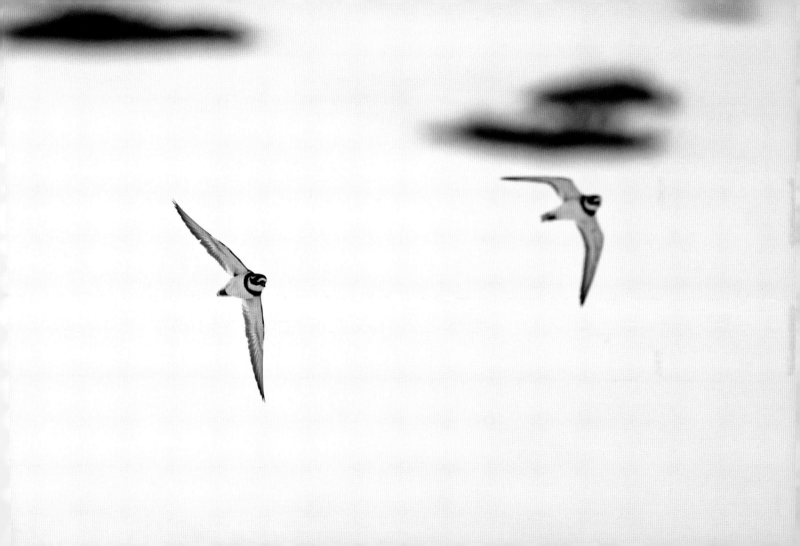

Mallard

The mallard is an omnipresent bird; there is hardly a body of water, no matter how small or urban, that does not have its couple of resident mallards. If there is a duck that everyone recognizes, it is this one. The mallard will eat bread out of our hands, and in its semi-domestic state, it displays an infinite variety of different plumages. One almost thinks of it as a domesticated animal, like the canary or the hamster.

But these flocks of wintering birds, landing on a half-frozen lake in the south of Russia, are mallards as well. Those birds taking off from a swamp amid a great hubbub of wings and calls may be mallards, too. (The mallard's famous *quack*, incidentally, is the exclusive domain of the female, while the male makes only a small stifled cry.) For the city duck that we know so well has its wild counterpart: the swamp duck.

So there are two different ways to think of the mallard. We are so used to seeing the bird in the slightly debased context of overcrowded parks that it may take the sight of a completely wild duck to remind us of the mallard's beauty.

With its very wide distribution, which extends across North America, Europe, all of Siberia, and into Asia, the mallard duck, *Anas platyrhynchos*, is the most common of the "dabbling ducks" (so called because they do not dive underwater with their whole bodies). The most northern birds are migratory, while those in the south are sedentary.

JUNE

13

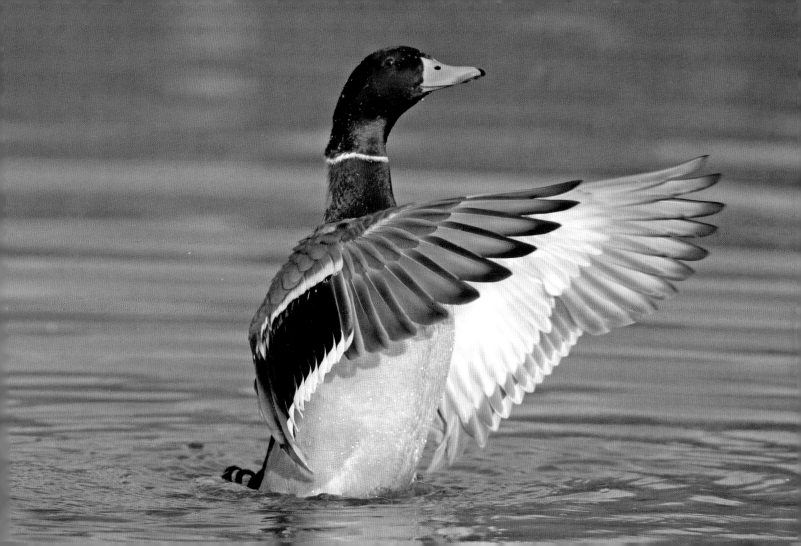

Peregrine falcon

In this early morning, the huge cliff seems deserted. There are only some stock pigeons that take off in a whirlwind and plunge into the valley, and a couple of jackdaws coming and going along the rockface.

All of a sudden, a shrill and powerful cry tears through the morning torpor. In the sky, a large falcon is returning, its substantial prey clutched in its talons. It is a female peregrine falcon, returning to feed her chicks. She flies straight toward her aerie, well hidden behind a small bush on the highest part of the cliff. With my telescope, I make out two chicks, still covered with down. One is larger than the other, but both throw themselves upon the prey that the female puts down for them. I can now see that it is a pigeon. Their mother begins to tear it apart and gives a beakful to each of her chicks. My fellow ornithologist calls to me. He has just spotted, a little farther off, perched nearly at the top of the cliff, the male surveying the scene (and us, too, no doubt). We are struck by his size; he is smaller than his companion. This is typical; male raptors are smaller than the females.

Two pigeons fly past, grazing the cliff. However, they have nothing to fear: peregrines do not attack their neighbors.

The peregrine falcon, *Falco peregrinus*, is found nearly all over the planet, except for Antarctica, but always with minimal density. Around the end of World War II, in fact, the species came close to disappearing over a large part of the northern hemisphere. The culprit was DDT, a powerful pesticide that thinned the shells of eggs. The peregrine is the fastest raptor in the world, reaching speeds of up to 200 miles (320 kilometers) an hour.

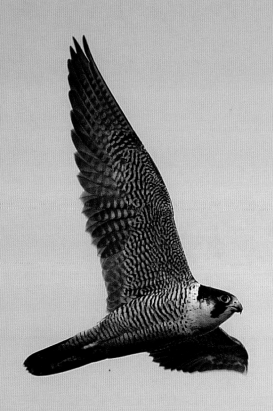

Black-eared wheatear

In the *garrigue*, or low-lying scrubland, of the Roussillon region of France, June marks a turning point in botanical life. Already, the orchids have faded and other flowers, too, are beginning to wilt. Among the birds, however, it is high season for incubation, feeding, and, for certain birds, romantic displays.

Perched on a block of limestone, a male black-eared wheatear, his beak full of insects, sounds a continuous alarm call of *tek-tek!* He is splendid, garbed in ochre with black on his wings, tail, and face. The nest must be somewhere nearby, so I step back a few yards—and he seizes the chance to fly off down the slope.

A few minutes later, I spot him again, as he hunts for food on the ground to feed his insatiable chicks.

Here, in the west of Europe, things are not going too well for the black-eared wheatear, a victim of changes that have interfered with its habitat over many decades. The abandonment of pasturing and subsequent reforestation of the plateaus are among the factors contributing to its decline. And what is happening, meanwhile, on the African land where it winters? So many questions occur to me as I observe the comings and goings of this wheatear, feeding its nestlings in all obliviousness.

The black-eared wheatear, *Oenanthe hispanica*, lives from the Iberian Peninsula in the west all along the Mediterranean coast and as far east as Iran. The birds are migratory, spending the winter in Africa as well as on the Arabian Peninsula.

JUNE

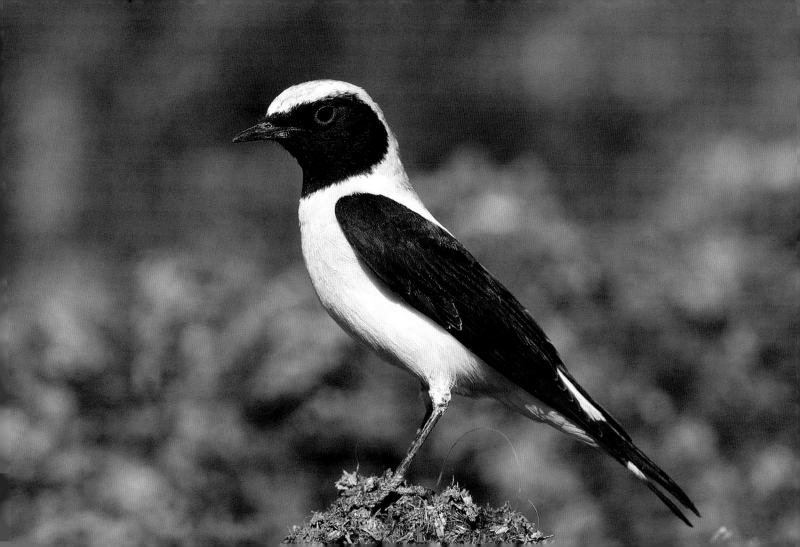

Sand martin

In the sandpit, a huge commotion reigns. A colony of sand martins has set up camp on the sandbank's steeply pitched face. The birds have dug a multitude of little tunnels, which are in fact their nests. The adults come and go without pause, for the rearing of their chicks is in full swing. If the youngest of the hatchlings wisely keep to the deeper recesses of the holes, the bigger chicks grow bolder, and one sees their little brown heads poking out of the cubbies and, with forceful cries, demanding their share of the food.

For the adult sand martins, there is no time to dawdle. They go hunting over the nearby pond and return with beaks full of insects. Barely have they unloaded their haul than they bravely fly off again, punctuating their flight with a rasping *chirrp!* They must be quick, since a big storm is rumbling in the distance. The insects will disappear in the rain, and the birds will have to wait for long minutes, taking shelter at the back of the sand tunnels in the company of their young.

For the moment, the dozens of birds circle and trace coded messages in the sky, designs whose meaning is known to them alone.

JUNE

16

The sand martin, *Riparia riparia*, is found on the Asian, North American, and European continents. Their nests are never far from water. The European populations winter in Africa, the North American birds in South America. The European martins can be badly affected by drought, endemic in the Sahelian region where they winter.

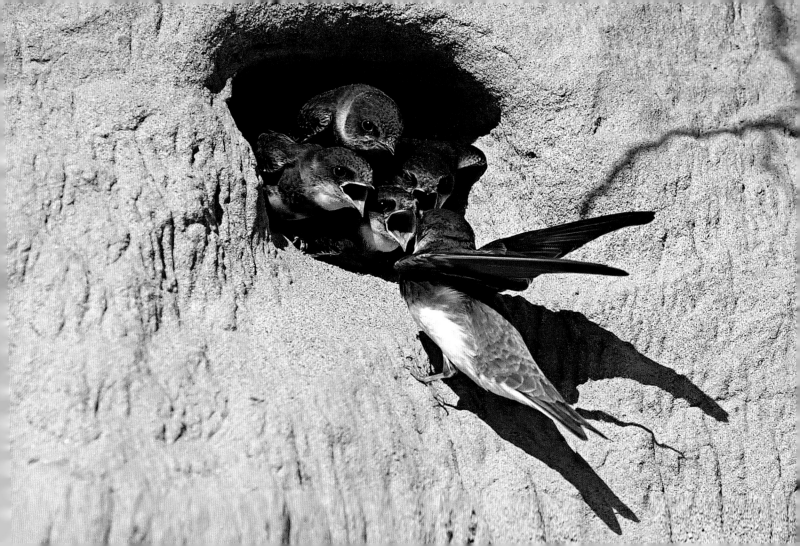

Ross's gull

For ornithologists of the northern hemisphere, Ross's gull is one of the mythic species that you have to see before you die. Confined to the High Arctic, in places inaccessible to common mortals, Ross's gull is not easy to observe. Fortunately, from time to time, some individual gull gets the bright idea to come wandering into more southern latitudes. Thus New Jersey, Ireland, Brittany, or the Dutch coast may at times experience a migration of ornithologists, who come hurrying over when they hear a Ross's gull has landed there.

I first saw this gull in northern Canada, near the town of Churchill, where the species had nested. We had heard that one of the birds had been spotted in the neighborhood, and waited nearly a day at the place where it had supposedly been seen. It did not return that day. It was only the next day, barely a half hour before our plane left, that the Ross's gull deigned to reveal itself.

If you hope to see the gull, the Siberian Arctic is the best place to go. But even there it is not so easy since, thanks to global warming, the tundra where the Ross's gull nests is receding as the forest advances.

JUNE

17

The Ross's gull, *Rhodostethia rosea*, nests at points in the Siberian tundra, in Greenland, and in the extreme north of Canada. It winters in the cold waters of the Pacific, between Alaska and eastern Siberia. The adult is rosy white with a little black collar.

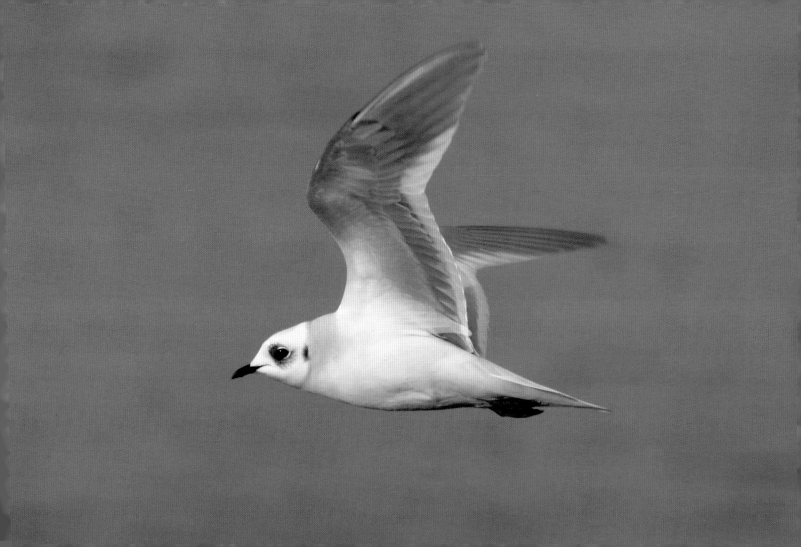

Marsh warbler

Among the long-distance migrators who fly back north to nest in spring, the marsh warbler is one of the latest to arrive. The birds are not seen back in Europe until well into the month of May, or even into early June in northern areas. As soon as the male reaches his future nesting site, therefore, there is not a moment to lose. Off he goes with his vocalizations, singing to attract a female.

The marsh warbler is a famous singer. It's not that it has a particularly remarkable voice, like the nightingale, for instance, but it is an imitator beyond compare. Researchers have found that the marsh warbler can imitate dozens of other birds. It can even mimic the cries of various tropical species from Africa, where it spends the winter. It puts on an astonishing performance—but one that our human ears may find it difficult to fully appreciate, since most of us westerners are hardly familiar with all the sounds made by African birds!

Perched at the end of a branch, the marsh warbler, with its drab brown feathers, delivers a message in a southern language completely unknown to us.

JUNE

18

The marsh warbler, *Acrocephalus palustris*, is found principally in northern and eastern Europe. To the east, its range spans as far as Iran and western Siberia. In the fall, all the birds leave for East Africa. The warbler nests in damp places, but also needs access to bushes and shrubs.

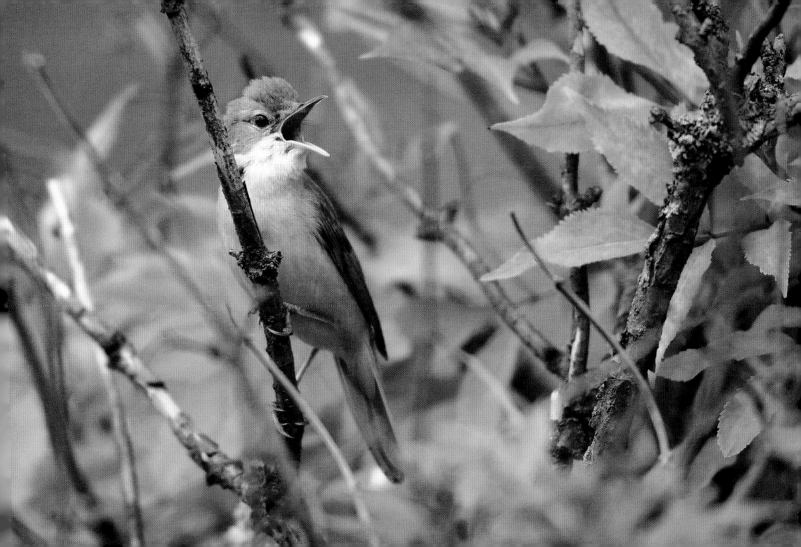

Harlequin duck

Birds sometimes have odd names. The name of the harlequin duck, for one, is intriguing. Certainly the "duck" part requires no explanation, but why "harlequin"? Once you see the male, it all becomes clear. Here is a bird that has put on the costume of a Harlequin. Even if his plumage does not precisely match the diamond pattern of the famous clown of the commedia dell'arte, the male duck's red-brown, black, white, and blue feathers irresistibly call the character to mind.

The place where it nests, however, is far removed from Italy. To see this duck, you must go and search along the tumultuous streams of rural Iceland, Canada, or Siberia. And you must be very patient, as you brave the solitude of these remote places and their mosquitoes. For even with its vivid plumage, the male harlequin is discreet. It does not show off its plumage, shimmering with multicolored fires, any more than the female flaunts her coat of sober brown.

As soon as reproduction is completed, the birds leave the rushing rivers and return to quiet lakes or, in winter particularly, to large estuaries or sheltered bays. This is a good time to observe the harlequin duck if you live in North America or Iceland.

The harlequin duck, *Histrionicus histrionicus*, breeds in Iceland, in Greenland, and in eastern Siberia. Migrating over short distances, they may be found in winter on the Pacific coasts as far south as Japan. The Icelandic birds are resident, while the population from Greenland spends the winter on the northeast coast of North America.

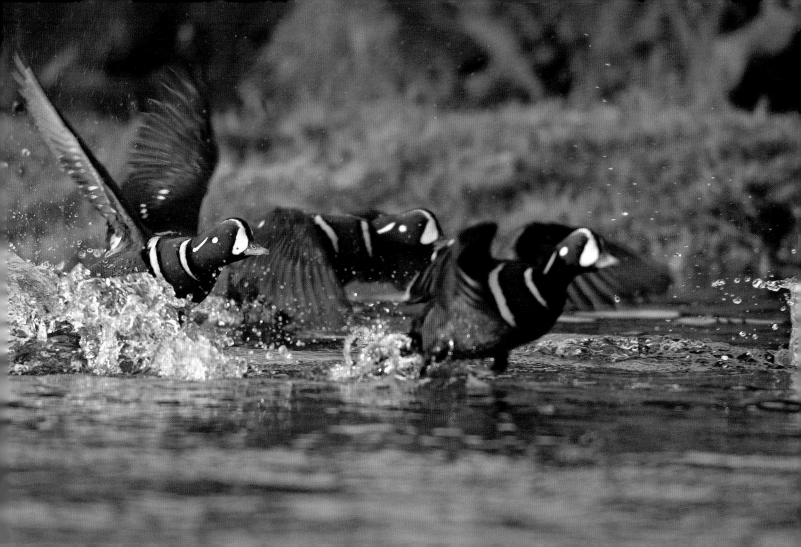

Corn crake

The corn crake is one of a long list of species threatened with extinction, a list that grows longer day by day. Unlike some birds, the corn crake does not find itself in this position because it is too exposed to humans. Indeed, if it is possible to hear the corn crake (though one can depend on it less and less), catching sight of it practically requires a miracle.

In the wet meadowlands of the Charente valley, this part of June is the best time to go out at dusk to look for the corn crake. Its scientific name—*Crex crex*—is a fairly good transcription of its song. Or you can run a fingernail down the teeth of a comb, and you will also get quite a good imitation of its voice. With the regularity of a metronome, perfectly hidden in the tall grass, the corn crake "sings" like this for a good part of the night. And you might count yourself lucky simply to hear it. Sometimes it also sings during the day, but it has a talent for wriggling away as soon as you try to get near it. You hear it in one place, go there—and then, nothing. A minute later, there is its song again, coming from two hundred yards away.

Aside from this endless game of hide and seek, the future of the corn crake, at least in Western Europe, is dark. The natural meadowland is disappearing from view, and the haying season comes earlier and earlier. How long will the corn crake's *crex crex* be heard?

Spanning from Western Europe to central Siberia, the range of the corn crake, *Crex crex*, continues to retreat in the west. The bird, also called the landrail, is migratory and winters in tropical Africa.

Lesser yellowlegs

It is impossible to seal out the mosquitoes in the Canadian boreal forest. They are fazed by nothing, and will slip through even the tiniest fold in your clothing. At the edge of the impenetrable pine forest is a swamp, whose stagnant water is a strange, rusty color. At the top of a tree, a longlegs is perched and delivers its song, an insistently repeating *tiu…tiu…tiu!* Evidently, the bird is not much of a soloist. But like all small shorebirds, it is not famous for its song. They leave that to the passerines.

The bird takes off from its tree, makes a swooping flight, and goes to land on a pond swarming with mosquitoes. It turns its attention to eating, and soon I see its long, bright yellow legs. They stand out strikingly in this brown and green landscape. In the time it takes to kill one more mosquito, the bird has disappeared. It has no doubt slipped off to join the female, who is likely sitting on her nest not far from here. And who is, naturally, quite indifferent to the thousands of mosquitoes swarming around her.

The breeding ground of the lesser longlegs, *Tringa flavipes*, is found in the Canadian Arctic, where the bird favors the edges of the forest and wooded swamps. A migrator, it leaves its northern territory in the fall to fly down to South America, even to the most southern parts, for the winter.

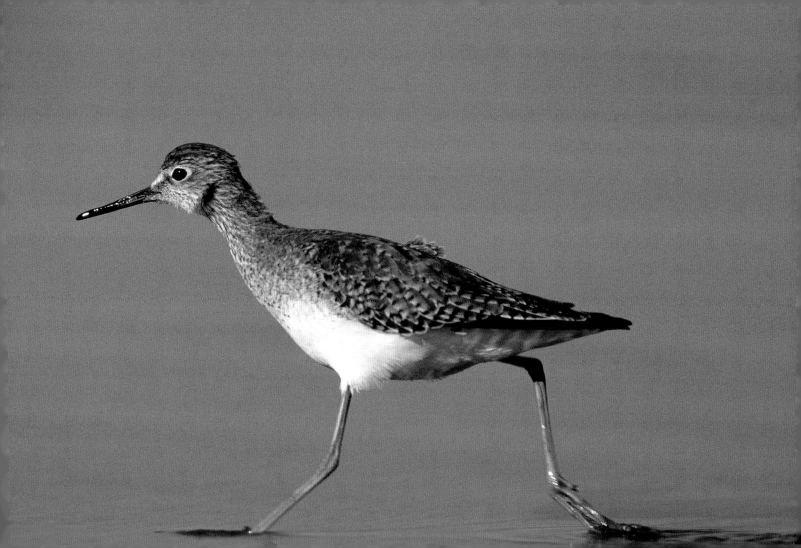

Whiskered tern

The pond is covered with big water lilies. Here, a couple of black-necked grebes quietly weave a path among the broad leaves, followed by two chicks like balls of black feathers. Some broods of mallard ducklings forage in the vegetation at the pond's edge, while a marsh harrier patrols above the swamp.

Like large butterflies patterned in gray and black, a group of birds hunts ceaselessly over the water. These are whiskered terns, a freshwater bird. In search of insects, they race endlessly over the surface of the pond and congratulate themselves from time to time with a brief *hurx!*

A couple of the birds are standing on a lily pad. This is where they have built their nest. The male, eager to please, has returned with a small fish that he gives to his female companion. Next to them, their neighbors are slightly ahead, and one of the adults is already sitting on the nest. There is in fact a great bustle afoot on the lily pads, and I eventually note that in total several dozen couples have settled on these floating rafts. In a short while, the chicks will be born and, all of a sudden, the colony will become noisy, the adults calling and responding to the chirping of the hatchlings.

The whiskered tern, *Chlidonias hybridus*, nests from the Iberian Peninsula to eastern Asia. It winters in Africa and Asia. It has benefited from global warming, as it extends its range toward the north. At the same time, it suffers from the disappearance of ponds rich in marsh vegetation, which are increasingly being turned into fish farms.

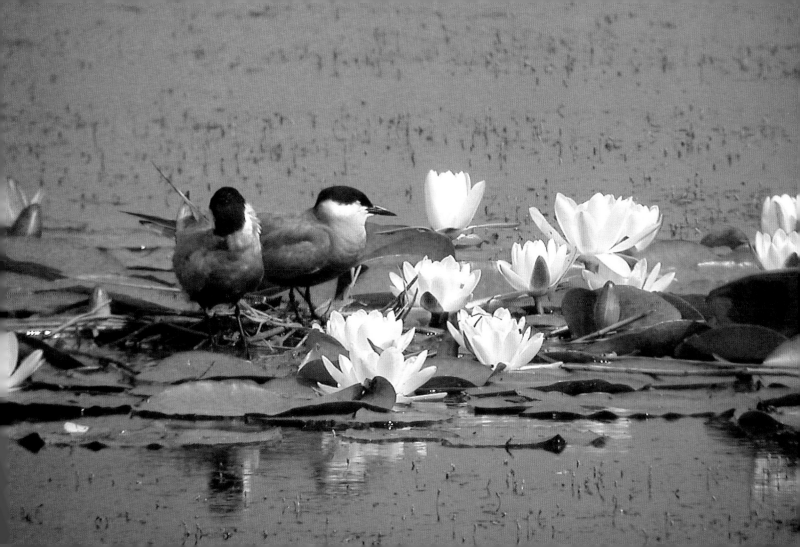

Great northern loon

The night has been cool, at the edge of this lake in northern Alberta, in Canada. Well before dawn, we were wakened by the noise of some distant ethereal wailing. The couple of great northern loons that we spotted yesterday evening are already making their calls. In the pure air of the pre-dawn morning, their strange call echoes high above the pine branches.

A little later, as we emerge from our tent, we find the couple not far from the bank, two dark shapes gliding over the mirrored surface of the water. Deeply sunk into the water, the birds glide away from us, watching us carefully. It is impossible to make out any details of their plumage; they are simply two ghostly silhouettes that sink into the mist forming at the surface of the lake.

Many years later, I came across dozens of northern loons, wintering in a sheltered cove of Bodega Bay in California. And I could not help imagining that these birds might have come from those thousands of lakes deep in the Canadian boreal forest, far from everything and especially from humankind.

The great northern loon, *Gavia immer*, nests along the boreal belt, from Siberia to Canada, as well as in Iceland. The Iceland birds spend the cold season in the waters of northwest Europe, but many other northern loons winter in the north Pacific and on the east coast of North America.

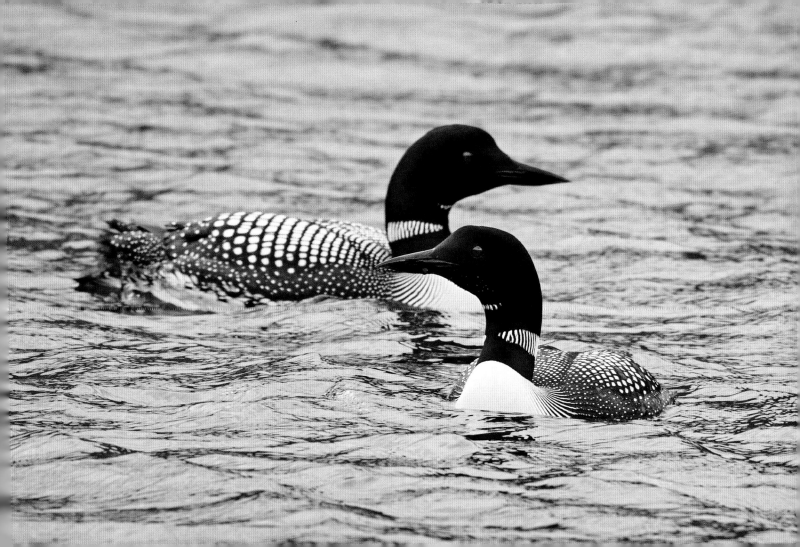

Snowy egret

Just past the sand spit of the barrier island, on Long Island, in New York state, the marshes overflow with waterbirds. Here, a little group of black skimmers shear through the water with their enormous lower mandible; there, the sandpipers peck through the silt. With measured steps, neck extended and a vigilant eye, the snowy egret inspects the shore, where the water laps at the saltwater plants. Sometimes, it stops abruptly, extends its neck even a little longer and lowers it toward the surface, freezes—and moves on. The prey must have run off too quickly. The egret continues its slow promenade, always on the lookout. You need not wait long to see it fold up its neck like a spring, strike the water, and, in a split second, seize a small, wriggling fish. The fish doesn't suffer for long, for the egret swallows it immediately.

Such is the life of the snowy egret. In the course of its walk and its search for prey, it advances across the marsh and away from us, as we stand transfixed by its patience and determination.

JUNE

24

The snowy egret, *Egretta thula,* lives in North and South America. It is found from the center of the United States down to Chile. They are generally very sedentary, with the most northern birds moving a bit toward the south in winter.

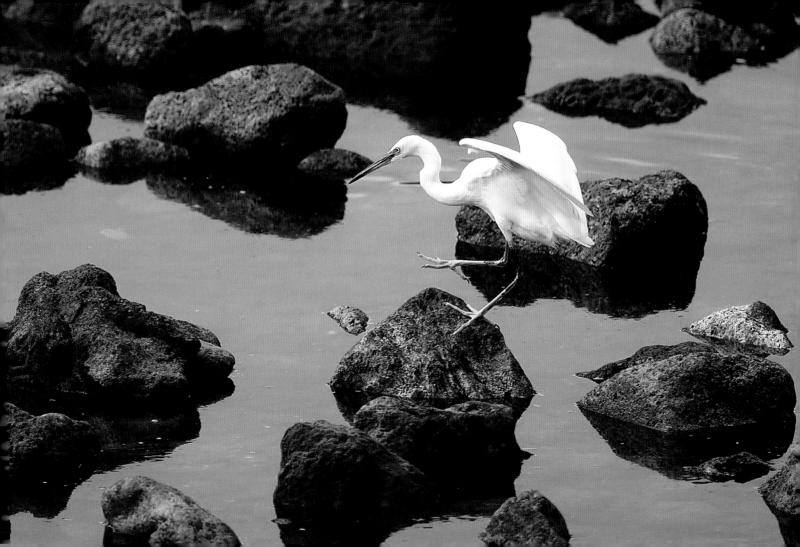

Common rosefinch

Its song is unforgettable, and the English have aptly transcribed it as *pleased to meet yoooooouuuu!* Returning well after the stream of spring migrators from southeast Asia and India, where it winters, the rosefinch settles rapidly into its future breeding site. And the male strikes up his refrain, which he will not abandon until the end of July. The adult male, who wears beautiful red markings on his belly, chest, and head, is a flirt. At first, he perches well in view at the top of a willow; then, he instead conceals himself deep under cover. He may well gratify us with dozens of cries of *pleased to meet yoooooouuuu!* in a row, or he may remain silent for hours on end. So as not to be frustrated, it's best to go see the rosefinch where it is common, which is to say in northern and eastern Europe—not to speak of Siberia. But if the adult male is easily recognizable, you must look closely for the female and the immature male. With their striped gray plumage, they look like nothing much at all and can easily be confused for a female sparrow.

The geographic range of the rosefinch, *Carpodacus erythrinus*, is vast. It stretches from the middle of Europe to central and eastern Siberia. In the 1990s, the species pressed a little into Western Europe and nested, for a dozen or so years, in northern and eastern France. But today this adventure seems to have ended.

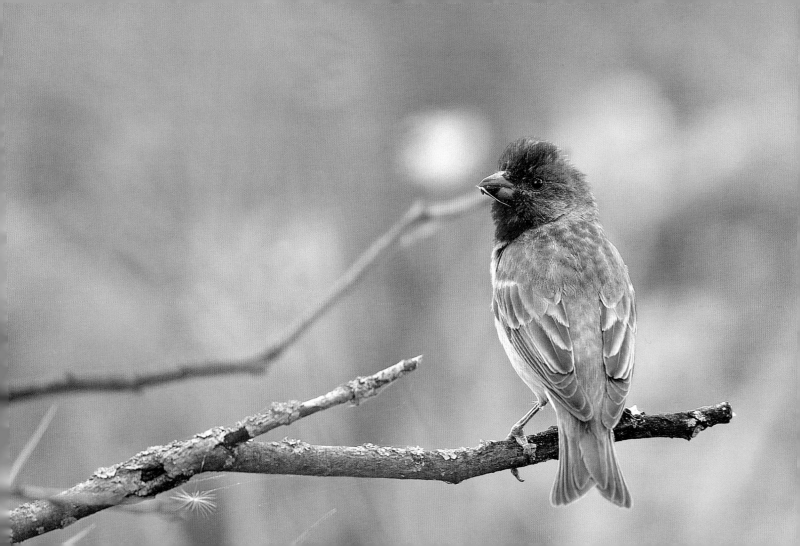

Long-tailed skua

We have been walking for at least two hours through the Canadian tundra—and not without difficulty. We pause only barely long enough to catch our breath, taking the opportunity to watch a snipe making its display. And then we are off again, putting one boot before the next and praying at each step that we will not fall into a hole … And since it never rains but it pours, here are a couple of long-tailed skuas, whom we have no doubt disturbed, coming to scold us with piercing cries of *kriie!* Nor is it enough for the male simply to try to burst our eardrums. Here he comes diving down to peck at us, in a kamikaze attack, grazing us so closely that we are forced to cover our heads or risk getting a bad slash in the scalp. He dives, crying all the while, strikes our hats with his beak, and makes a quick sally that suddenly propels him 45 feet (14 meters) overhead. So things go until we leave the place. Meanwhile, having fallen into a hole we did not notice, we find ourselves with boots full of water. And to top it all off, if this causes us to forget the mosquitoes for a moment, they, for their part, have not forgotten to bite us!

JUNE

26

The long-tailed skua, *Stercorarius longicaudus*, is distributed across the area known as the circum-Arctic. It nests on the tundra belt of North America, Europe, and Siberia. A great migrator, it winters in the sub-Antarctic waters off the coasts of Africa and South America. Like all skuas, the species feeds parasitically, eating food caught by other birds.

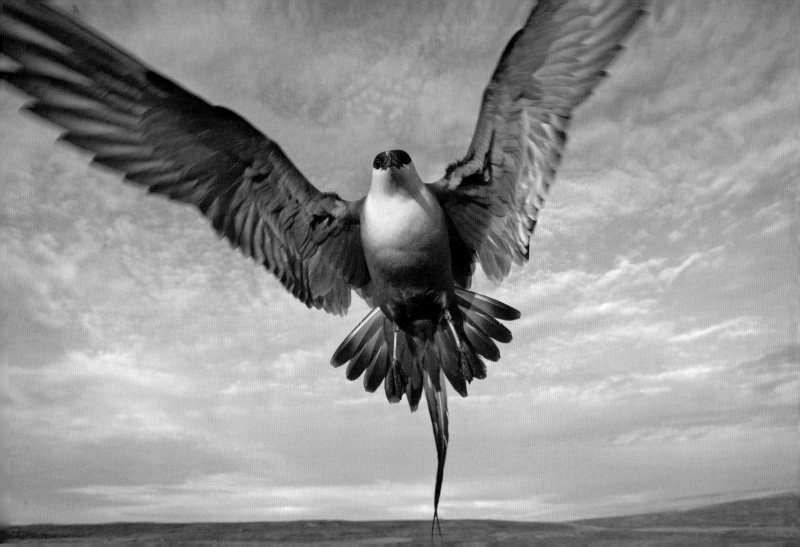

Eurasian stone curlew

The moor has taken on the colors of evening. We are posted at the foot of a bush, well hidden, waiting for the stone curlews to show themselves. Nocturnal birds, they do not become active until most other birds have gone to sleep. In the silence of the setting sun, a fluting and sad call rises over the moor. A drawn out, slightly trembling cry of *couourlii!* The curlew is named for a approximation of the sound of its cry.

A bird is watching us and goes to land not far away. With the binoculars, one can see it staring at us with its large round eye, which allows it to see well in the dark. A little hunched, as always, it makes a few steps and begins to peck the ground. Soon, a second bird arrives and goes to stand close to the first. They are, no doubt, a couple. Although we can hardly see a thing, we hear the male, who must have taken off to survey the great expanse, giving its wistful cries. There are only crickets and grasshoppers, along with a distant nightingale, to answer him. In the early hours of night, the stone curlew punctuates the shadows with its sad and mysterious cry.

From the Limicoline family of small wading birds, the stone curlew, *Burhinus oedicnemus*, is a rare nocturnal species. By day, it remains well hidden on the ground. Occupying a large part of the southern portion of Europe, the birds are, for the most part, migrators, but they hardly ever travel farther than North Africa and the Middle East.

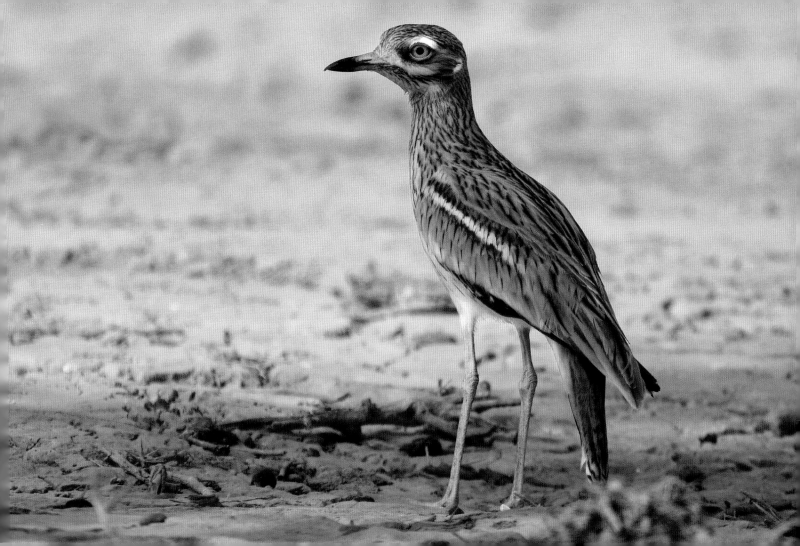

Whooper swan

For many Western European ornithologists, the whooper swan is a winter visitor, one that favors the crop fields and pastures of the region in numbers that swell depending on the harshness of the season.

So it is always surprising to see this beautiful white bird again when you travel into more northern territory, but now floating on a lake in full summer. Here, in Norway, a couple has built their nest between tundra and forest, on a lake lined by reeds. The female sits on the nest, well hidden in the vegetation, while the male serves as lookout, near the lake's edge. Now and then, it makes a resonant *whoop!*—which gives it its name.

I have seen the whooper swan in many different contexts. In Mongolia, for instance, it favors the saltwater lakes of the steppe, which is far from the boreal tundra but offers a similarly desertlike environment. Among all the swans, no doubt because of its haughty bearing and strange calls, it is the one that seems most wild. Not for nothing did Europeans formerly refer to it as simply the "wild swan."

JUNE

28

The whooper swan, *Cygnus cygnus*, is found in the northern parts of the Old World, from Iceland to eastern Siberia, but also in central Asia, as far as Mongolia and China. The birds flee the cold and frost in the fall and move toward the south, though without crossing beyond the Mediterranean.

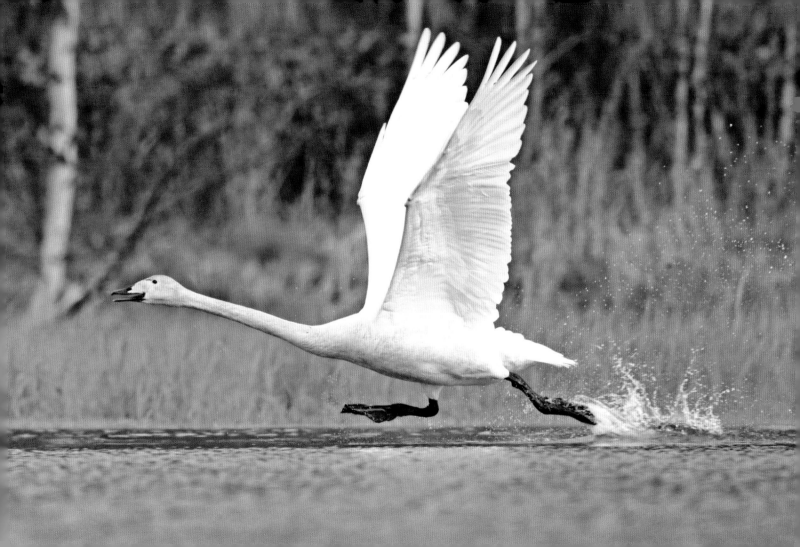

Black-legged kittiwake

June is the ideal month to see the black-legged kittiwake in its nesting grounds. This pretty gull is very gregarious, and prefers to reproduce among its fellows. It nests in large colonies, clinging to the steep face of the cliffs. As tightly packed as sardines, the couples build their nests mostly from dried seaweed, grass, and plants. The birds that sit on the nests pass their time in neighborly squabbling. With strong blows of their beaks and nasal cries, the kittiwakes insult each other. At worst, a bird thrown off balance takes off from the cliff, then quickly circles back. These turbulent relations last as long as it takes the kittiwakes to raise their young. And woe to the fledgling who unwisely places a foot on a neighbor's turf. The result will be an immediate sharp thwack of the beak from one of the adults nearby.

In a month, the colony will suddenly fall silent again. Parents and young alike will have left these sites and set out, for a period of long months, on a life of wandering the high seas, mainly on the Atlantic.

The distribution of the black-legged kittiwake, *Rissa tridactyla*, follows the rocky coasts of the northern hemisphere. It often nests in mixed colonies in the company of auks, penguins, and cormorants. The kittiwakes spend the rest of the year at sea, living out on the open water.

American avocet

On the lagoon that borders the Pacific Ocean, in southern California, the avocets have set up their colony. The nests are strewn across the silty edge of the lagoon. As one adult sits on its four eggs, the other endlessly strides through the shallow water in search of the tiny invertebrates that these birds eat. Chopping the surface with its upward-curved, saber-like beak, the avocet thus advances, "sweeping" the water before it with lateral movements of its neck.

A buzzard has ventured into the area, and surveys the colony. As soon as it reveals itself, the majority of the birds take off and pursue the imprudent raptor, scolding it and filling the air with the *klut…klut…klut!* of their indignant cries. Their dance through the air is lovely to behold, but the sun beats down fiercely, and soon the birds give up, settle back down to earth, and return to their nests to continue their brooding. The buzzard is already far off. But it will surely come back to prowl as soon as the chicks are born. Until then, this interruption has at least given the adult avocets a chance to switch places. And the bird who was just sitting on the eggs can now go refresh itself with shrimp and other tiny beasts from the brackish water.

As its common name indicates, the American avocet, *Recurvirostra americana*, is found only in the Americas, from the south of British Columbia down into Mexico. In the winter, it is found primarily in Mexico, Florida, and California. It is the American cousin of the pied avocet, which fills a similar niche in the Old World.

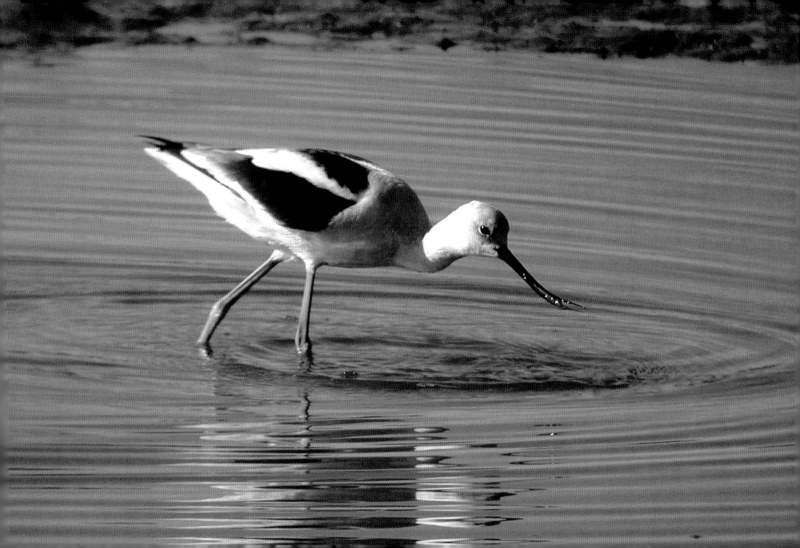

Common quail

At this time of year, the wheat is high and close to maturity. After dinner, we go out to walk along the country roads, just to smell the evening air. A lark is still singing in the sky. A corn bunting chimes out its trilling notes. A little farther on, without revealing itself, the quail repeats its song, which is sometimes translated as *wet my lips! wet my lips!* The quail is one of those species that you can never count on seeing. It is at home in fields of grain, creeping through the rows of wheat. But it rarely shows itself, and, in the great majority of cases, you must be content simply to hear it.

If you do want to see the quail, your best chance is during its migration. After its nocturnal voyage, it lands wherever it can: in a meadow, in a bush, on an oasis. With luck, if you walk slowly, you will see a little bird take off from underfoot, in a direct and noisy flight, and land again in some thick tangle of vegetation, always very far from the observer.

Closely related to pheasants and partridges, the common quail, *Coturnix coturnix*, nests throughout Europe, into central Siberia to the east and North Africa to the south. The birds of North Africa nest very early in the season, and some individuals fly back north toward Europe after breeding. That is why in some years we encounter "invasions" of quail in June and July.

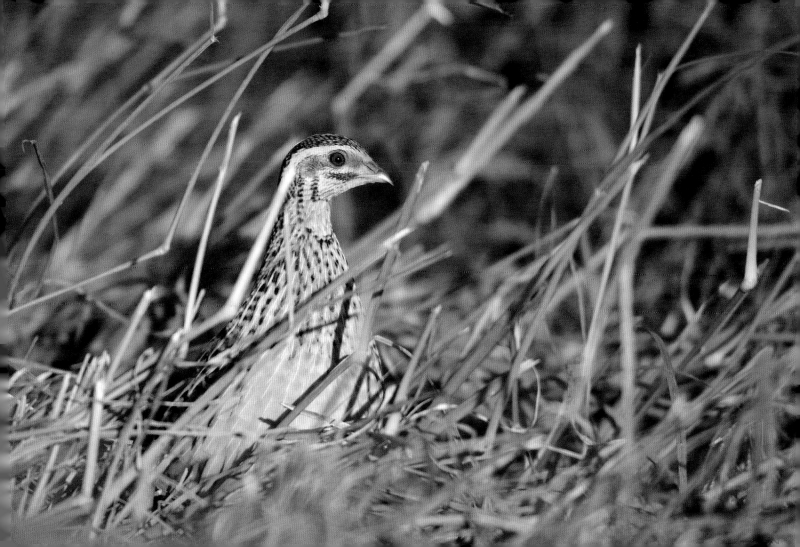

Red-throated pipit

O nce again, our steps lead us toward the Arctic tundra, which is so rich and abundant with life at this time of the year. You have to be quick about it, for the show lasts no longer than a month and a half. In barely a few weeks, the cold and snow will stage a return.

For the moment, we are observing a male red-throated pipit who is singing his lungs out in front of us. Perched on a fence post, near the edge of the sea, he registers his alarm, proclaiming loudly and forcefully that we are on his territory. Already back here for the last month, he must, like the other pipits, raise his brood quickly. No doubt the female is brooding or the couple is already caring for their young. We are able to get closer to the bird and see for ourselves that, as his name indicates, he has a beautiful salmon-pink throat; the color descends as far as the top of his breast before fading into the black striations of his belly. Here, we are able to observe the bird at leisure, which is not always the case during migration. During the birds' rapid passage across Europe, they have a knack for taking off from underfoot, giving a long, high, and searing cry as they fly far away. Here at home in Lapland, however, they are much more cooperative.

The red-throated pipit, *Anthus cervinus,* nests in the northern European and Siberian tundra. It is a long-distance migrator, and travels to spend the winter in Asia and tropical Africa. When it passes through Western Europe, it may often be observed near water, and more easily observed in spring. But it is always seen in small numbers (it tends to migrate more toward the east).

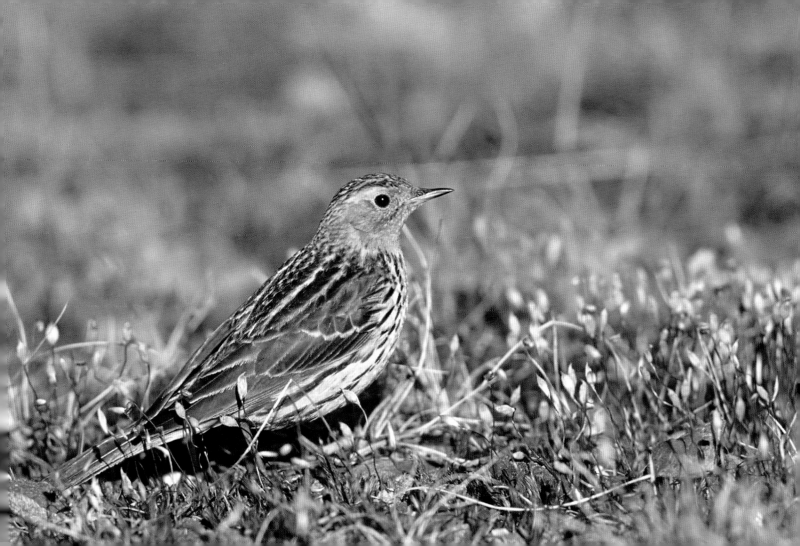

Lesser black-backed gull

For several years, I have gone to tag lesser black-backed gulls in the north of France, using colored and numbered rings that allow us to trace the birds through the course of the year. Like other species of gull, this one is a migrator that may travel as far as Africa, while its more common cousin, the herring gull, is satisfied with much smaller displacements.

In the colony where we are working, our arrival to tag the chicks provokes strong indignation from the parents. Cries, alarms, pecks on the head: the gulls deploy every dissuasive tool in the avian arsenal. It is something of a waste of time: we are fully prepared for the attack, including the droppings that they seem to take malicious pleasure in letting loose on our heads.

When we capture a young bird to put on its nice colored tag, it's impossible not to think of the place where it will have built a nest in a few months. In some port of Asturias? Somewhere in the south of Portugal? Farther still, along the Moroccan coast, even to the shore of the western Sahara, on a beach deserted but for the presence of hundreds of fellow gulls? In this moment, we touch for an instant on the marvelous mystery of migration.

The lesser black-backed gull, *Larus fuscus*, nests for the most part in Europe and on the Siberian coast, as far as the Taimyr Peninsula. Depending on the particular population, the species may be almost completely resident (Brittany, southwest Great Britain), or a long-ranging migrator (like the birds of Siberia, which fly to tropical Africa).

JULY

3

Bearded vulture

On the slopes of Monte Cinto, in Corsica, we had walked a long way, perhaps even dangerously so, since we had gotten lost. But as we moved closer to the summit, we felt repaid by our first sight of the bearded vulture—the bone breaker—when an adult flew over us at fairly low height, then slowly glided along the slope to disappear behind a ledge. Since then, I have had several occasions to see this large vulture again, in locations from Turkey to the Himalayas, where it is much more common than in our European mountains. And I always remain fascinated by this bird of prey, which feeds primarily on the marrow of dead animals. It takes a bone and rises into the sky, then lets the bone fall to crack open on the rocks below, waiting until the bone breaks so it can eat the inside. There is a theory that the Greek dramatist Aeschylus—who is famously said to have been killed by a tortoise falling on his head—may have been killed by a bearded vulture who mistook his head for a stone.

In the dance of vultures that occurs around an animal that dies in the mountains, the bearded vulture arrives last, when the carcass has been almost totally picked clean. It seizes the bones and flies off to let them shatter against the rocks—in solitude, and with hardly a flap of its wings.

JULY

4

The bearded vulture, *Gypaetus barbatus*, is found in the mountains, from the Iberian Peninsula to the Himalayas. In the Alps, where humans had hunted it into extinction, a small population has been successfully reestablished since the 1990s. The species is sedentary and hardly moves from its vast breeding territory.

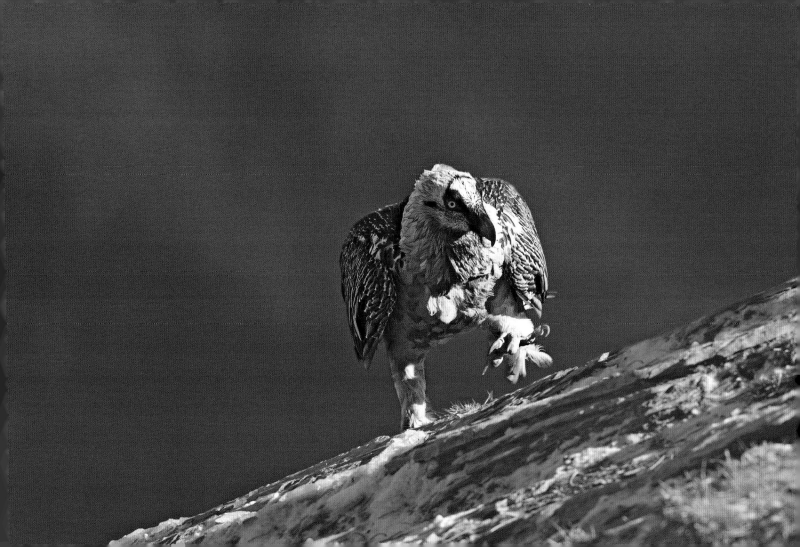

Lapland longspur

I enjoyed what probably was my most beautiful summer sighting of the Lapland longspur in the remote Aleutian Islands. It was there, in any case, that I have seen the bird in the most significant numbers. The longspur lives in the green meadows there that slope down steeply from the cliffs. Despite the frequent fog, even at this time of year, and the difficulty of walking in this wet area, I had little trouble finding several couples billeted on the deserted little island where my scientific expedition had taken me. The male, with his beautiful red scarf, sounded the alarm repeatedly, perched on a little rock covered with lichen. The female was not in evidence, and was no doubt sitting on her eggs. As I approached, the anxious *triu!* of the male came faster. He was saying to me, "Get lost! Get lost!"—that much was clear. I retreated slowly, hoping to see either the female or the chicks, if they were hatched already. After flying around me, the male had taken up his place again on the rock. Farther away, I heard other males giving their cry of alarm. These birds, I realized, were absolutely everywhere, and my intrusion was not to their liking at all. It was time to leave the island.

The Lapland longspur, *Calcarius lapponicus*, frequents the circum-Arctic tundra in summer. It reproduces here, but does not remain in the area otherwise, and as soon as the end of the season comes, it heads south again. But it does stray beyond the latitude of the Vendée in Europe and the central United States.

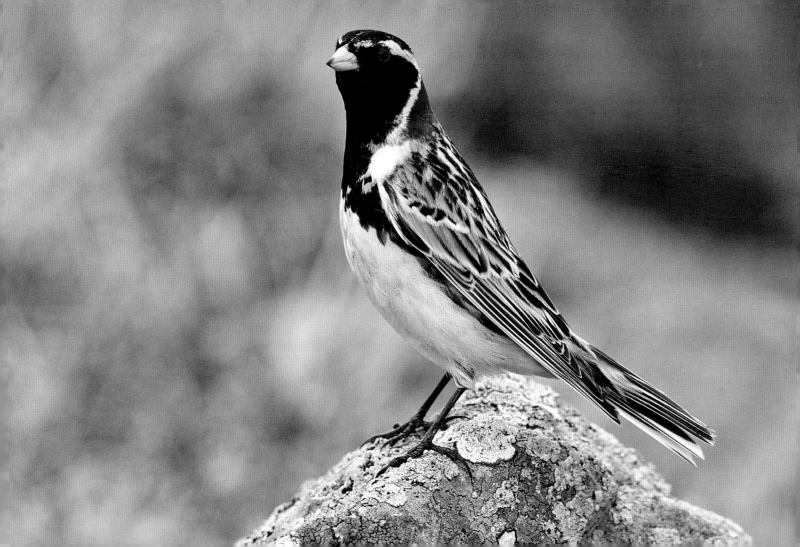

White-winged snowfinch

The best place to see birds at this time of year is in the tundra or the mountains. The birds are fully in the swing of their breeding season, and one can observe them more easily, since the presence of the chicks makes them more visible.

In the Alps, hiking in the mountains above 6000 feet (1800 meters) allows you to see the white-winged snowfinch. Despite its name, the species is not closely related to the finches but to the sparrows. It takes time and patience to find the secretive snowfinch among the stones, as it ambles around in search of insects for its chicks. But once you have spotted it, all you have to do is follow and wait for it to take off. Then, suddenly, you see its spread wings boldly marked with white. This makes them very visible, though seconds earlier the bird could hardly be distinguished at all, so well did its brown, gray, and cream plumage blend into the environment.

Later in the season, when the cold moves in at the mountain heights, you can return to these places. And, with a little luck, you may stumble on a small flock that has assembled here before descending toward the valleys to find shelter and cover better adapted to the winter conditions.

JULY

6

A dweller in the high mountains, the white-winged snowfinch, *Montifringilla nivalis*, does not hesitate to settle as high as 15,000 feet (4500 meters) above sea level during the summertime. Starting in fall, the birds leave the highest peaks and head toward the valleys to spend the winter. Certain alpine birds may descend even farther, sometimes all the way to the sea, or may go to spend the winter on the Massif Central.

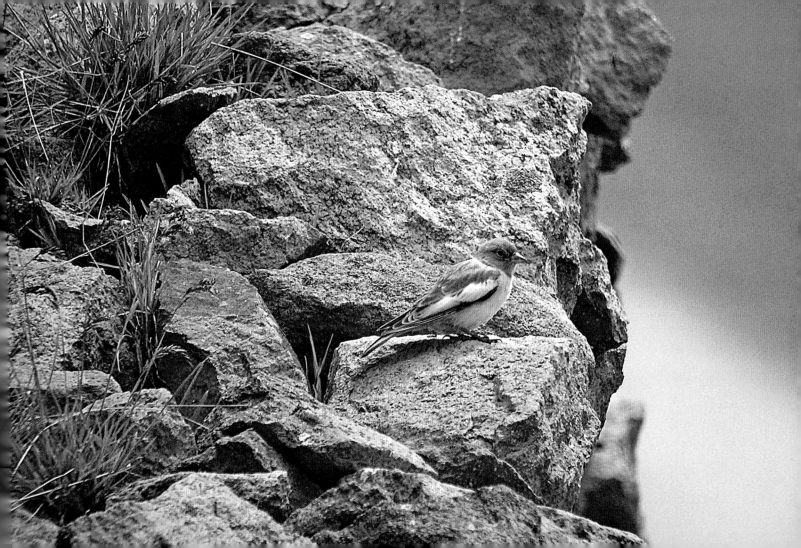

Pallas's sandgrouse

The Mongolian steppe seems infinite. Rutted trails trace lines between the rare villages. Here and there in the distance, white yurts, or domed tents, signal the presence of seasonally migrant herders. The animals, among them the sandgrouse, also wander according to the seasons. The sandgrouse, which looks a bit like a strange pigeon, has a quick flight and is rather shy. These birds live in groups, in extremely arid zones; they will gather at morning or evening around a lake to drink a few sips of water.

For the ornithologist living in the west, the sandgrouse is a mythic bird. Until the nineteenth century, and the very beginning of the twentieth, Pallas's sandgrouse actually made regular forays into the west that brought it as far as France and Great Britain. It must have been climate conditions and food scarcity that pushed these flocks of sandgrouse away from their native steppe. But since then, the sandgrouse no longer appear. Perhaps this is because the range of the species has shrunk considerably and is withdrawing toward the east.

Today, we must go to the country of Genghis Khan to see this bird with its energetic, high-speed flight, rather than simply waiting for the bird to come to us.

Pallas's sandgrouse, *Syrrhaptes paradoxus,* is found from Kazakhstan to western China and, most especially, in Mongolia. These days, the species makes only modest seasonal movements, based on the availability of food.

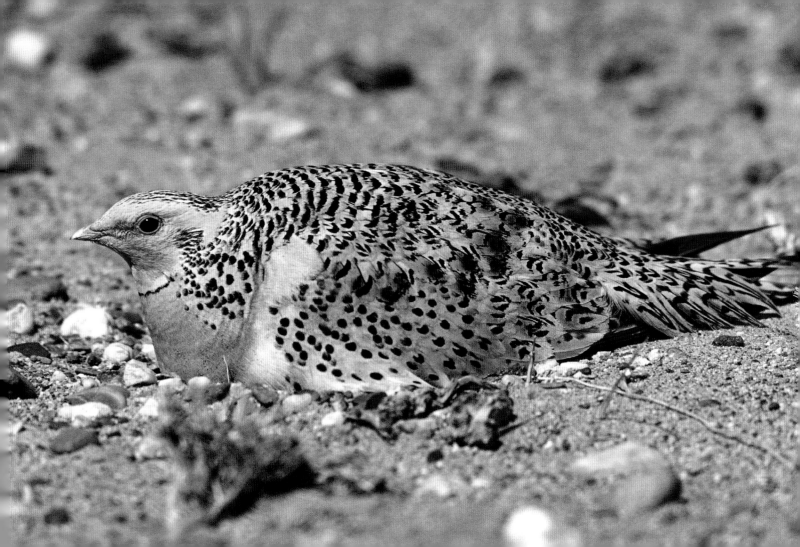

Red-necked grebe

On the lakes that dot central Canada, the red-necked grebe is common. At this time of year, the adults have regained their breeding plumage, which is characterized by a red neck (hence their name), creamy gray cheeks, and a black cap. The bird's beak is a bright yellow spike between its eyes.

The couple that I am observing have already hatched their young, and thus they mostly stay hidden in the riverbank vegetation. They have two chicks. One chick is perched on the back of one of the adults—which, all things considered, is an excellent way to travel for free.

In winter, I have often seen the red-necked grebe in Europe as well, frequently at the coast where it seeks out sheltered bays. There, it no longer wears its beautiful breeding costume, but a gray-brown plumage that makes it look suddenly much more drab. Only its yellow beak, with a black point, still stands out brightly. In this phase, it can be hard to tell it apart from its larger cousin, the great crested grebe. The only telltale distinction is that the red-necked grebe's neck has become grayish, while the great crested grebe's is white.

JULY

8

The territory of the red-necked grebe, *Podiceps grisegena*, is vast, encompassing the western half of North America, eastern and northern Europe as far as central Siberia, and then eastern Siberia and Manchuria. Each winter, Western Europe welcomes small contingents of wintering red-necked grebes.

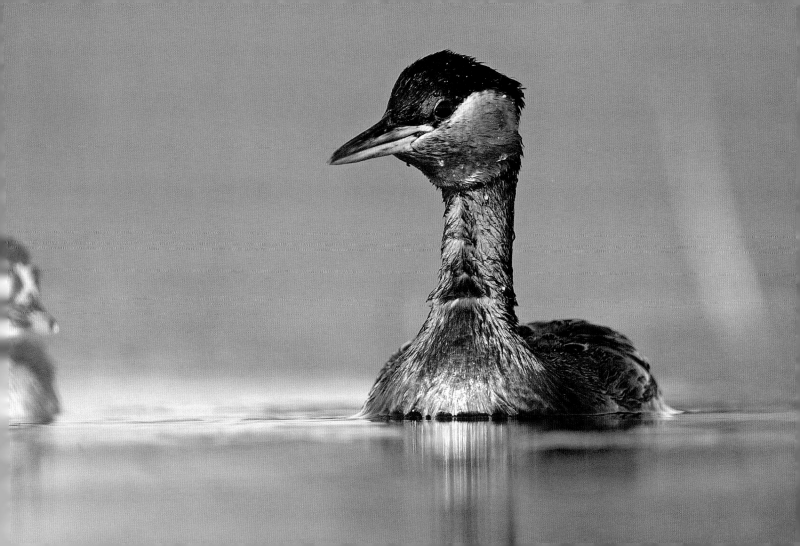

Sedge warbler

In July, the sedge warblers are less voluble than in the springtime, when, newly returned from Africa, they fill the swamp with their mumbling, joyous song. At present, the birds are more focused on feeding their hatchlings than in flirting. Nevertheless, certain males (perhaps those who did not succeed in reproducing) are singing again at this time of the year. Perched at the top of a reed, they give forth their rapid song, the notes by turns fluting and rasping, flowing from the singer's throat. As soon as the song is done, very often the bird dives into the bushes and disappears for a long moment. Sometimes, he sings from only halfway up the reed, and you will have a hard time making him out amid the abundant vegetation of the reed bed, so well is he hidden by the stalks. His plumage, streaked with brown, tan, and black, provides him with ideal camouflage amid these kinds of plants. Sooner or later, however, the bird always ends up climbing to the top of the stalk and showing himself in full sun, or gratifying us with a courtship flight, all while continuing to sing.

JULY

9

The sedge warbler, *Acrocephalus schoenobaenus*, nests in a large part of Europe and western Siberia. A long-distance migrator, this bird spends the winter primarily in Sahelian Africa, just south of the Sahara. It is therefore particularly vulnerable to the episodes of drought that are endemic to that region.

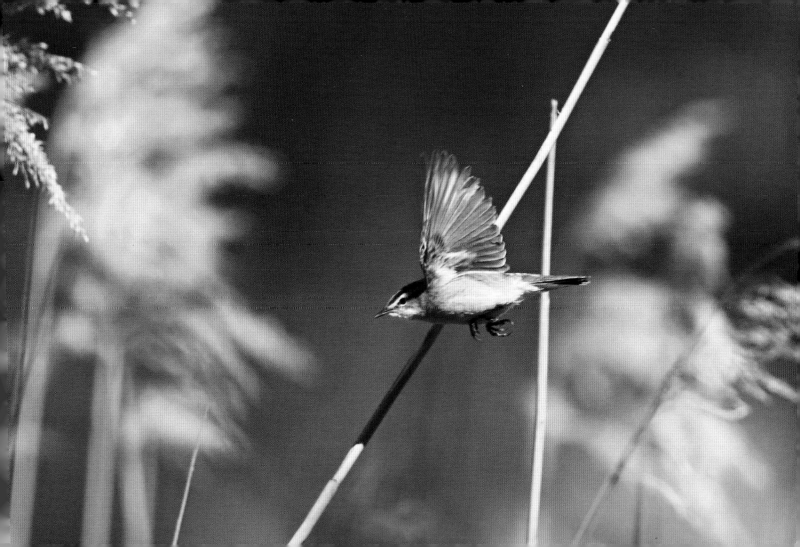

Golden eagle

If you hope to see a golden eagle, lift your eyes to the sky starting around eleven in the morning. Before that, the air is not yet warm enough for the bird to soar into the sky and begin its exploratory flights. Spotting an eagle in the sky is not hard. First, there is its large silhouette, with long wings, slightly curved up at the tip. It spirals upward, rising on the currents of warm air. But unlike the vulture, which can remain airborne only by gliding, the golden eagle is also capable of swooping down to pounce on prey, which it can spot from great heights with its piercing eyes.

Sometimes, also, especially during the reproductive period, you may see a golden eagle flying along a steep cliff face. This is the moment to follow it with your binoculars, for it may be that it is going to land directly at its aerie, inaccessible to humans. And there, with a bit of luck, you may spot one or, more rarely, two downy eaglets excitedly awaiting the return of a parent. If the adult is returning with prey, you will see the chicks flapping their wings in their eagerness to devour it. But most often, you will not see the young eagle of this year's brood until fall. Then, when it takes flight, it will reveal its white tail edged with black, which is typical of the birds at this age.

In most of Europe, the golden eagle, *Aquila chrysaetos,* remains limited to the mountainous zones. It is the same in North America, where it also nests. In northern Europe, on the other hand, it may nest in large trees, as it no doubt did farther south back in the Middle Ages.

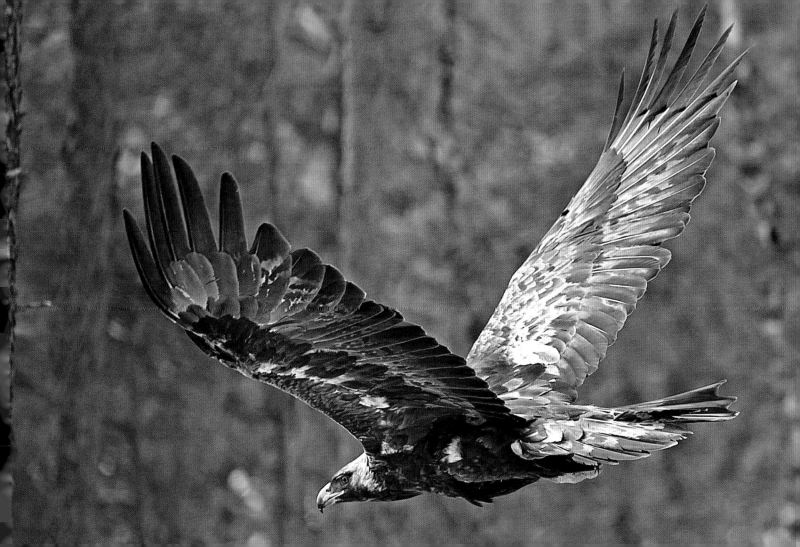

Red-eyed vireo

We are walking through a forest in New Jersey early this morning in search of songbirds. Here, titmice, warblers, and other passerines are singing their hearts out, and it is not easy for beginners' ears to know who is singing which part. At the request of my walking companion, I stop to listen to the song of the red-eyed vireo. It is a simple theme, consisting of three slightly staccato chirps. My friend translates it as "Here I am … in the tree … look up … at the top!" which seems just about right. Looking up, I locate our singer: perched quite still on a branch, it chimes out its couplet. What I glimpse first is its gray cap and big white eyebrow. Its red eye, which gives the bird its name, is apparent to me only afterward. The same applies to its beak, which is slightly hooked at the end, and quite strong for a passerine.

At a later date, walking alone in the forest both here and in Canada, I will hear this characteristic song without being able to see the bird at all. Hidden in the leaves, unmoving, it will continue to taunt me: "Look up … at the top!"

JULY

The red-eyed vireo, *Vireo olivaceus*, has a very broad range and is found all over North and South America. The North American birds are migratory, and travel to spend the winter in South America. The species nests as far north as the Canadian northwest.

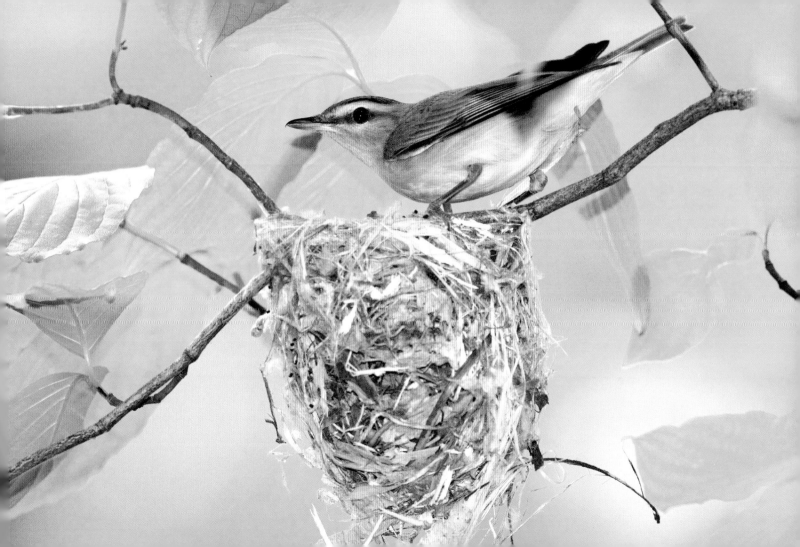

European nightjar

It has become a regular ritual to go see the European nightjar in a forest of the Ile de France at this time of the year—and, perhaps even more so, to go hear it. In the evening, the moor is tinged with purple, while a distant grasshopper warbler makes its strange noise, resembling the sound made by the rubbing of a grasshopper's legs. To see the nightjar, you must take cover at the edge of the woods and wait. As soon as night falls, the bird will strike up its song. It can't be confused with anything else: it sounds like the noise of a distant moped, mixing the purr of a small two-stroke engine with an occasional choking sound…a sort of gradually slowing *toftoftof…tof…tof!* as if the moped were running out of fuel. And then the bird is off again, and, for one or two minutes, you can hear its *rrrrrrrrrrrrrrrr!* echoing against the trees.

This time, we are lucky enough to spot the singer. It is perched at the bare top of a pine tree. After each song, it takes off and flaps its wings, giving shrill cries of *cooik…cooik!* Here it is pursuing a female; then, after tracing a few figures in the starry sky, it comes back to land in the same spot again. And it begins its song anew, standing out like a shadow puppet against the darkness.

The European nightjar, *Caprimulgus euro-paeus*, is found in Europe, North Africa, and the Middle East. It winters in Africa. The genus acquired its scientific name meaning "goatsucker," because it was once thought that these birds nursed at the teats of goats. In fact, they were simply hunting for insects in the evening among the resting animals.

JULY

12

Northern wheatear

Perched on the dry stone wall, the male northern wheatear sounds the alert again and again. *Tchac!* it cries, and each time it shakes its body feverishly. A little farther down the wall, two fat fledglings await their meal, while at the top of a neighboring bush, the female watches us, a big green caterpillar in her beak. To end this commotion, we step back a few yards. Then, the male ceases his frantic shaking and the female comes closer to her young, who continue to beg insistently for their food.

Here, in the mountains, northern wheatears can still be seen. But on the plains, on the seashore of La Manche or the North Sea, the species these days is hardly found at all. It is a victim of vanishing or increasingly disrupted habitat, and perhaps also of climate change. At present, the northern wheatear seems at ease only above 4500 feet (1300 meters). Or else in the tundra, which, like the high mountains, enjoys cool temperatures even in summer.

For the moment, the young birds are sated and their parents depart on the hunt once more. In flight, they reveal their white rumps and the characteristic *T* shape of their tails.

JULY

13

Spread widely through Europe, the northern wheatear, *Oenanthe oenanthe*, also nests all along the Russian tundra and as far east as Alaska, where at present it lightly touches the Americas. Great migrators, the birds all winter in Africa (even the American population, impressively). The birds of Greenland travel in one unbroken flight over the ocean from there to the African continent.

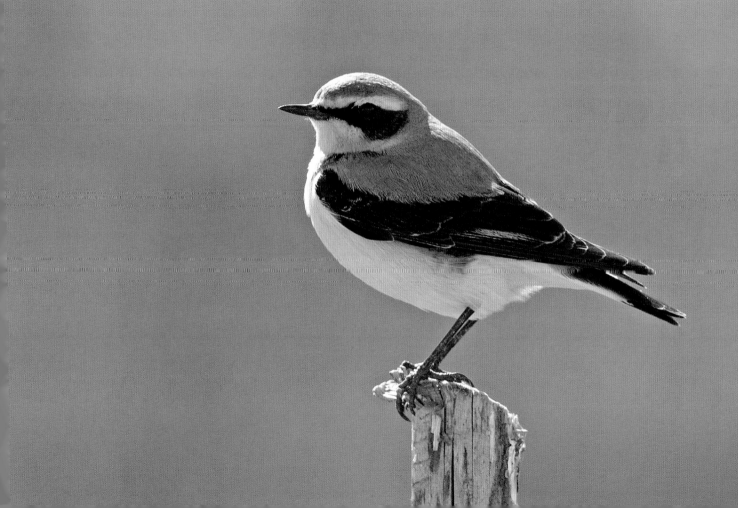

Red junglefowl

T his bird may look a little like our big, plump domestic chicken, a familiar sight in the barnyard. But it is a wild chicken, or red junglefowl, a bird that lives in the Asian rain forest. It is strange indeed to walk through the dense jungle and hear, in the early morning, a *cock-a-doodle-doo!* erupt out of nowhere. But hearing it is one thing; seeing it is another. This smaller ancestor of our domestic chicken is a past master of the art of camouflage. It takes a great deal of stealth to surprise it, scratching at the thin soil of the forest. Always on the alert, it will usually slip away well before you can catch sight of it. And quite reasonably so—in the rain forest, after all, the chicken has many more predators than the beech marten or the neighborhood fox.

If you do manage to see it, however, you will be surprised by the beauty of its unusual colors. The junglefowl makes it seem a pity that some varieties of our chickens are entirely white.

JULY

14

Intimately linked to the rain forest, the red junglefowl, *Gallus gallus*, is found in a large part of southeast Asia. This bird is the ancestor of the widely varied domestic chicken varieties of today. There exist three other species of wild chicken, all in tropical Asia.

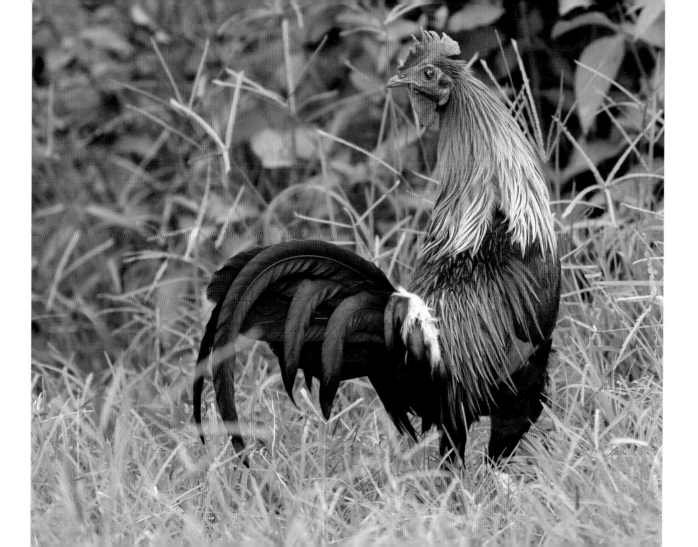

Alpine chough

Very high above the cliffs, a group of black birds wheel. From time to time, high-pitched whistling sounds are heard emanating from the flock. These birds are choughs, the crows of the mountains. You will encounter these altitude-defying birds all the way up to the summit of Mont Blanc and in the vicinity of Everest. They accompany mountaineers in summer, while in winter, they can be found near ski lodges, prowling around the trash cans and ready to snag any scrap of ham that falls out of a sandwich. Like all the Corvidae, in other words, they are remarkably adaptive. In summer they live in the near solitude of the heights, in winter in close proximity to humans.

Up close, one can admire the chough's bright yellow beak and red legs. The rest of the bird is black. In flight, the choughs are extraordinary acrobats, playing amid the air currents and excelling at loops and dives. So one can perhaps forgive them when, driven by hunger, they behave like common sparrows.

JULY

15

The alpine chough, *Pyrrhocorax graculus*, is a bird of the mountains, and it can be found in all the mountain ranges of Europe, North Africa, and Asia. It is sedentary, but moves to lower altitudes in summer, coming down from the heights to the altitudes where there are people, and often entering mountain towns and villages.

Purple martin

Before my first visit to North America, I would never have thought that there were apartment buildings made for birds. Then came the day when, not far from Montreal, I saw a communal roost for martins. It was a sort of little wooden house, affixed to a post, with several stories. On each floor were a number of openings, each of which represented the entryway to a nesting hole. The martins sit on their eggs and raise their young in one of these nesting spots. There may be twenty or even more. These communal nest boxes are generally covered with a charming little roof. All they need is a lace curtain at the door of each apartment!

At this time of year, the purple martins come and go, feeding their young. You can see their dark and heavy silhouettes (purple-black for the male, more brownish for the female) circling in the sky in search of insects, which are numerous in this season. Sometimes, a big chick demanding its share will poke its tousled head out of the entrance hole. And, as in all crowded apartment buildings, there is always plenty of agitation and noise.

The purple martin, *Progne subis*, ranges over a large portion of North America. In the fall, it migrates toward Brazil and neighboring countries in the eastern part of South America.

Sandwich tern

There is great commotion in the sandwich tern colony. The chicks are now practically old enough to fly and have been grouped together in a "nursery," under the watchful eyes of several adults. The parents come and go in order to feed this little community of birds, as they cry, chirp, and beg. I am always filled with admiration to see an adult return with a small fish in its beak and, without hesitation, pick out its own chick, among the dozens of others, to feed. How can the tern recognize its young one in the crowd when, to my eyes, all the chicks look completely identical? It seems that the parents and chicks actually recognize each other by their cries. Nevertheless, when we hear them all at once, as we do, the only impression is of a huge cacophany of high, scraping sounds.

In a few days, this noisy, lively spot will be deserted: the entire colony will leave. The young birds will then travel with their parents to tropical Africa, and get fed by them along the way. Each time the birds stop to rest on a deserted ocean beach, the chicks will issue their raucous cries while the parents go out over the crashing surf to fish.

The sandwich tern, *Sterna sandvicensis*, is found in Europe as far as the Caspian Sea, as well as along the east coast of North America, while a closely related population lives in the Antilles and in South America. The birds are migratory, though in Europe some birds stay through the winter, especially near the Mediterranean.

Ostrich

I am not impressed by the ostrich. I have seen it so often in zoos and animal preserves that my first contact with the species in South Africa left me somewhat indifferent. However, there I was faced with the largest bird in the world, a flightless one, moreover, and the fastest runner in the avian tribe. At full tilt, the ostrich can reach a speed of up to 45 miles (72 kilometers) per hour. Given its size—up to nine feet (three meters) tall, for the male, with his neck extended—it is no surprise to learn that it also lays the largest eggs. And yet, the ostrich would still be small compared to the now-extinct elephant bird of Madagascar or moa of New Zealand.

If the ostrich does not impress me, its physical characteristics and the tales that are told about it are still fascinating. People say that it can disembowel a lion with one kick, and that is true. They also say that it sticks its head in the sand in case of danger; that, by contrast, is completely false. Thus, the expression "to stick your head in the sand" is based on nothing more than a hoax. In reality, everything about the ostrich is still immoderate, even the size of an ostrich steak. Believe it or not, a male ostrich can weigh up to 340 pounds (150 kilograms).

The ostrich, *Struthio camelus*, lives exclusively in Africa, mainly south of the Sahara. It was hunted at the beginning of the twentieth century for its feathers. Today, it is raised for meat on big farms scattered all over the world.

Common crossbill

Ki-ep…ki-ep…ki-ep! A flock of common crossbills flies over the pine forest. Their slightly bulky silhouette, with big heads (accommodating their powerful beaks) and short tails, identify them easily to the observer. This group of a dozen birds swoops down onto the highest branches of a spruce, and then immediately sets about stripping the cones in search of seeds. As their name indicates, the mandibles of the birds are crossed, which allows them to dig out seeds from the pinecones with incredible dexterity. The red males stand out well against the bottle green of the pine needles. The greenish yellow females are harder to locate among the branches, while the young birds, garbed in blackish stripes, blend perfectly into the tangle of vegetation. Head low, solidly gripping a twig from which a pine cone hangs, some birds play like acrobats. All of a sudden, for some reason that escapes us, the flock takes off and disappears through the line of trees, calling ki-ep…ki-ep…ki-ep!

JULY

19

The common crossbill, *Loxia curvirostra*, lives all over northern Europe, northern Asia, and North America. The birds are subject to regular "irruptions," in which they turn up in temperate regions starting in the summer. This occurs only if the pinecones in the boreal forest fail to flourish, driving the crossbills to search for food farther afield.

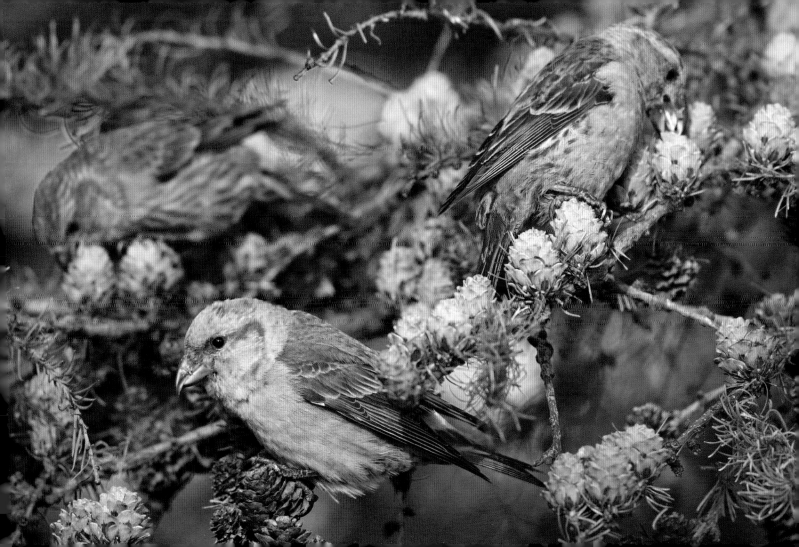

Killdeer

The killdeer is around 10 inches (25 centimeters) long, not a large bird, but a noisy one. As soon as we enter its territory, the male shoots into the air and begins to shout every protest he can think of to persuade us to leave. Its cry has been rendered as "*kill-dii!*," and that is what led to its name.

The adult birds are standing in the grass, not far from us. They are wagging their hindquarters rhythmically, as they continue to emit piercing cries. No doubt there are young birds in the area. In fact, we can see two little balls of feathers on legs, trotting along a little farther away. This explains why the birds were so demonstrative. To draw us away even more effectively, the male begins a curious little game: he allows one wing to hang as if it were broken, and crawls along the ground. A perfect strategy to sidetrack a predator who might readily go after a bird it believes to be wounded. But in our case, there was no need. We prefer to leave the birds alone so that the young can return to the warm down of their mother, who will soon hide them once again between her feet.

JULY

20

The killdeer, *Charadrius vociferus*, nests in North America. The most northern birds are migratory and fly as far south as northwest South America. The birds of the southern United States are resident.

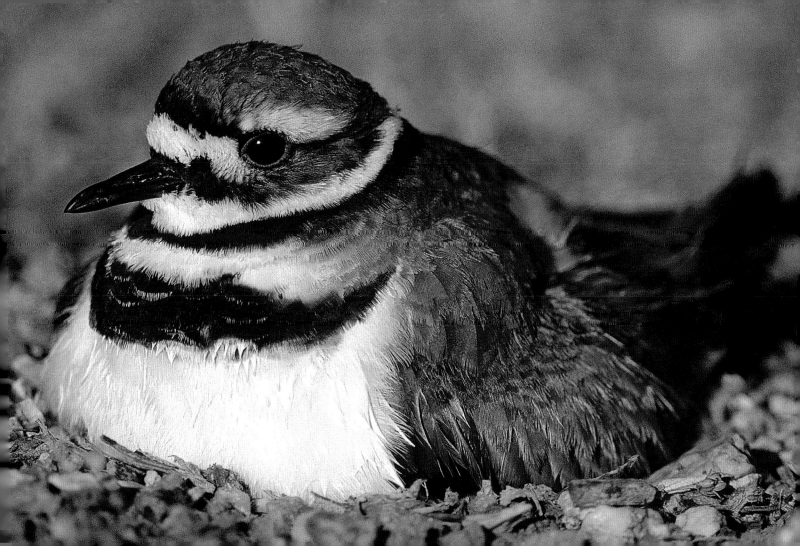

Little owl

A summer evening falls over the plateau. As the heat blurs and gives way to darkness, the daily life of the little owl begins. *Kooee-yook!* It gives its small, high-pitched cry, which reverberates in the clear air of evening. It will soon take off to hunt. Perched on an old stone wall, it inspects its surroundings with golden eyes. With an undulating and slightly slack flight, it leaves the wall to take up a position on the roof of an old sheepfold, silhouetted like a shadow puppet against the purpling sky. *Kooee-yook!* In the distance, the tinkling bells of a flock of sheep and the barking of dogs mark the close of day. It is the hour of the goddess of wisdom—Athena—whose name is reflected in the little owl's scientific name. Soon, the owl will have disappeared, swallowed up by the darkness. It will hunt all night, no doubt in order to feed its young. And in the starry blackness, one will hear only the small telling sound punctuating the nocturnal hours: *Kooee-yook!*

The little owl, *Athene noctua*, is one of the six species of the genus *Athene*. The species lives in Europe, in North Africa, and in the east, from Turkey to China and eastern Siberia. The populations of the Middle East and the Arabian Peninsula, once considered a variety of little owls, are now classified as belonging to a completely different species.

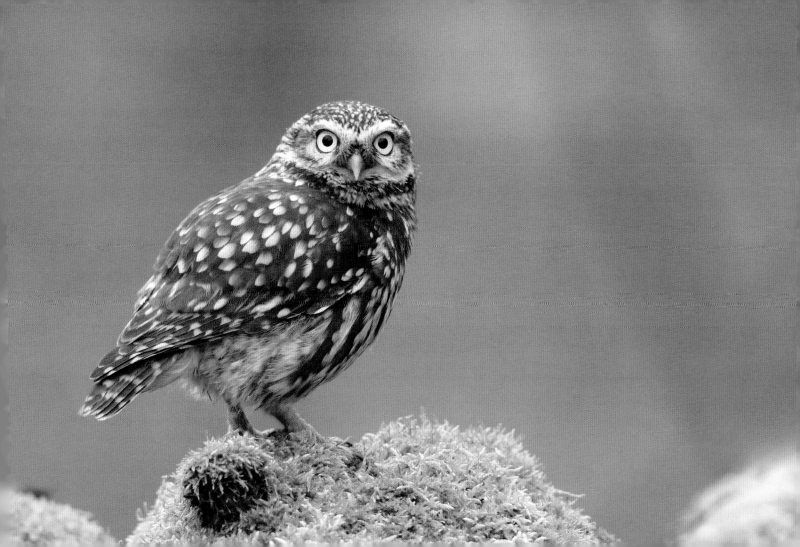

Rufous-tailed rock thrush

We have walked a long while before arriving at the first screes of rocks. Up to this point, we were accompanied by the northern wheatear, the dunnock, and the water pipit, but now we are also welcomed by the black redstart. In the scree, meanwhile, I have seen a larger bird take flight—a bird that seemed to be multicolored, with a white lower back. Now we must search among the blocks of stone. The rufous-tailed rock thrush—for this is indeed the bird who has just flown off before us—may have put on its beautiful colors of red and blue, along with the white, but it remains no less inconspicuous.

It is astonishing that such a colorful bird could blend so completely into the grays of the rock. A shy creature, it hardly ever permits observers to approach, and it is through its song, slightly recalling that of the blackbird, that you have the best chance of finding it. Often, you must angle your binoculars high up to spot the male bird at the top of the cliff, perched on a rock and singing out into the void. The female, a drab brown dotted with little black markings, is even harder to see, especially at this time of the year, when she tends to stick close to her nest.

The range of the rufous-tailed rock thrush, *Monticola saxatilis*, extends from North Africa to central Asia, by way of the south of Europe (and the Alps). This species, which primarily dwells in the mountains, does not stay for the winter but instead flies south, mostly to sub-Saharan Africa.

Brown pelican

When you see a television show set on the California coast, look closely. Behind the muscular boys and bikini-clad girls, there are gulls strolling along and, sometimes, a few large birds making spectacular dives into the Pacific, completely oblivious to the unbearable suspense of the plot unfurling on the beach. These are brown pelicans. Without much exaggeration, one might say they are part of the local decor. It is these birds that you see in Monterey, perched on sea walls or pontoons, and vying for a spot among the sea lions. You can also find the brown pelican competing in a frenzied group for the tiny fish that populate certain lagoons or large lakes not far from the West Coast. Brown pelicans are as intimately connected to these landscapes as pink flamingos to the swamps of the Camargue or snow geese to Cap Tourmente in Quebec.

Once you've seen them nose-diving like kamikazes into the waters of the Pacific, it is obvious that these remarkable fishers are more than just extras on some second-rate show.

JULY

23

The brown pelican, *Pelecanus occidentalis*, lives on the southern coasts of the United States and in the western part of South America. Though some migratory movements are noted, especially among the most northern birds, a good number of brown pelicans are essentially sedentary.

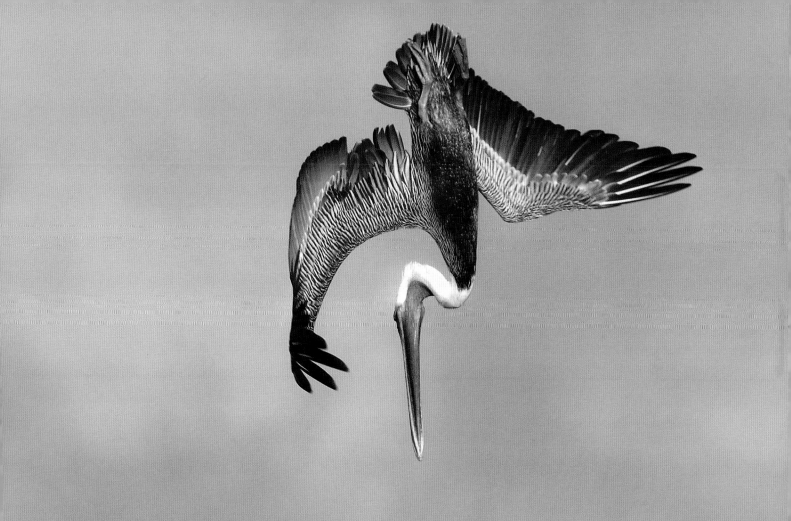

Rock pigeon

The countless pigeons that populate our large cities and take a perverse pleasure in soiling the statues in our public squares are the direct descendents of the rock pigeon. The rock pigeon is wild, living only on the vertical cliff faces of mountains and gorges. In Morocco or the Arabian Peninsula, as well as in Corsica, one sees its gray silhouette sail between the rocks as it returns to the outcropping on which it has made its nest. It is an ace flyer, brushing along the cliff face at top speed. Once it lands, it disappears against the rock, and becomes extremely difficult to spot. A telescope is often necessary to finally reveal some of the birds perched up high, coming and going between a crag of the cliff and a crevice in the rock, where the species nests.

In this context, the rock pigeon is a far cry from the fat pigeon that comes to peck at the remains of a sandwich at a city dweller's feet. The city pigeon and the pigeon of the cliffs have their origin in common, but their lifestyles are radically opposite.

The wild rock pigeon, *Columba livia*, is distributed here and there over North Africa, southern Europe, and the Middle East, and then in central Asia and as far east as China. It is sometimes hard to tell the difference between wild birds and domestic birds that have returned to the wild. In France, only the Corsican population is today considered to be wild.

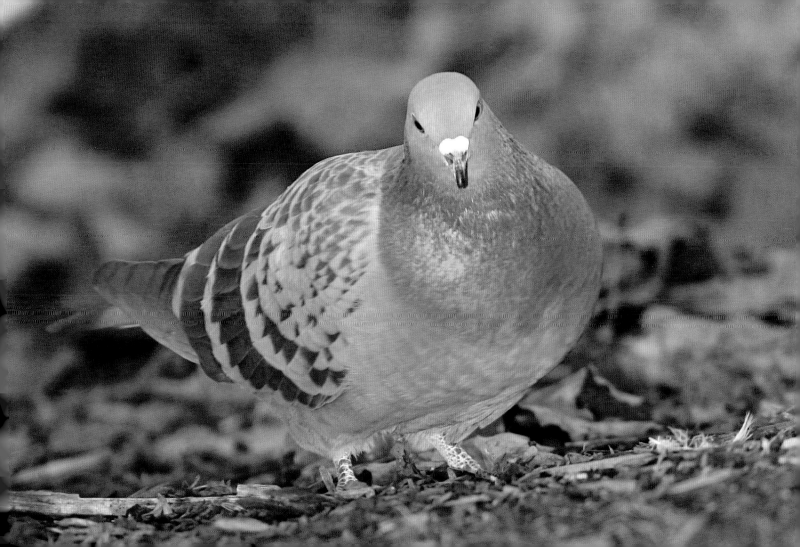

Crab plover

Why are ornithologist fascinated by the crab plover? Is it because it lives in distant and nearly inaccessible places? Or because of its funny silhouette, with its overly long legs and beak and slightly too-large eyes? No doubt it is both of these things together. And the crab plover is, after all, something of a curious bird. On the Arabian Peninsula or on the shores of the Persian Gulf, it can be seen striding along the beaches and mudflats, or in the mangrove swamps, taking rather slow steps for a little shorebird. It seems lost in thoughts of the food it is seeking. Suddenly, the crab plover runs toward its prey (often a small crab) and captures it. Then, its back a little stooped, it stops for a few instants, as if thinking, before taking off again on a new trajectory. It always seems both nonchalant and contemplative, and that is what makes the crab plover strange. With its black-and-white plumage that makes it resemble an avocet, the bird seems slightly out of place in this gray and white environment of silt and sand.

The crab plover, *Dromas ardeola*, is spread over a relatively limited territory. Indeed, for most of the year one finds it only on the coasts of the Arabian Peninsula and the Persian Gulf, as far east as Pakistan. In winter, it can be found on the western coast of India and along the coast of East Africa.

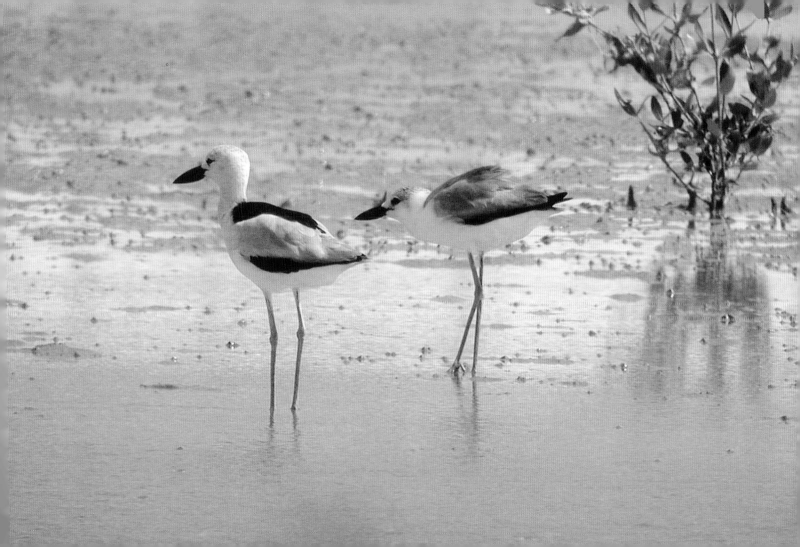

White-throated dipper

Well hidden between the trees along the stream, I lie in wait. I know that otters are common in this area of the rushing water, but it is not otters that I've come to see. Anyway, I would be unlikely to see them in broad daylight. No, this stakeout is dedicated to the white-throated dipper. The dipper is unusual, as passerines go. It lives on rivers with fast-moving water. Perched on a rock, it studies the surface of the water. Then, all of a sudden, it dives in to seize its prey. Other birds, such as the kingfisher, are also divers. But the dipper will even walk along the bottom of the stream to seek out its food! Here it is emerging once more and, perching again on a rock, frantically shaking its hindquarters. A fisherman reaches the river, inducing our scuba diver to take off. It flies downstream, skimming the water, toward another large rock sticking out of the stream. It is not easy to hear the shrill *tzitt!* that it makes over the noise of the rushing water. The dipper likes the whitewater, the whirlpools, the raging streams. It is utterly loyal to this habitat, however challenging it may be, and builds its nest on the bank, in order to be as close as possible to its swimming hole.

JULY

26

The white-throated dipper, *Cinclus cinclus*, is distributed over a fairly wide area; it is found in nearly all of Europe and in North Africa, wherever there are fast-flowing rivers. To the east, it lives as far as central Asia. Though it is a sedentary bird, it may leave a stream if it freezes over in the winter. Then the dipper moves slightly southward, toward open water.

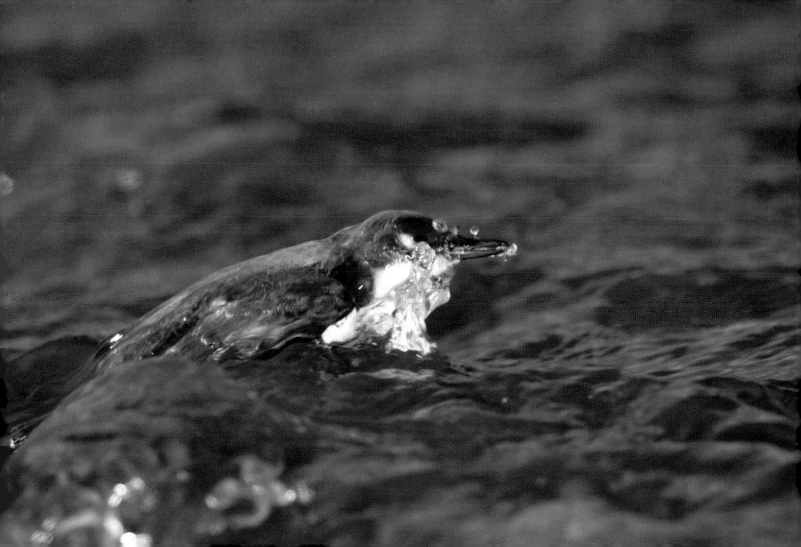

Cory's shearwater

We are on a glassy sea, offshore from the Azores. It's an ideal time to watch the whales that pass through the area. In terms of seabirds, things are more complicated, because without wind, it is hard for large gliders to fly. Off the coast of Pico, flocks of shearwaters are floating on the water. At the approach of a boat, they reluctantly take off, forced to beat their wings vigorously to rise above the water.

Under strong winds, you will see something else entirely. Then, you see the big Cory's shearwaters thrilling to the waves, gliding over the foamy crests and letting themselves be carried to the next mountain of water. Some birds fly very close to the boat. To see them follow us without a single flap of their wings is a marvelous spectacle. They look like miniature albatrosses.

Later, once we have returned to land and are camping out under the starry skies, we hear these birds' nocturnal calls as they return to their nesting colonies. Nothing is stranger than their cries, which sound like infants wailing in the distance. Echoed by hundreds of birds all along the steep cliffs, the cries of the shearwaters fill the night, creating a singularly bewitching atmosphere.

JULY

27

The Cory's shearwater, *Calonectris diomedea*, nests partly in the Mediterranean and partly on the islands of the Atlantic, from Portugal to Cape Verde. After they reproduce, the birds disperse out across the Atlantic Ocean.

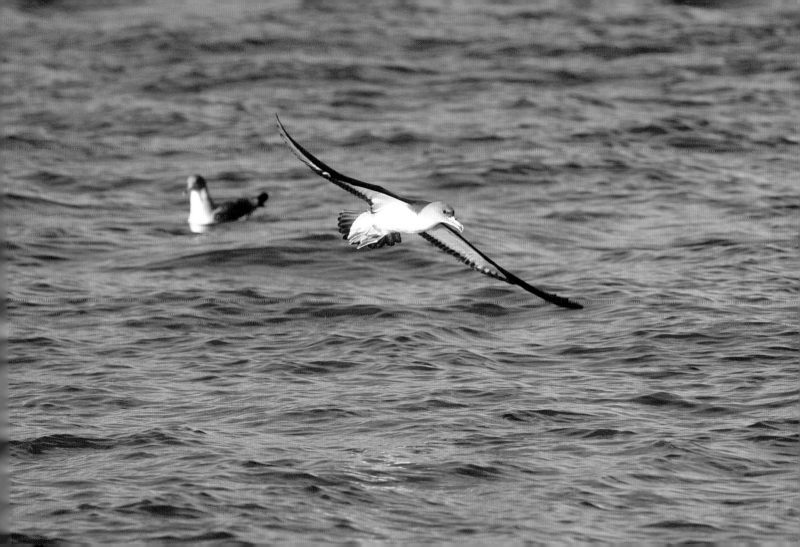

Yellow-legged gull

What would Marseille be without its gulls? They are everywhere in the city and, of course, particularly plentiful along the port. Perched on roofs or boats, they harangue the passersby with their raucous cries. And they are anything but shy. They do not hesitate to come right up to your feet to scrounge a few scraps of food while you soak up the sun along the Canebière. Nesting happily in the city—not always to the joy of the residents—they especially love the rocks of the tiny islands strung along the Mediterranean coast. And when your boat passes close to their colonies, you are saluted by their inquiring cries of *gagagak!*

At this time of year, the young birds have taken flight, and one sometimes sees, around the colonies, rafts of big brownish birds giving their shrill little cries. Soon, this whole little universe will dissolve, and some of the Mediterranean gulls will not delay in flying back north—as far as the North Sea. They will be looking for food, which often becomes scarce here at this time of year, with so many beaks to be fed.

JULY

28

The yellow-legged gull, *Larus michahellis*, nests primarily on the Mediterranean, as well as on the Atlantic coasts of North Africa, from the Iberian Peninsula to the mouth of the Loire in France. The species has also colonized the shores of certain large rivers and their tributaries, including the Rhine, the Rhone, and the Loire.

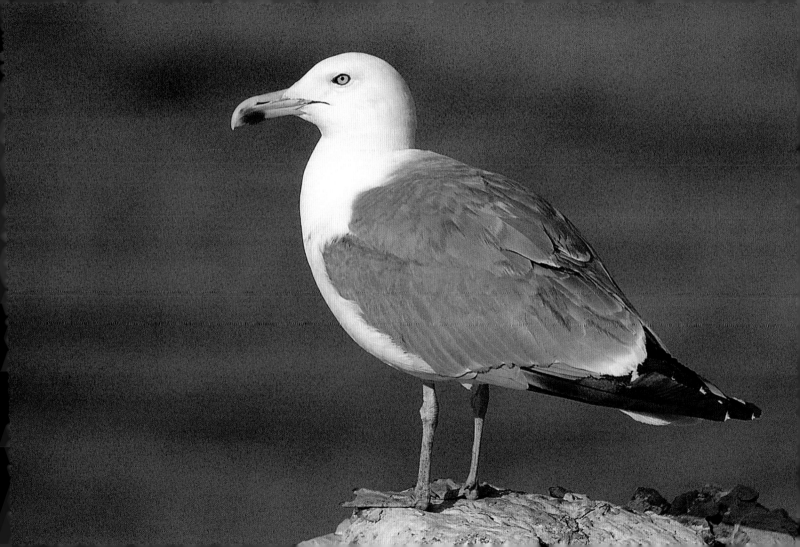

Common swift

Now is the time. In a few days, the swifts will desert the skies of our towns and villages. This evening, however, several dozen swifts are chasing one another in mad acrobatic formations, grazing the walls and crying out as if mad. It is a moment redolent of summer and the warmth of evening. Tomorrow will be identical to today, of course. Except that, perhaps, there will be no more swifts above the roofs; no more cries to enliven the end of day. So it goes with these birds: at the drop of a hat, they take off some fine day and are not seen again till the following April. It's the same in the spring. Starting in mid-April, the bird-watcher walks with his nose raised to the sky, to see if they have arrived yet. Nothing. Then, one morning, the air is filled with swifts circling high in the sky, still silent. These birds are the best celebrants of the longest day of the year, during which they may circle for up to 23 hours. In July, when the juveniles in their turn take flight, their elaborate ballets brighten the streets and squares where we go to stroll in the cool air of evening. Their presence assures that the heavens will be full of life, to our great pleasure. So seize the day, because tomorrow the swifts may have departed for Africa.

JULY

29

A late migrator, the common swift, *Apus apus*, arrives only in April, most often at the end of the month, and departs again starting in the last days of July. Except for when it nests, it spends its days in the air, even when it sleeps and mates. The swifts of Europe, North Africa, and the Middle East all pass the winter in equatorial Africa.

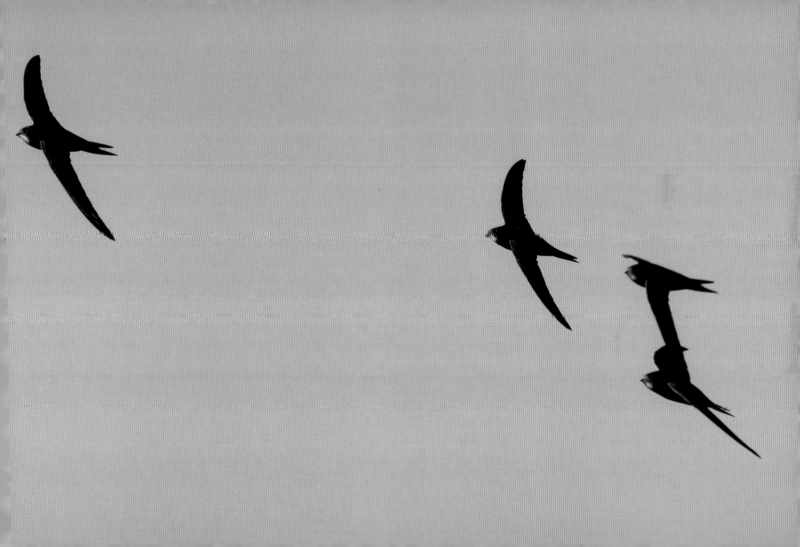

Lesser kestrel

The church of the little village snuggled into this Spanish sierra shelters a colony of lesser kestrels. At first, in studying the bell tower and its surroundings, you see nothing. But with a little patience, you may spot a falcon's head poking out of an opening. A bird soars into the air, followed by another and another. There are so many that in the space of an hour, we will have counted around fifteen couples coming and going between the church, where they have sheltered their young, and the surrounding countryside, where they hunt for insects, notably may bugs.

Lighter than its close relative the common kestrel, it shares that bird's ability to fly in place while it hunts, but it seems more graceful in the air. At present, a big, tousled young fledgling has emerged from the bell tower and demands its food with forceful cries. An adult comes to take care of matters. Clearly, it was an emergency!

The lesser kestrels are true migrators and spend the winter season south of the Sahara. There, they sometimes form very large roosts. In a few months, these Spanish birds may be sleeping in one of those roosts themselves.

JULY

30

A southern bird, the lesser kestrel, *Falco naumanni*, nests from North Africa and the Iberian Peninsula across the south of Europe to the Middle East, central Asia, and Mongolia. During the winter, the entire population reunites in Africa.

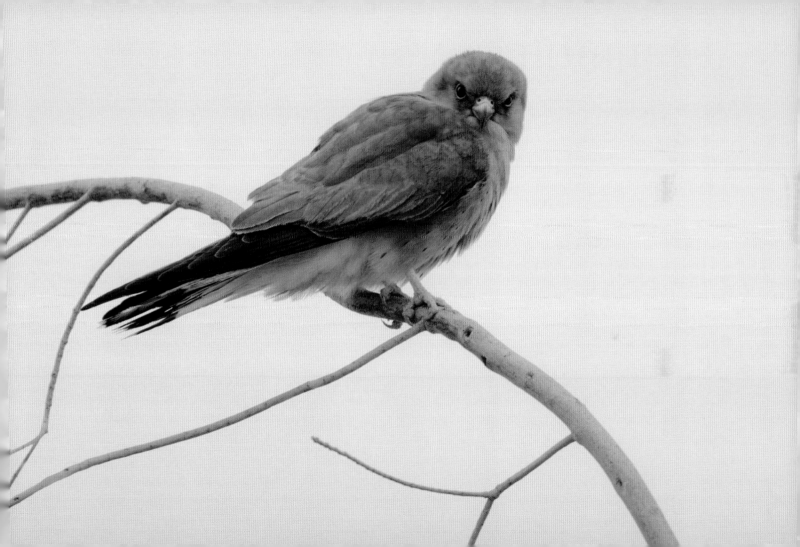

Common scoter

For certain species it is already the season for fall migration. For them, the summer hardly exists, and they pass directly from spring, when they breed, to preparations for the coming winter. Such is the case for the common scoter. Among these ducks, which nest in northern Europe as well as in Siberia, the males hardly occupy the nest at all. As soon as the female begins to brood, the males band together and take off. They travel fairly far to the south and begin to molt. For some time, they find themselves unable to fly, so much so that they remain at sea, well offshore, where they have the least risk of being disturbed. This is why in temperate Europe, so called sea-watchers, who look out for seabirds from the coast, may already see long black streams of birds gliding over the water: these are male common scoters sailing off toward the south. Later in the fall, the male birds will be rejoined by the females and that year's juveniles, and this whole little community will spend the winter at sea. It is no easy thing to spot these scoters, once they are floating on the sea and playing hide-and-seek among the waves.

The common scoter, *Melanitta nigra*, nests primarily from Scandinavia to eastern Siberia, but also in Iceland and in the northern parts of the British Isles. The most western populations are found in winter on the Baltic and North Seas, but also down the Atlantic coast as far as Spain and Portugal, and sometimes even farther to the south.

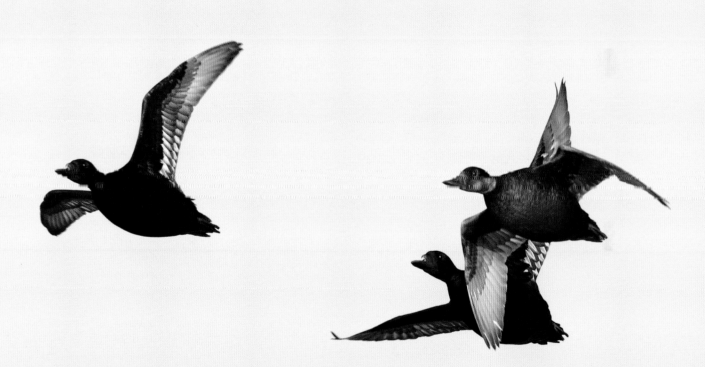

Dark-eyed junco

In my first encounter with the dark-eyed junco in North America, I noticed similarities between this species and our European chaffinch. The same build, the same way of hopping along the ground, the same impudence. However, the junco and the finch are not closely related. The junco is an American sparrow, while the chaffinch is, naturally, a kind of finch. But even the great Swedish botanist Linnaeus stumbled into the trap of describing the junco as a member of the finches.

The junco is very common in wooded habitats. Like the finches (goldfinches, rosefinches, grosbeaks), it is a constant at the bird feeder in winter, and never hesitates to squabble bitterly with its neighbors over the seeds.

There are several subspecies of this bird, which is distributed over a huge area. Its range is so wide that, from one subspecies to another, its plumage varies greatly.

Its song is a repetition of a single metallic note, with a slightly vibrating trill, recalling that of most American and Eurasian sparrows. More evidence that the junco is not a finch at all.

The range of the dark-eyed junco, *Junco hyemalis*, is in North America. Only the most northern populations are migratory, leaving their breeding territory in the fall. The others are generally resident. Among the birds of the mountains, there is also some altitudinal migration.

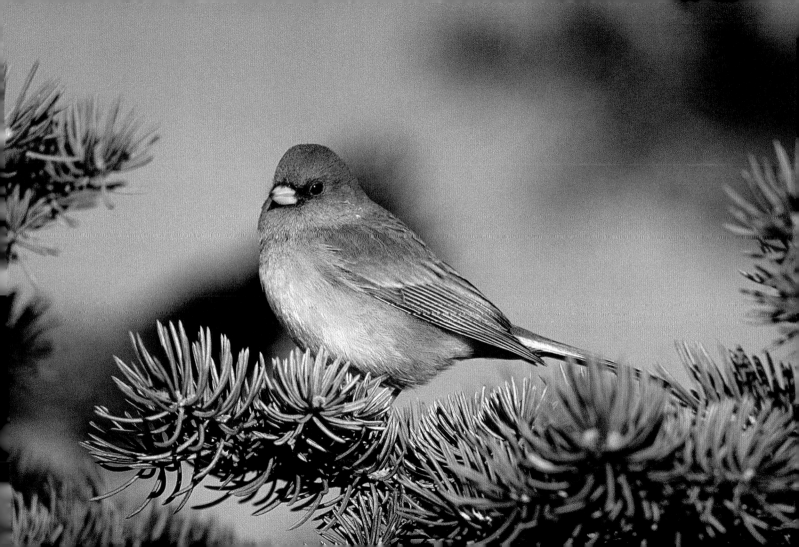

Black kite

This morning, a gentle wind from the north has chased away the clouds. It is still warm, and this same wind favors the migration of raptors. Around eleven in the morning, a first group of them circles fairly high over the houses. With binoculars, I identify them as black kites. The black kites are never late. Indeed, they are among the earliest migrators to leave Europe and head back to Africa. While other species are still feeding their chicks, the kites are already on their way. They circle higher and higher, having found a thermal updraft, then, one by one, they peel off and sail toward the southwest. Toward the Pyrenees, then Spain, then the Strait of Gibraltar, and then Morocco, which they traverse in its entirety, only to go on and brave the hard test of the Sahara. After this difficult passage—during which some of the birds may perish—they will arrive in the Sahel and in tropical Africa.

Watching them glide overhead and disappear little by little, I think of this mysterious journey, of which we truly know so little—except that, for sure, we will never make such a journey ourselves.

A raptor of the Old World, the black kite, *Milvus migrans*, nests from North Africa and Europe to central Asia and Pakistan in the east. One subspecies nests in Africa and several others in Asia. As its scientific name indicates, this kite is a great migrator. It prefers wooded habitats for its breeding sites and the savannah during the winter.

Greater flamingo

As with the ostrich (see July 18), I was not impressed when I saw the greater flamingo for the first time. It was in the Camargue at the beginning of August. I had seen these birds so often, in magazines, on postcards, or in documentaries, that they were already very familiar to me. Or so I thought. For in the course of my observations since then, I have become fascinated with the social life and behavior of the greater flamingo. I have met scientists who study this species. I have observed the breeding display of the flamingo, an amazing sight. And I have come to find the moniker "flying vacuum cleaner," as one of my colleagues has termed the flamingo, a bit unfair!

I have often seen these greater flamingos amid superb environments, from Morocco to Senegal to Iran. I have seen them in brackish lagoons in the middle of the desert, in the steppe, and on little lakes buried high in the plateaus of Anatolia. In the end, the tall pink fowl of the postcards of my childhood has evolved, little by little, to become for me a majestic and extremely engaging bird.

Colonies of greater flamingos, *Phoenicopterus roseus*, are disseminated across the Old World and beyond: in Spain, France (in the Camargue), and the Middle East, as well as here and there in Africa and southern Asia as far east as India. After nesting, the birds disperse, sometimes over considerable distances. For example, one bird tagged by researchers in the Camargue was later spotted in Iran!

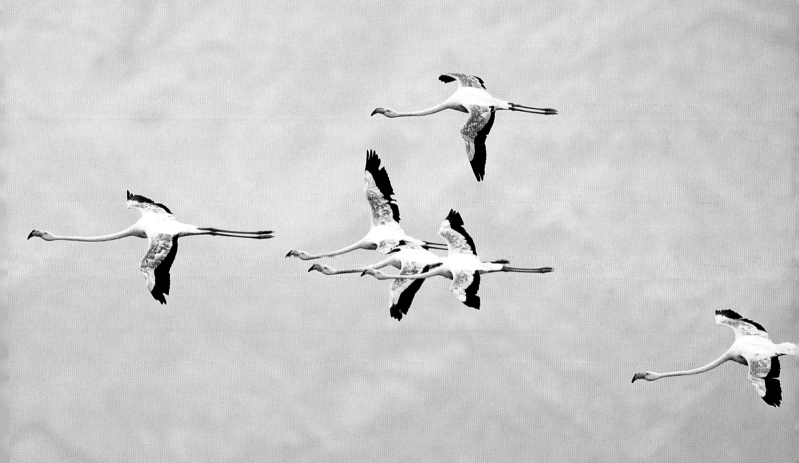

Village weaver

The rainy season in Africa is always grueling for a traveler from Western Europe. In the bush south of Mbour, in Senegal, I found a large colony of village weavers nesting in several acacias. What a commotion! The birds build individual nests piled one on top of another, creating an enormous ball of twigs with multiple entrances. The males are resplendent at this time of year. Dressed all in yellow, they have entirely black heads and red eyes. The females wear drabber colors, a greenish yellow streaked with brown. Starting with the return of the dry season, all the birds wear a similar costume.

Fierce quarrels transpire in front of the nest's entrances. Indeed, for these birds, anything seems a pretext for a fight. They never cease their complaining, mixing rasping and chirping notes, and it all creates an indescribable racket. One wonders how each bird manages to make it back to the nest without being plucked bare by its neighbors.

But a huge cloudburst is brewing on the horizon. Soon, for a short moment, the hundreds of birds will take shelter, and nothing will be heard beyond the sound of the rain pouring down on their nests.

AUGUST

4

Widely spread over tropical Africa, the village weaver, *Ploceus cucullatus*, is the most common member of its family. It nests in large colonies and disperses during the dry season, sometimes causing significant damage to crop fields.

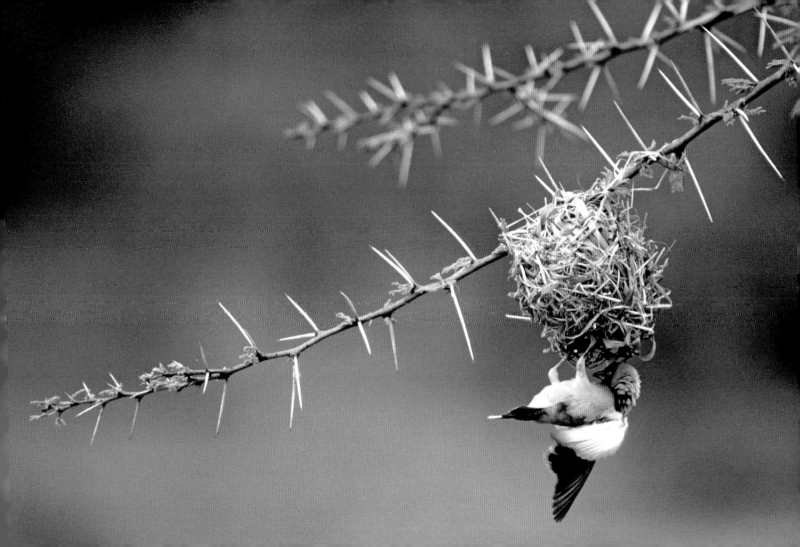

Alder flycatcher

Every continent has its nightmare birds—that is, birds that are a nightmare to identify. In North America, the flycatchers are at the top of the pack. What is challenging for the American ornithologist is a nearly impossible feat for ornithologists from elsewhere who lack the same experience over the years.

Flycatchers belong to the Tyrannidae family. Its species in the Americas number in the dozens. But the flycatchers of North America have, for the most part, a drab and similar plumage. The question then becomes how to pinpoint, in each bird you see, a small and distinctive characteristic, often an extremely subtle one, that distinguishes one species from another. A white orbital circle, a hint of red on the flanks, a slightly thicker beak, a few feathers that stand up on the back of the neck: these are all things that an inexperienced eye will surely miss at first glance. To make matters worse, alder flycatchers often live in the forest, and are thus observed in what are not always favorable lighting conditions. They give us only one advantage: they are fairly static and hunt from a perch, like Old World flycatchers. Even so, what is a head-scratcher for American ornithologists can be a nightmare for everyone else.

The alder flycatcher, *Empidonax alnorum*, is one of 37 species of flycatchers (or closely related species) in North America. It nests over a large portion of North America, even reaching as far as Alaska. As with other species of *Empidonax*, it is recognized particularly by its voice.

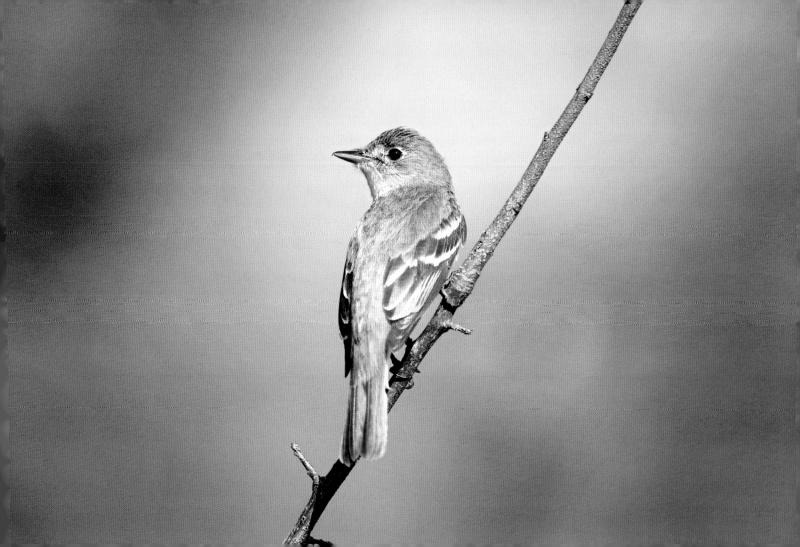

Caspian tern

At the beginning of August, the Camargue fills once again with migratory birds. In the salt lakes and lagoons, small shorebirds who are freshly returned from the Arctic tundra throng over the surfaces of the mudflats. In the middle of a flock of black-headed gulls, which have assumed their winter plumage, four large birds stand out of the pack. These birds, with their imposing size and red beak shaped like a dagger, are Caspian terns. They have likely come from southern Scandinavia, which houses a small population, and are flying down to tropical Africa.

These are the giants of the tern family: they are the size of a gull. With their heavy flight, they are impossible to miss, their aerial style being quite different from that of other terns. Besides the large red beak and this silhouette, they are distinguished by their cry: it is a low and scraping *cray-ik!*, not very melodious, quite different from other terns' high-pitched calls. Nevertheless, in flight as on the ground, the Caspian tern is a beautiful bird, and rather elegant. When it makes a stop at this time of year, in the Camargue or at other sites on the Mediterranean, it is a sign that the nesting season of these birds is at an end, and that fall has nearly arrived.

The Caspian tern, *Sterna caspia*, is distributed more or less all over the world; it is known as a ubiquitous species. It nests in fairly scattered fashion on all the continents except South America. It is migratory, dispersing over tropical Africa in the case of the European birds and through Central America in the case of the North American population.

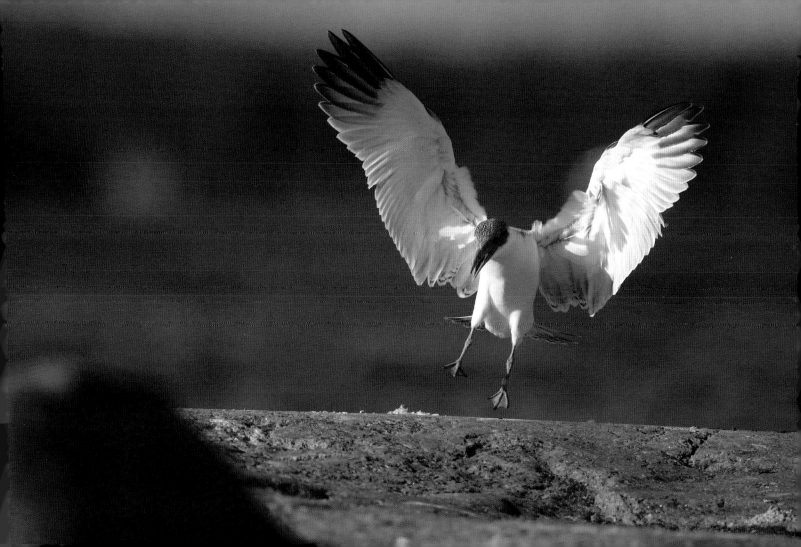

European storm petrel

The European storm petrel certainly belongs on the list of birds that are not easy to observe. These little black birds, with their erratic, bounding flight, are typically seen only on the high seas. If they do venture onto dry land, it is most often on tiny islands, and only to nest—and they come only at night. Unless you participate in a targeted (and nocturnal) scientific study, or watch them from a boat sturdy enough to brave the high seas, the only opportunity to see these lovers of the open ocean comes when a good squall drives them onto the coast. And then you must still arm yourself with good binoculars or a telescope, for the birds, no larger than swallows, love to frolic among the whitecaps. They are masters at the art of playing hide-and-seek among the tall waves—and succeed, in this way, in driving ornithologists crazy.

So, why not attempt a journey around this time of the year, on a sailboat, a pleasure or fishing boat, even a ferry? You could plan the trip specifically for the observation of seabirds—but whatever you do, you will probably need to go thousands of miles out to sea to meet the petrels. You might then see them skimming the water, endlessly changing direction, approaching as close as possible and then fleeing back to the open water, like little swallows. Their Breton name is *satanig*, or little devil, and they deserve the name indeed.

The European storm petrel, *Hydrobates pelagicus*, is one of the petrel species having the greatest distribution in the northern Atlantic, as well as in the Mediterranean. It disperses out to sea after nesting, and can be observed at the coast only in the event of very strong winds or storms. Petrels can be found on all of the world's seas, including those around Antarctica.

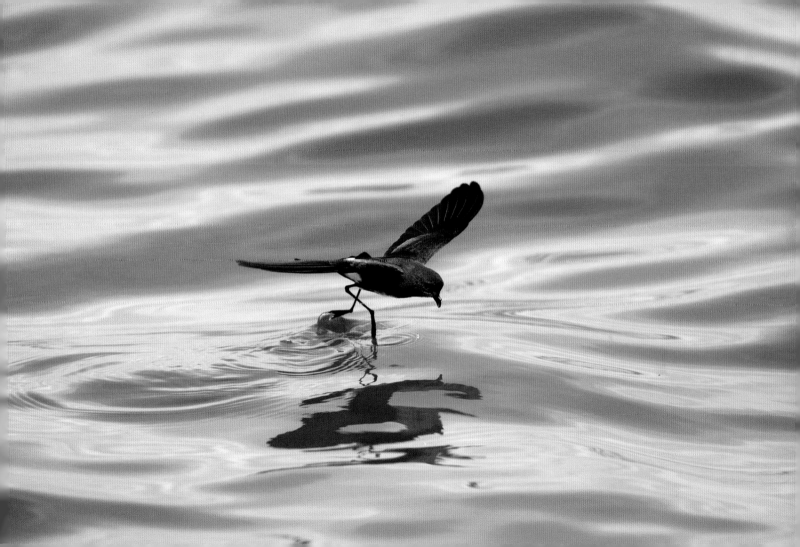

Zitting cisticola

Zitt…zitt…zitt…zitt! This swamp on the Dalmatian coast is overflowing with cisticolas. This bird, from the warbler family, is not very large, but it has an unmistakable song. The song is just one sound—*zitt!*—repeated unceasingly, while the bird makes its bounding flight. With each bound, it gives a *zitt!*, in a metronome-like rhythm. If you hear the sound, all you have to do is look up to spot the little yo-yo bird itself, leaping through the air. After a certain time, the male (for he is the singer) dives into the vegetation. Then you can seek him out in the tall grass, or perched on a reed or a giant cane stalk. You will be struck by the small size of the bird, with its short tail and the red-and-black-striped pattern on its back. It continues to give small, shrill cries; perhaps its chicks are still in the area? But soon it has taken off, rising a little in the air, and heading away with its undulating flight punctuated by calls of *zitt!*

Whenever I witness this simple scene, it never fails to remind me of the coastal habitat of the Mediterranean.

Once confined to the Mediterranean perimeter and to tropical Africa, the zitting cisticola, *Cisticola juncidis*, has extended its range to a good part of Western Europe, no doubt aided by the warming climate. At present, it is found as far north as northern France and Belgium.

AUGUST 8

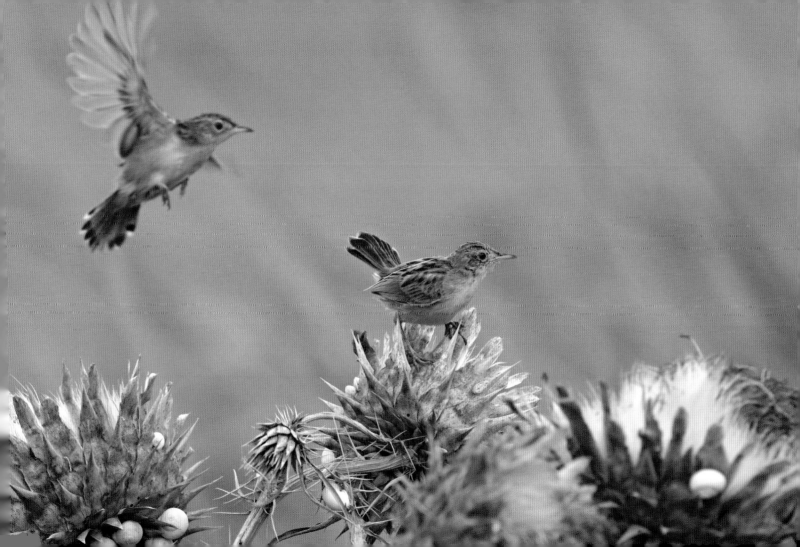

Red-winged blackbird

In the wet meadowlands of Oregon, I remember seeing thousands of red-winged blackbirds, which, in the month of August, were flocking back together after breeding. From a distance, they made me think of starlings, but they are larger. More particularly, when they are closer up and perched, the otherwise black male displays a pair of brightly colored epaulettes. From a distance these look plain yellow, but when you see them better you can tell that they form, at the elbow of the wing, a pale yellow bar topped with a red one. For African ornithologists or those who have traveled there, the red-winged blackbird also recalls the indigobird, or at least the long tail of the males.

The flock lands in the neighboring hedges, then takes off again, seemingly for no reason at all. With each stop, the birds give a variety of cries, ranging from a shrill *bzzzzz!* to a ringing sound to metallic clicking. It is strange to encounter what sounds like an experimental music concert out here in the natural world, far away from any theater or arena.

While the males are jet-black, both the females and the young birds are covered with brown and blackish streaks. At this time of the year, it is hard to tell them apart.

The red-winged blackbird, *Agelaius phoeniceus*, belongs to the Icteridae family, which is spread throughout the Americas. The species is dispersed widely over North America and ranges south into Central America. The Canadian populations, notably, are migratory and winter as far south as the southern United States and Mexico.

AUGUST

9

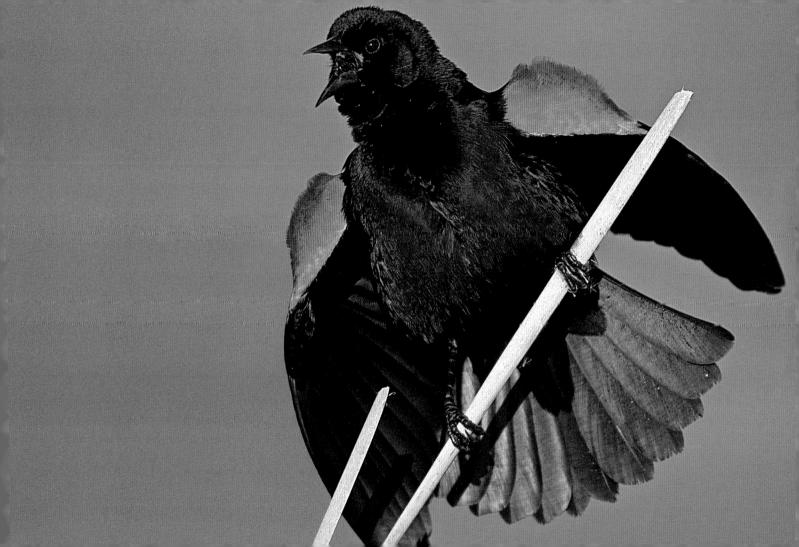

Common raven

On the Austrian mountains, the alpine meadows of summer extend out of sight. We are walking peacefully among the grazing cattle, listening to the pretty chorus of their bells. They make a great deal of noise, these cows, but not enough to drown out a low but powerful call of *cro…cro!* I look up to see two common ravens crossing the little valley where we are walking. They are headed for a high cliff. They glide and drift without a flap of their wings, a bit like raptors. But their black silhouettes and, especially, their wedge-shaped tails betray the identity of these birds. They are not raptors, but birds of the Corvidae family especially well-equipped for flight. They can make loops in the air and even glide on their backs along snow-covered slopes. The raven is a true sportsman, besides being clever like all the crows.

Here, the raven is a mountain-dweller. But it may also be found on the seacoasts of Scotland or Corsica, as well as in Death Valley in California. In the Great North, it is deeply linked to the conifer forest. The raven is an opportunist that knows perfectly how to take advantage of many different environments, even those that are the most challenging.

The common raven, *Corvus corax*, has a wide distribution area that spans from North and Central America to Europe, North Africa, all of Siberia, and temperate Asia. Thus, it frequents many varied habitats, from the city to the highest mountains. It is sedentary, and the couples tend to be very devoted.

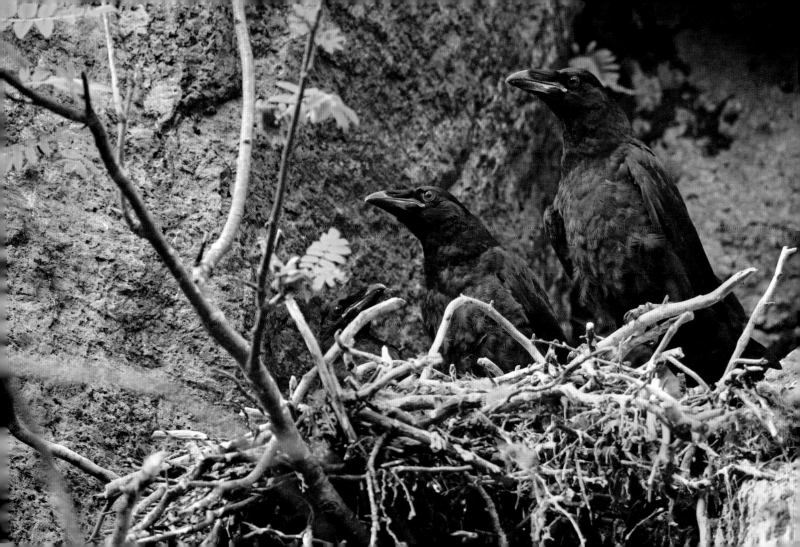

Spoon-billed sandpiper

There are few species that point to something being wrong in the world as much as the spoon-billed sandpiper. Certainly, the species is not well-known to the general public. And for good reason: this small wading bird lives in the most remote part of Siberia—in the northeast corner, to be exact. From there, after reproducing, it flies toward Asia, and its rather meager numbers then disperse around the Bay of Bengal, in Thailand and Vietnam, and generally in places that are particularly difficult to access.

The beak of the spoon-billed sandpiper, which is shaped like a spatula, makes it particularly intriguing. But so does its history. Just a few years ago, hardly anything was known of its breeding sites. When they were discovered, the species was seen to be in great decline—to the point where today it is unknown whether the bird will be able to survive the twenty-first century.

Having had the chance to observe this bird in China and Siberia, and having even seen a stray once near Vancouver, I have always felt that the species carries with it all the immense fragility of our animal biodiversity.

Restricted to northeastern Siberia, the spoon-billed sandpiper, *Eurynorhynchus pygmeus*, survives today as a population of what is surely fewer than one thousand mature birds. With its spatula-shaped beak, which works as a filter, it has a very specialized diet adapted to a certain kind of invertebrate prey. It appears to have suffered from a loss of its winter and migratory habitat (coastal swamps, mudflats), as well as from disturbances in its breeding sites (clutches of its eggs are more and more frequently being destroyed by stray dogs).

AUGUST

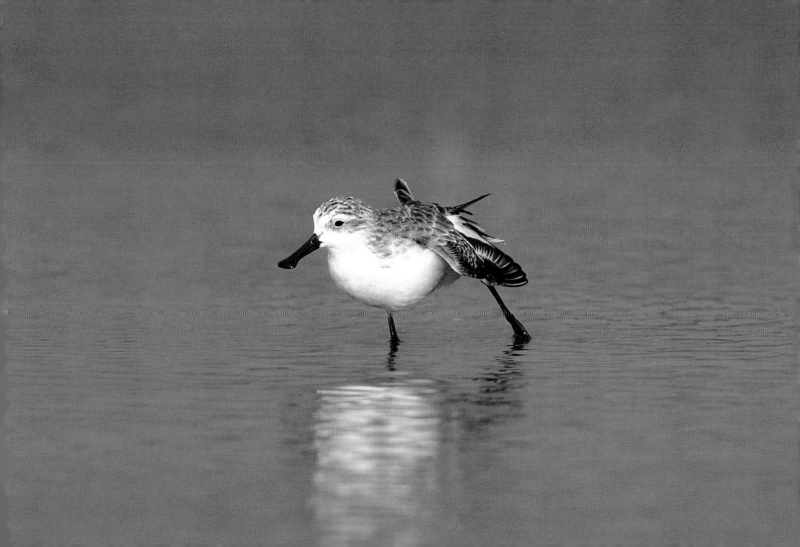

White stork

It is at this time of the year that the first groups of white storks pass across Europe. The nesting birds from all over the continent head for the south. Since they do not like to cross the sea to reach tropical Africa, the white storks make a detour to shorten this part of the journey as much as possible. Thus, the birds of Western Europe migrate over the Strait of Gibraltar, while those from Eastern Europe pass over the Bosporus strait.

At the hottest hours of the day, the thermals, or rising currents of warm air, are at their strongest. On the migration paths of the species, you may see groups of these large birds riding the thermals at those times, with no more than a few flaps of their wings. As much as possible, the storks let themselves be carried through the air as they journey south.

Many silly things are said about storks. Of course, they do not really bring babies. There is little more truth to another superstition that exists about them in Europe: that depending on how early or late they pass by, the winter will be more or less harsh.

The white stork, *Ciconia ciconia*, nests in scattered fashion in Europe, North Africa, and the Middle East, and as far away as central Siberia and south Asia. For several decades, thanks to an effective policy of protection, its numbers have been on the rise, notably in France. The progression of global warming has permitted a growing number of the birds to winter in southern Europe (including France), which allows them to avoid the perilous journey to tropical Africa and back.

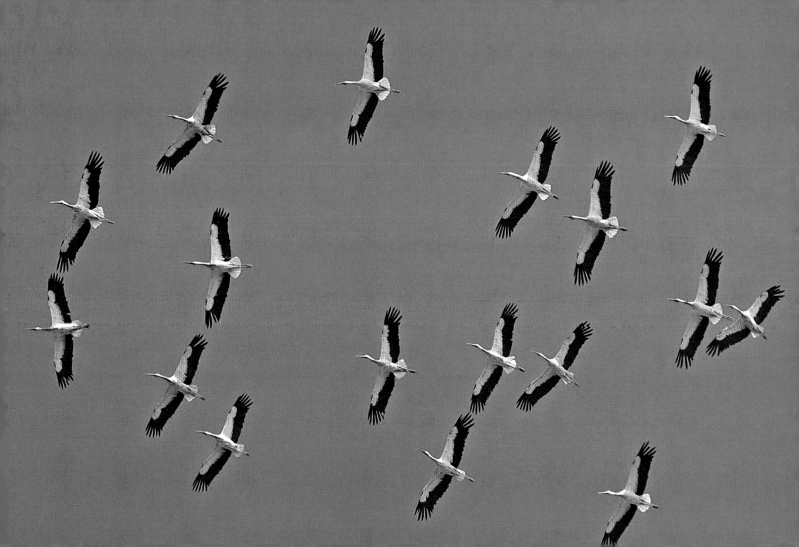

Emperor penguin

While many of us bake in the sun at this time of year, the emperor penguins are enduring the worst possible cold at the other end of the earth. Remarkably, it is in this same period that they choose to nest. The birds form colonies a number of miles from the sea. The emperor penguin sits on its solitary egg, which it holds between its feet, amid temperatures that easily reach -40 degrees Fahrenheit and unthinkably violent winds. Once the egg is laid, it is actually the male that takes the first shift. The male will brood over the egg alone for more than two months, unmoving in the frigid air, while the female goes to the ocean to feed abundantly and create reserves for her chick. Some time after the egg hatches, the female returns, with food for the chick stocked (and not digested) in her digestive tube, and it is the male's turn to head off across the ice. A penguin has to locate its own chick by recognizing its cries; it is one of thousands thronging the penguin colony.

Confusingly, the French name for the penguin is *manchot*, while the French word *pingouin* designates the bird that English-speakers know as the auk. Auks, which live in the northern hemisphere and fly extremely well, are quite different from penguins, which live in the southern hemisphere and, of course, don't fly at all.

The emperor penguin, *Aptenodytes forsteri*, nests in large colonies in Antarctica. It is also the recordholder for diving among birds, able to attain depths of up to 1500 feet (450 meters) below the surface. Global warming, which has profoundly changed the distribution of the krill on which the penguin depends for food, is disturbing the biological balance of the penguins and seems likely to eventually cause a significant decline in their numbers.

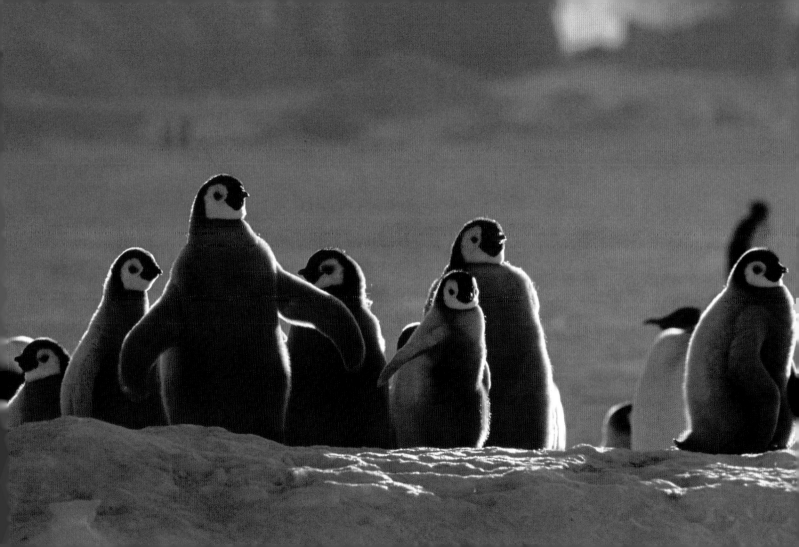

European bee-eater

Near an ochre quarry, you hear sweet and rolling cries, as if from far off. Then, as you study the cloudless blue sky, you notice colorful birds soaring overhead and calling. These are bee-eaters, which apparently must be nesting here, in the great cliff face of the quarry. If you look closely, you will see holes dug into the soft stone. Once in a while, a bird rushes inside, its beak full of wasps or other insects. It must feed its last big chicks, a little late in the season, for migrators have already been seen filing toward the south.

The bee-eater is a representative of a genus that lives almost exclusively in Asia and tropical Africa. This European species has pushed toward the north and is found somewhat beyond the distribution area of the other bee-eaters. But its brilliant colors and its affinity for the south remind us of its origins. In France, some call it "le chasseur d'Afrique" (the African hunter), and the name suits it perfectly. It is a great hunter of insects, and, no doubt, the birds of this colony will soon be leaving to rejoin their African cousins. When you see their yellow, green, red, and blue feathers, you can't help but think of tropical birds and their dazzling colors.

AUGUST

14

The sole representative of the genus *Merops* in Europe, the European bee-eater, *Merops apiaster,* nests in the most southern part of the continent, and also in North Africa and the Middle East. However, aided by more mild temperatures, the species has recently settled farther into the north, reaching as far as the north of France, for example. A strict migrator, it winters beyond the Sahara.

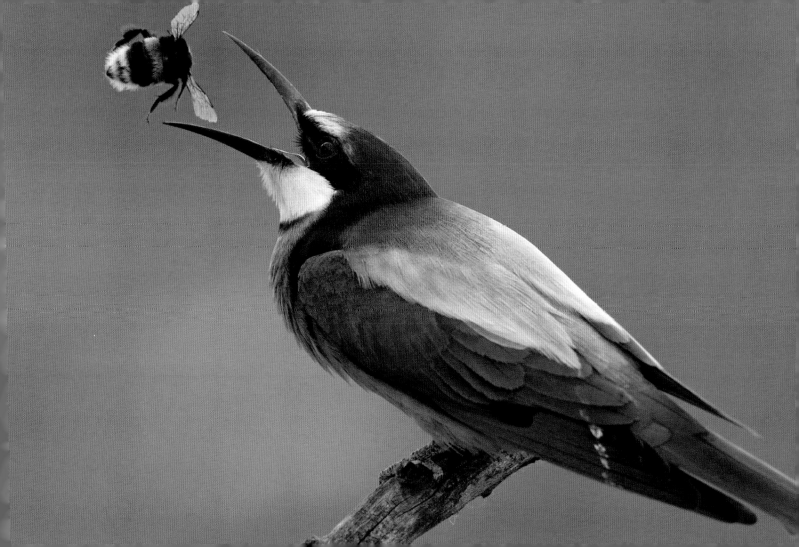

Northern gannet

The little boat that leaves from Perros-Guirec, in Brittany, brings tourists and naturalists for an excursion around the archipelago of Sept-Iles (Seven Islands). For ornithologists, the moment when the boat passes the island of Rouzic is the most eagerly anticipated. Indeed, the island is entirely white with birds. Rouzic is home to the only French colony of northern gannets; nearly 20,000 couples come there to nest each year. You can hardly get near the island, but the atmosphere, even from a relative distance, is remarkable. First, there are the incessant comings and goings around the colony, as they adults fly back and forth, feeding their growing chicks. And then there is the odor of fish, which you can smell from very far off. It is a typical scent for a colony of seabirds, and a powerful one.

There are many occasions to see the northern gannets again. If you take up a post on a well-oriented point or cape in the fall, all you need is good meteorological conditions and a steady wind to have a chance of seeing the birds go by. Thus a little farther north, at Cap Gris-Nez, flocks of birds travel in single file, in perfect synchronization with the waves. The black-and-white adults stand out against the water, while the brown-gray juveniles mimic its colors more closely. All of them are headed for the Atlantic and the high seas.

Northern gannets, *Morus bassanus*, generally reproduce in large colonies in the north Atlantic, on both sides of the ocean. They nest at fairly high altitude and, for the most part, spend the periods between breeding seasons on the high seas, occasionally flying south to tropical waters.

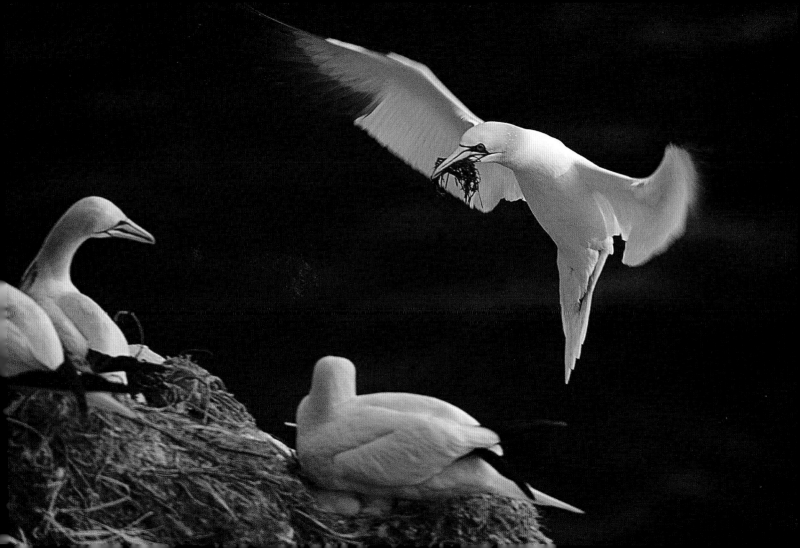

Collared pratincole

From a distance, when these birds fly lightly over the swamps, you would guess that they are terns. But with binoculars, you can distinguish the white body and tan wings with a pretty patch of brick red flashing underneath. These birds are pratincoles, small gull-like shorebirds. When the bird is at rest, one can easily see that its beak is not long and tapered, but slightly curved, adapted to capture flying insects rather than fish.

The colony has finished its nesting. Adults and juveniles are now gathered around the horses and cows that graze on the slightly flooded meadowland, dotted with bare spots where the birds like to land. Their hoarse, somewhat shrill cries again remind the ornithologist of the cries terns make when they gather en masse on the beaches in summer. It is another trait that these birds have in common, but it in fact is nothing more than an instance of "evolutionary convergence." Though they are two quite different species, over time their similar ways of life and environments have caused them to develop morphological and behavioral similarities.

With its misleading resemblance to the tern, the collared pratincole offers us a fine lesson in evolution.

AUGUST

16

The collared pratincole, *Glareola pratincola*, is found from southern Europe to central Asia, but also in northern and tropical Africa, where the birds are sedentary. Everywhere else, they are migrators and leave in the fall to rejoin their fellows in Africa.

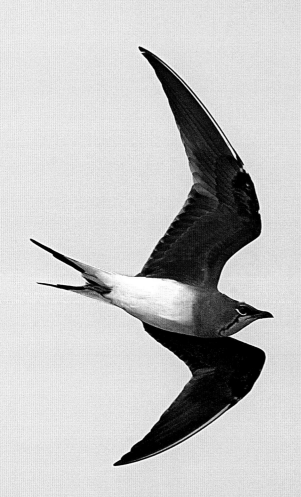

Great egret

Along the pond, among the gray silhouettes of the herons, an elegant white figure stands out. With binoculars, you can see the long yellow beak that signals the presence of a great egret. With its haughty, dignified air, it strolls serenely through the shallow water. Suddenly, it freezes, then lowers its neck very slowly, until the point of its beak brushes the water. It holds this position for a good moment. Then, in a flash, it extends its neck, plunges its beak below the surface, and pulls it back out with a wriggling fish trapped inside. The egret swallows its catch promptly, and then departs tranquilly as if nothing has happened.

In Western Europe, the great egret has provided a number of surprises. Long hunted for its ornamental feathers, which were used to trim hats, it had become very rare, and to see one was always a highly unusual event. Then, starting in the 1980s, and under the effect of protection especially in central Europe, it began to be seen more and more often. Over the years, it became a fairly common wintering bird in large swampy areas, and even a nesting bird here and there; today, it is no longer a rarity. But seeing one is still a pleasure, no doubt because one never tires of its elegance.

The great egret, *Casmerodius albus,* has a wide geographic distribution and is found on all the continents. Depending on the region where it lives, it may be either resident or migratory. It is most frequently seen in Western Europe.

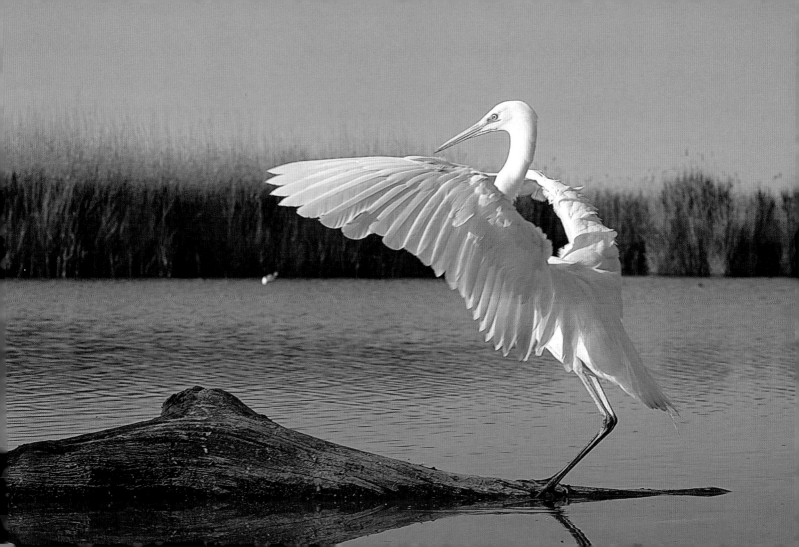

Cactus wren

Both Europeans and Americans know the typical wren, that small, cheeky bird that favors the woods and gardens. It is a quick little mouse, furtive and noisy. European ornithologists who turn their attention to the wren in North America are, however, likely to be surprised. First of all, they will notice the great variety of this species in the Americas as compared to Europe. Second, they will see that the American cousins of the European wren are bigger and plumper.

Finally, they may take note of the cactus wren, the largest bird of the wren family, which is found in the extreme south of the United States and in Central America. Perched on a saguaro, the huge cactus that is shaped like a candelabra, the male sings at the top of his lungs. Indeed, "sings" is hardly an appropriate term to describe the noise he makes, a sort of rasping, hiccuping screech that accelerates as it goes. But what is even more surprising than these vocalizations is the size of this wren, which is closer to that of a thrush. It is about twice as big as the tiny winter wren of Europe. To European eyes, it looks almost like a prehistoric bird, with its long curved beak and big feet. It is not very shy, and will allow you to observe it perched at the top of its cactus, utterly indifferent to the monstrous spines that poke from the surface. An odd bird, the cactus wren.

The cactus wren, *Campylorhynchus brunnei-capillus*, lives in desert habitats in the southern United States and in Central America, wherever it finds the cactuses to which it is closely linked. It is completely sedentary.

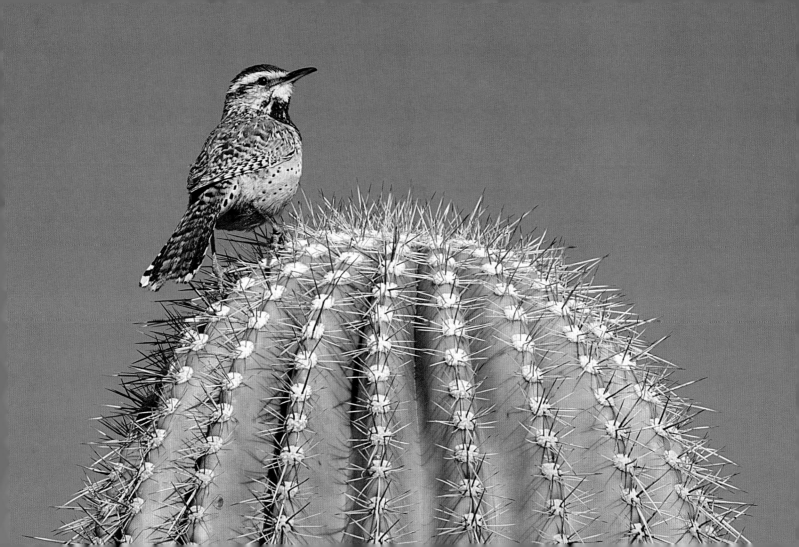

Guineafowl

If it is surprising to see a rooster in the middle of the Asian forest (see July 14), it is equally so to come nose to nose with a group of wild guineafowl in the bush of southern Africa. If you're used to seeing these fowl in a barnyard, you may be startled the first time you spot them here and watch the cackling flock bolt off to hide in the undergrowth.

It always seems easier to get close to them in a car. With a little patience, you can see these birds up close, and then you will likely be surprised by the fine detail of their plumage. Despite a minuscule head mounted on a large body, the guineafowl does not lack for elegance. It walks with small steps and inspects each square inch of ground for worms. Guineafowls are diligent and leave nothing to chance. As they travel together, one scratches the ground, another turns over leaves, and a third keeps a lookout, for predators are not scarce in this neck of the woods.

Farther on, we see a band of guineafowl march in single file right up to the grass around a pavilion, not so shy this time. All the while, they continue methodically scratching everything within range of their feet.

There are six species of guineafowl, all African. The most common is the helmeted guineafowl, *Numida melagris,* which is the ancestor of our domestic guineafowl and shares the same plumage. These species, near relatives to pheasants and partridges, are sedentary and live in the forest or on the savannah.

AUGUST

19

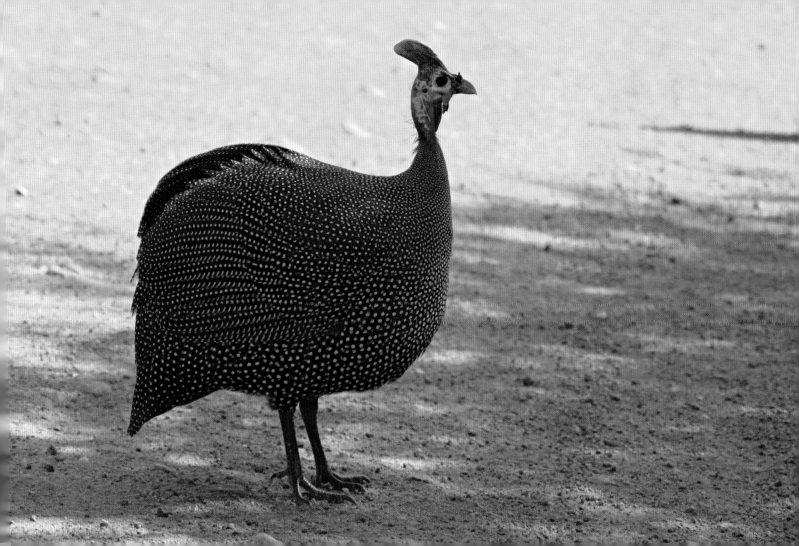

Mediterranean gull

On the mudflats near the port, gulls flock together at this time of the year. The Mediterranean gulls here currently lack the plumage that gives them their Latin name (*melanocephalus* means "black head"). They have molted, swapping their beautiful black cap for a head of pure white, with just a little leftover black dot. The rest of their body and wings is pure white; the only contrast is the bright red of their beak and their legs. Their plumpness and the pure white of their plumage make them stand out immediately from the flock, especially when they are in flight and fighting over stale bread thrown by passersby. (They can sometimes be confused with a species of somewhat smaller gulls, actually called "black-headed" in English; but these "black-headed" gulls have prominent black tips on their wings.)

A bird glides over our heads, giving its slightly raucous cry, and we admire the translucence of its wings as we watch it against the blue of the sky. On the beach, a few new adults have landed, some still bearing vestiges of their dark cap. They are accompanied by young birds that are entirely gray, unendingly demanding their food with heartrending cries. Tomorrow, this whole little world will no doubt have taken off for a new beach, a little farther south.

AUGUST

20

The Mediterranean gull, *Icthyaetus melanocephalus*, nests in discontinuous fashion from Western Europe, including the British Isles, to the Black Sea and Turkey. The birds winter especially on the Atlantic coast of Europe and along the Mediterranean Sea.

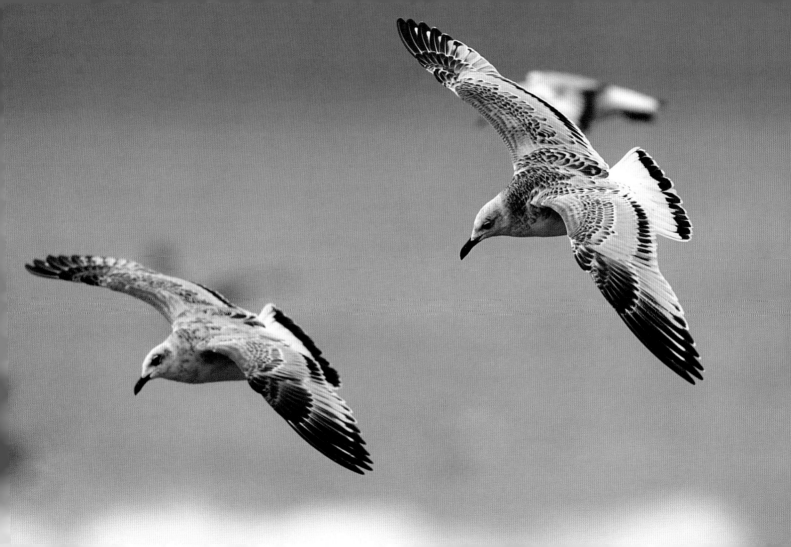

Long-billed curlew

In the prairie bordering a large wetland in Oregon, a flock of curlews has made a stop. They slowly survey the field, pecking from time to time at insects in the grass. What is immediately surprising is the length of their beaks. The Eurasian curlew is fairly well equipped in terms of its long, curved beak, but the long-billed curlew beats it hands down. Indeed, the long-billed curlew's beak is nearly as long as its body. You may wonder what the point is of such an appendage, where a small beak would seem to serve perfectly well. In fact, these birds are heading south and out to the Pacific shore. There, in the soft mud of sheltered bays, they will use their astonishing beak to its fullest, since it allows them to search out tiny animals, especially little crabs, buried deep in that silt.

At the passage of a harrier, the flock takes flight. I admire the cinnamon-colored underside of the wings, which contrasts with the rest of their gray, tan, and white plumage. Backlit against the sun, the silhouettes of these birds stand out, with their long, long beaks.

AUGUST

21

The long-billed curlew, *Numenius americanus*, nests in the great American prairie. In the fall, most of the birds fly back to the southwest coasts of the United States and to Central America; some spend the winter in Florida.

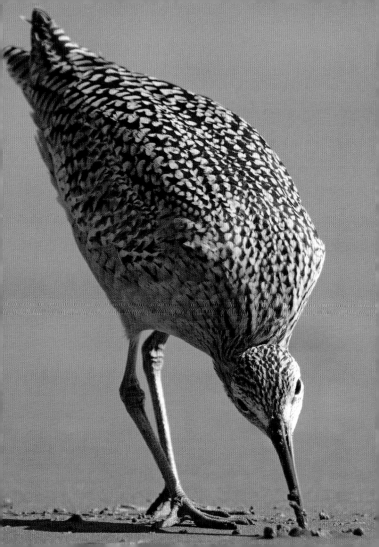

Common pheasant

To speak of the pheasant, if you are neither a hunter nor a butcher, is not easy. This poor beast has a hard life, for it is most often raised on a farm for food. It does not attract much attention from ornithologists or naturalists. However, it must be acknowledged that, as is true for all species of pheasant, the male is a glorious bird.

The common pheasant was introduced ages ago in Europe, and only somewhat later in America, as a game bird. It is really a native of the superb landscapes of Asia: great old-growth forests and idyllic places where the mountains touch the sky. Yet this animal, if it is not domesticated, is displaced into the huge and dreary plains and, once hunting season opens, is vulnerable to being tracked down and slain. It is worth taking the trouble to observe the pheasant, to understand its habits and behavior. Obviously, it is best to avoid doing so amid the baying of hounds and the sound of gunfire.

On the edge of the road this evening, a female is leading her chicks. I watch this little family with tenderness—and with fear, as well. For before Christmas comes, most of them will have passed from life into death.

The common pheasant, *Phasianus colchicus*, was introduced in Europe during the Middle Ages, perhaps even in Roman times. The "colchicus" of the Latin name refers to the ancient kingdom of Colchis, in what is now part of the country of Georgia. But the species is found all over Asia, reaching as far as China in the east.

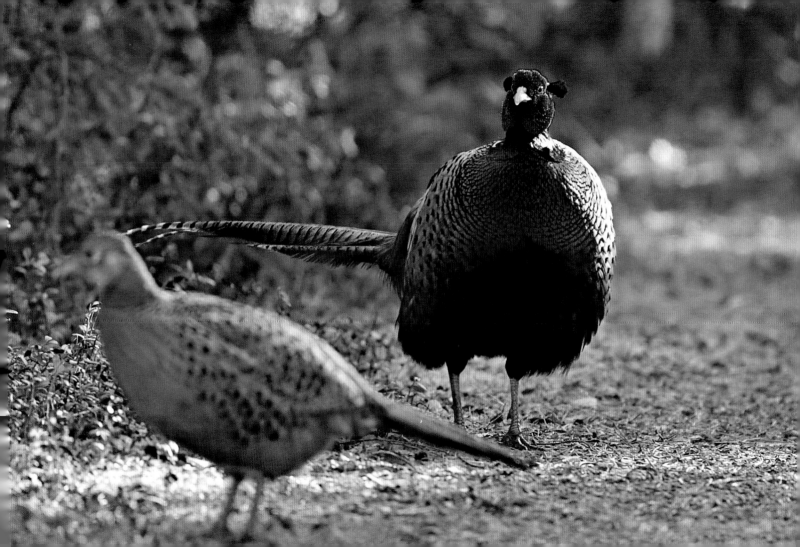

European goldfinch

For many birds, it is the end of the summer: fall is already here and migration has begun. In the tall poplars along the edge of the road, near the house, the goldfinches have been reassembling into a flock for several days. There are the adults, always brilliantly dressed in bright colors, and with them now are their young, as well. These juveniles are drabber, with a gray-brown head instead of the red mask and black crown and nape of their parents. The whole little society is singing loudly, with shrill and clattering cries of *stiklitt!* and *didelitt!* The birds come and go between the branches of the trees and the thistle bushes at their feet. There, balancing carefully, sometimes with their heads below their feet, they peel their beloved thistle seeds and eat them. (In French the species is known as the *chardonneret elegant*, which refers to the birds' love of the thistle, or *chardon*.)

Sometimes, without anyone knowing just why, the whole flock takes off, jaunt through the air, circle a few times, and return to the spot they started from. And then they continue to delight us with their babble and beautiful colors.

For humans, the summer is drawing to a close, but for the goldfinches it will soon be time to depart for slightly warmer lands.

The European goldfinch, *Carduelis carduelis*, is found in all of Europe, North Africa, and the Middle East, and beyond as far as central Asia. The most eastern and northern populations are migratory, but over rather short distances. Most of the European population spend the winter on the Mediterranean coast.

23

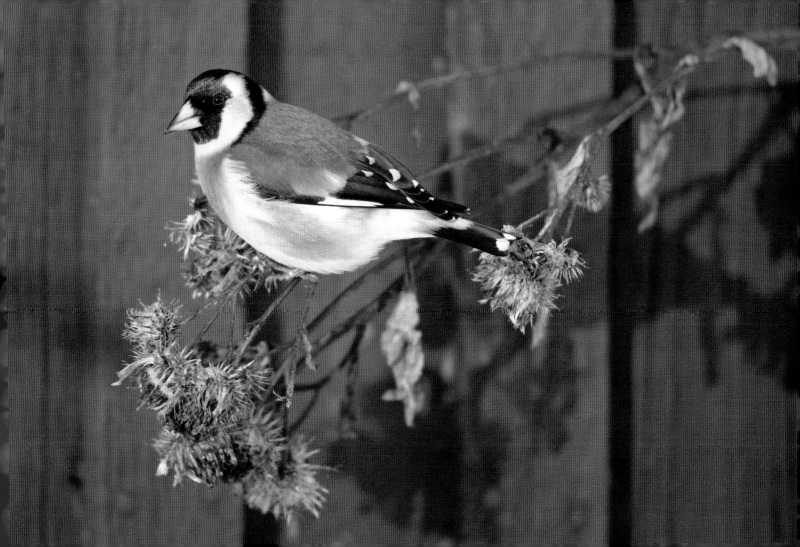

Purple swamphen

For a giant, colorful bird, this swamphen is hard to spot. It most often betrays its presence with its cries, which are fairly strange and resemble trumpet blasts. Then, with a little patience, you will see it emerge very slowly from the reed bed where it normally stays hidden. With deliberate steps, it skirts the edge of the vegetation, trapping with its long toes one of the reed stalks on which it subsists. Against the gray-brown wall of the reeds, the swamphen's blue plumage, with tinges of green, large red beak, and red legs, stands out in singular fashion.

In Europe, there are few places where you can find this species. It is best to go somewhere where you can see them in significant numbers, such as here in the *marismas*, or salt marshes, of the Guadalquivir in Spain. Elsewhere, the species remains localized, unless you go to Asia Minor or tropical Africa. At the latitude of France, the species remains exotic.

We will return here tomorrow morning, early in the morning. At that time of day, the birds will be less shy, and perhaps we will come across three, four, or even more. And we will be surprised to observe so many within such a small area.

AUGUST

24

The purple swamphen, *Porphyrio porphyrio*, is found on the Iberian Peninsula and in the south of France, as well as in North Africa and Egypt. But it is most common in Asia and tropical Africa. It is mostly sedentary, except for the populations of central Asia, which flee the cold in winter.

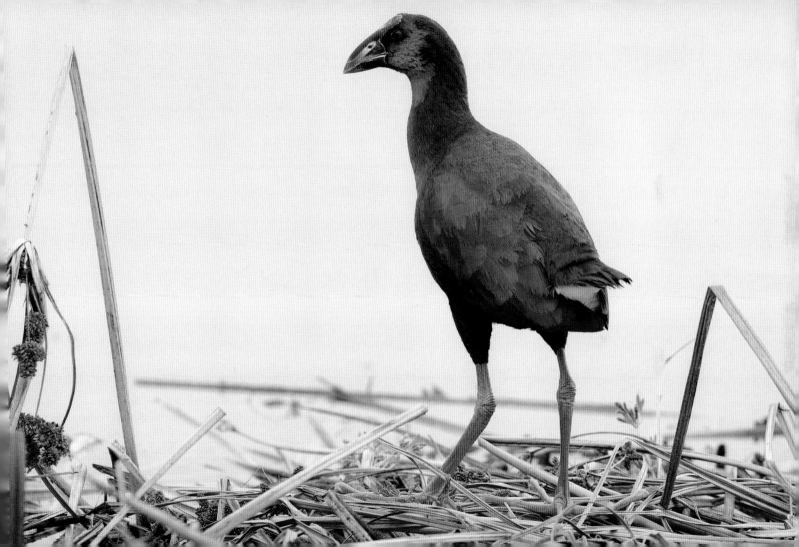

Baird's sandpiper

A crowd of sandpipers jostles on the edge of the coast at Año Nuevo State Park, in California. Next to the elephant seals, which are the main attraction at this nature preserve, the little shorebirds lay in food reserves before flying off toward South America. Among the semipalmated and least sandpipers are some that are slightly larger, with elongated bodies and with chests covered in fine streaks that stop cleanly at their cream-colored bellies. With the aid of a telescope, I am able to identify these birds as Baird's sandpipers. They have nested very high in the Canadian tundra and now are flying very far to the south, reaching anywhere from Ecuador to Chile. For the moment, they gorge themselves, like the other sandpipers, on the myriad sand hoppers that swarm on the wet sand left by the tides. Completely absorbed in their meal, they easily allow themselves to be approached. I have traded my telescope for binoculars, and at the moment I am having trouble focusing them. So I decide to observe the birds without them. And it is funny how much smaller they now seem. From time to time, one of them watches me out of the corner of an eye, but soon enough it returns to gorging itself.

A Nearctic species (that is, one that lives in the northern part of North America), the Baird's sandpiper, *Calidris bairdii*, nests in the Canadian and Alaskan Arctic. It crosses the rest of the continent in the course of its migration to the southern half of South America.

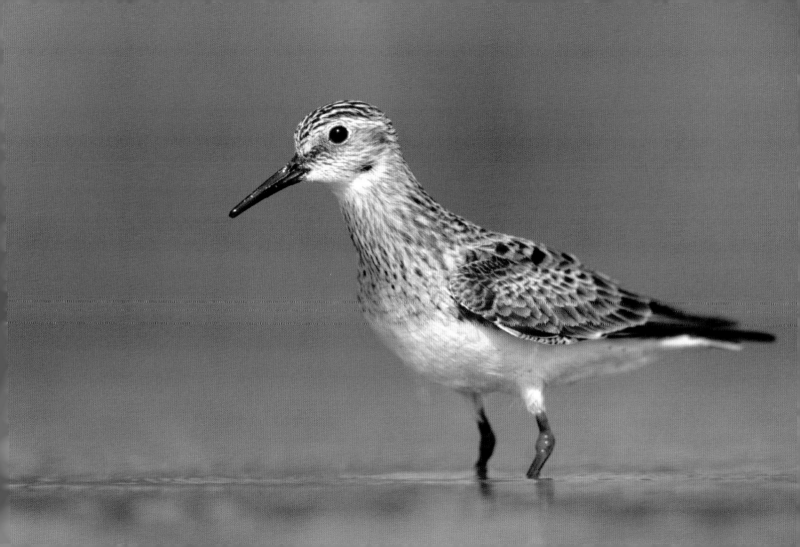

Oxpecker

The African savannah attracts naturalists eager to study the large mammals that roam there and capture their spectacular images on film. Giraffes, elephants, rhinoceros, buffalo, and zebras are all actors in this remarkable animal drama. And for the ornithologist, all the African mammals have something in common. Perched on their backs are strange brownish birds, busily searching for lice on the animals' skin. These are oxpeckers. They exploit the mammals for the sake of protection and a solidly stocked larder—but in exchange, they keep their carriers free of ticks, fleas, and other pests. Scientists call this "mutualism": each organism benefits from the presence of the other.

With their powerful beaks—yellow or red, depending on the species—to dig out parasites, and their large white eyes, the oxpeckers, gripping tightly onto the backs of their mounts, seem not at all impressed by the giant masses on which they ride. They hardly let go, except to switch occasionally from one mount to another. And a number of birds—sometimes a dozen—may be found on the back of the same animal, seeking to outdo one another in finding tiny bugs to eat.

AUGUST

26

There are two species of oxpeckers in Africa: the red-billed oxpecker, *Buphagus erythrohynchus,* of East Africa and the yellow-billed oxpecker, *Buphagus africanus*, which is found over a large part of the continent. Both behave similarly with regard to large fauna, from whose skin they pick parasites.

Arctic tern

At this time of year, the Arctic terns have left the Arctic. They are en route to sub-Antarctic waters, one leg in an annual round-trip journey that covers up to 44,000 miles (70,000 kilometers). In the end, they fly around the whole world.

For the moment, the birds have made a stopover—at least those that rest at all—in the temperate waters of the Atlantic, and with luck, one or two of the birds may be seen fishing in a port, in the company of other "local" terns. But it is by watching birds on the ocean, or sea-watching, that you have the best chance of seeing this species. Closely grazing the water, aided by fair winds, Arctic terns fly south in numerous small groups without stopping, as if pulled along by some invisible magnetism. Around Dakar, I have thus observed thousands of these birds steadily migrating at the end of August, having flown down from the High Arctic, and now hurrying to reach the southern seas again. It is an impressive spectacle to see these great migrators engaged in this immense voyage over water. And it reminds us of our own humble place, poor flightless humans who cannot cover even a mile of ocean on our own.

The Arctic tern, *Sterna paradisaea*, nests all along the Arctic belt in the northern hemisphere. The most southern birds hardly nest any farther than the British Isles. But they are among the most long-distance migrators, capable of flying tens of thousands of miles to escape the winter.

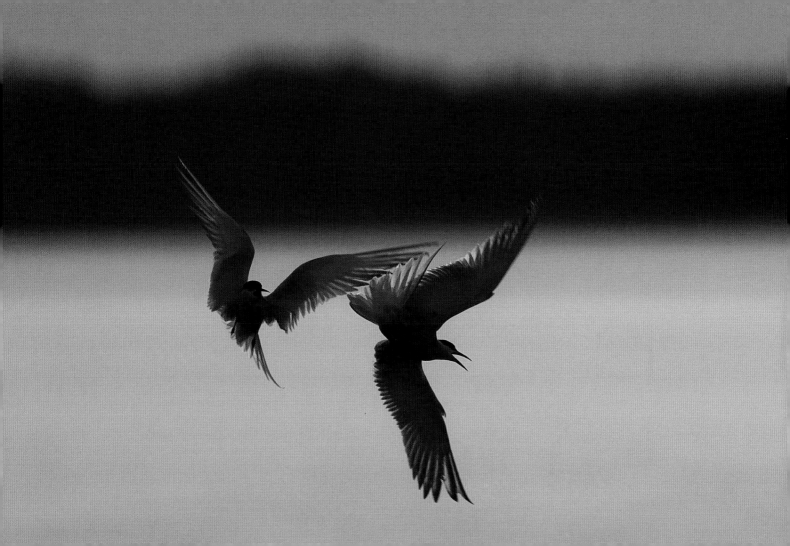

Little bittern

The slightly creaky boat that floats on one of the small branches of the Danube, near where the river pours into the sea, at least allows us a good view of the birds that populate the tall curtain of reeds on both sides. With regularity, we see egrets, herons, ibis, and a few spoonbills take flight. Occasionally, a little shadow with tan and black plumage takes off at the last moment, and rises with difficulty above the reeds, only to dive immediately back into this sea of green. It is a little bittern, the smallest and most secretive of the herons. At this time of year, the young have gained their independence, and, with arrival of migrating bitterns from elsewhere, they are more numerous than usual in the Danube Delta. To observe them now is easier than in springtime. When it nests, the little bittern is more or less invisible; only the strange barking of the male signals its presence.

Now that the boat has cut its motor, we have the good fortune to spot one, perched on a broken reed. But at our arrival, the bird extends its neck to the sky and elongates its body, so much that one can no longer distinguish it among the reeds it is imitating.

The distribution ground of the little bittern, *Ixobrychus minutus*, is vast, since it nests from the south of Spain to central Siberia. It frequents large reed beds and tends to sing at night. The birds are migratory, and spend the winter in tropical Africa and the Indian subcontinent.

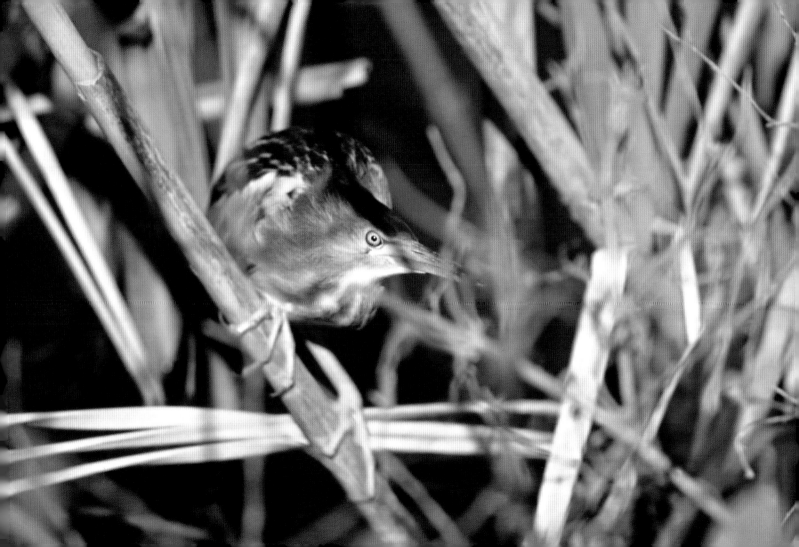

Greater roadrunner

This bird has a fantastic silhouette. It looks as if it came straight out of a cartoon. And for good reason: it is the basis for the famous Roadrunner, the companion and enemy of the no less famous Wile E. Coyote, both created in 1949 under the pencil of animator Chuck Jones.

But then look at the roadrunner: it has a large head with a powerful long beak, a tail much too long for its body, and strong legs built for running. Its name suits it perfectly. The celebrated naturalist Elliott Coues said of it, many years ago, that it was a cross between a woodpecker and a chicken—which is completely apt.

I have never seen it fly, only running, running, running. When it stops, looking a bit concerned, it displays a crest on top of its head; it raises its long tail then slowly lowers it again.

In California, this bird is not rare; it can most easily be found in semi-desert zones. Since we are used to seeing it permanently on the run, it's hard to believe that it belongs to the cuckoo family, those secretive birds always hidden deep in the leaves. The roadrunner is an omnivore; it will eat nearly anything it finds. Truly, it is a bird made for the movies.

The greater roadrunner, *Geococcyx californianus*, lives throughout the southern deserts of the United States and in Mexico. It is sedentary and hardly ever leaves its breeding ground in winter.

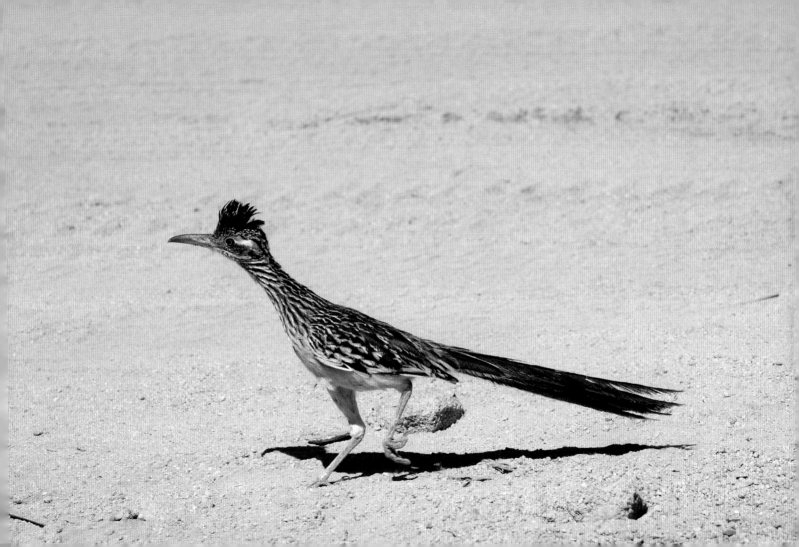

Savannah sparrow

The foghorn echoes this morning around the Point Reyes Bird Observatory in California. It is hard to distinguish the Pacific waters from the fog. But from my first steps around the observatory, it is apparent that a large number of small migratory passerines have arrived. Among them, one species stands out today: the savannah sparrow. These birds are everywhere: in the bushes, on the ground along the paths, on the rocks, in the fields. Each time one of them takes off, you hear a terribly high-pitched *tzic!* When it stands still, there is nothing particularly pleasing about this bird. Like many other species in its family, it is deeply streaked with brown and black on its back, with black streaks on its mostly white underside. A slightly pronounced eyebrow, a little black "mustache," and that is all, in terms of its markings. If these birds were not so abundant this morning, they would pass unnoticed.

In front of me, a bird hops, indifferent to my presence. In the distance, the foghorn reminds us both that the fog is still there. We must both bear our frustration with patience. He must wait for better visibility in order to be able to leave again, and I must wait to continue my observations under better conditions.

A species very widely distributed in North America, the savannah sparrow, *Passerculus sandwichensis*, is a typical bird of the continent. It nests from the extreme north of Alaska to the south of the United States, where many birds winter, as well as in Mexico.

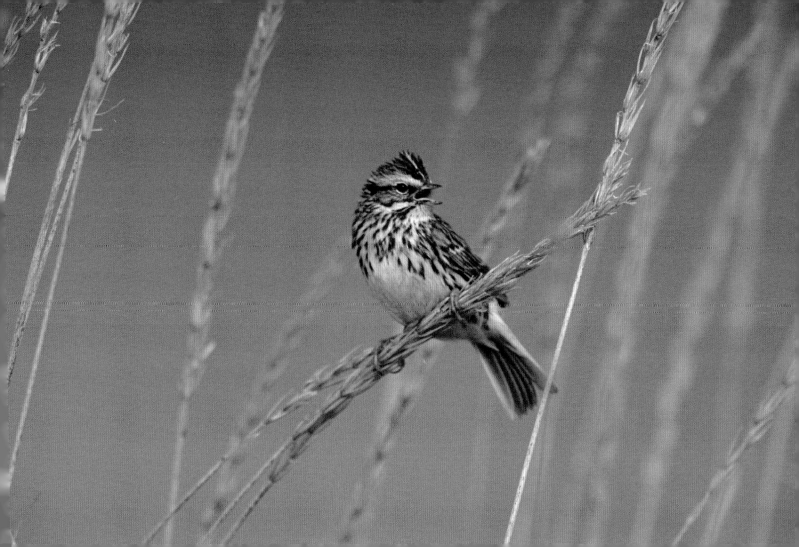

Black oystercatcher

My first encounter with the black oystercatcher was also on the Pacific coast of the United States, in the state of Washington this time, more specifically on the gorgeous Olympic Peninsula. There, the beaches are strewn with big trunks of dead trees carried by the sea, and, in the distance, I could see islands buried in a light fog, from which only the tops of those same trees emerged. On a pebbled beach, I saw my first black oystercatcher. It was clad all in black, with just an orange-red beak and pink legs.

The birds were searching for mussels or oysters on the surrounding rocks. Here, the temperate rain forest with its giant tree ferns descends right to the edge of the gray sea. As I followed the path offshore of an oystercatcher that had just taken off over the waves, I caught sight of a whale sounding. In this landscape, which seemed to me suddenly like virgin land clear of all human presence, the oystercatchers were the only thing that gave life to the scene. In this world before humankind, the mystical shadows of the enormous fir and spruce trees created an even more magical atmosphere.

The black oystercatcher, *Haematopus bachmani*, is loyal to the Pacific coast of North America, from the south of Alaska to Baja California. Only the most northern birds migrate a short distance south in the fall.

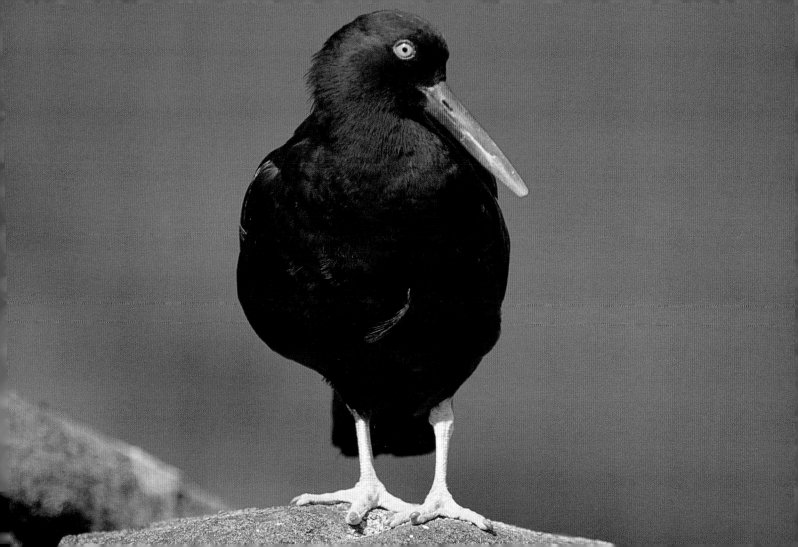

Sultan tit

SEPTEMBER I

When tits come to the bird feeder, it's impossible to miss them. And certain species in this well-known bird family are often praised for their grace, even for the beauty of their colors and shapes. The blue tits, great tits, and crested tits of Europe, and the tufted titmice, chestnut-backed chickadees, and mountain chickadees of North America are some of the most beautiful.

However, a little foray into Southeast Asia allows us to see a bird in this family that outclasses all the others—to my eyes, anyway. This is the sultan tit. Two times bigger than its fellows, all dressed in black and yellow, bearer of a majestic yellow crest on top of its head, it cuts a fine figure. In a flock of tits from our temperate regions, it would stand out immediately. And the faithful companions of our bird feeders would no doubt cede it a place and pay homage.

In addition, the sultan tit has a powerful voice. Its song, strong and a little rasping, is well in accordance with its size, as are its lightly raucous cries. It sounds nothing like the tart and crystalline notes of its cousins in Europe and America.

The sultan tit, *Melanochlora sultanea*, is found in all the tropical forests of Nepal and here and there in China, by way of all of Southeast Asia. It is completely resident.

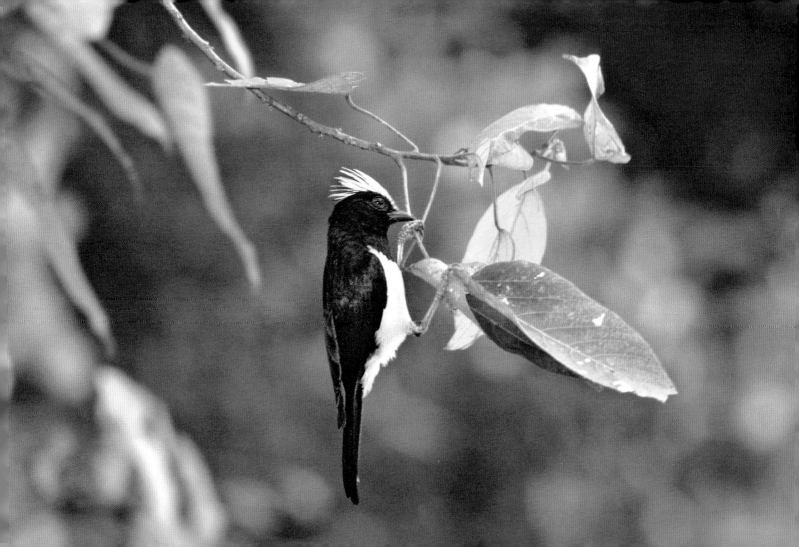

Victoria crowned pigeon

I have still never been lucky enough to see this fabulous pigeon in nature. Until I do, I must content myself with admiring it in zoos, behind the bars of a cage. Each time I've seen it I have imagined myself in a nearly impenetrable forest in New Guinea, catching my breath as I observe a little troupe of crowned pigeons prowling over the ground, in search of seeds or fallen fruits. This pigeon looks as if it has stolen a peacock's tail to wear on its head. With such an accessory, and despite the lackluster colors of its plumage, tending toward gray, it never passes unnoticed. When disturbed, apparently, it may take off, beating its wings with a great noise, to perch at the top of a palm or a big bushy tree. But those I have seen did not have to fly much in order to reach the small branch placed in the cage for their use.

With its beautiful costume, it is easy to understand why people in distant lands hunted the Victoria crowned pigeon and used its feathers to adorn their leaders. Partly because of this history, the species, though not endangered, has become highly vulnerable. But deforestation and the destruction of its habitat have emerged as a much greater threat, at the end of the day, than the few plumes that ended up being worn by humans.

There are three species of crowned pigeons in the world. The Victoria crowned pigeon, *Goura victoria*, inhabits the north of New Guinea. Another species lives in the south, and a third is more closely contained in the western region. All are sedentary.

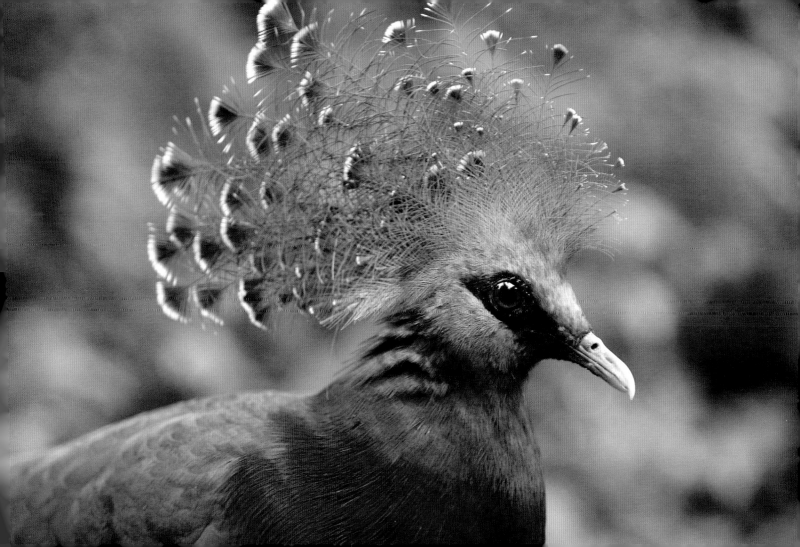

Wilson's storm petrel

There are two ways to observe the impish Wilson's storm petrel. The first is to go out to sea, in the summer or the beginning of fall, between the Irish Sea and the south of the Gulf of Gascogne, or else off the east coast of the United States—and then wait. With patience and determination, you may finally see a Wilson's storm petrel. Having arrived from the southern hemisphere, some birds fly farther north after the reproductive period, or after their "childhood" in the case of the juveniles. They can be observed as far north as the temperate latitudes of the northern Atlantic—to the west in particular. For the bird-watcher, it is obviously a thrilling moment when you see this tiny bird playing among the waves (and a nerve-racking one when it disappears behind them).

The other option, which is significantly more onerous but more likely to bear fruit, is to head out to the waters off South Africa or South America, or, better yet, to the oceans of the Antarctic or sub-Antarctic, in search of these seabirds. There, the Wilson's storm petrels abound—they will be everywhere around your boat—mingling easily with other species. And then, you will have the chance to see how small this bird is when you compare it to its neighbor, the albatross.

The Wilson's storm petrel, *Oceanites oceanicus*, reproduces for the most part on the islands of the sub-Antarctic and on the Antarctic coast. After the nesting period, the species disperses through all the southern seas, but also flies up north and beyond the equator.

Black-necked grebe

The summer is ending, especially for the birds. Among certain species such as the black-necked grebe, it is the period when all the birds look the same, and the adults and that year's juveniles are now indistinguishable. The adults have lost their beautiful colors of red, black, and gold for a much more austere winter plumage that features only a muddy black and white. Here, on a sedimentation tank in the south of England, three of these birds have gathered. Observing them with the telescope, one can no longer distinguish any bright note except their red eyes. Much farther away, even farther west than the Rocky Mountains, tens of thousands of birds have formed a crowd more than a mile long on Mono Lake in California. The inland waters are usually no more than a rest stop, with the birds then flying on to the coast. There, they will spend the winter, rarely venturing far out to sea, but instead seeking out the quietude of a shallow bay sheltered from the prevailing winds.

We must then await the spring. Starting in the month of March, the black-necked grebe will once again appear in its elegant breeding plumage.

The black-necked grebe, *Podiceps nigricollis*, also known as the eared grebe, is a very widely distributed species. It can be found nesting in the western United States and the south of Canada and over a large part of Europe spanning as far as central Asia, as well as in southern China and South Africa. A great number of the birds are migratory and travel in winter toward the seacoast.

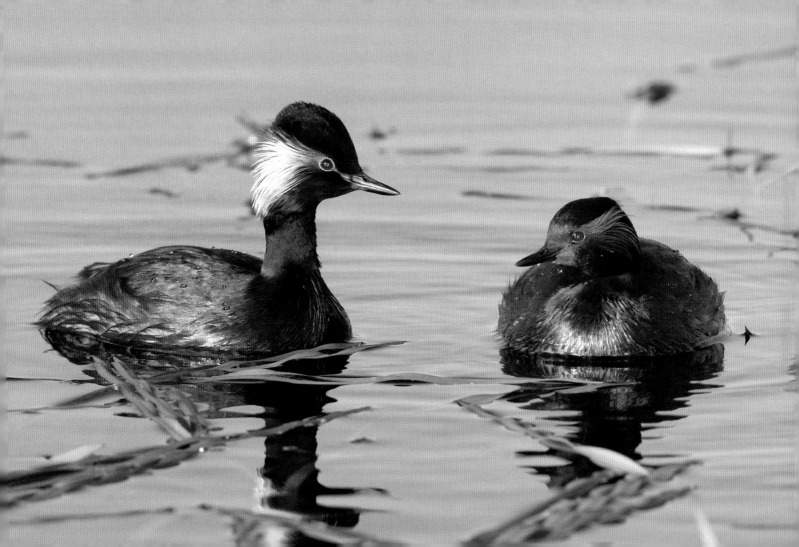

Whitethroat

In the first days of September, many passerines who in the spring returned from Africa to nest in Europe must now make the journey in reverse. The trip, if all goes well, will carry them back to the warm land of Africa. This is the season when you see warblers, and the whitethroat in particular, stuffing themselves with berries and ripe fruit in order to build up their reserves, so that they can make this migration under the best conditions. For the whitethroat, like other migrators, must usually cross a good part of Europe, and certainly the Mediterranean, before even getting to the dangerous trial of the Sahara. For some birds, alas, wintering in Africa will remain little more than a pipe dream; they will meet death during their journey, perhaps on some burning dune of the great desert. Thus there is no time to lose, and the rush is on to eat, eat, eat. The fruit the whitethroat consumes will turn to fat, giving it a round belly but enabling it to fly over a long distance. The bird will also gain nourishment eating the last insects of the summer.

The whitethroat we are watching for the moment, this September morning, is a young bird enjoying some blackberries, still ignorant of the perils to come.

The whitethroat, *Sylvia communis*, nests from North Africa to central Asia and in most of Europe. A migrator, it leaves Europe for the fall and winter, taking up residence primarily in the Sahel, just south of the Sahara.

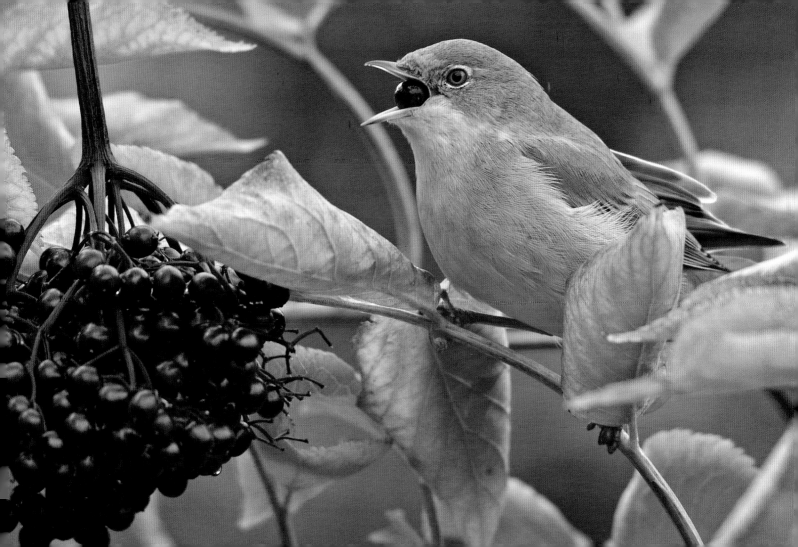

Dunlin

At the back of the bay, at low tide, the exposed mudflats spread as far as the eye can see. Birds that have stopped to rest in the course of their migration come here in droves to search for food. Worms, mollusks, tiny crabs, all are here for the taking. A compact flurry of little birds flies over the sunlit silt, and the white undersides of their wings flash with each change in direction. They are a flock of dunlins, ready to put on a show with their aerial maneuvers. These acrobatic pilots of the sky rapidly come and go, pretending to land only to jet off for another whirl over the mudflats. One wonders just what is keeping them, at the last minute, from coming to earth. There is no predator on the horizon. A second pass, and a few birds touch down, but the rest of the squadron soars upward again, so high that the daring birds who landed, no doubt feeling themselves abandoned, take off again and quickly rejoin the rest of the pack.

At the fifth or sixth pass, the birds finally settle down—and all at once. Barely have they landed than they seem seized with a frantic appetite. They begin pecking away at top speed, walking with quick steps as they probe the soft mud with their beaks. Enough of the airborne acrobatics: now there is not a second to lose.

Nesting all along the circumpolar tundra, the dunlin, *Calidris alpina*, winters from the temperate zones of the northern hemisphere down to southern and tropical latitudes. It is a type of sandpiper, and certainly the most common.

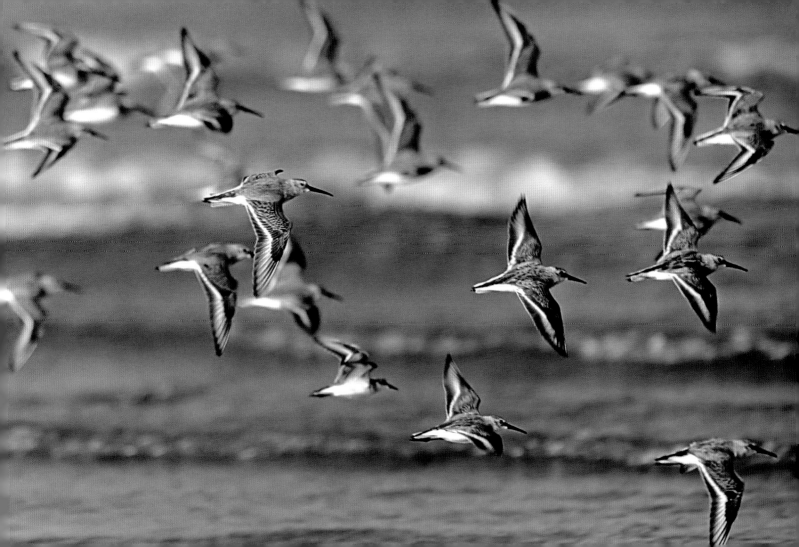

Burrowing owl

The Palo Alto Baylands, to the south of San Francisco, are an incredible place to observe birds. Along the paths that border the great stretches of water, joggers and walkers mingle with bird-watchers, all under the indifferent regard of the birds. A little off these paths, in a grassy area, one can see holes here and there dug in the ground. Out of one an owl suddenly emerges. This is the well-protected territory of the burrowing owl.

If you took the little owl of Europe and gave it a big pair of feet, you would get a burrowing owl. Through my binoculars, I spotted three other birds, perched on a little hillock not far from a hole. This owl is a social creature and may thus form small colonies. While observing the owls here for more than an hour, I saw one on top of a little post let itself drop down onto its prey, an unlucky passing insect. Another, with funny little bounds, chased after a grasshopper, and finally captured it with aplomb.

Farther south, in the desert of Arizona, I saw burrowing owls in larger numbers, scanning their surroundings like prairie dogs.

The burrowing owl, *Athene cunicularia*, is present in the southeast quadrant of North America, in Central America, and as far south as Tierra del Fuego. It likes prairie habitats or desert areas, as long as there are old burrows in which it can nest.

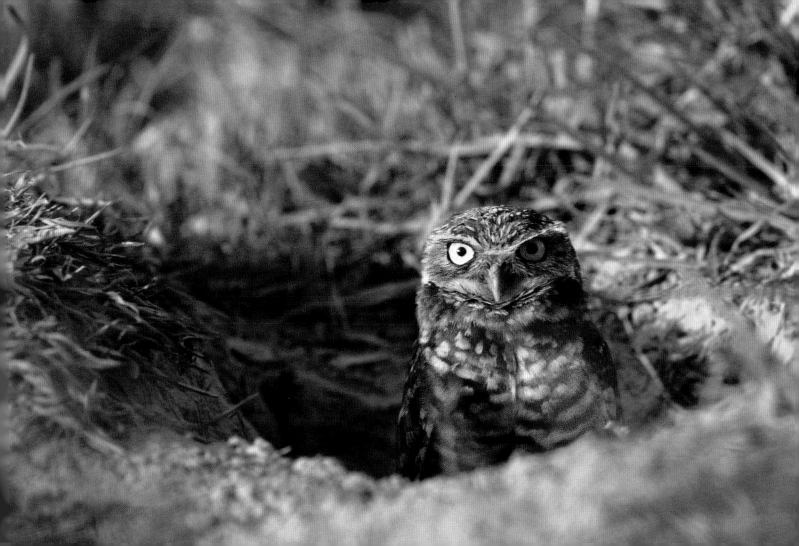

Spotted nutcracker

At this time of the year, the forest can appear particularly barren of birds. Here in the southern Alps, the larch needles are beginning to turn yellow. One can walk for a long time, at nearly 6000 feet (1800 meters) above sea level, without encountering anything more than a few coal tits or a little group of chaffinches.

All of a sudden, a slightly muffled cawing is heard in a valley below this path snaking through the trees. A brown shadow slipping away: that's all we see. But the cry is characteristic enough to confirm that the bird was a spotted nutcracker.

At this time of the year, the bird is secretive. Like its close cousin the Eurasian jay, it is busy hiding away seeds for the winter. It has so many hiding places that it will forget some of them over these next months. But this is at least a good way of planting trees.

With a little patience, I finally discover the bird, perched at the top of a larch. It is hardly more than a silhouette, but I am able to make out its strong beak and distinctive stocky body. Before I can approach for a better look, it sees me. Taking off with indignant cries, it disappears into the dense autumn forest, this time for good.

SEPTEMBER 8

The spotted nutcracker, *Nucifraga caryocatactes*, is found in the Alps and from Scandinavia to Siberia. The birds of the latter region sometimes make forays into the west when seeds become sparse in the fall.

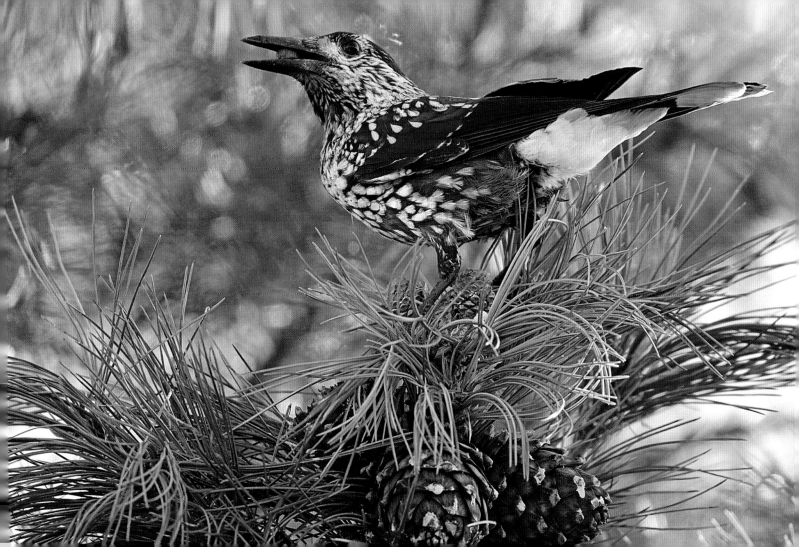

Sooty shearwater

The wind blew fiercely last night, and this morning, it is blowing out of the northwest. These are ideal conditions for observing the migration of seabirds. Recently settled on the cliff that dominates the pale green and blue sea, the birds file past the sights of my telescope: terns, kittiwakes, some skuas. Soon, they are joined by a bird that is entirely dark, with long rigid wings, and that seems to be playing amid the wind and waves. It is a sooty shearwater. Driven by the winds, this bird has ventured as far as the North Sea and is now headed back to the Atlantic, via the English Channel. To the shearwater, flying an extra few thousand miles is no trouble. Three or four flaps of the wings, then long glides over the waves: this is how it makes its rapid way along the coast. It will soon overtake any terns or gulls, which in comparison might as well be flying into the wind.

Once it leaves the southern hemisphere where it nests, the sooty shearwater traces its route over all the oceans of the world. It travels far to the north, then descends back to the south to begin a new breeding cycle. In this way, it will fly tens of thousands of miles over the most raging seas—for it flies most easily on the back of powerful winds. If faced with a calm sea, it will touch down and await the next storm.

The sooty shearwater, *Puffinus griseus*, nests on the islets of the southern hemisphere, near Chile, the Falkland Islands, southeast Australia, and New Zealand. After its eggs hatch, the shearwater disperses throughout the world's oceans.

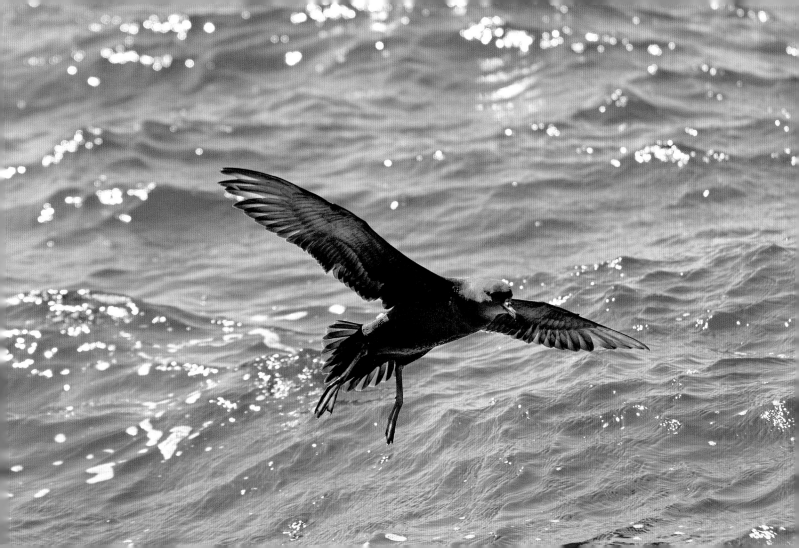

Sunbittern

The name of this bird may mean nothing to you, but that reference to the sun indicates that there is something special about it. And the sunbittern is indeed a special bird. First of all, it is the only member of its family, the Eurypygidae. It has no close relatives, only very distant ones, like the celebrated kagu of New Caledonia.

When the bird is at rest, one is struck by the delicate patterns that ornament its gray back and its pretty reddish neck, while at the same time its head is boldly marked with black and white. It has a long beak. Too long, perhaps, compared to its head, which would have been better supported by a longer neck. And when it walks, it seems a little short in the leg! This bird is not, in other words, a model of elegance. At least in its present position. But if you surprise a sunbittern brooding on its nest, in the heart of a tropical rain forest in South America, you will truly appreciate the glory of the sunbittern. Faced with an intruder, it suddenly spreads its wings—which is an astounding sight. You will see two enormous butterfly wings, with black and red eyespots like two huge eyes staring back at you. For a potential predator confronted with this terrifying gaze, there is no alternative but to flee. In this domain, the sunbittern is the uncontested master of the avian world.

The sunbittern, *Eurypyga helias*, nests in the forests that span from Guatemala to the Amazon basin in the middle of Brazil. It is a strictly resident species. The plumage, with its linear patterns, provides excellent camouflage in the forest.

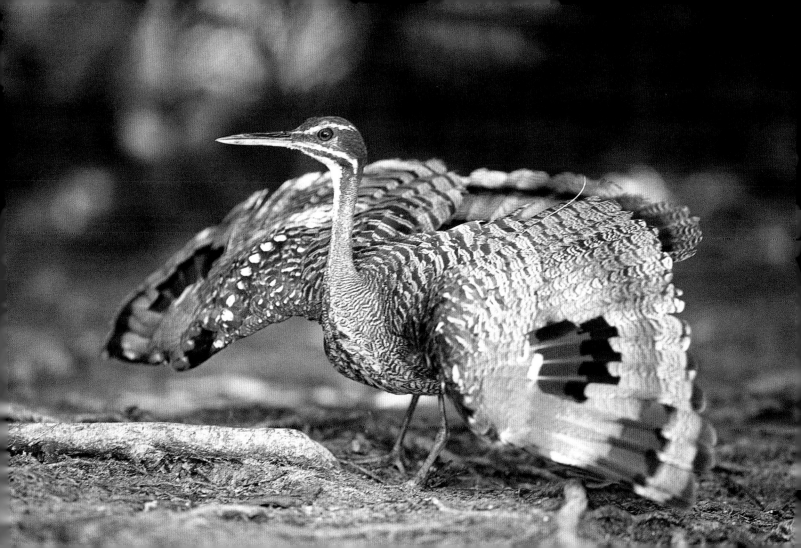

Northern flicker

On Cape May, in New Jersey, it is the season of great migrations. The ornithologists search among the hundreds of warblers for rare species, perhaps ones that have strayed far afield from their usual home on the West Coast. No one seems interested in this flicker, as it serenely traces a path along an ancient tree trunk.

With its brown back dotted with black and the gray and black feathers of its head, the flicker blends in beautifully with the bark. If you look at it head-on, only its bib and a few fat black dots decorating its belly stand out from the tan background of its plumage. It is in flight that the northern flicker is more likely to catch your eye. Then it displays the white rump that contrasts with its black tail and with the bright yellow underside of the wing—the source of its Latin name *auratus*, or "golden."

While the bird pursues its highly detailed analysis of the trunk, from time to time it gives a rather shrill cry of *kiou!* A little later, it makes a series of sounds, *wik…wik…wik…wik!* These are a little closer to the typical vocalizations of woodpeckers, the family to which the northern flicker belongs.

But now the bird comes down to the ground and begins to avidly gobble up tiny creatures there. Intrigued, we approach, only to provoke our flicker to take flight. And we discover that the bird was gorging on ants that had unwisely set up camp at the bottom of the old trunk.

The northern flicker, *Colaptes auratus*, is present over all of North America, and it is one of the most common varieties of woodpeckers. The birds that nest in the most northern regions are migratory, while the rest are resident.

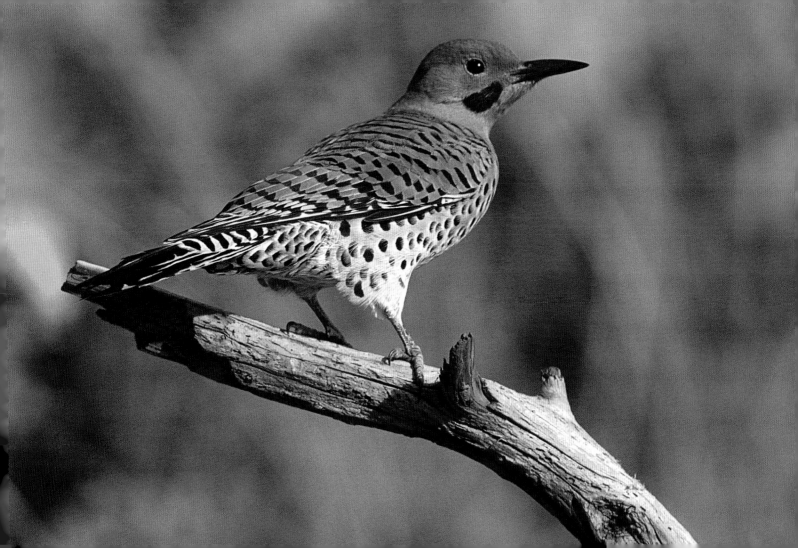

Linnet

The little group of birds has flown off from the Baroque grapevines, where they were evidently looking for food. There they are, flying and filling the air with their high, joyous cries. Now the birds have already landed again, in nearly the same spot they flew off from. Among them are the year's juveniles; with their feathers finely streaked with gray, they might easily pass unnoticed. The female linnets have brown backs that distinguish them, while the males alone display beautiful rose-red marks on their chests. Their perfect breeding plumage is already a little dulled by this time of year.

Like the goldfinch (see August 23), its close cousin, the linnet is a joyful bird. The dance that the linnets perform between the grapevines, taking off and landing at who knows what whim, suggests a certain insouciance. And also an indifference to the shortening days.

In observing them, I can't help remembering that this species, still common here in the southwest of France, is in alarming decline in some regions of the country. Too much a bird of the countryside, it is adapting poorly to the brutal transformations of what has historically been an agricultural habitat. Someday, perhaps, the cries of the linnet will be no more than a memory.

The linnet, *Carduelis cannabina*, nests throughout Europe, as well as in North Africa and a part of the Middle East. Many of the birds are migratory and spend the winter around the Mediterranean, where the temperatures are milder.

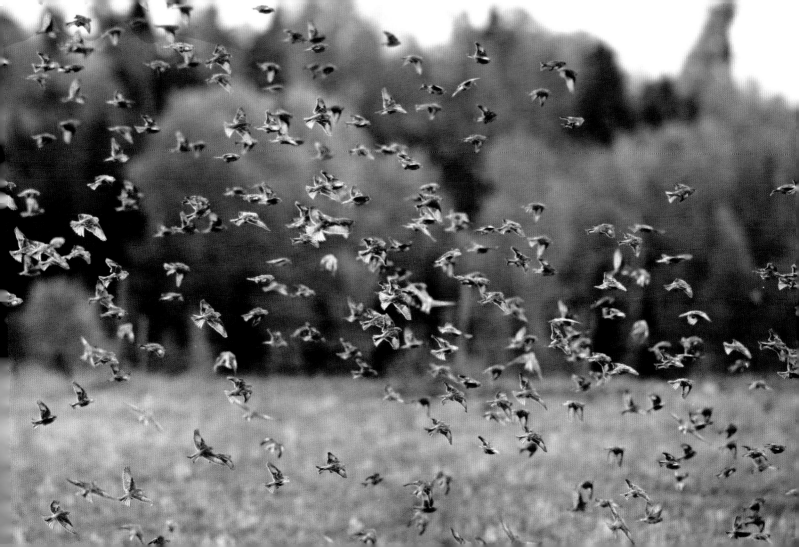

SEA-WATCHERS

In September, at the first indication of a squall offshore, all ornithologists know to go dig out their boots, put on their windbreakers (over warm clothing), and rush to the nearest cape or point. One must first let the body of the storm pass, when the wind carries in the driving rain. Once that phase is over, as the powerful winds continue, dark clouds filled with rain battle with patches of blue sky where the sun has been able to poke through. In Europe, as on the Pacific coast and the eastern shore of the Atlantic, a northwest wind is needed to push the seabirds toward the coast. The stronger the wind, the better. Not necessarily for the birds, but for the sea-watchers.

A great parade then unfolds before scurrying observers armed with telescopes and binoculars. Gannets, shearwaters, storm petrels, gulls, terns, skuas, phalaropes, anything that constitutes a seabird could be expected to make an appearance. The event does not last long—a day or a day and a half at most. This is why, like die-hard surfers, the sea-watchers scan their computer screens for weather warnings with the greatest urgency.

Bundled up and protected by the seawall, sea-watchers often brave violent winds, and these only get colder through the course of the fall. Given such close contact with seabirds, however, sea-watchers are guaranteed at least some moments of great excitement.

Red-legged partridge

On this Greek island, the scrubland is by now both empty of birds and burned by the sun. At the end of the season, many winged visitors left for the south, and it is a long time now since the flowers have faded. The resident animals, however, remain. In the early morning, in the silence of the first hours of day, you can hear raucous cries, below the path that twines through the mastic trees, strawberry trees, and kermes oaks. The red-legged partridges are not far off. *Kot…kottor…kottor!*

You can try to approach on tiptoe, but you will then be wasting your time. Always on the alert, the partridges will have slipped away into the bushy vegetation well before you get a chance to see them. On terrain that is flatter and less covered with bushes, however, you can sometimes surprise them while they retrieve little seeds from the edges of the road. Here, a "covey" of partridges—that is the lovely name for a group of these birds—explores with small steps the loose stones strewn with white gravel, where thyme and lavender grow. One of the birds keeps its head raised to scan the surroundings. Then it continues its search for seeds or tiny insects. Another has already craned its neck to watch. Among the birds are the year's juveniles, with less sparkling plumage than that of the adults.

A completely sedentary species, the red-legged partridge, *Alectoris rufa*, lives principally in the Mediterranean basin. Its various introductions as a game bird have transported it as far north as Great Britain. Originally, in fact, the species was found in the wild in France beyond the Loire.

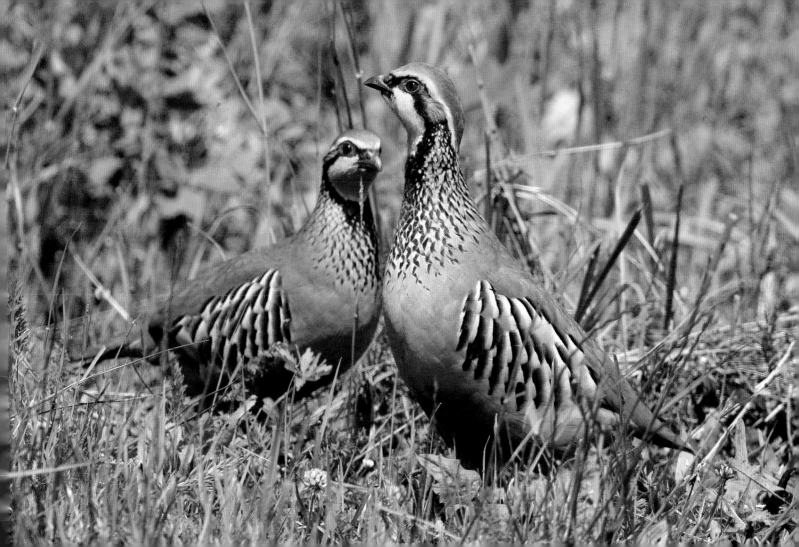

Eurasian dotterel

In my life as an ornithologist few birds have fascinated me as much as the Eurasian dotterel. My most beautiful memories of them are from the dunes carved out by time along the Bay of Audierne, in Brittany. Three young birds were standing, one September morning, on the cropped grass, not far from the Point de la Torche. They had just arrived from their distant Scandinavian tundra and no doubt were seeing a human for the first time in their lives. And so they allowed themselves to be approached at incredibly short distances. Having sat down, I watched them approach me, pecking nervously after a little run of a few feet, fixing me with their big round black eyes. But my presence seemed not to bother them at all: they came steadily toward me. Soon, one of them was only two or three yards away. If a barking dog had not gone by in the distance, causing the birds to retreat, I might perhaps have ended up touching them.

The Eurasian dotterel has long paid a price for this boldness. In crossing France, it was a special target for unscrupulous (and not very sporting) hunters. Though it is protected today, its numbers remain small.

The Eurasian dotterel, *Charadrius morinellus*, nests principally in the Scandinavian and Siberian tundra, but also in Scotland. It spends the winter on the arid plateaus of North Africa and the Middle East and thus passes through Europe twice a year. It shows itself more readily in the fall than in the spring, when it travels at a faster pace.

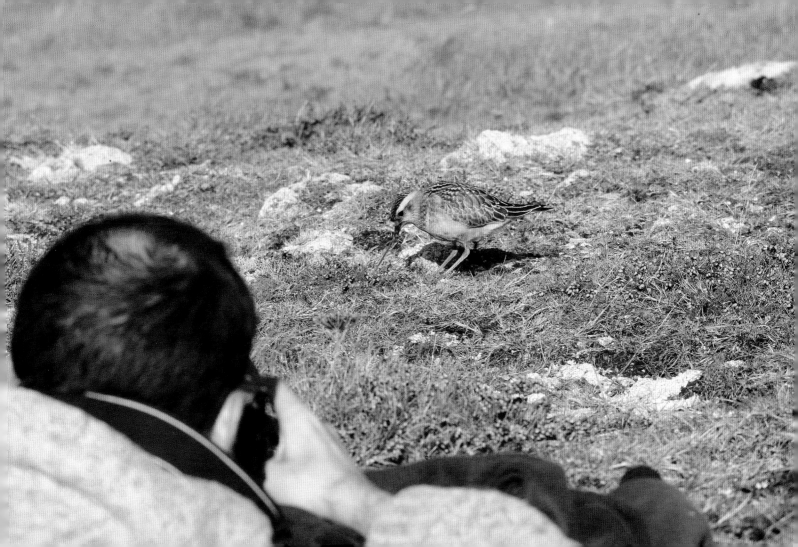

American goldfinch

In the United States, as elsewhere in the temperate regions, it is now the season when the birds gather into flocks to search for food, in anticipation of the icy temperatures of winter. Here in Vermont, the fall brings glorious colors to the trees; the goldfinches, to a limited extent, participate in the display. During the breeding season the plumage of the males was bright yellow, with black wings and caps. At this time of year, most take on a browner plumage, but certain among them still wear their flamboyant summer costume. The females and young birds, yellowish or brownish, are much more drab. Like the European goldfinches, they have a leaping flight and are hardly ever still. At the least danger, real or supposed, the flock swoops into the air, circles, and comes back to land on the thistles that border this wood filled with multicolored leaves.

All the goldfinches of the world are the same: gregarious, joyous, and colorful. That is why I never get tired of watching them. In a few weeks, the cold will strike here, and the goldfinches will have run off to Florida or Texas, or elsewhere in the south, happy as retirees to spend the winter in the sun.

The American goldfinch, *Carduelis tristis*, nests in a large part of southern Canada and in the United States. Many birds that nest in the north spend the winter in the southern part of the United States. The southern populations are resident and do not move much in the fall.

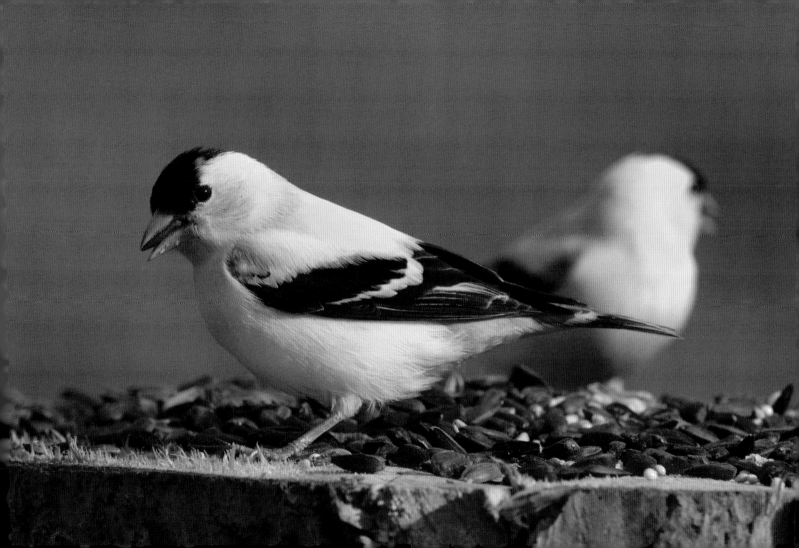

Sabine's gull

The Sabine's gull is the light at the end of the tunnel, paying back the loyal sea-watcher for many gloomy hours spent in the cold and wind, scanning the sea and counting the seabirds that fly past. This pretty gull from the High Arctic unites aesthetics with grace. Its airy, nimble flight recalls that of the tern, while its plumage, made up of gray, black, and white triangles, seems perfectly designed.

I have spent hundreds of hours watching the migrations of seabirds in France and elsewhere, and the sight of one of these birds in Brittany or off the American West Coast is always a powerful moment. Then came the day when, in Dakar, Senegal, I encountered thousands of Sabine's gulls streaming by. There my emotion was at its height. As evening announced its presence over the darkening ocean, I watched the gulls pass, skimming the water and heading due south toward distant sub-Antarctic seas, after they had emerged directly from the lands of the Arctic. It was an unforgettable event in the life of an ornithologist.

SEPTEMBER

17

Closely linked in summer to the circum-Arctic tundra, the Sabine's gull, *Larus sabini*, nests at very high latitudes. In fall, it leaves these place to head, via the Atlantic or Pacific, for sub-Antarctic waters. It will spend the winter in those southern seas.

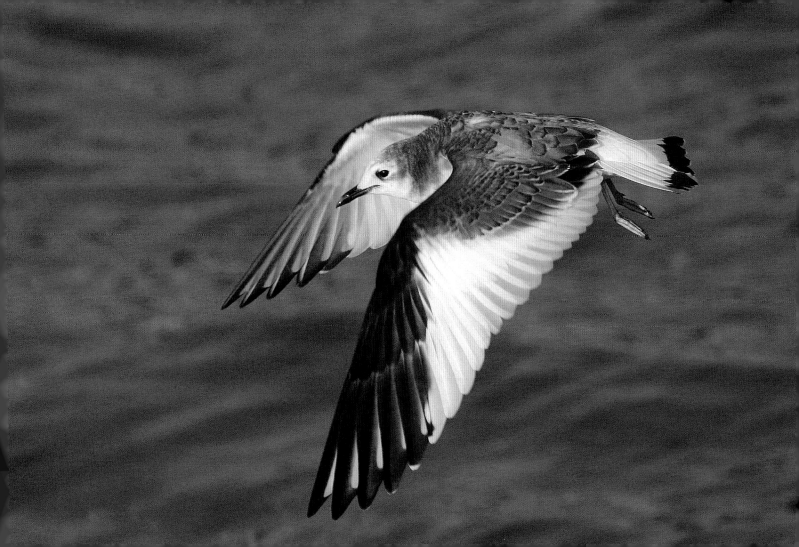

Barn swallow

A common proverb warns us that "one swallow doesn't make a spring." True, but an assembly of swallows on the power lines, one fine morning in September, is a sure indication of fall. The birds, both adults and juveniles, land, take off, and return again, all with a chorus of sharp little cries. They certainly have much to discuss: the current weather (favorable or not for an imminent departure) and the weather to come (important in guiding a perilous itinerary of many thousands of miles). Observing them is a little like watching the beginning of a nautical race, with the sailors adjusting their gear and exchanging opinions, hopes, and apprehensions. One can only imagine that amid this general babble, many important and serious things are being said in the language of the swallows.

The assembly continues for several days, and the swallows grow more and more numerous. Then, one day, the site is empty, the power lines deserted. And you look up into the sky: blue, with a light southeast wind. These are ideal weather conditions for a dawn departure toward a far-off destination. And in the sky the migrating barn swallows fly by.

Widely distributed through the world, the barn swallow, *Hirundo rustica*, nests throughout the northern hemisphere and winters in subtropical and tropical regions. Under the influence of the warming climate, a growing number of birds are attempting to spend the winter in higher latitudes, as far north as southern Europe, for example.

SEPTEMBER

18

Pectoral sandpiper

Every fall, the pectoral sandpipers that have nested in the Canadian Arctic descend toward South America, following the great western or central migration routes through North America. You see them in small groups on freshwater ponds and lakes, rummaging through the mud for invertebrates. Observing this little wading bird is routine for the jaded American ornithologist. No doubt the sandpipers are most easily seen during this fall migration, when they pause here and there before leaving for their next stop, a little farther south. In their spring return trip, they are in a hurry to regain their tundra nesting grounds, and their stopovers are thus more brief. But bird-watchers in those regions who go out regularly will see the pectoral sandpiper during both migratory passages.

What may be banal for the American ornithologist is, however, remarkable to their European counterparts. Each fall, thanks to storms out of the west, a few pectoral sandpipers are pushed eastward as far as the European coast. And they are always greeted by a large welcoming committee of ornithologists. Which goes to show that a bird's arrival may have a very different impact depending on where it takes place.

The pectoral sandpiper, *Calidris melanotos*, nests in the tundra of the North American continent, and, in small numbers, in northern Siberia. The birds winter in the southern portion of South America, and also in southeast Australia and in New Zealand.

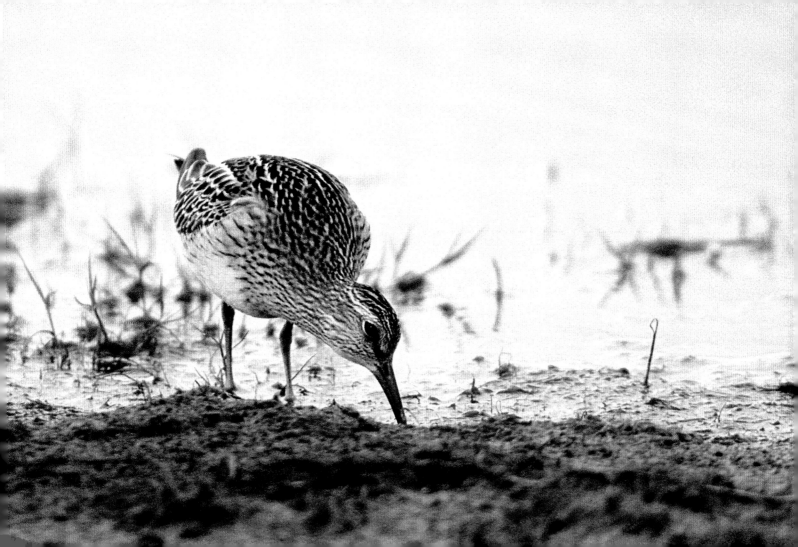

Gray partridge

A few days ago, we were discussing the red-legged partridge. Here is the gray partridge, its cousin. This bird is not a southerner, but rather a habitué of the great crop-growing plains. At this time of year, in the regions where it is still hunted, many of these birds are living out their last peaceful days. At the border of a field of wheat stubble, a few gray partridges are feeding not far from the road. Among them are juveniles who have not yet reached the size of adults—these are this year's chicks. Pursued by hunters, impacted by encroaching farmland and the extensive use of pesticides of all sorts, the gray partridge has seen its European numbers melt away rapidly. Today, population numbers must be artificially increased by the release of game birds, so as not to see them disappear completely.

Watching the little covey soak up the last rays of sun on this beautiful fall day, I think of these birds as the epitome of nature mismanaged by humans, and of a crumbling ecosystem whose resilience seems to weaken from year to year. That this species, once common everywhere that agriculture existed, should become so rare in the wild speaks volumes about the life that surrounds us and about its future—which is ours as well.

SEPTEMBER

20

The gray partridge, *Perdix perdix*, is found in all of temperate Europe and beyond, as far as central Siberia. It is sedentary. The mountain populations and the most southern birds are today the most threatened with extinction.

CAP GRIS-NEZ

Among the French migration sites that I particularly love in the fall, Cap Gris-Nez heads the list. This cape offers you a ringside seat for watching migration in action. We arrive before sunrise. But the darkness is dispelled by the lighthouse there, whose glowing arms cast beams of light over great distances. The first thing to confirm is the direction of the wind. If it is from the west or northwest, it is best to find a sheltered place under the cliff to observe the migration of seabirds, pushed toward the coast by the wind. If it is from the south or southeast, we need to await the break of day to witness the flight of the migrating passerines. Given that it is fall, these may be swallows or yellow wagtails (in September), or larks, pipits, or finches (in October), all filing by in a long stream of birds. And if there is no wind, if the anticyclonic weather has left a night fog that obscures the first moments of day, then we will walk along past the bushes in search of passerines that have migrated during the night and are taking advantage of the day to recuperate.

In this place, and everywhere, there is a magical instant to be experienced at the start of the fall migration.

Situated in the north of France, facing the British coast and the length of the English Channel, Cap Gris-Nez has been long known to Western European ornithologists as a showcase for the passage of migratory birds between the months of August and November.

Turkey vulture

On occasion, in driving on American highways, you may see a group of large black birds gliding along over the prairies and fields, their wings in a slight *V*. When you locate one of these birds perched at the top of a tree, you should be able to distinguish its bare head, covered with bright red skin. It is a turkey vulture. It looks hardly anything like a turkey, aside from its color and bare face. It has a much greater resemblance to the Old World vulture. However, though it has not been proven, these American vultures may be more closely related to storks.

It is in the desert—where the only things that grow are cactus and a few stunted bushes, where the roads are infinitely straight and lined with wooden telephone poles—that you can most expect to see the turkey vulture. It haunts the deserts of the southeast United States, and serves as a faithful companion to the undertaker in Westerns. These birds are necrophages: they eat dead animals, often those hit by cars. But though they are excellent natural undertakers, their somewhat unpleasant faces and unnerving dietary habits remain dead weights on the poor birds' reputations.

22

The turkey vulture, *Cathartes aura*, nests from the extreme south of Canada to Tierra del Fuego, in South America. Only the most northern populations are migratory.

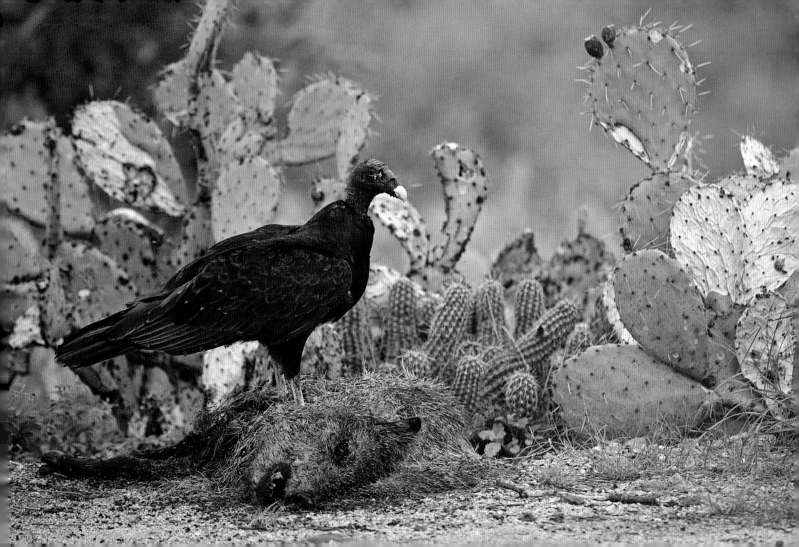

Bar-tailed godwit

Among the birds that travel the longest distances in the course of their migration, the bar-tailed godwit has recently become a recordholder. The insertion of miniature Argos transmitters has allowed us to discover that a bar-tailed godwit, tagged at its breeding site in Alaska, is capable of reaching its wintering ground in New Zealand in a nonstop flight of 7200 miles (11,600 kilometers) over the Pacific Ocean—and in only eight days!

To begin with, this species seems to have nothing exceptional about it. With its long beak, curved slightly up toward the end, and its brown plumage marked with black, it passes relatively unnoticed amid the flocks of little wading birds that stop in the fall to feed on the mudflats. If not for its size, you might even mistake it for a curlew. In the spring, on the other hand, it sports a beautiful breeding plumage of a deep red.

If the species avoids the Americas, the birds of western Siberia and Scandinavia do at least pass through Western Europe. Some settle there for the whole winter, while others, seized with the spirit of the journey, continue on to spend the winter as far away as South Africa. The bar-tailed godwit is truly a champion.

SEPTEMBER

23

The bar-tailed godwit, *Limosa lapponica*, nests in the tundra from Scandinavia to Alaska, via northern Siberia. The birds, depending on their geographic region, winter from Western Europe and Africa to tropical Asia and Australia.

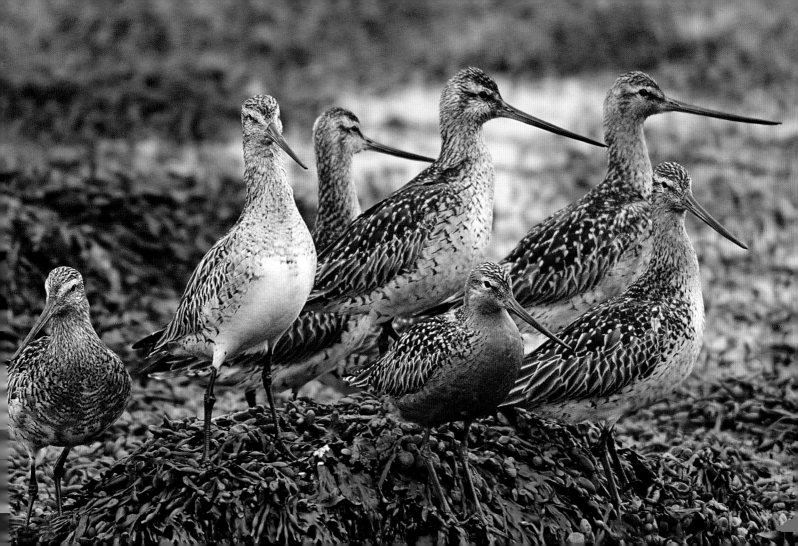

Meadow pipit

Crossing the meadow, where cows and horses are grazing, I startle a little group of passerines into flight. Cries of *psit…psit…psit!* ring out from all sides, as the birds gain a bit of height, flutter, and then settle back to earth a little farther away. A flock of meadow pipits has stopped to rest. They have perhaps arrived from southern Scandinavia and have paused a few hours in the meadow before taking up their route again.

It sometimes happens that I have the chance to observe migration from home, and to count the birds that fly over the city. In September and October, the meadow pipit is always one of the hordes of migrators, along with the finches and thrushes. Often alone, sometimes in twos, or even in a loose little flock, the pipits pass resolutely toward the south and let fly their *psit!* with the regularity of a metronome. All I see of them is a silhouette that stands out against the sky, but their cries betray them. For a few weeks they stream by like this, small, dark, and buoyant, with a slightly jerky flight that is no more than functional. It is best to go look for them in the countryside, at the edge of a swamp or on a beach, when winter arrives. For, in fact, many of these birds will accompany us through those long months.

The meadow pipit, *Anthus pratensis*, nests in Europe and in part of western Siberia. Many of these birds migrate, and they are fond of the Mediterranean coast as a place to spend the winter. They do not like the frost at all. The most reckless of the pipits, those who choose the highest latitudes as a site to spend the winter, are most likely to encounter it, and will then quickly flee.

Parasitic jaeger

Among the numerous seabirds that pass along the Atlantic and Pacific coasts, the jaegers are surely the most remarkable. Agile sailors, long-distance migrators, uncontested pirates of the seas (they feed by acting as parasites on the gulls and terns)—these are superb birds built for flight and distance. To recognize this, you have only to see a parasitic jaeger chasing down a tern to rob it of its fish. The poor tern, its freshly caught prey in its beak, wheels in every direction, making sudden swerves and lightning dives, but the jaeger follows along closely, perfectly matching the tern's trajectory. For the ornithologist, it is an unforgettable display.

The coveted fish often ends up in the beak of the jaeger, when the exasperated tern finally lets go of its prey. There are also times when the jaeger, no doubt exhausted, gives up instead. But in any case, unlike the battle between the cheetah and the antelope, this "kleptoparasitism" (the formal name for such behavior) ends without the death of either combatant. In the end, the tern, like the jaeger, will simply continue its migratory flight, acting as if nothing has happened.

SEPTEMBER

25

The breeding territory of the parasitic jaeger, *Stercorarius parasiticus*, coincides almost precisely with the outlines of the circum-Arctic tundra. Then, with their chicks reared, the parasitic jaegers go romping over the oceans. They winter mainly at southern latitudes, often below the equator.

Eurasian jay

In September, the Eurasian jay reveals itself. You see these birds coming and going, seemingly without purpose. In reality, they have much business to accomplish. They are busy collecting seeds to bury, as a provision for the cold days of the future. Thus you may even observe two or three jays flying one after the next, their beaks half-open and each holding an acorn between their jaws. They will soon find a hiding place in which to stash their provisions. These jays will eventually hide thousands of seeds. Many will be forgotten, and will give rise, next spring, to sprouting oaks.

Sometimes, you may witness spectacular movements of jays in the fall. The birds of Siberia and northern Europe sometimes abandon these regions—no doubt because of a shortage of food—and depart in little groups for the western part of the continent. Thus you may see streams of jays, in single file, making their way at low altitude and with a jerky flight, toward unknown destinations. I have even seen them at the outermost point in Brittany, flying due west out over the sea.

Widely distributed from northern Africa to central and eastern Asia, the Eurasian jay, *Garrulus glandarius*, is fairly sedentary, except for the northern populations. These jays make regular invasions into the west and the south, and one can then see thousands of them irrupt, for a time, into the countryside of the temperate regions.

Laughing kookaburra

A giant among giants, the kookaburra is a legend unto itself. This enormous bird, related to the kingfishers, is essentially a kingfisher adapted for life on land rather than on water. In Australia, the birds is particularly symbolic (it was chosen as one of the three mascots for the Olympic Games in Sydney in 2000). Besides being noted for its unusual bulk (it weighs more than a pound), the laughing kookaburra is especially famous for its call. It is a sort of full-throated laugh (hence its name), halfway between a human laugh and the call of certain forest-dwelling monkeys. If you have not yet seen the bird, it is always shocking when you first hear it laugh in the Australian bush. You certainly wonder what strange creature could make such a sound. Directors of films that are set in the jungle have often used this cry to evoke a realistic atmosphere and convey a sense of menace.

Our kookaburra is a carnivore that feeds on lizards, small birds, or mice. Its name, which comes from one of Australia's numerous aboriginal languages, is simply an onomatopoeia for its cry. There it is again!

Of the four species of Dacelo that live in Australia and New Guinea, the laughing kookaburra, *Dacelo novaeguineae,* is the largest. In Australia, it is found in both damp and dry forests and around houses, even in residential neighborhoods within cities.

Maribou stork

To say that the maribou stork is a beautiful bird would be an exaggeration. With its bare skull ornamented with a few isolated little feathers, the pink sack of skin under its beak, and a slightly stooped posture, there is nothing appealing about it. In addition, the bird is a necrophage, or eater of dead animals, a characteristic it shares with vultures. This, indeed, is why its head is naked: to prevent its feathers from being soiled with the entrails of a dead animal. But beyond its physical aspect, the maribou is an extremely useful animal in the ecosystem of the African or Asian savannah. It is one of nature's garbage collectors, and thus helps prevent the spread of disease.

In the savannah, where it strides along with slow steps, the maribou stork mingles with big cats, vultures, elephants, and antelopes around watering holes. It has a pensive air and appears a little indifferent to the animals nearby. It seems as if nothing can touch it—as if it is meditating. Perhaps this is the reason for the name *maribou*, a reference to the holy men or hermits of Moorish North Africa; in fact, the word *marabout* is still used today for certain Islamic spiritual leaders in Africa. It is also true that in Africa storks are often considered sacred birds.

28

There are three species of maribous in the world: two in Asia and one in Africa, the maribou stork or *Leptoptilos crumeniferus*. The African species is found over a large part of the continent south of the Sahara; it is not rare but never appears in large numbers. The species is in large part sedentary.

Black-billed cuckoo

European and American forests both have their cuckoos. They are cousins, though quite different from each other in some ways. The simple song of the European cuckoo is paralleled by the whistling *pou…pou…pou!* of the black-billed cuckoo of the Americas. And like its European relation, the black-billed cuckoo is an expert in the art of camouflage. You may hear it, certainly, but to see it is something else entirely. Despite its long tail, it knows just how to sidle furtively through the leaves and branches, passing unseen even when you are desperately scanning the area from which its song emanates. Often, you must content yourself with this repetitive little song and accept that this caterpillar-eater will remain impossible to observe.

However, the American cuckoos, unlike their Old World cousins, do not systematically lay their eggs in the nests of other species. If they do so, it is only occasionally.

The black-billed cuckoos are nocturnal migrators; they disappear one September day and fly off, in the starry night, to their winter territory in the tropics of the Americas. Sometimes, after storms, a bird is driven as far as the coasts of Ireland or England. On such a morning, inhabitants of those countries may wake to find that a chilled and exhausted black-billed cuckoo has arrived from overseas. Most often, the bird will perish in the hours that follow.

The black-billed cuckoo, *Coccyzus erythropthalmus*, reproduces in the eastern, southern, and central parts of North America. In the fall, it leaves to spend the winter in South America, primarily in the northwest part of the continent.

Rosy starling

Amid the flock of European starlings feeding on this beach covered with algae, one bird stands out, with its pale beige color and a yellow beak. It is a young rosy starling, arrived perhaps from the Balkans, Turkey, or central Asia, who has followed the first migrating starlings coming to spend the winter in Western Europe. A little longer in the leg, it has a gangling walk. In this region, it is an occasional species and one that the passionate ornithologist is always delighted to see.

Though it's a nice-looking bird, this young starling does not resemble its parents. The adult birds present the eye with an assortment of pink and black feathers, to beautiful effect. The head is set off with a long black crest, and the beak is bright pink. You must go as far as Kazakhstan to see, on abandoned buildings or the stone seawall of a lake, thousands of the birds nesting elbow to elbow in the crevices of the stone. In the spring, the adults come and go, their beaks full of bright green caterpillars.

As with other species, in the spring of certain years some birds aim their beaks farther west than their regular distribution area. In these years, one may occasionally see up to four or five rosy starlings in the south of Europe, dressed in their superb breeding plumage.

The rosy starling, *Sturnus roseus*, nests from Turkey to Kazakhstan. Sometimes, in certain years, it ranges farther west, reaching as far as Romania, Bulgaria, and Greece. In the fall, the whole population takes off for the winter, which it spends primarily in western India.

SEPTEMBER

30

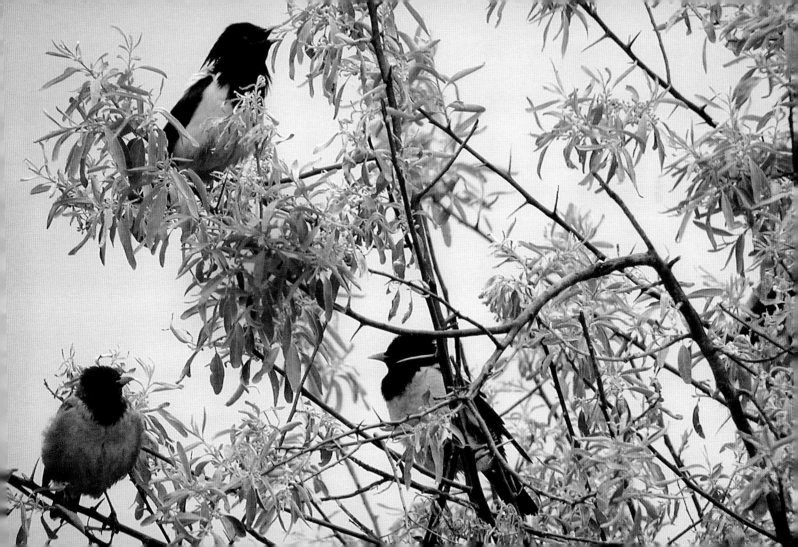

Muscovy duck

I begin the first day of October with a species that is at once wild and domestic. I remember first seeing the Muscovy duck as a child, in a farmyard that I visited regularly. It came at me, with its odd, bright red outgrowth ("caruncle") on the beak, hissing and swaying its head and preparing to bite. I was scared out of my wits. Later, in consulting the dictionary, I learned that the term *Muscovy* refers to the Moscow region. In fact, however, the bird is not from that area at all, and it is unclear where the name originated. I had to become an ornithologist before I learned that this fearless duck is actually a native of Central and South America, and was brought to Europe by the Spanish during the sixteenth century. The species was already being farmed by South Americans before the arrival of the conquistadors.

This discovery suddenly gave me a different picture of this duck. It was no longer simply the aggressive barnyard fowl of my childhood, but the descendant of a bird still living today in the swampy forests of South America.

The Muscovy duck, *Cairina moschata*, which is also called the Barbary duck in a culinary context, lives from Mexico down through a good portion of South America. It is sedentary. It is commonly raised on farms, and is considered an excellent poultry bird.

Western marsh harrier

Above the reed bed, the passerines have gone quiet. Most of the singers from this past spring have now departed for Africa. The pond itself is nearly silent. There are only the coots and ducks, freshly arrived from the north, to lend a bit of life to the scene. Then, too, there is a western marsh harrier. The bird here is one of the year's juveniles, with blackish brown feathers and a nearly golden cap. With its swaying flight, it surveys the edges of the pond and the reeds. With each pass it causes the coots to halfheartedly take flight, making as if to flee a few dozen yards away. But any weakened bird should genuinely beware, for the marsh harrier will spot it instantly.

For the moment, this young bird is simply practicing its patrol flight. In a few days, no doubt, the harrier will leave this place, like the majority of its fellows, to head for the south, where the water will not freeze during the winter. Perhaps another ornithologist will soon observe it flying over some mountain pass, high in the sky, gliding without a flap of its wings.

The western marsh harrier, *Circus aeruginosus*, is widely distributed in Europe and beyond as far as central Asia. Most of these birds spend the winter in India or in tropical Africa, but the populations of southwest Europe are resident.

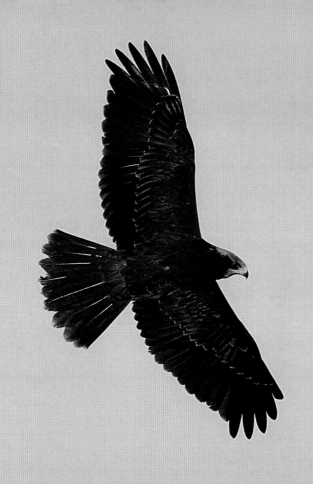

Coal tit

This year is a year of coal tits. For several days, we have been seeing them everywhere, in the yards and gardens of the suburbs but also in small groups at the seashore and in the countryside. We are witnessing what the French call *migration rampante*, or a crawling migration. The coal tits fly from bush to bush, barely stopping to devour an insect or seed, and in this way gradually advance due south. There is no directly migratory flight, but a progression in little leaps, giving the appearance of aimless meandering. These birds are coming from northern Europe, where they must have been faced with a scarcity of food resources. So they departed for the unknown, and are now advancing at the whim of the opportunities that greet them, until they arrive in more temperate land that is richer in food.

In the little flock that I am watching there is a ceaseless contact among the individual birds, who give shrill chirps of *tsu-ee!* Soon, the tits move a little farther along, always advancing south. They have arrived at a hedge, which they skim along. Suddenly the whole group topples over to the other side and disappears, and I hear their cries fade into the distance.

The coal tit, *Periparus ater*, lives in all of Europe and North Africa, in Siberia all the way to the Pacific coast, and in temperate Asia. It is closely linked to conifers, which it seeks out in particular. The mountain birds come down a bit toward the valleys in winter, while the northern birds make regular invasions toward the south.

OCTOBER

3

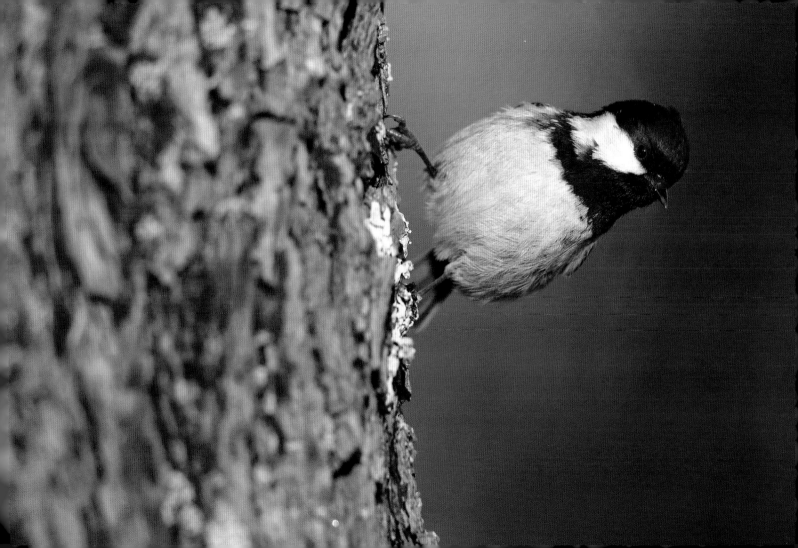

Great cormorant

In the sky, what appears to be a flock of wild geese is heading for the south. With binoculars, however, the birds appear completely black—whereas geese are normally lighter in color. The long *V* weaving through the sky and the clouds is in fact a flock of migrating great cormorants. Many people confuse the two kinds of birds, and few know that cormorants can fly over land like this. For the most part, the species is found only on the coasts. In reality, however, the great cormorant is both marine and terrestrial, as much in its winter territory as in its nesting grounds. So it is wholly possible that you would see cormorants on a river, on a large body of water, or migrating over a mountain pass.

In the middle of winter, the great cormorant may enliven many different habitats: a fishing port, a rocky islet off the coast, the wide river that flows through the city, immense wild swamps at the edge of the delta, or a little pond on the outskirts of the forest. As long as it doesn't freeze: this is the essential thing that allows the cormorant to stay and bring cheer to the gray days of winter.

Present on all the continents, the great cormorant, *Phalacrocorax carbo*, nests at the edge of sea as well as on large inland bodies of water. The most northern populations are migratory, and the European birds may travel as far as tropical Africa.

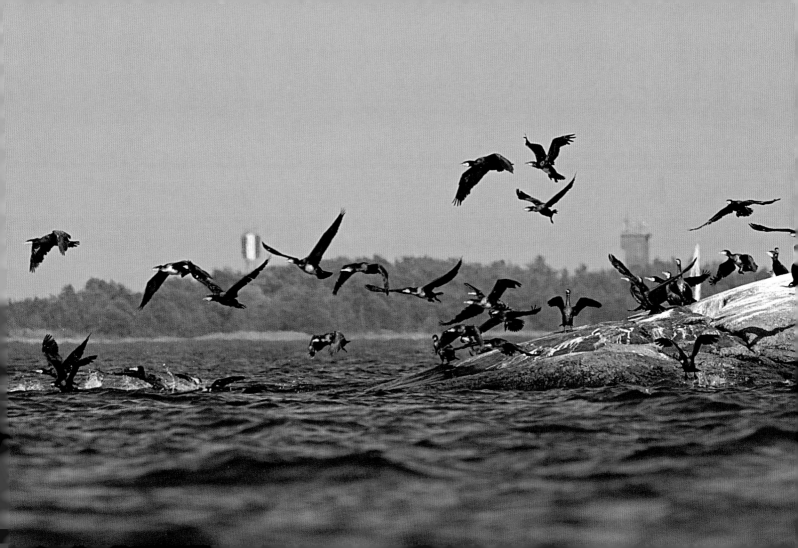

Blackpoll warbler

When the majority of North American warblers leave their breeding grounds to return to tropical lands, it makes for an enormous population in motion. On some fall mornings on the east coast of the United States, the bushes groan with members of this feathered universe, all laying in reserves before they brave the long journey.

The blackpoll warbler is among the most common of these passerines. At this time of the year, it has traded its pretty gray, black, and white plumage for a drabber costume dominated by gray, olive, and cream. From the still thick foliage comes a high-pitched *tzip!* Then you can quickly spot a blackpoll warbler rummaging through the leaves in search of an aphid. This call is a clue to its presence, but no guarantee, since very similar sounds are made by other species. You need an extraordinarily well-trained ear to tell the difference between the various warblers' cries. And you must also know the warblers well to register the subtle variations in their fall plumage, which are not apparent at first glance.

OCTOBER 5

Widely represented in North America, the blackpoll warbler, *Dendroica striata*, nonetheless avoids the southwest of the continent. In the fall, the whole population heads down to tropical regions of the Americas for the cold season.

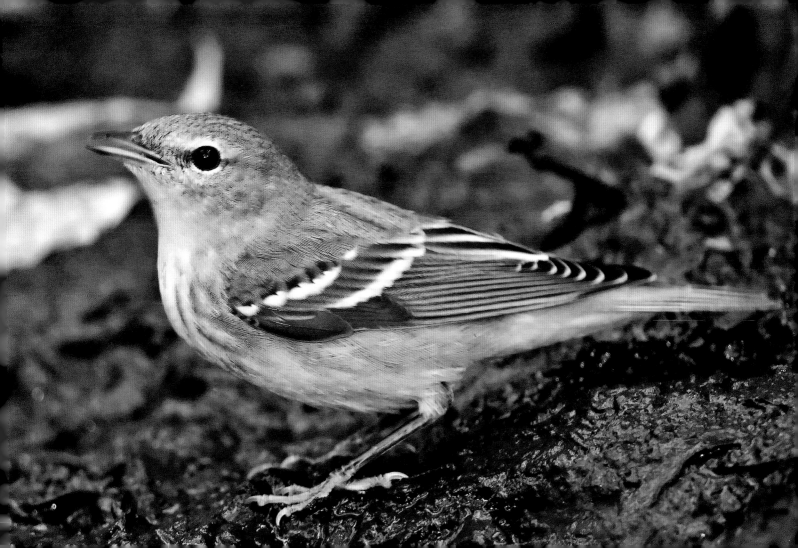

Wandering albatross

It had been a particularly turbulent night, as our boat emerged from the Beagle Channel and headed into Drake's Passage to reach the Antarctic. In the depths of the lower decks, my cabin swayed sharply. Casting an eye out the porthole, I suddenly saw a big black and white shape flying along the hull of the vessel: my first albatross! Staggering up the stairs as the boat pitched and tossed, I finally reached the bridge. And there it was, following the boat. By turns it flew, skimming the waves, then rose up and watched me. Sometimes, it took the lead and I thought I would lose it, but it circled back rapidly to settle back into the boat's wake.

It did this for at least a good three hours, following us and reveling in the air currents as the boat tossed more and more drastically and the troughs became truly frightening. Three hours without once flapping its wings. Three hours of gliding flight, playing perfectly on the aerodynamics of its body to make fullest use of the air movement created by the boat.

We saw many other albatrosses in the course of our expedition. And each time, I was profoundly moved by the intimate relation between the bird, the ocean, and the wind.

The wandering albatross, *Diomedea exulans*, is the largest of the albatrosses. Its wingspan is more than 9 feet (2.7 meters) wide and can reach upwards of 11 feet (3.3 meters). The species lives in the Antarctic and sub-Antarctic waters, and it never strays far from that area. Like many other albatrosses, it is severely endangered by commercial long-line fishing.

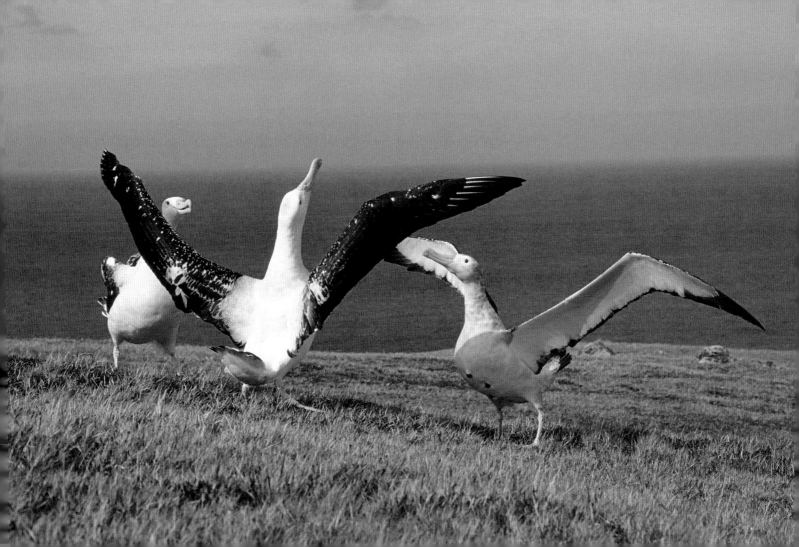

Bird of paradise

To observe birds of paradise, you must be willing to get on an airplane. Most species live in New Guinea. And there, the birds are not found just anywhere. They live in the rain forest, just where it is most impenetrable and difficult to access. Accordingly, the number of ornithologists who have ever gone to see birds of paradise—and have actually succeeded in seeing them—is little more than five percent.

Everything about birds of paradise is seductive. First, their feathers, each one longer, more forked, and more astonishing in color than the next. It was this asset that in the early twentieth century nearly caused the birds to vanish completely. Fashionable women in western countries were obsessed with the feathers, which they wore on their hats and dresses. Second, in a good number of species, the breeding display is highly ritualized, and the males—which are often polygamous—perform incredible dances to attract the females. Seeing such birds, it is truly hard to imagine that their closest cousins are the crows, with their uniform black plumage! Finally, the species so frequently interbreed that in the course of the nineteenth century and the beginning of the twentieth, scientists were regularly led to declare the discovery of a new species—only to eventually discover that it was, in fact, a hybrid of two old ones.

There are forty species of birds of paradise, nearly all of them from New Guinea, though some live in Australia. All belong to various genera of the family Paradisaeidae. For nearly a century, these species have been protected, and it is illegal to export the birds from their countries of origin.

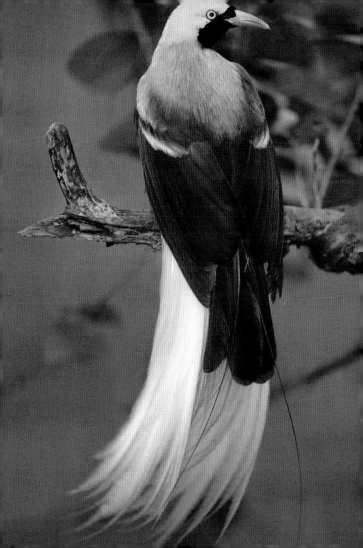

Sora

With the soras, one must be patient. These miniature moorhens or rails spend their lives hidden in the deepest part of the reed bed. They go out only at the beginning or very end of the day, to feed around the edge. And even then they behave with extreme caution, always ready to duck undercover at the smallest noise or gesture. Thus, to see the sora, as well as its cousins the world over, you need to find a good place to watch for them unseen, and then to sit there and not move.

If you are familiar with the place and the habits of the bird, and if you are patient, you will have some chance of seeing a little bird barely bigger than a thrush emerge from the thicket. The sora walks with deliberate steps, nervously shaking its hindquarters all the while, then stops to glean some seeds or little insects. With a little luck, you will be able to see its characteristic yellow beak and the little black mask over its eyes. At the smallest noise, however, there it will go, fleeing back into the vegetation. And there will be little hope of it coming out again any time today.

The sora, *Porzana carolina*, nests in a large part of North America. It is sedentary in the extreme southeast of the continent and otherwise winters in the southern United States and in Central America.

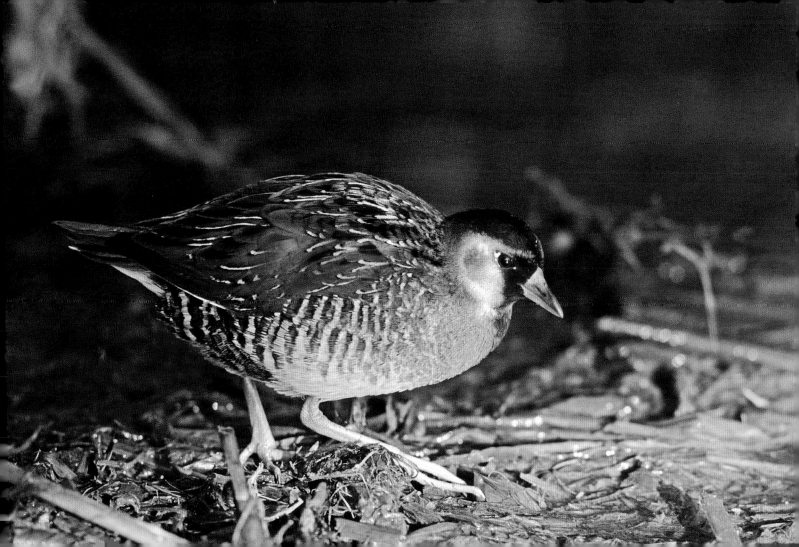

Paradise tanager

I still have never seen the paradise tanager. But what I have heard about it fascinates me. Its plumage is made up of no fewer than seven different colors. Its French name describes it as a seven-colored tanager—and one could just as well call it the rainbow bird. I looked up photos of the bird, and it truly is beautiful, even if its predominant color is black. As for the other colors, blue competes with violet on the front of the bird, while yellow and red vie with each other on the back and the rump. A little green on the head, along with red again on the legs, and there we have our rainbow.

With its beautiful plumage, the tanager frequents the rain forests of South America and the Amazon basin in particular. Here it suffers from stiff competition with a multitude of birds as colorful as itself, if not more so. And believe me, to search for this beautiful collection of feathers in the high canopy is no easy affair. As brightly colored as they are, these birds are experts at escaping our gaze, thanks to the leaves among which they conceal themselves so marvelously.

The paradise tanager, *Tangara chilensis*, lives in all the tropical and subtropical forests of northern South America, from Brazil to Peru. It is sedentary and not currently endangered.

Eurasian spoonbill

I never get tired of watching spoonbills fish in shallow, swampy water, clustered close together. With their large spoon-shaped beaks, they come and go, cutting through the water. The spoon structure at the end of the beak allows them to filter water and retain the tiny invertebrates that swim within it. The spoonbills advance with their heads held low, three-quarters submerged, completely occupied with sweeping the surface of the water. It seems that nothing can break their concentration: not a slamming door, not a barking dog in the distance.

This little group comes to us directly from the Netherlands; the birds have stopped here for a time before taking up their migratory journey once again. No doubt these spoonbills will travel as far as tropical Africa, in their endless quest for food. In flight, as they move from place to place, with their neck and legs extended, you will immediately notice their immoderately long beaks, rounded at the end. Spoonbill: these birds could hardly have a more appropriate name.

The Eurasian spoonbill, *Platalea leucorodia*, nests here and there in Western Europe and more frequently as you head into Asia and India. It also nests along the African coasts of the Red Sea. There are six species of spoonbills in the world, including the roseate spoonbill in America.

OCTOBER

IO

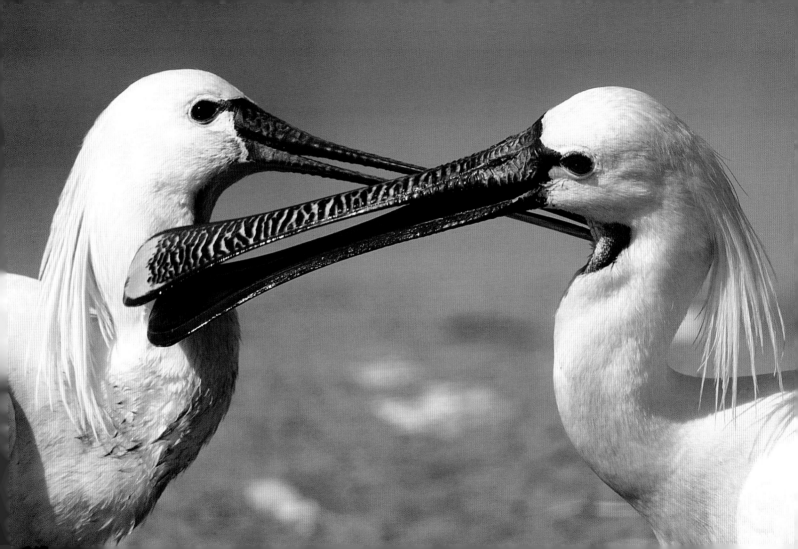

Blackcap

Tac... tac! From the dense leaves of the elder tree come staccato cries. A blackcap is gorging on the black berries of the tree. This bird has probably come from northern Europe and has stopped here to regain its strength before continuing its voyage toward the south. Where is this blackcap headed? To the south of France? To Spain? Farther still, to Morocco or even to the gates of tropical Africa? No one knows. Or, in any case, not yet. For, around the bushes where the blackcap is strolling, the taggers have placed their nets. The bird is soon captured. The scientists measure it, weigh it, and place a minuscule steel ring on it bearing a number. With a little luck, it will be checked by another team in two weeks, a month, a year. But there is always a possibility that it will keep its secret forever.

Released and now wearing its tiny anklet, the bird is once again eating ravenously. It is waiting for night to come to depart once more, navigating by the stars, by landmarks, and by other cues still unknown to us.

Common in Europe, the blackcap, *Sylvia atricapilla*, spends the winter primarily on the shores of the Mediterranean. However, recent studies show that some of the birds from central Europe have modified their migration routes and now winter in the British Isles and western France, no doubt thanks, in large part, to milder climate conditions.

OCTOBER

II

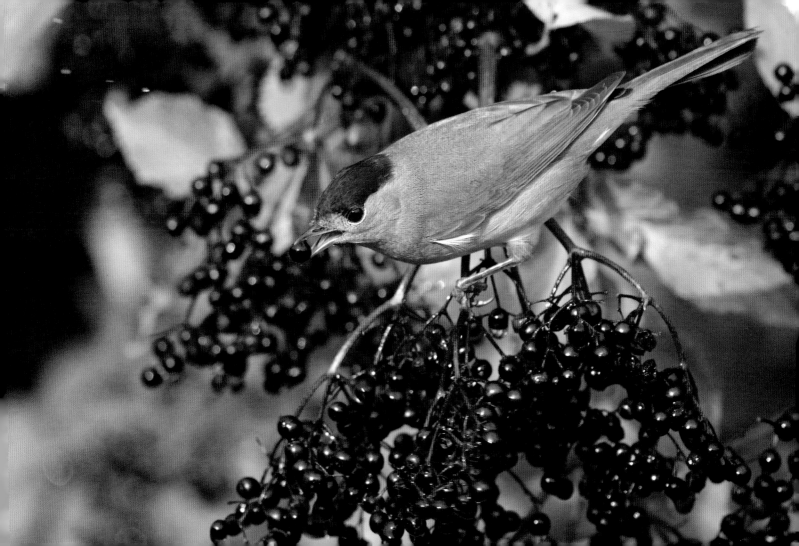

Red-breasted flycatcher

The red-breasted flycatcher is typically seen among the passerines that populate the great forests of Russia. In the summer, if you visit this energetic species in the timber forest that it calls home, you may find it difficult to follow among the leaves. You have to use the tart but musical song of the male to track the bird, which displays a beautiful orange-red throat.

In the fall, it is another matter entirely. Like many flycatchers, the red-breasted species then favors more open habitats. At this time of year, it can be more easily observed, especially when it hunts from the end of a branch and then, after catching a midge, returns to almost exactly the same spot. With its alarm cry, which sounds like the muffled noise of a rattle, and with its way of slowly raising its tail—which has very visible white corners—it is more easily detected here than in the deep forest where it nests.

For Western Europeans, the red-breasted flycatcher is one of the cohort of occasional species you can hope to see at migration sites. Ornithologists will search for the flycatcher after an eastern wind, hoping to find a slightly off-course bird that will nevertheless bring a thrill to our day.

The red-breasted flycatcher, *Ficedula parva*, can be found nesting from central Europe all the way to central Siberia, where it is replaced by a close cousin, the taiga flycatcher. The species spends the winter in south Asia. In fall, some of the birds follow a more western route and can then be found in Western Europe.

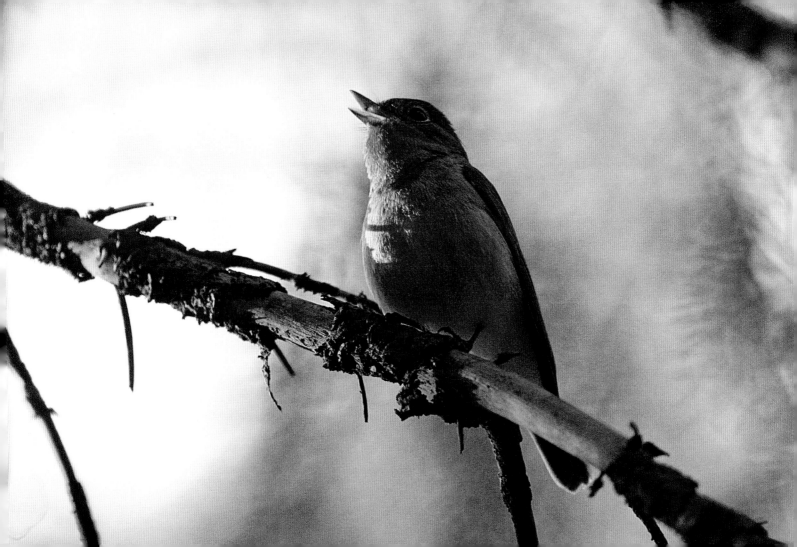

Sanderling

Watch the sanderlings run on the beach and come and go with the wash of the waves. With their hurrying steps, they look almost like mechanical toys, as if they have been wound up with a key. As one wave retreats, they rush at top speed to feed on the tiny creatures that the ocean has deposited. But as soon as the next arrives, they all rush back up to the top of the beach, as if worried above all about getting their feet wet.

This little game continues until the waves come too high for them to be able to eat. Then, the birds regroup at the top of the beach or on a nearby rocky islet, and these dozens of little balls of gray and white feathers press against each other, waiting for the tide to go back out again. Heads under their wings, standing on one foot, their bodies turn like weathervanes in the wind. Soon they will take off again, with boundless energy, on their mad and infinite race against the movement of the waves on the beach.

Nesting in all of the circum-Arctic tundra, the sanderling, *Calidris alba*, is a great migrator that leaves its summer quarters starting in the beginning of August. For the winter these birds may travel to the temperate regions of the northern hemisphere or as far south as the beaches of southern Africa, Patagonia, and Australia.

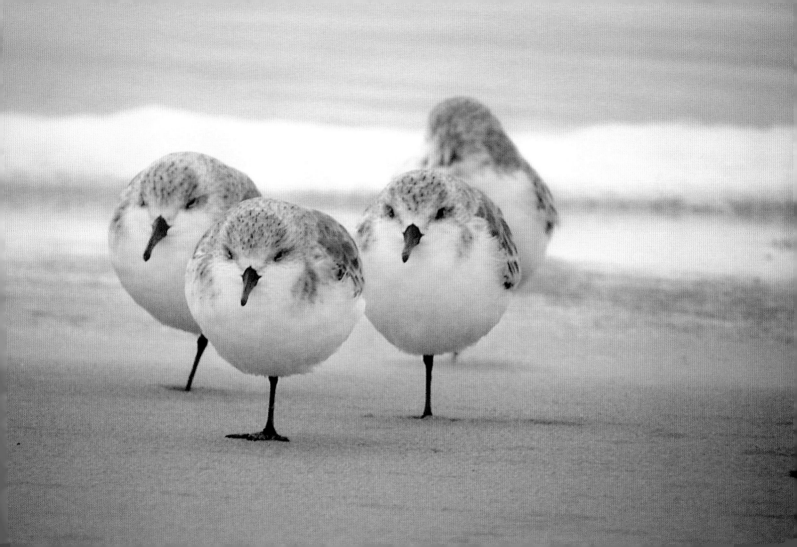

Red-capped manakin

To see this manakin, you must go to Central America. Once there, prepare yourself for an incredible show—if you have never seen a bird imitate Michael Jackson's moonwalk. (Or is it rather that the moonwalk was an imitation of this small South American passerine?)

To seduce his mate, the male perches on a branch, suddenly spreads his wings, and walks backward on the branch, while somehow keeping his balance. He does this so smoothly and rapidly—showing off the yellow feathers of his thighs, lifting his tail and lowering his head—that he looks as if he is gliding. It is quite an impressive spectacle. To put the finishing touches on the show, he gives strange high-pitched chirps.

The males will gather on what is called a "lek," and wait for a female to present herself. When she appears, they throw themselves into their mad dance, trying to seduce this future partner by offering her the most remarkable exhibition. We humans, who would be totally incapable of such feats, are amazed. But the female manakin remains imperturbable. No doubt she has seen it all before.

OCTOBER

14

The red-capped manakin, *Pipra mentalis*, is a bird of Central America, from southeast Mexico to Colombia and Ecuador. It lives in the tropical rain forest and is hardly ever seen at higher altitudes. It is totally sedentary.

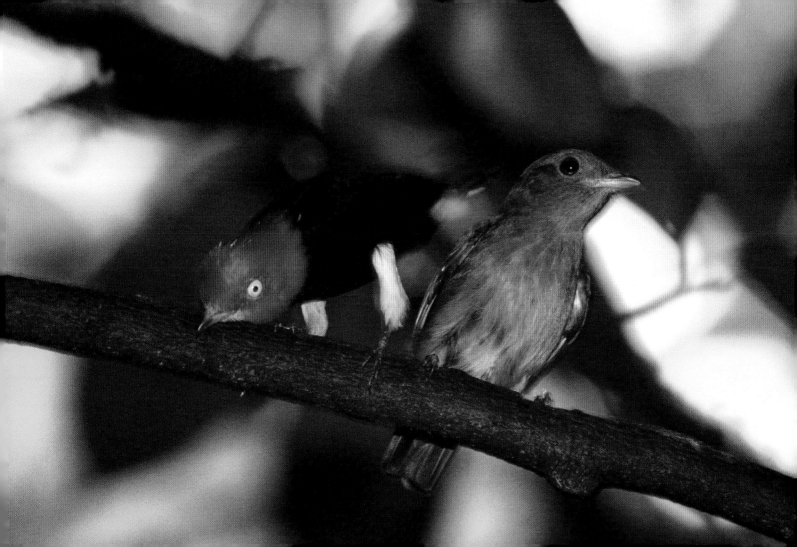

Common wood pigeon

In the southwest of France, October is the month of the wood pigeon. More precisely, it is the time when migrating common wood pigeons arrive from Northern Europe and ready themselves to cross the Pyrenees to go spend the winter months in Spain. In the mountain passes of the Pyrenees, there are sometimes spectacular great flights of the birds.

Here, in Organbidexha, ornithologists armed with binoculars and notebooks endlessly count the flocks that fly by, one after the next, to cross through the pass half-buried in mist. Barely a half-mile farther on, however, there are hunters awaiting the birds. The cool morning air around us is abruptly filled with the noise of their shots, which salute the passage of the wood pigeons in another way entirely. We all have our own ways of appreciating nature. I love to contemplate the life of these birds, others are more gratified by causing their death … We try to avert our eyes from the west, where the hunters, concealed behind blinds, are wreaking havoc on a flock that has been unwise enough to fly lower to cross through the pass. Before us, another group of birds is migrating, up high enough to have nothing to fear. That flock, at least, is safe.

The common wood pigeon, *Columba palumbus*, is widely spread through all of Europe and Russia. Only the northern populations are migratory. The species is more and more present in cities, where it is sedentary.

OCTOBER

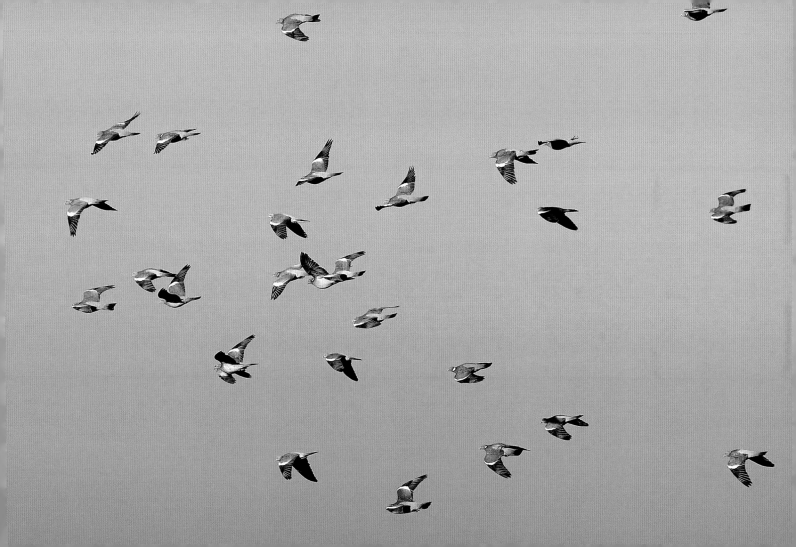

White's thrush

If the blackbird or its cousin, the American robin, is easy to see in our gardens or our forests, the same cannot be said for the White's thrush. This large Turdida is particularly shy and quick to hide behind a tree trunk when surprised by an attentive ornithologist. I remember waiting a long time, in China or in Nepal, before being able to observe this thrush under good conditions.

Once it has descended to the ground, there it is, walking more than hopping, unlike other thrushes. Now one can see its feathers, which make a multitude of little black, white, or gold crescents on its body, as well as its big black eyes and strong beak. And as always, it displays this air of constant alertness, ready to fly off at the least alarm.

In the spring, in the great Siberian forest, I have heard its song, and it is difficult to imagine a purer sound. It is a very high tweeting sound—*siiiiiiiii!*—followed by another very sweet one—*huuuuuuu!* That is all. But in the solitude of these mossy forests, which extend infinitely in every direction, this crystalline song is particularly striking.

The White's thrush, *Zoothera dauma*, nests in Siberia as well as in China, and hibernates a little way to the south. Occasionally it will wander into Western Europe. When a rare bird strays into Sweden or the British Isles, many bird-watchers will follow.

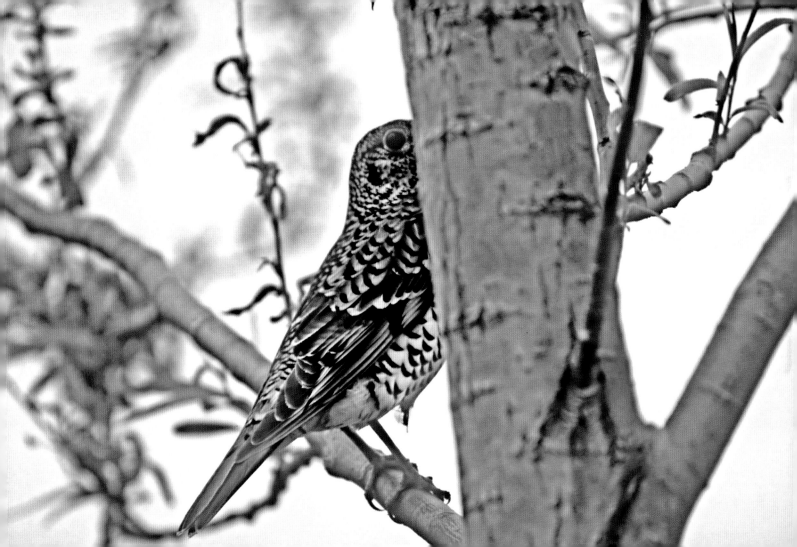

American kestrel

In North America, there is a little kestrel that may be easily observed in the countryside. It slightly resembles the common kestrel of the Old World, but it is smaller and its face is more marked with gray and black. In the male, gray wings distinguish it from the European kestrel, whose wings are tinted red-brown.

This lively little raptor is a hunter of small creatures: insects, dragonflies, mice, and lizards. It frequently flies in place, frantically batting its wings so as to avoid losing altitude. Once it spots its prey, it hovers overhead and then drops down like a stone. Sometimes, with a gliding flight, it explores the hedges or the side of the road in search of food. But soon, it will find a perch on a tree, post, or power line from which to survey its surroundings and ready itself for another hunt.

This bold bird is afraid of nothing. If a golden eagle eyes its territory, the kestrel will charge at it to chase it off. Of course, that generally has no major consequence for the larger raptor other than, perhaps, slowing it down a little.

The American kestrel, *Falco sparverius*, also called the sparrow hawk, is found throughout the Americas, from Alaska to Tierra del Fuego. The northern populations (those of the northern United States and points north) migrate in the fall.

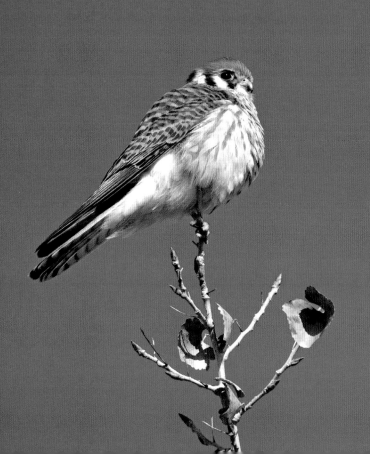

Jacana

Out of all the waterbirds, the jacanas hold a special place. What is striking above all in these birds is their feet and, in particular, their toes and talons. It would be hard to imagine longer ones. Why are these birds equipped with such toes? It is because they have the habit of walking on floating plants, those big lily pads that you see growing on ponds and tropical swamps. Where any other bird would sink into the water, the jacanas, completely at ease, stroll along the surface of the lily pads where they find their food, far from any rivals. It is a truly lovely adaptation. In Africa, as in Asia, I had the opportunity to see these curious birds walk on water. Indeed, in South America, they are sometimes called "Jesus birds."

Contrary to the norm, it is the female that is larger and the male who takes care of the chicks. Accordingly, the females of some jacana species may be polyandrous, that is, have multiple male mates at the same time.

There are eight species of jacanas in the world, all tropical. Most are sedentary. However, the pheasant-tailed jacana, *Hydrophasianus chirurgus,* is fairly migratory; some birds that nest in India spend the winter on the Arabian Peninsula, and thus cross a portion of the Indian Ocean.

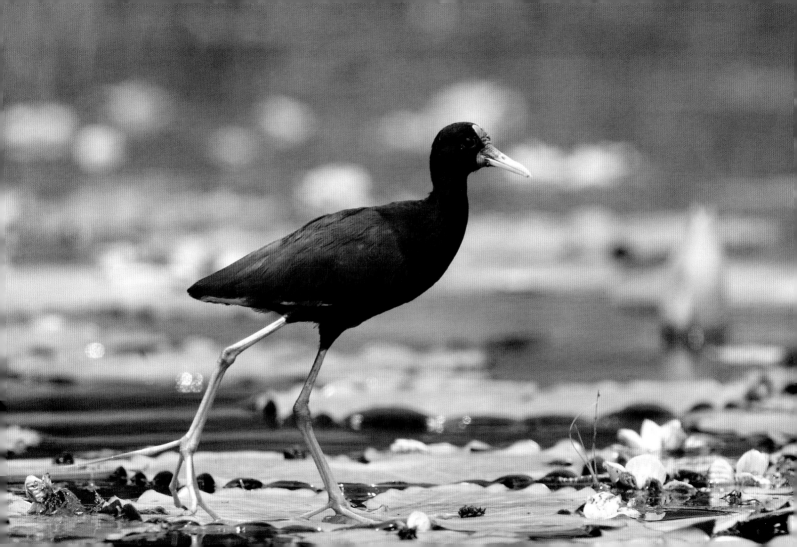

Tropical woodpeckers

At our temperate latitudes, woodpeckers often, if not always, wear fairly drab colors. Black, white, gray, or greenish tones may be offset by a flash of red, particularly in the male, on the cap or on the bottom of the belly. But if you open a guide to the birds of tropical Asia or South America, you will discover the far greater diversity of color worn by woodpeckers that live in the jungle. Yellow, orange, red, and bright green compete on these birds' radiant plumage. These tropical woodpeckers are as bright as parrots. Their feathers are nothing like the black and white of most European or North American woodpeckers (though, on the latter continent, ornithologists have several species with brighter colors within reach).

So in Asia, for example, I am always surprised to discover in the sights of my binoculars a colorful woodpecker climbing up a trunk. Despite the palette of bright colors that shimmers before me, it is striking to observe that, from a distance, the bird might have passed totally unseen. The tropical woodpecker truly teaches us that drab colors are not always a necessity when it comes to blending in with the environment.

OCTOBER

19

The thickness of the foliage in tropical forests allows many species with colorful plumage to pass unnoticed through the trees. With the play of sun filtered through the leaves, the brightest colors melt into the jungle's blend of shadow and light.

Eurasian sparrowhawk

I n October, during the flight of the passerine migrators over the countryside, capes, mountain passes, and cities, one only has to wait for a sparrowhawk to turn up. The species feeds on small birds, and so it is not surprising that it follows the travels of its larder. This is what the sparrowhawks of northern Europe do, wintering like warblers or larks in temperate regions that are less seized by cold. In North America, the sharp-shinned hawk, a close relation of the Eurasian sparrowhawk, does the same.

It is easy to spot a sparrowhawk in the sky, even at a distance: the style of its flight betrays it. The bird alternates rapid flapping and long glides with perfect rhythm. Hardly any other raptors move like this. Falcons, for example, fly with more beating of their wings and glide much shorter distances. The round (rather than pointed) wings of sparrowhawks also distinguish them from falcons. To an ornithologist, in short, the silhouette of the sparrowhawk in flight tends to identify it clearly.

Very widespread throughout the Old World, the Eurasian sparrowhawk, *Accipiter nisus*, nests from Western Europe to eastern Siberia. Many birds of the high latitudes are migratory and winter in temperate regions, as far as tropical Asia and East Africa.

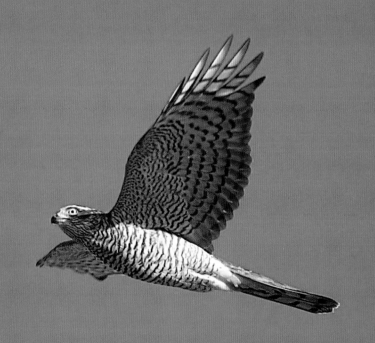

Yellow-browed warbler

No doubt the name "yellow-browed warbler" means nothing to most. But mention the bird to a European ornithologist or serious bird-watcher and you may get a glint of recognition. This little passerine of a few grams, from the family of the well-known chiffchaff, is originally from the Siberian taiga. Each fall, a certain number of these birds, instead of flying off serenely to their winter quarters in southeast Asia, carry out a sort of reverse migration, and turn up one beautiful October morning in the coastal bushes or on a little island of northwest Europe. They are more than 3100 miles (5000 kilometers) off course. But its bright, strident cry—*tsu-hui!*—will reveal it to the patient and attentive observer.

With its prominent eyebrows, its bright green plumage, and the two white bars on its wings—and with its hyperactivity—the yellow-browed warbler stands out sharply from the drabber and more oafish chiffchaff (although following a chiffchaff through the branches is itself no easy affair). To discover this little jewel amid the fleeting green of the leaves is always a real joy for the ornithologists in the area. It also brings to mind the migration from afar that so captures our imagination.

The yellow-browed warbler, *Phylloscopus inornatus*, nests in the Siberian forest as far away as the Pacific shore. The birds normally winter in tropical Asia, but among Siberian passerines they are the ones with the best chance of wandering into Europe in the fall.

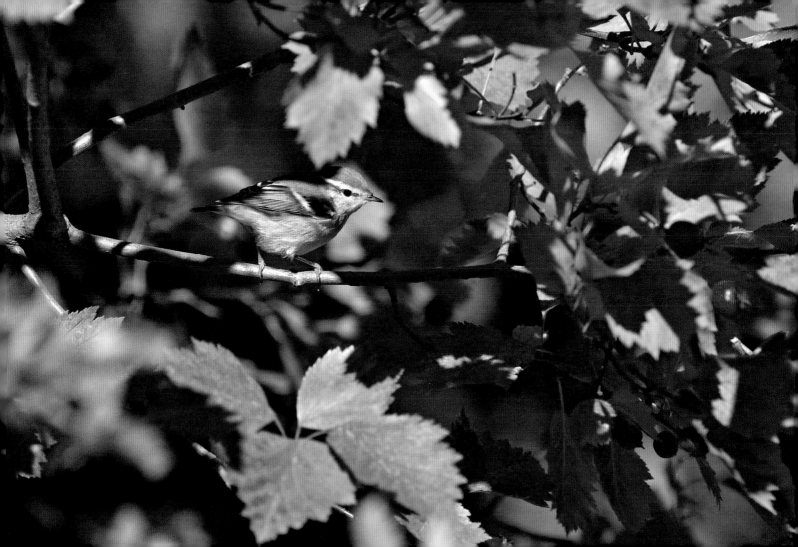

Snow goose

It was in Quebec that I saw my first snow geese. More specifically, it was at the Cap Tourmente wildlife preserve, where tens of thousands of the birds arrive each year from the Arctic tundra. There, they gather briefly on the banks of the Saint Lawrence River before continuing their voyage farther south. Each time the birds take off, it is as if a snow shower has filled the sky, and this enormous flapping, honking spectacle of thousands of geese leaves the observer totally speechless. There is so much agitation and excitement in these birds. You can see they are anxious to build up the energy reserves they need to continue to their destination and survive the rigors of the coming winter. The juveniles, with their grayer feathers, are still in the company of their parents, whose plumage is an immaculate white except for the black tips of their wings. In a few days, the geese will desert Cap Tourmente—whose name, meaning "Cape Storm," seems all too appropriate when the geese are there—and allow the wildlife preserve to be plunged into the icy solitude of winter.

Later, on the other side of the American continent, one midwinter in the Sacramento Valley of California, I witnessed the swirling flight of the snow geese once more.

The snow goose, *Anser caerulescens*, nests in all of the Canadian Arctic, in Alaska, and (in small numbers) in eastern Siberia. It makes fall migrations that carry it to the southeast and southwest of the United States, where nearly the entire population of the species spends the winter.

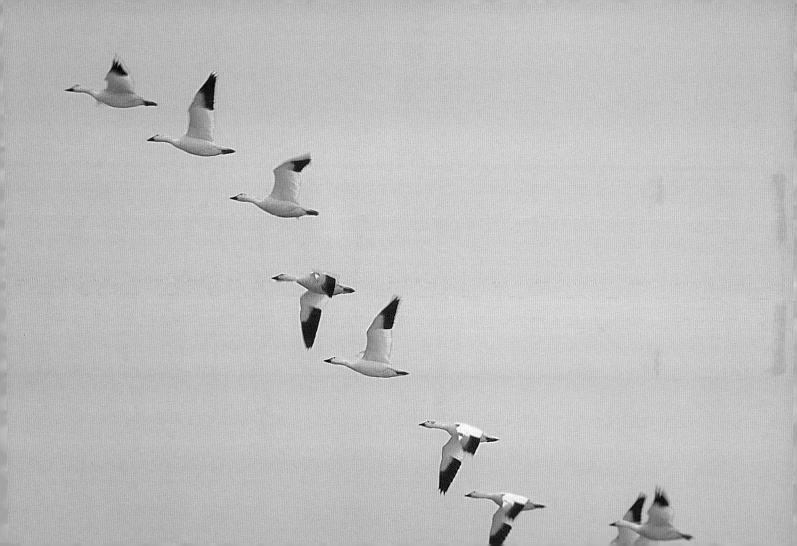

Chaffinch

This morning, I have taken up a strategic post in my house and I scan the sky. A light southeast wind and a sky dotted with clouds are ideal conditions under which to observe the active migration of passerines. And at the first glimmers of day, the birds are already on the scene. Among them, the chaffinch is predominant. This is the moment when it heads back to regions with a more forgiving climate.

In groups that range from a few individuals to a few dozen, the birds fly over the city, heading directly southwest, clearly decided on some destination unknown to me. No time to stop, to pause in my garden. With a steady flight, slightly undulating but determined, they fly at an altitude of 1500 or 1600 feet (450 or 490 meters). Regularly, a resonant *twick!* is heard. It is the sound of contact that the birds make to keep their migratory group together.

Here, where we are inland, the flow of birds is much lighter than it is to the east, at the coast. For diurnal migrators have a tendency to follow the coastline during their journey. Along the English Channel, some mornings, I have seen thousands of birds flying one after the other in a long stream, like the tail of a kite. In these coastal journeys, as well as in the flight of birds overhead this morning, the chaffinch, along with the European starling, often plays an important role.

OCTOBER

23

The chaffinch, *Fringilla coelebs*, is one of the most common passerines in Europe, North Africa, and all the way into Siberia. The name *coelebs*, which means "bachelor," derives from the fact that the males often travel separately from the females.

ORNITHOLOGISTS IN USHANT

Ornithologists and passionate bird-watchers—those so crazy for birds that they will follow them anywhere—regularly journey at the height of the fall migration to privileged sites known to attract birds from nearly every corner of the globe. These include Falsterbo in Sweden, Helgoland in Germany, Texel or Schiermonnikoog in the Netherlands, Fair Isle or the Isles of Scilly in Great Britain, Ushant or the Ile de Sein in France, the Farallon Islands in California, and others. The list is long, without even speaking of the Azores, out in the middle of the Atlantic, as a veritable life raft for birds who have lost their way.

Among these, Ushant is my island. Off the coast of Brittany, it faces out to sea, toward the Americas, and is a haven for birds who stray from the Continent and find unhoped-for shelter there. This is true for the Siberian birds as well. One can only hope they understand that they have gone far enough, that beyond Ushant lies the infinity of the sea.

Here, when a bird is found, there is a rush toward the bush where it perches. The bird-watchers huddle close together, while being careful not to jostle one another, and train their binoculars on the stray American or eastern bird browsing for insects to build up its strength. A magical moment for those who experience it: to think that this clump of feathers, weighing a tiny fraction of an ounce, has traveled thousands of miles to land here before our marveling eyes.

In the fall, the islands serve as a funnel and refuge for stray birds. Often, these birds have been caught in Atlantic storms or powerful jet streams that carry them beyond the lands they normally traverse to reach their winter quarters.

Little auk

As we have already said several times: when the autumn storms come, it is all sea-watchers on deck. On a sea wall, cape, or protruding point, the birders line up, bundled in warm and waterproof clothing, to scan the sea for birds tossed by the wind. Among the species of the high seas, the little auk holds particular interest. This tiny Alcida (the family of puffins, murres, and other such seabirds), barely the size of a starling, lives only very far out to sea and far to the north, nearly at the line where ocean turns to ice. If it occasionally shows up to tantalize those on the temperate coasts, it is certainly not of its own accord.

In a cold and powerful wind, the ornithologists of the north Atlantic hopefully await the passage of a few little auks who have been diverted from their usual course. This bird skims the water at high speed, and it is quite a feat to capture it in the sights of your telescope or binoculars, since it is almost constantly hidden by the waves. Except for when it is landing on the water, exhausted by a storm, you are likely to catch no more than a fleeting glimpse of this little black and white bird, flying at top speed amidst the wind and troubled sea.

The little auk, *Alle alle*, nests in the high cliffs of the Arctic, from northeast Canada to Greenland, Spitsbergen, and various islands off the coast of Siberia. In winter, it comes south only a little, to the edge of the ice, except when northern storms push the birds farther to the south.

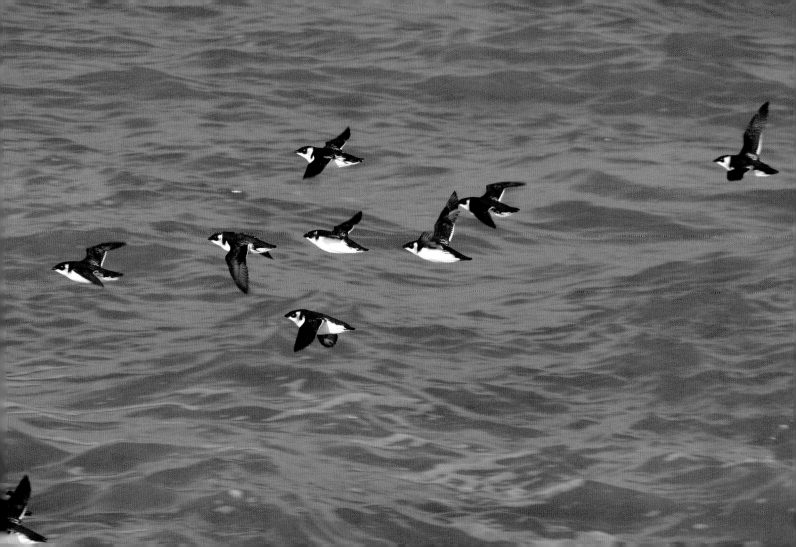

Skylark

In October, I often walk with my eyes gazing upward; the habit has cost me several sprained ankles. But it is irresistible, for at this time of year, at our latitude, the whole feathered tribe migrates rapidly toward the south. Each morning, if the weather conditions are good, one is likely to see the sky streaked with squadrons of passerines. Sometimes in tight groups, like starlings in Europe, sometimes in looser formations, the birds pass by with their bounding little flight. I like to witness this spectacle, especially when I am in the middle of the city. It feels like an invitation—if not to a long vacation, at least to a brief escape.

The skylarks are one of the species that migrate during the day, but also at night, like the thrushes. With their slightly jerky flight—which alternates between flapping and very short glides—and their large wings and short tails, their silhouette in the sky is unmistakable. In addition, if the place is not too noisy, you can hear their regular, rolling cry. It is often this sound that alerts you to their presence. If the sky is blue, you will not see any birds; you will simply hear this sound, without quite being able to tell whether it is one bird or a whole little flock passing through the sky overhead.

The skylark, *Alauda arvensis*, is very widely distributed throughout Europe and beyond as far as northern Asia. There are numerous species of lark, migratory or sedentary, but, curiously, only one species lives in North America.

Graylag goose

They passed through heading north in February, and here they are now, heading back down. Quite often, one sees no more of these migrating geese than the more or less even *V* that they draw in the sky. You may have seen many flocks of graylag geese, but the spectacle is arresting every time. There are few species that challenge us as much as these geese to ponder the mysteries of migration.

In the fall, the birds are in less of a hurry. They travel in families, with the juveniles remaining in the company of their parents until the end of the winter. Sometimes, a flock stops on a pond, a lagoon, or a coastal meadow. Most often, the birds seek out a protected area, for the graylag goose is prized by hunters. Here in France, these geese have learned that it is better to stay in the enclosure of a preserve than take their chances outside one. It is only when the birds are crossing the sky at great heights that they are safely out of range.

But how long will we see these flocks of migrating geese? It is not that the species is in decline, fortunately, but the milder winters now make them more inclined to stay in the north. Will they end up becoming resident here? This would no doubt be good for the birds, but too bad for those who love to watch them passing overhead.

With the warming climate, the passage of the graylag geese, *Anser anser*, tends to occur later and later in the fall and earlier and earlier in (or before) the following spring. The birds in Western Europe may now wait until the beginning of December to fly south, and may return north starting as early as January.

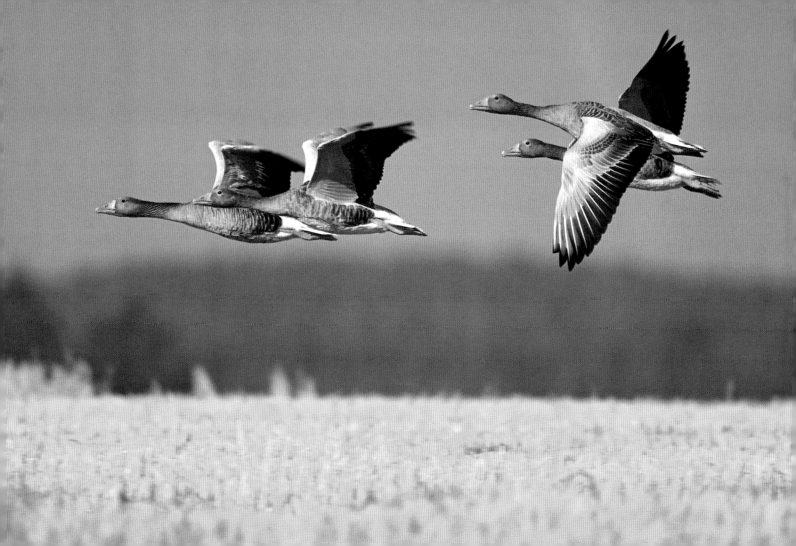

Hooded crow

As soon as the French bird-watcher crosses into eastern Germany or the south of the Scandinavian peninsula, or even into Scotland, the carrion crow gives way to a closely related species: the hooded crow. This bird has traded the black plumage of its cousin for a more elegant gray-and-black habit. Even so, it has a personality similar to that of the carrion crow: the same curiosity, the same intelligence, the same mischievousness. Like the black crow, the hooded crow is habituated to large cities, finding its meals in trash cans, on sidewalks, anywhere, in truth, that humans leave their scraps.

In ancient times, as the painter Pieter Bruegel the Elder shows us, the hooded crow left the north and east to spend the winter in Western Europe, fleeing the winter cold. Today, it no longer does. It has become sedentary, thanks to humans and, no doubt, as a consequence of the milder winters in those breeding grounds.

The hooded crow, *Corvus cornix*, lives in Ireland, in Scotland, in northern and eastern Europe, and beyond as far as central Siberia. To the west, it also reaches into Italy, Corsica, and Sardinia. Once migratory, the northern populations are now resident.

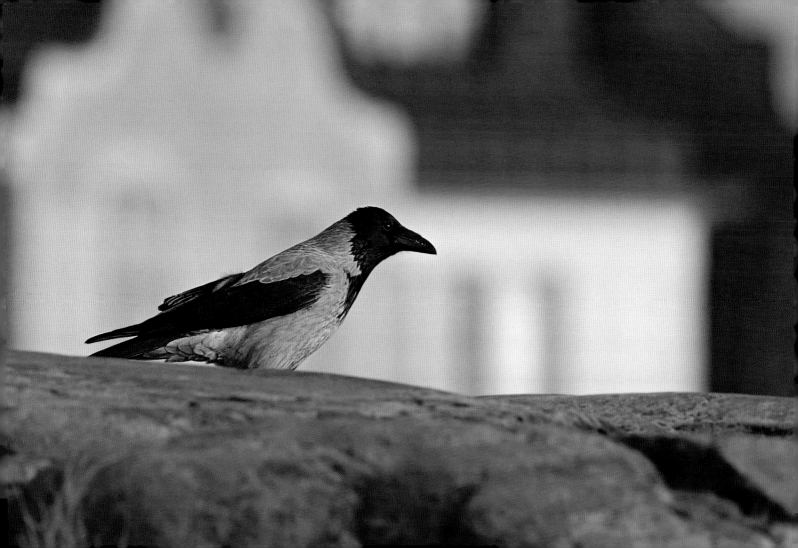

Indian roller

When an ornithologist leaves Europe and goes to Asia, he quickly notices that the roller there is different from the European species. While the European roller is various shades of blue, the Indian roller substitutes touches of tan and cream-colored shaft streaks on the breast and belly. The Indian roller's behavior is fairly similar to that of its western cousin. In Asia, however, the Indian roller is much more common throughout. You see it as much in dry regions where acacias grow as on certain lush coasts amidst palm trees and colorful flowers. Similarly, it doesn't hesitate to venture into the city, and sometimes you will see it perched at the peak of a roof, scanning its surroundings for prey. As soon as it spots an insect or a small lizard, it dives to the ground to catch it. The Indian roller is also, to my eyes, a signature bird of the rice paddies and crop fields of Asia. You always see one perched somewhere in a palm tree, watching the whole tiny world milling about at its feet.

OCTOBER

29

The Indian roller, *Coracias benghalensis*, lives from Iraq to Thailand. As its name indicates, it is particularly common on the Indian subcontinent. Generally sedentary, the birds may nevertheless make local movements on a seasonal basis.

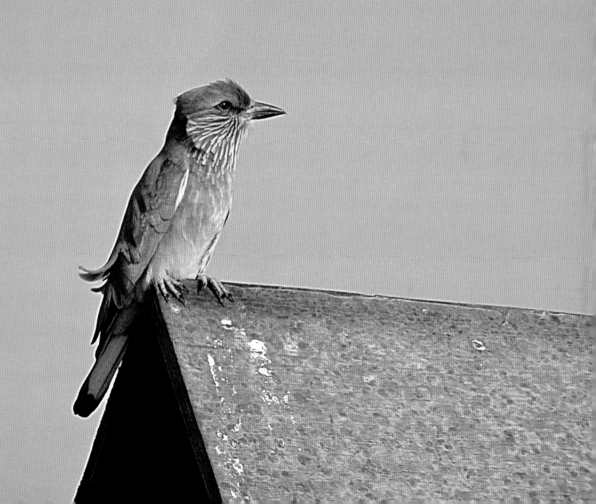

Hawfinch

With its enormous beak, the hawfinch is impossible to miss. Its French name means "nutcracker grosbeak," and one imagines that with such a tool, it could, indeed, easily crack all the nuts in the world. In addition, its plumage, without being colorful, is conspicuous. And yet the hawfinch is quite a discreet bird. In the trees where it lives, once it is settled, it is very difficult to distinguish. It doesn't move much, and when it does, its movements are rather slow. Its cries are very simple: just a small, shrill, and piercing *tsik!* when it flies. To the experienced eye, in truth, the best indicator of its identity is its silhouette in flight. Then, it displays an enormous beak that gives the impression of a large head, a body that is rather round and even a bit stooped, and a short tail that gives it a distinctive squat and stocky shape.

A member of the finch family, as its name suggests, the hawfinch, despite its size, knows how to melt perfectly into the trees of the forest. In winter, it comes to the bird feeder, but it is not the most eager of the birds who do so. In the end, to encounter it is always a happy accident, and its discreet habits make it seem a rare bird even though it really is not.

OCTOBER

30

The hawfinch, *Coccothraustes coccothraustes*, lives in the large forests of Europe and Russia. It is fairly sedentary, but like a fair number of forest species, it may make invasions into other areas if food becomes scarce.

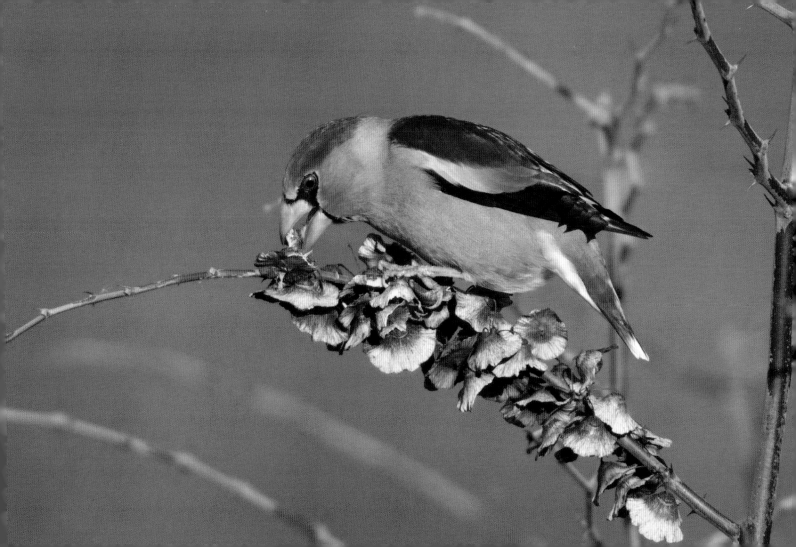

USHANT

Let us return for an instant to the islands that lie off the coasts of the continents. Not to the distant islands of the Pacific or the Indian Ocean, but those of the northern Atlantic or Pacific—these little pieces of land detached from the great continental mass. In fall, these are magical meeting places between the birds and their loyal devotees, the ornithologists. In the fog of the North Sea is Fair Isle, a haven for thousands of birds, often lost at these latitudes. Here, a few lucky souls can observe a grasswarbler from eastern Siberia or an American warbler who has strayed far from home.

The isles of Scilly are also known for attracting lost birds. But there, dozens of ornithologists range constantly over the islands in the course of their research. Farther to the south, Ushant, in France, also welcomes its share of strays. Between sky and sea stands the Creac'h lighthouse. At night, migrating birds ceaselessly circle through its beams of light.

What extraordinary moments I have spent here on early fall mornings. The air echoes with the cries of these nocturnal voyagers, as they seek a place to land and regain their strength.

In October, field ornithologists criss-cross the favored areas (islands, capes, rocky points) where migrating birds tend to concentrate. This great seasonal meeting takes place in most countries in the world.

OCTOBER

31

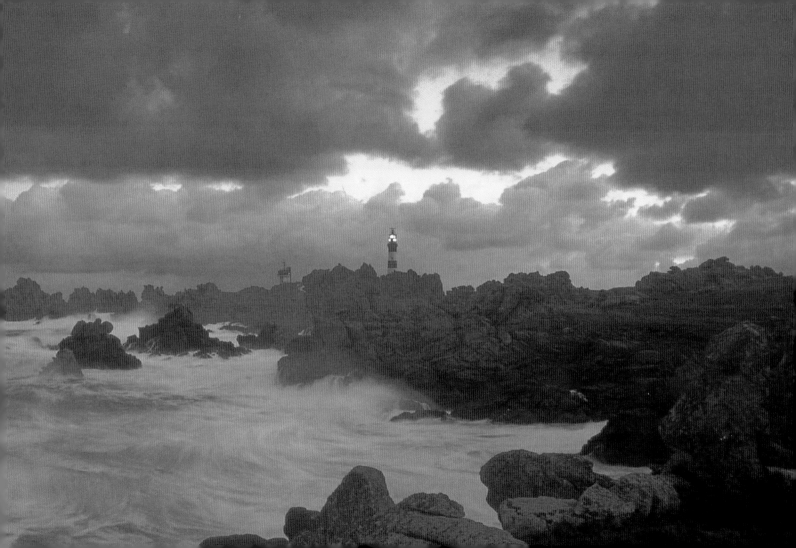

Franklin's gull

Not far from Calgary, in the Canadian province of Alberta, the prairies have gone silent. No more birds enliven the fields and surrounding wetlands. A few months ago, this area was full of life. Notably, it was inhabited by a colony of Franklin's gulls, who generated a constant hubbub with their screeching calls and vocalizations. Today, however, all is calm. There is only a hawk, flying off as if he'd been caught stealing, skimming over the ground.

The Franklin's gulls are now in the southern hemisphere. They have gone to the Pacific coasts of Peru to spend the winter, far from their Canadian homeland. I have never traveled to visit them in that part of the world. I have seen them here, in North America, in their noisy Alberta colonies and, a little farther to the east, in Manitoba. And three times I have had the pleasure of seeing this gull in Dakar, Senegal. It always seems strange to find a gull of the Great Plains circling with other species on a densely populated African beach, or in a port lined with palm trees. Here was one gull who would not see the Peruvian sun!

A North American species, the Franklin's gull, *Larus pipixcan*, nests principally in the Great Plains region. A migrator, it flies south to the Pacific coasts of South America. Sometimes, birds stray, and they may then be found on the Atlantic coasts.

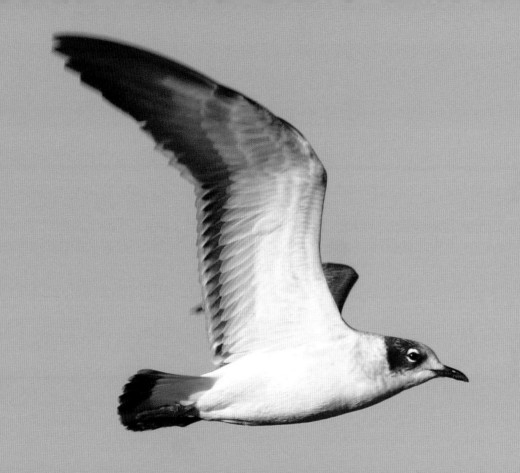

Hooded merganser

The first time I saw a hooded merganser, it was on a little pond on Long Island, in New York State. It was snowing, and terribly cold. The cottony silence around us, a white-tailed deer who seemed not to have scented our presence, and the huge flakes that dropped from the sky to drown in the frigid water: these were the elements that composed the scene. But within it swam the feathered jewel that is the male hooded merganser. In the general whiteness, its shimmering feathers stood out almost too forcefully. It was an outsider that seemed to disturb the immaculate white of our environment. It dived regularly into the water, which one sensed would not be long in freezing. With each dive, the landscape regained its uniformity. And when the duck reappeared, it again stained the scene, a colorful intruder.

I later saw this merganser again under less wintry conditions, in a great display around the much drabber females. Winter was distant, and the colors of nature had regained their rightful diversity. And the merganser, at present, was in perfect harmony with its environment.

The hooded merganser, *Lophodytes cucullatus*, nests in western and eastern-central North America. Once reproduction is finished, the birds will spend the winter a little south of their nesting area, without leaving the continent.

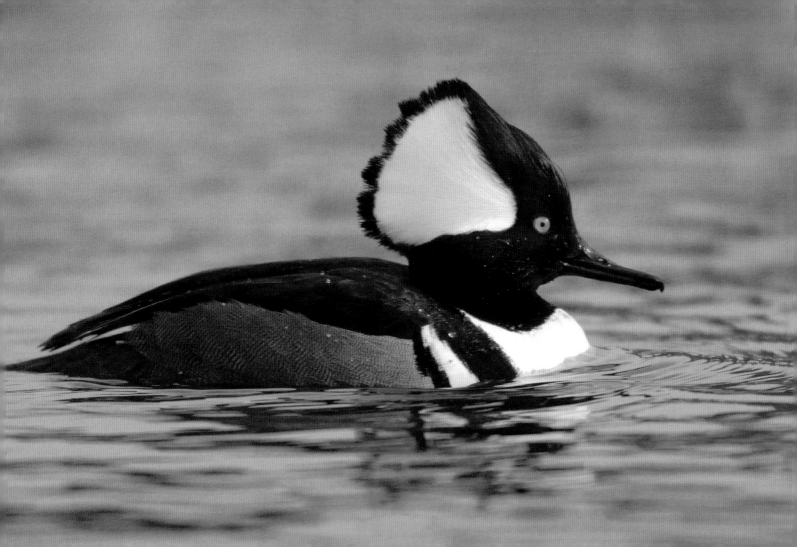

Pine grosbeak

In the world of the finches, the grosbeak is one of the largest species and nonetheless one of the most discreet. Ordinarily, it lives in the great boreal forest, moving silently among the conifers. At the top of a pine tree, it peels a pinecone with almost complete immobility, with only its mandibles moving. With a hushed flight it takes off, and you must not let it out of sight unless you want to risk losing it for good.

The pine grosbeak is indissolubly linked in my memory to these boreal forests of the Great North, whether Scandinavian or Canadian. In summer, when the mosquitoes pursue you without respite, you may try, despite everything, to spot the birds amid this universe of vertical trunks, trees fallen in tangles of branches, and soft and mossy ground. One must be attentive—no easy task given the fearsome mosquitoes—and scan for the smallest trembling amid the high branches in order to finally find the birds. Though they are discreet, paradoxically, they are not very shy. Once you spot them, you can approach them quite closely. What a contrast to seeing this same species now, in an eastern Canada winter. Amid a fierce cold that has laid waste to the mosquitoes, the birds search for food at the top of a spruce, easily visible in the middle of the countryside. And we stand below, with frozen feet, as the ground beneath us creaks with snow.

The distribution area of the pine grosbeak, *Pinicola enucleator*, follows the belt of the boreal forest of Eurasia and North America. In the western part of the latter continent, the species nests as far south as California. Generally sedentary, it is subject to irruptive migrations that can lead the bird south of its usual territory.

Merlin

Skimming over the ground, with an ultra-rapid flight, a merlin is on the hunt. That is how this little flying bomb—one of the smallest falcons in the northern hemisphere—hunts the passerines on which it feeds. It is skilled at the surprise attack, and the imprudent lark oblivious to its approach will either be brutally torn from the ground or forced into a high-speed chase. The lark's chance of escape will depend on its capacity to dodge the merlin with zigzags and swoops worthy of a flying ace.

In the temperate regions where it does no more than spend the winter, the arrival of the merlin coincides with that of the migrating passerines from the Great North. It follows the migrating flocks and dips into this flying larder when it sees fit. In watching its lively, slightly jerky flight and slight silhouette, one is struck by this raptor's small size. But the passerines have long learned to mistrust it and fear it as much as the hawk or the eagle.

The merlin, *Falco columbarius*, is a species that nests in the boreal and Arctic regions of the northern hemisphere. In winter, it leaves these areas overtaken by ice and snow and finds refuge a bit farther south, extending as far as Mexico or North Africa depending on the continent where it lives.

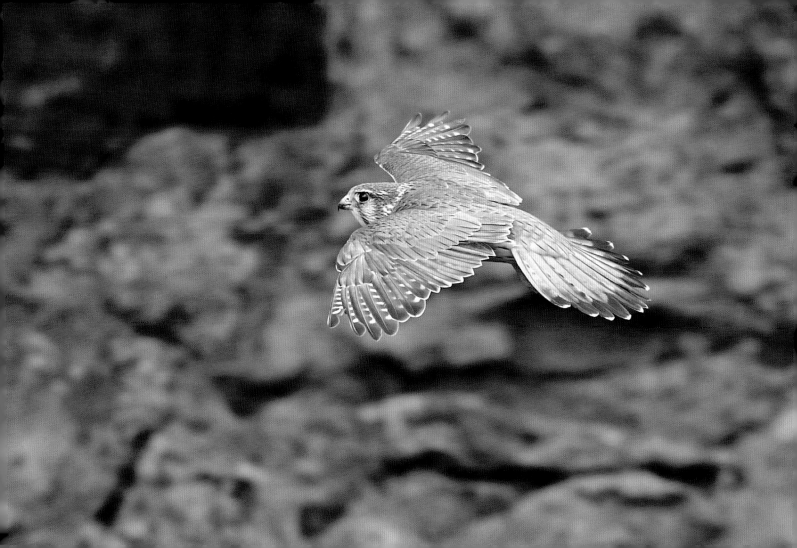

Sacred ibis

The sacred ibis is familiar as the bird featured on Egyptian bas-reliefs. It is the symbol of Thoth, the god of languages and of knowledge. The bird disappeared from Egypt nearly two centuries ago, however. Today, it is found in all of sub-Saharan Africa, where it has become very common.

You might say that the sacred ibis is the Jekyll and Hyde of Old World birds. You can see it grazing among the antelopes along an African river, or on a wetland filled with thousands of birds. It is beautiful. But sometimes, less appealingly, it hangs around the trash cans in large African cities. And as escapees from zoos, ibises now live in the wild in several European countries (France, Italy) as well as in the United States (in Florida). There, the ibis has become nearly an invasive species, sometimes competing with and overpowering local bird species. What is beautiful in rural Africa becomes a problem outside of Africa. In general, while biodiversity is a good thing, the addition of introduced or transplanted species is another matter; they can pose an array of concerns in their new habitats. It's enough to make the god Thoth cringe.

The sacred ibis, *Threskiornis aethiopicus*, lives in a large part of Africa south of the Sahara, where it is more or less resident. It was found in Egypt until the middle of the nineteenth century. The species was introduced in France, where there are at present more than 1000 couples, mostly in the west of the country.

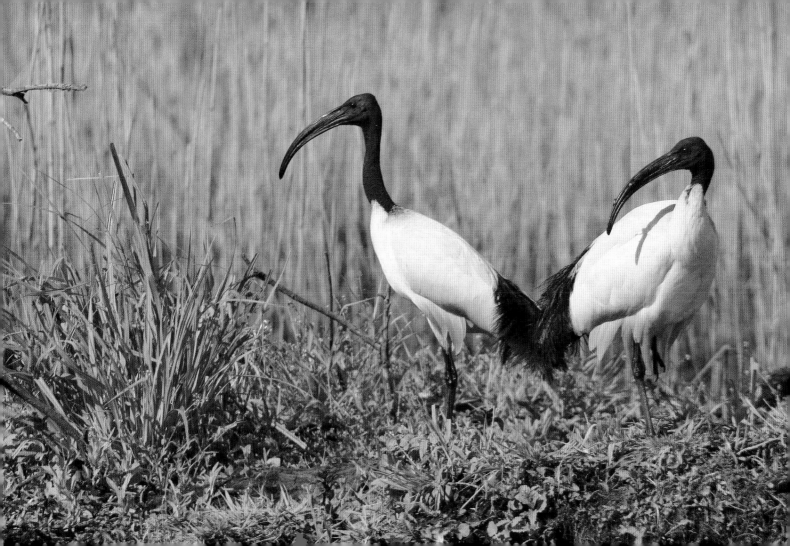

Ivory-billed woodpecker

You have almost no chance of seeing the ivory-billed wood-pecker—for the simple reason that the species is (very probably) extinct. It once lived in the riverine forests of the southern United States (and another subspecies lived in Cuba). The species was immortalized by the great French-American naturalist and painter John James Audubon. This giant woodpecker with black and white feathers apparently disappeared sometime in the course of the twentieth century, the last bird having been "officially" seen in 1944.

In recent decades, there has been a long saga of unproved observations and rumors, and in 2004 and 2005, scientists succeeded in filming what appeared to be an ivory-billed woodpecker in the Arkansas woods. After fierce discussions, debates, and even polemics, however, the scientific community concluded it was impossible to confirm that the video was of an ivory-billed woodpecker—which somewhat resembles the pileated woodpecker, a far more common bird.

People searched for months in the part of Arkansas where the bird was believed to have been spotted in 2004, but to no avail; the hopes then raised were never fulfilled. Most likely, the ivory-billed wood-pecker is now sleeping forever in some drawer of the natural history museum—and will never again be seen in the great riverine forests.

The ivory-billed woodpecker, *Campephilus principalis*, once lived in the southern United States, particularly in the states of Arkansas, Missouri, and Florida. A creature of the vast swampy forests, it was never terribly abundant. It was the gradual disintegration of these great forest areas that, apparently, led to the disappearance of this legendary species.

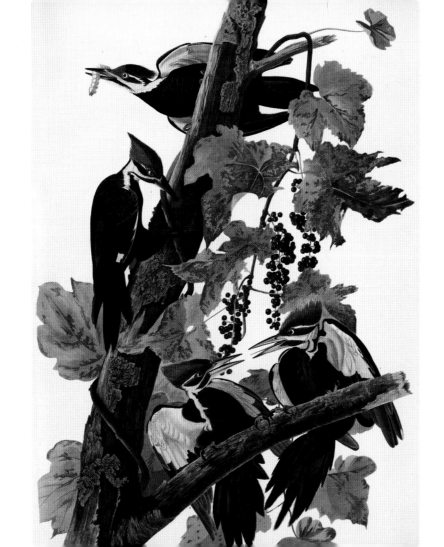

Pitta

The pittas are among the strangest birds in the tropical forest. These birds, which are primarily terrestrial, are known for being remarkably furtive and discreet. When you look at illustrations of pittas, you would certainly imagine it is not too hard to spot these brightly colored birds feeding on the ground. Wrong! Finding them is a nightmare, and one that I have all too often experienced. No doubt it is my elephant-like steps that prevent me from seeing them—but whatever the reason, I can count my sightings of the bird on the fingers of one hand.

Perhaps someday, with much luck and patience, you will have the opportunity to observe a pitta scratching the ground of a forest in Cambodia, Thailand, or Congo. If you do, you will be amazed by the colors of its plumage. Enjoy the moment. Hold your breath and know that you are experiencing one of those magical moments that nature provides to those who look.

There are 32 existing species of pitta. These birds, which live on the ground, are found in various regions of south Asia and Africa. They are nearly all sedentary, though some species make small seasonal moves.

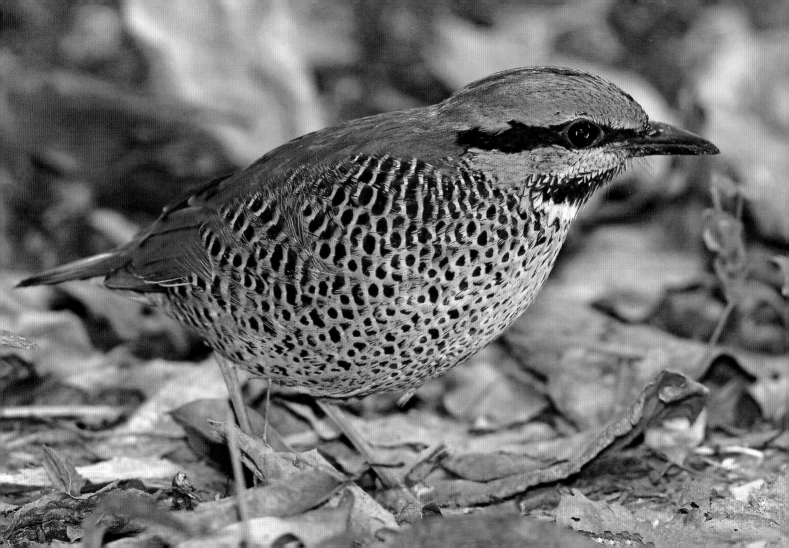

Common crane

Kroo…kroo…krookroo! Raising my eyes, I see a large *V* formation of gray birds, at low altitude, visibly seeking a place to land. Their flight is slow, the flapping of their wings full, with their legs stretched out horizontally behind their bodies. They are common cranes. This group has perhaps come from Germany to fly over the humid Champagne region of France, and it will land near the Lac du Der-Chantecoq, one of places in Europe best-known as a stopover (and, these days, as a winter home) for migrating cranes.

Slowly, the birds turn, beginning to lose altitude, without ever ceasing their cries. Already, some cranes are beginning to put out their landing gear: they release their legs and let them hang vertically from their bodies, ready to touch down. The flock makes a few orbits and then the birds finally hit the ground, one by one. All this with slow elegance and powerful honking.

The spectacle of the cranes in fall is unforgettable. Unfailingly, it attracts crowds of ornithologists, nature lovers, and simple passersby.

The common crane, *Grus grus*, nests from northern and eastern Europe to Siberia. The birds fly south in the fall toward warmer winter territory in southwest Europe, on the Mediterranean coast, and in the Middle East. The migratory movements of these birds occur along a narrow geographic axis, which is particularly well-known to ornithologists.

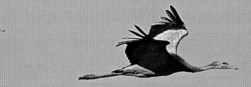
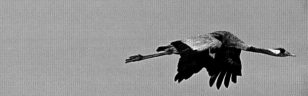

Mandarin duck

There is hardly a zoo without its collection of strikingly beautiful mandarin ducks. On the pools and lakes of public gardens, one regularly encounters these ducks as well. The males display a superb plumage. This duck has adapted well to Europe and to the Americas, though it is originally from Asia. It has become almost more common in the countries it has colonized than in its land of origin.

But it was on its original terrain, in its natural habitat, that I most wanted to see this duck. And I succeeded one morning in May, in eastern Siberia, not far from the city of Khabarovsk. On a beautiful pond swam a little group of mandarin ducks, the males in full display. But they were shy, and quickly disappeared from our view. The lake was bordered by a forest. Curiously, for a duck, this species nests in trees and searches for holes there to lay its eggs. Hardly have the mandarin's chicks been born when they leap from the nest into the void, rejoining their mother who calls to them from the ground. For the mandarin duck, life begins with a jump.

Originally from eastern Asia, the mandarin duck, *Aix galericulata*, is frequently kept in captivity for the beauty of its plumage. In Asia, it is a symbol of fidelity (the duck mates for life), and in China mandarin ducks are often given as gifts to young married couples.

Steppe eagle

At this time of year, at the boreal latitudes, migration is nearing its end. In the Middle East, however, one still sees raptors passing through from Central Asia and Siberia, heading to East Africa for the winter.

Among these birds, the steppe eagle is, along with the eastern imperial eagle, the most majestic. With their wings spread wide, these large eagles may have a wingspan of up to six feet (two meters). Against the blue sky, in Jordan, Egypt, or Israel, one sees their large silhouette glide slowly toward some point unknown to us, from which it appears nothing could divert them. The birds winter in the southern Arabian Peninsula and beyond. In Yemen, in Oman, one sometimes sees them perched on poles, almost unmoving, or circling in the desert sky in search of prey.

As for the source of their names, in Kazakhstan and in Mongolia, you can find the steppe eagle nesting in this habitat. It has very few requirements there: a bush, an abandoned building, or a pile of stones will do. The steppe eagle is skilled at making do with the materials at hand.

The steppe eagle, *Aquila nipalensis*, nests from the Caspian Sea through all of central Asia and even in Siberia. While a good part of the population winters in East Africa, another portion spends the season on the Indian subcontinent.

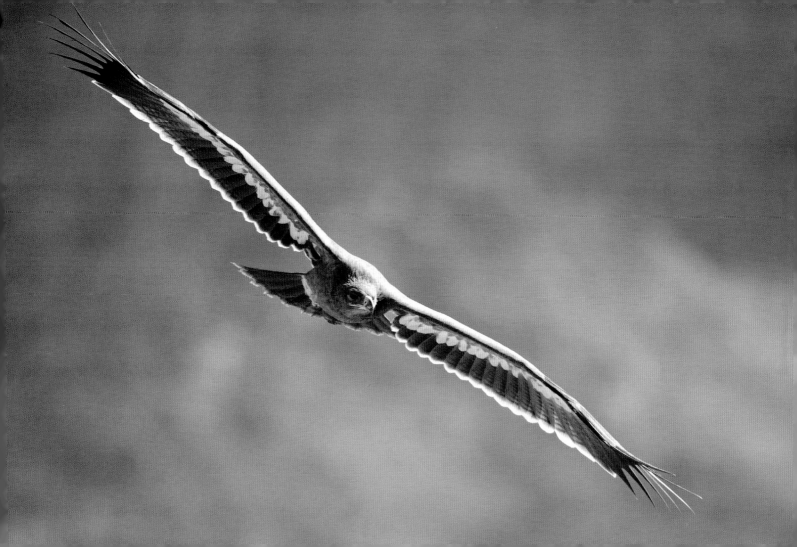

Common eider

Just offshore from the seawall, on the island of Texel in the Netherlands, a flock of ducks plays in the waves. Most are brown, but some have beautiful black and white feathers, while others wear a funny motley costume of brown and white, like white birds who have gotten slightly dirty. They are common eiders: females and juveniles, adult males, and immature males. This whole little society is taking turns diving and coming back up again, often with mussels in their beaks. The eiders have come here from Scandinavia, with the firm intention of spending the winter.

And so they will, unless a passing cold front forces them to pack their bags and fly farther south in quest of less frigid weather. The same thing occurs on the other side of the Atlantic, in the United States, where tens of thousands of birds retreat south to the eastern coastline. Though the eider is a hardy bird, it cannot tolerate oil pollution. It was, for example, one of the major victims of the *Exxon Valdez* spill in Alaska in 1989, and of the crash of oil tanker *Erika* in 1999 off the French coast. Both incidents claimed the lives of many of these birds.

The common eider, *Somateria mollissima*, nests throughout the European, North American, and Russian Arctic. It migrates in winter toward southern seas that are free of ice. The bird is known for the softness of its down, which has long been used to fill quilts and line clothes. The down is harvested from the nests of the females; they pull it from their bodies to line their nests.

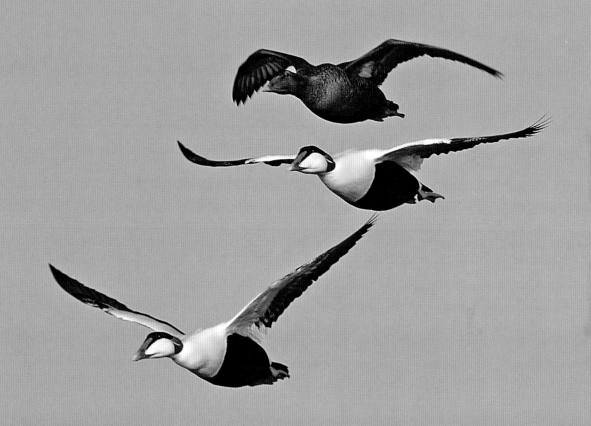

Red phalarope

This is yet another species most easily seen in stormy weather. The red phalarope actually does little to show itself to the observer at any time. In summer it nests in the most remote parts of the tundra. Once reproduction is completed, the birds go to spend the winter on the open water, far from everything (a curious habit for a little wading bird to prefer the high seas to dry land). Thus, short of making a special expedition to meet them, you must wait for the natural elements to work in your favor. A good fall storm can drive the birds as far as our coasts. It is an opportunity to see them, always busily in motion, searching for plankton on the surface of the water and spinning like tops. Seize the opportunity if it comes, for as soon as the wind slackens a little, they will head back out to sea.

I have often seen the bird at this time of year, but it took me more than thirty years to see my first red phalarope in breeding plumage, which is a superb brick red.

Nesting in the far northern reaches, from Canada and Alaska to the northern parts of eastern Siberia (and here and there in Greenland, Spitsbergen, and Iceland), the red phalarope, *Phalaropus fulicarius*, winters on the open water off the Pacific coast of South America and the Atlantic coast of Africa. Among the phalaropes, it is the female who sports the beautiful breeding plumage. She may take several male mates (the bird is polyandrous), and it is they who sit on the eggs and take responsibility for raising the chicks.

Eurasian bullfinch

The Eurasian bullfinch is an inconspicuous bird. Despite an attractive pink and gray plumage, with a black cap on top of its head, this finch knows how to go unseen. A creature of the woods, the bullfinch often stays high in the trees; when it flies from branch to branch, one can sometimes spot its white hindquarters, to fine effect. That, in sum, is about all there is to say. In terms of vocalizations, it is no great shakes. Its cry is a soft *hoo!*, low and sustained, and does not carry far. Its song is no easier to hear; picking it up requires a good ear. And the sound is far from beautiful. With its hoarse, feeble chirps, the bullfinch is no competition for the song thrush or the nightingale.

It is inconspicuous all year long. Along with the grosbeak, which is a similarly temperate bird, and the pine grosbeak, which is more northern, it forms a trio of tiny forest birds. In the fall, the birds show themselves more clearly, and this is the only opportunity to observe them in slightly more open habitats than the depths of the woods. One then can better admire the delicate nuances of the bullfinch's colorful plumage.

NOVEMBER

13

The Eurasian bullfinch, *Pyrrhula pyrrhula*, nests in all the forests of Europe and temperate Siberia. It is fairly sedentary, but the most northern and most eastern nesters often move in the fall, searching for food that may be lacking in their nesting quarters.

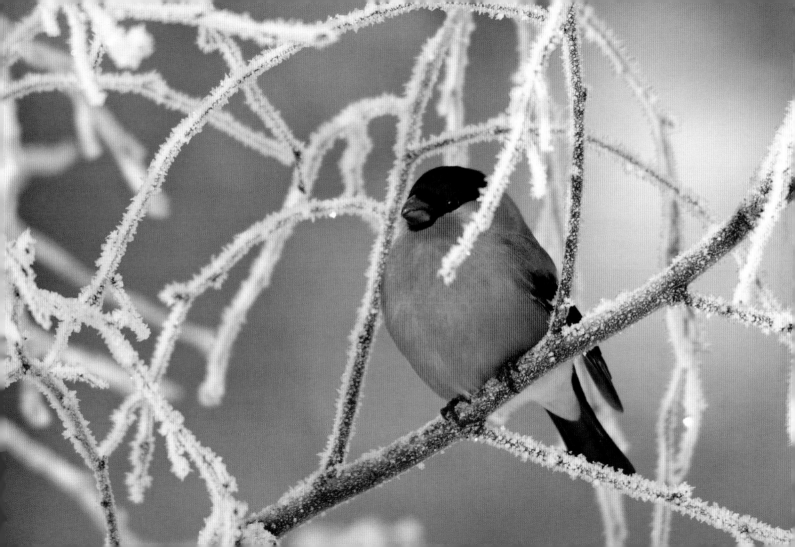

Common mynah

Around the temples of Angkor, the common mynahs hunt for scraps from the tourists' meals. Like our starlings, they are bold birds, and do not hesitate to come close to steal a few crumbs fallen to the ground. The mynah is indeed the starling of Asia. And, besides, it is closely related. Like the European bird, it is a devilish opportunist, always ready for trouble. Typically, it can be seen waddling along, contemplating its next heist. Also like the starling, it has gone in conquest of new regions beyond its native territory. At present, it is found here and there in the Middle East, and it has already set foot in the Americas (in Florida, to be precise); it has even tried to expand into Western Europe, but without success for the moment.

It must be said that the mynah is not an ugly bird, and that is one reason it is sometimes kept as a pet—that and the fact that various species of mynahs are said to be able to speak. But the cleverer it is, the more likely a bird is to liberate itself from its prison, make itself at home in the wild in the country where it has gained asylum—and raise a family. Today it is considered one of the most potentially invasive species in the world, and a menace to local biodiversity.

Originally the common mynah, *Acridotheres tristis*, was widely spread over the Asian continent. It has now acclimated to many other countries and may in time gain a nearly worldwide distribution, following the example of the European starling.

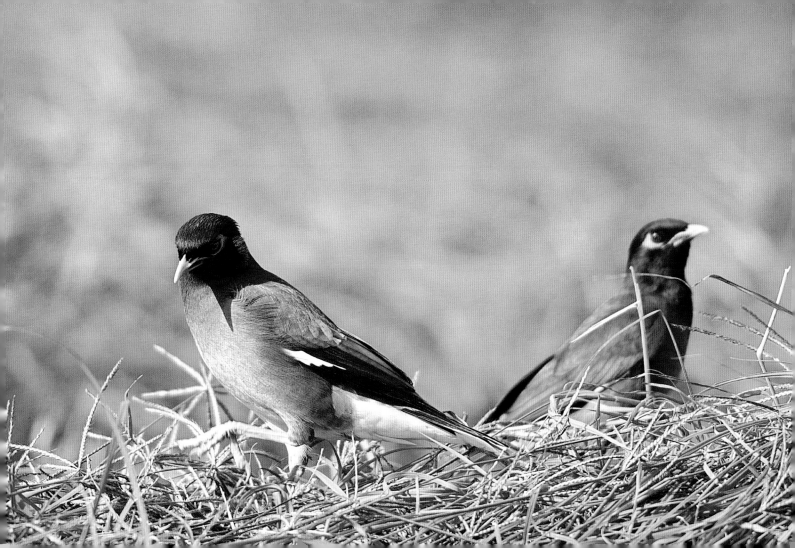

Common teal and green-winged teal

A large flock of common teals has taken shelter in this private wetland in the Camargue, in France. Here, the birds are not hunted, and are thus safe. For the moment, while an icy storm sweeps the surface of the water and makes it ripple, the birds are nearly all sleeping, heads under their wings. The teals will refuel during the night and then scatter into the surrounding swamp to feed. Then, when night ends, they return to the peaceful swamp and spend the day resting and preening themselves. A few are swimming, but without straying far from the reed bed that protects them from the wind. They come from far away, these teals—no doubt from Siberia. Highly prized by hunters, the teal will not necessarily have a restful winter, here or elsewhere.

On the other side of the Atlantic, the common teal's American cousin, the green-winged teal, benefits from slightly greater tranquillity, though there, too, it is appreciated by hunters. In California, in the middle of winter, I have seen this teal under similar conditions to the European birds. Until some years back, the two varieties of teals were even considered to be one and the same species. Genetic analysis has since indicated otherwise.

The common teal, *Anas crecca*, is widely distributed through Europe and Siberia. It migrates toward temperate zones in winter. The green-winged teal, *Anas carolinensis*, resembles it a great deal. It nests in the northern half of North America and winters particularly in the southern half.

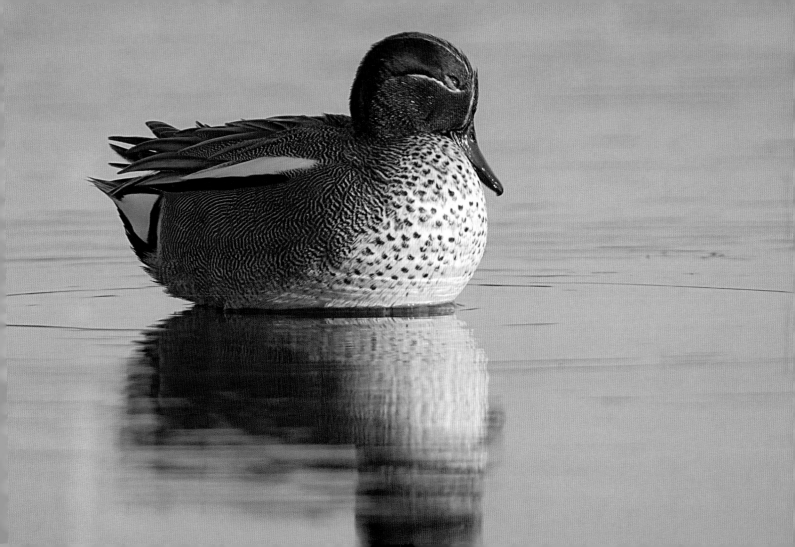

Northern lapwing

Huddled close together on a large field in the north of France, facing into the harsh north wind that has been blowing for two days, the lapwings brave the cold of a premature winter. They must have arrived during the night, fleeing the north seized by frost, for just yesterday this freshly plowed field was empty. Their crests pinned against their backs, they blend in with the thick clods of earth, and it is not easy to count them. Many are crouched down, so that only their heads can be seen, sticking up amid the hillocks. Others are sleeping, three-quarters hidden by their companions. It is already too cold this morning for them to search for worms or insects in the ground. They wait, patiently, for the sun to truly show itself and shed a little warmth on the upturned earth. Then, with tiny steps that suddenly stop short, they will look for the food that is so necessary for their continuing peregrination.

But tomorrow is Saturday. The hunters will be out, and these birds will be too enticing to remain here undisturbed. At the first shot, the lapwings will be off in an undulating flight, like an army of black-and-white butterflies, sailing toward a more peaceful location.

The northern lapwing, *Vanellus vanellus*, nests throughout Europe and in a good portion of Siberia. In the western part of its nesting territory, it has suffered greatly from losses of swamps and meadowland, and its numbers have plummeted considerably. It is now protected in a number of European countries.

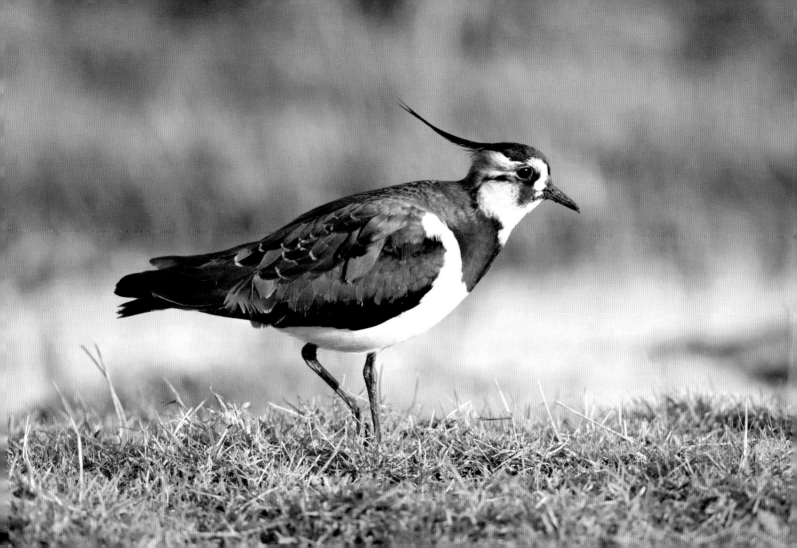

Baillon's crake

By this time of year, the Baillon's crakes have abandoned Europe. To see them, you must go to Africa, tropical Asia, or the Arabian Peninsula. It is in Oman in November, and in Thailand in the middle of winter, that I have had my most beautiful sightings of this bird.

The Baillon's crake is from the same family as the coot and the moorhen; it is these birds' small cousin. Small, indeed, for it is barely bigger than a sparrow. The crake is a nightmare for European ornithologists. In the first place, it is extremely rare in the whole western part of the continent. Secondly, it makes its nest only in the deepest of swamps, in flooded areas that are very difficult to access. Finally, it comes out only at night for most of the year. One might even say that it does everything it can not to be detected. Not only does it sing mostly in the middle of the night (between midnight and two in the morning), but its song also strongly resembles that of certain frogs—which, being extremely abundant in the swamp, are also singing their hearts out. Thus tracking down the crake through its song is no easy task.

All in all, it is best to go look for the Baillon's crake in winter, when it shows itself at all hours of the day, and often at the edge of a wetland or river.

The Baillon's crake, *Porzana pusilla*, has a large geographic distribution, primarily from Europe to the Far East. The birds are migratory and abandon the great wetland areas, principally in Siberia, to winter in the tropical belt of the Old World. There are also populations living in Australia, New Zealand, and South Africa.

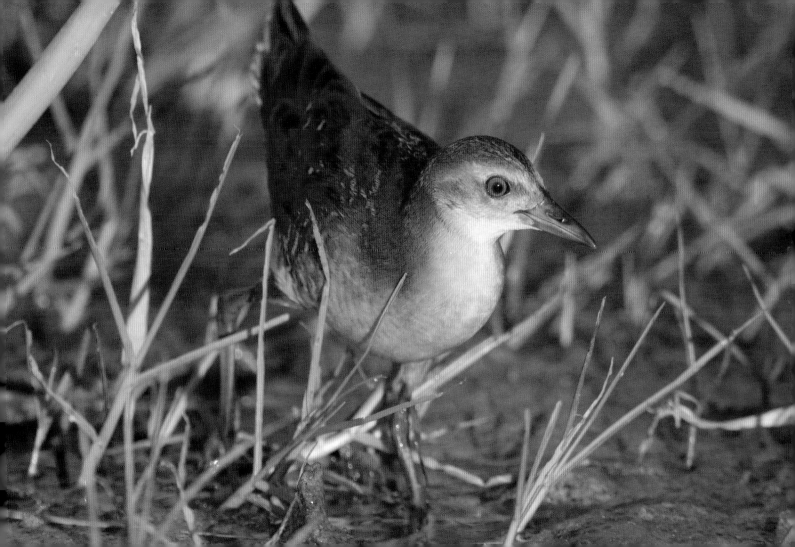

Sunbirds

The Americas have their hummingbirds; the Old World has its sunbirds. Though they do not belong to the same family—or even to the same order—they have several characteristics in common. Among other similarities, the sunbird, like the hummingbird, tends to have a long beak, tiny stature, and a rapid flight (though sunbirds are nevertheless far from having the flying skills of the hummingbird, which can even fly backward). Also, the males in both cases have a plumage with metallic highlights.

Sunbirds live in the tropical regions of Africa and Asia. They are frequently found around flowering trees, whose nectar they drink. They are also insectivores, always on the lookout for the tiny creatures that, like them, are attracted by the flowers.

With a lively flight, always in action, the males are very territorial; you often see them squabbling and chasing one another, giving out shrill and not very musical cries. In the northern latitudes, they hardly ascend past the Middle East; they are unknown in Europe.

If the males are clad in iridescent colors (though many are simply a metallic blue or purple), the females have a rather drab, greenish-yellow plumage. Particularly in countries where there are numerous species of sunbirds, it can be difficult to identify the females as belonging to one species or another.

There are more than 120 species of sunbirds in the world. Unlike hummingbirds, which are Trochilidae, sunbirds belong to the order of passerines. They are sedentary. Some species also live in Australia.

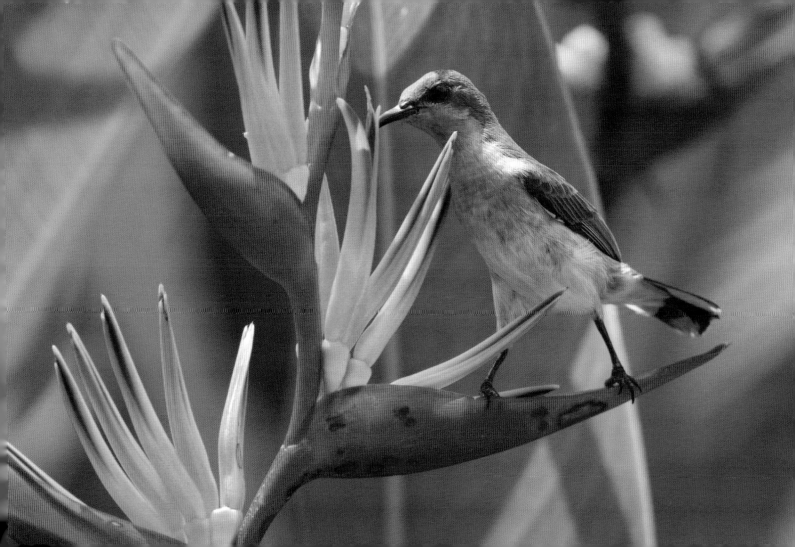

Eurasian bittern

In the spring, its strange song echoes through the great reed beds of Eastern Europe. It is a low *bouhoomp!*, a little like the foghorn imitation you can make with the neck of a bottle. But like many swamp birds, it remains well hidden amid the shelter of the deepest part of the reed bed. In the fall, when the birds of the north and the east head back to more southern latitudes, one may spot a bittern standing at the edge of a little pond, immobile, looking for food. Anxiously, it will then extend its neck as much as possible, beak pointed toward the sky, trying to pass for a reed itself.

But it is in winter, especially during the freeze, that fortune may smile on us. Driven by the cold, a bittern will sometimes desert the reeds to hunt for fish at the edge of the pond, thus revealing itself more easily. If the pond is completely frozen, you may even see a bittern trying to take a few clumsy steps on the ice. But usually, you must content yourself with hearing its song or with seeing its heavy silhouette flying over the top of the reeds after the bird has been disturbed.

The Eurasian bittern, *Botaurus stellaris*, lives in Europe and in Asia as far as China. If the populations of Western Europe are fairly sedentary, those of the rest of its range are largely migratory and may thus winter in tropical Asia, or sub-Saharan Africa.

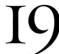

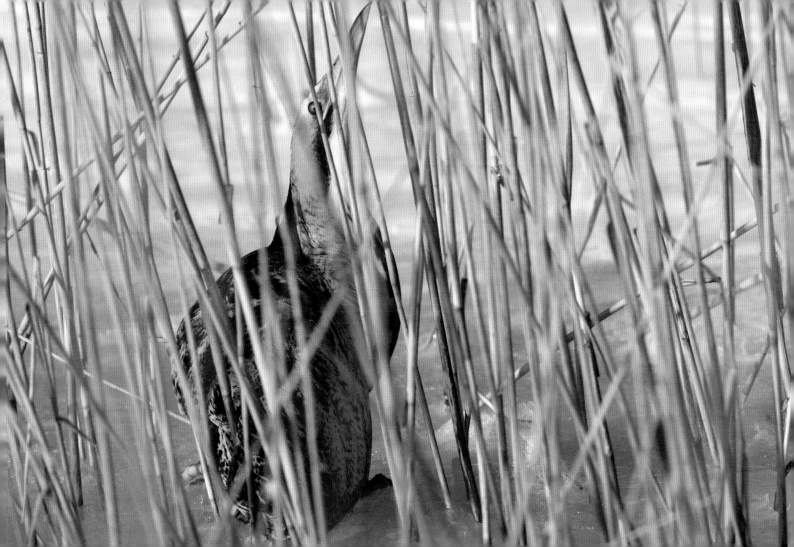

Great black-backed gull

Among the dozens of gulls perched around the port, the great black-backed gull is a giant. It dominates all the others by a head (and a beak). Its stature inspires respect, and one can guess that a good strike of its beak must leave a stinging memory. Here comes one flying in toward a streetlight on which a herring gull is standing. Without slowing down, the black-backed gull swoops to the top of the lamp-post and takes its place. It doesn't even have to push off the other bird; seeing it coming, the herring gull slipped away immediately. That's the great black-backed gull for you: a bird of great strength and power. It has been seen to attack exhausted migrating birds, catching them in mid-flight, as the birds arrive from over the sea full of joy to see firm ground where they can land. Nothing disgusts this gull. Not the migrating bird, not the fish rotting on the quay, not the rat trotting between the trash cans. And if you come to disturb it, it will welcome you with a raucous and indignant cry of *ahow!*

In the spring, the great black-backed gull nests on small islands close to shore, sometimes even in the middle of town. It tolerates other species, but, once again, it is the gull who will choose the best or highest places to make its nest. This gull is a commander among birds.

NOVEMBER

20

The great black-backed gull, *Larus marinus*, is found in North America and Greenland as well as in Europe from Aquitaine, in France, to the Kola Peninsula. Only the most northern populations are migratory, and they hardly ever go farther south than the temperate regions of the northern Atlantic.

Snow bunting

O n the white sand beach caught between the sky and sea of monochromatic winter gray, there is not a living soul. Everything seems set back to the days before human beings. Only the noise of the waves breaks the silence of the place. In the dunes, the vegetation is reclaiming its rightful turf and, here, the glasswort forms a reddening carpet as the plant takes on its fall color. Amid this scene, a little flock of snow buntings has made its home. When they are standing on the ground, one can barely distinguish them, so well do they blend in with the brown and tan colors of the landscape. But, surprised by our approach, as cautious as it is, the flock takes off and suddenly shows us the striking white of its wings—especially those of the males; the females and juveniles wear these marks to a lesser extent.

The birds circle around us, giving soft little cries that suddenly lend some cheer to this dreary beach. Quickly, however, they go to settle a little farther away and resume their frenzied quest for little seeds. It grows hard to see them amid the low vegetation. A second flight, and the joyous little flock once again traces beige and white designs against the gray of the sky.

The snow bunting, *Plectrophenax nivalis*, spends the summer in the circumboreal tundra. In winter, the birds head down to the south. They may reach as far as the countryside and inland meadows of North America, the edge of the sea in Europe, and even the steppes of central Asia.

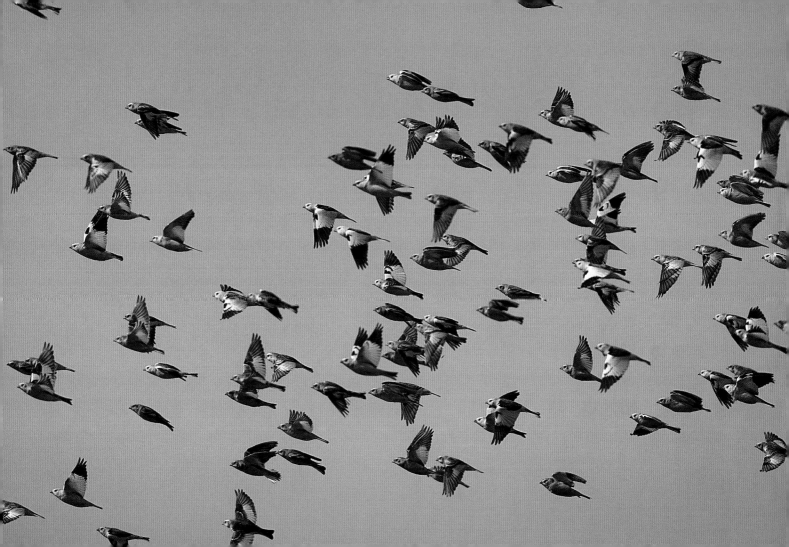

Blue jay

In North America the blue jay is truly everywhere—at least in a large part of the continent. In the city, in the country, in the woods: it is at home in all of these locales, though it doesn't particularly appreciate dense forest. Talkative, nervy, curious, it can be seen in Central Park coming to look for scraps with sparrows and other birds of the neighborhood. In the slightly gray and misty light of November, its blue plumage adds a touch of optimism amid the trees recently barren of leaves.

If it is no great singer—no jay is, any more than the rest of the Corvidae family to which it belongs—it is a brilliant imitator. It excels at counterfeiting the calls of raptors, so well that one often has the impression of hearing a hawk very nearby in the woods without being able to find it. Fair enough, since there is no hawk: just a jay right over your head. It also imitates other species, and even the human voice. Most often, you hear its own screeching cry, a little like meowing, which signals its presence even before you see it. Always curious and on the move, the jay is said to meddle in everything—including everything that touches the life of an ornithologist.

The blue jay, *Cyanocitta cristata*, lives in North America. In the northwest, it ranges as far as the Canadian province of Alberta, but does not live west of the geographic center of the United States. A sedentary bird, it stays all year near the places where it nests and is a willing resident of large city parks.

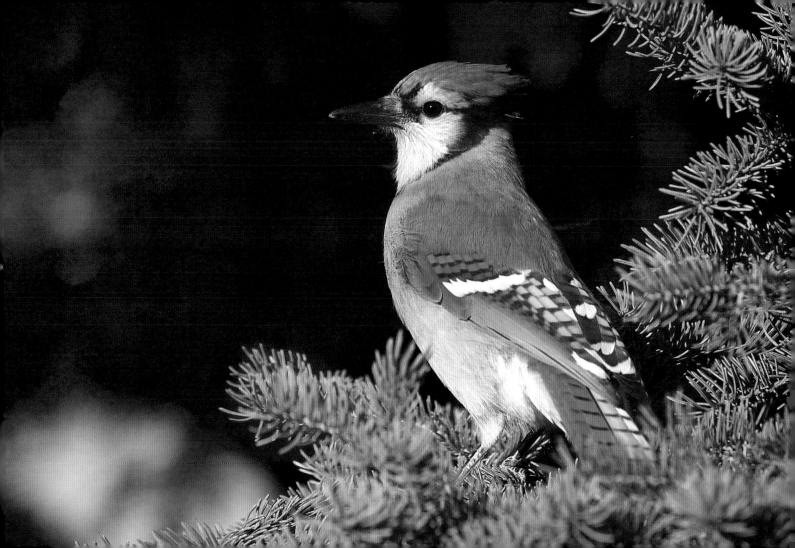

Red-throated loon

Even at this time of year, with November already well along, one can still see red-throated loons migrating. If the northern seas have grown a little colder after a particular weather event, the birds will begin a migratory flight toward the south. It is not actually a true migration, but a displacement that allows the birds to find better conditions for spending the winter. These movements, however, can still carry the loons hundreds of miles away.

Some days, one sees little groups of loons traveling toward the south—anywhere from two to twenty birds. The flight, though rapid and direct, has a heavy look. What especially characterizes the red-throated loon is its slightly hunched silhouette when it flies, its neck extended and its head a little lowered.

At this time of year, the loon's gray and white plumage is unadorned. Floating on the water, on the gray and slightly choppy sea, the bird can pass by perfectly unseen. One can also confuse it with the grebe, whose colors are similar in this season, except that the loon sits more deeply in the water with its beak often slightly pointed up.

The red-throated loon, *Gavia stellata*, nests in the tundra on small lakes (and on lochs in Scotland). In the fall, it leaves this habitat and spends the winter principally at sea, as much near the coasts as far offshore, in the eastern Atlantic and the Pacific. Its cry resembles a distant meowing.

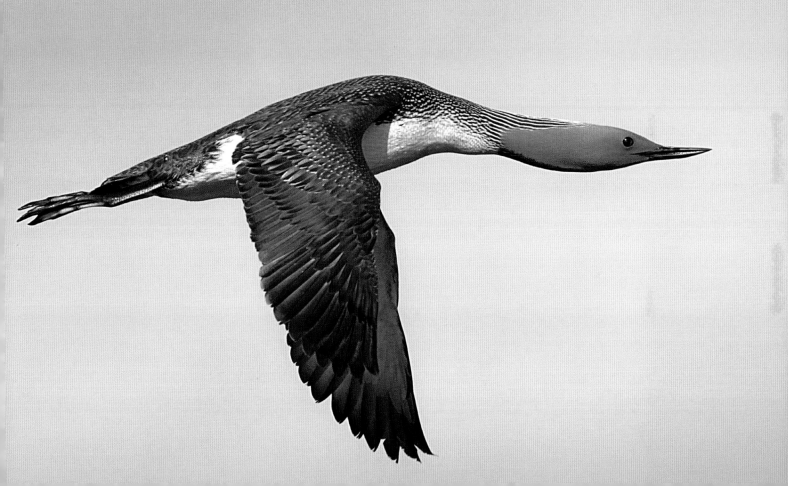

Goldcrest

It is hard to find a smaller bird than the goldcrest, which is a kind of kinglet. Of the three species of kinglets that live in Europe and the two others in North America, all are the same tiny size. These miniscule balls of feathers, which weigh barely one-fifth of an ounce, are fond of the leaves and branches. The birds spend their time exploring the tiniest recesses of the trees, where they are found, often very high up, signaling their presence only by tiny very high-pitched chirps. Some kinglets, like the goldcrest, particularly appreciate conifers, which makes detecting them a particularly unpredictable affair. When, finally, you spot the bird 75 feet (23 meters) straight up over your head, you will be lucky to observe it for more than 15 seconds (and certain to have a stiff neck for the rest of the day).

Like the American kinglets, the goldcrest makes migratory movements toward the south, at least in the case of the most northern populations. Some years, you see goldcrests everywhere, including in dunes where the migrators pause to look for food. Other years, not a single migratory bird reveals itself. But there are always the sedentary birds in temperate latitudes; they train you to raise your gaze very high and thus to notice that minuscule feathered ball, nearly invisible among the pine needles.

The goldcrest, *Regulus regulus*, lives in temperate and boreal Europe as well as in Siberia. The American species live in analogous habitats on the other side of the Atlantic. Only the northern populations move toward the south in the fall.

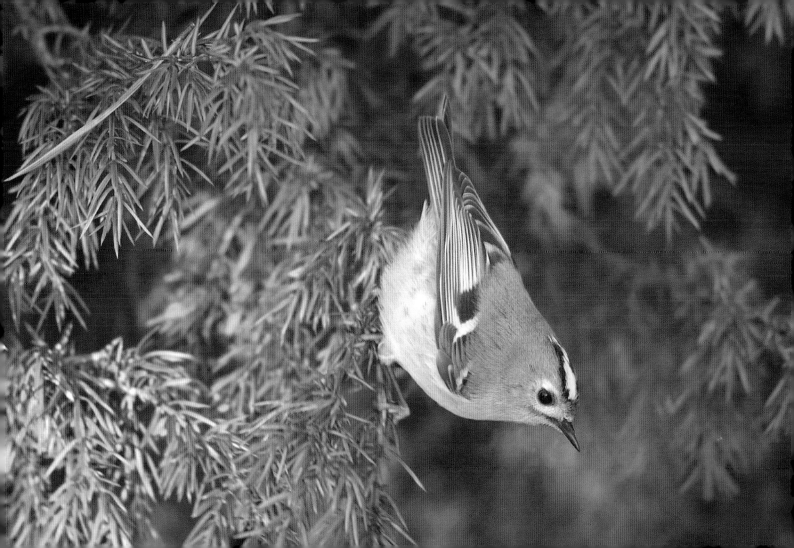

Snowy owl

For ornithologists, it didn't take the Harry Potter series to popularize this large white owl: it was already one of our favorite and most legendary birds. This big owl of the Great North remains rare to most observers living in the northern hemisphere. Nesting in the tundra, it tends not to stray far from home unless pushed by conditions of food scarcity. In that case, it can cross into more southern latitudes, but usually not below the northern United States or Brittany, in Europe. Farther to the north, in Scandinavia or Quebec, the species is seen regularly in winter.

I remember having seen the snowy owl for the first time on a snow-covered dune on Long Island. The bird stared at us with its half-closed yellow eyes. A big white ball of feathers against the blue of the sky, it looked a bit like an alien life-form: a bird from another planet. And then it flew off, with a flight simultaneously powerful and slow, showing its impressive wingspan. Each time I have seen the snowy owl since then, as on the snowy south bank of the Saint Lawrence River or on the clock tower of a little village in Flemish Belgium, the image of that great snowy owl on Long Island comes back to me. As if it were the same owl who, in the years since then and at regular intervals, is coming to meet me.

The snowy owl, *Bubo scandiacus*, nests in the tundra of the Great North. Very dependent on its prey (notably lemmings), the owl may be common one year and totally absent the next. It moves south only when the cold is extreme or food becomes scarce in the tundra.

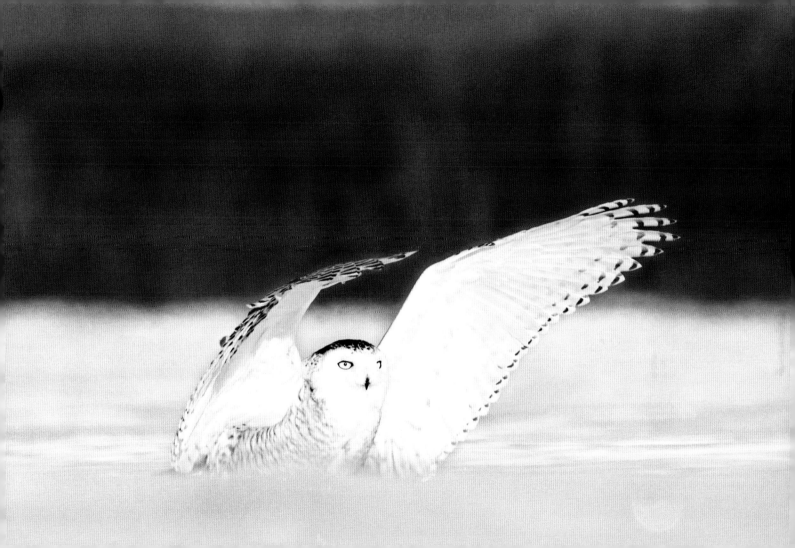

Brambling

The roost has been giving off signs for several days. You have to stake out the place around four o'clock in the afternoon, when the first flocks begin to return to the large trees for the night. The trees are bleached white with bird droppings and, given their extent, there must be many, many birds sleeping here.

Quickly, the speed of the arrivals picks up. Flocks of several thousand bramblings surge out of nowhere and dive into these barren trees. From more than 600 feet (180 meters) away, there is a muffled commotion of calls, like the babbling of a distant stream. The sky darkens with the coming night, but also with the sudden takeoffs of birds, frightened by an explosion from the other side of the woods. How many are there? A million? Two million? Even more? Local ornithologists think that more than five million birds come to sleep here. As the light fades, tens of thousands of birds arrive, springing up out of the twilight.

At this time of night, colors can no longer be distinguished. One simply observes the landings and takeoffs, the mass movements, and listens to the incredible uproar of these thousands of little voices. Soon, when night has fully arrived, silence will reign once again in the woods—as if there were not a single bird here.

The brambling, *Fringilla montifringilla*, lives in the boreal forests of northern Europe and of Siberia. It leaves in the fall to head for temperate Europe, from the west to Russia. Some years, gigantic roosts of the birds form here and there, in unpredictable places, but often on the plains and in the woods. They can include up to 100 million birds.

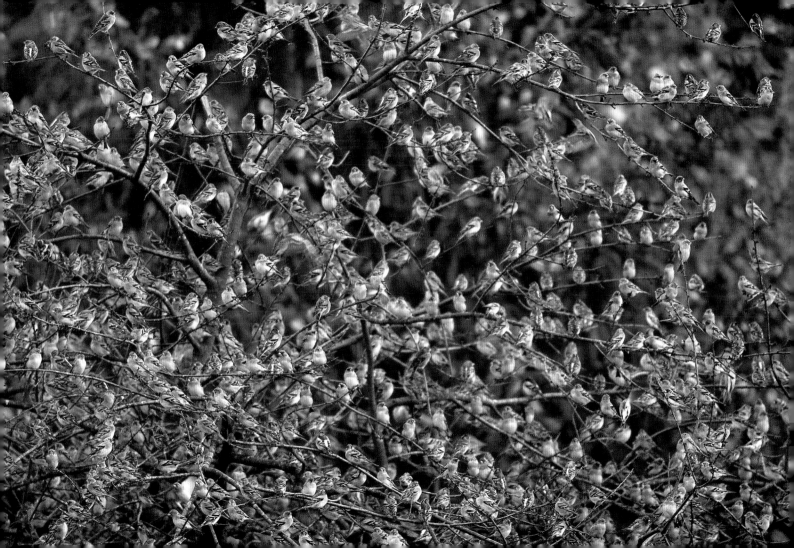

Jack snipe

In French, the jack snipe is known rather more expressively as the "becassine sourde," or deaf snipe. Why does it bear this name? It is because of the bird's unusual behavior. Rather than flee from intruders into its habitat, this little snipe crouches against the ground and refuses to move. You can approach it to within a few inches, and it will remain stock-still. It will not take off until your foot threatens to crush it. Then, with a slack flight, hardly rising at all, it will flutter several hundred feet away before landing back in the swamp. There, if you have carefully tracked the spot where the bird landed, you can advance, on tiptoe, to try to surprise it again. But you will search in vain, for the jack snipe is the king of camouflage. In vain will you systematically pace over the area, eyes peeled, and search around behind each blade of grass. It is impossible to find the bird again. Then, suddenly, it will take off underfoot a few inches away, with its slack flight, as if thumbing its nose at you. In fact, the jack snipe is not deaf at all, just very clever.

The jack snipe, *Lymnocryptes minimus*, nests in northern Europe and in a good portion of Siberia. It spends the winter in Europe but can be found beyond the Mediterranean, as far as North Africa and the Middle East—and even beyond, in tropical Africa and India.

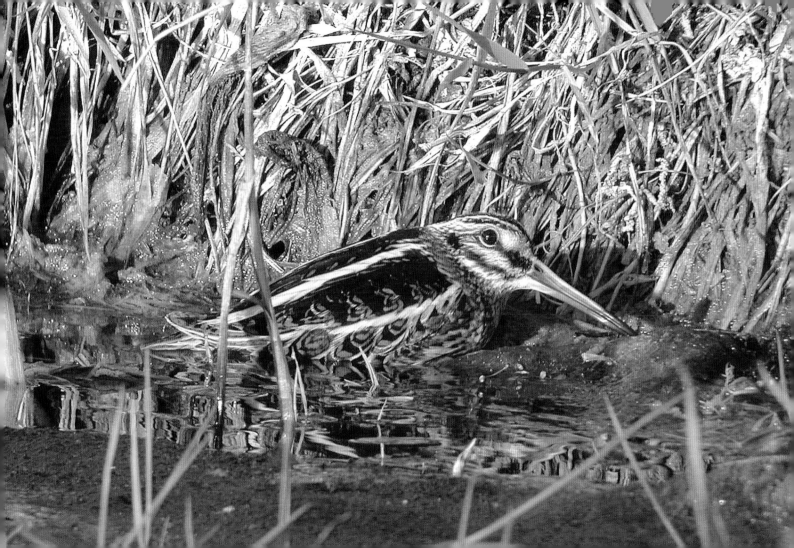

Rook

A gray November day, damp and misty. Though the afternoon has only just begun, it is already nearly dark. Everything encourages you to stay inside, in the warmth. In the freshly plowed crop field, some crows are bustling around. Looking at them more closely, you can distinguish two different types. Those that have a black beak are carrion crows; others that have a gray beak with a white base are rooks. Aside from their beaks, these are distinguished from the carrion crows by their harsher voices (they do not make the well-known *cro!* of their cousins). Less tied to humans and more wild, the rooks are less fond of cities than are crows. They prefer to gather in colonies to nest at the tops of large trees. These nests as a group, and also the colonies themselves, are known as rookeries. In general, carrion crows are more solitary, but in winter, they are there in number, sharing the field with the rooks—and wisely so. It is nothing more than logical conduct for these birds, who are, after all, considered the most intelligent members of the feathered race.

The rook, *Corvus frugilegus*, is spread through a good portion of temperate and northern Europe, and is found as far as Siberia as well as in central Asia, where it has profited from the planting of trees in the steppe to prosper. Until recently, it was fairly plainly migratory, but the warming of the climate has tended to make the birds more sedentary in winter.

Eurasian coot

On the pond, the coots form a compact black mass. Bumper to bumper, the birds search for food by pecking in the water. A little farther along, on the bank, others nibble the grass of the prairie. With their long white legs and long toes, they have an awkward gait. And as soon as they are disturbed by a human walker or a bird of prey, this whole little world will flee with great strides into the safety of the water.

The coot is not a graceful bird. To take off, it runs on the water, looking more like a seaplane or jumbo jet than a fighter jet. Even more than the moorhen, its cousin, it deserves the nickname of "water hen."

We ornithologists end up paying little attention to the coot given how unremarkable it is in the landscape of ponds, lakes, or swamps. It is surely, along with the mallard, the most common of the waterbirds. However, when nesting season comes, it is always surprising, and even touching, to see what good care the coot couple take of their downy chicks, who are already a little awkward, just like their parents.

NOVEMBER

29

The distribution area of the Eurasian coot, *Fulica atra*, is very wide: it runs across all of Europe and Asia, and even extends to Australia and New Zealand. North America is home to the American coot, a very close relative, while several other coot species live in South America.

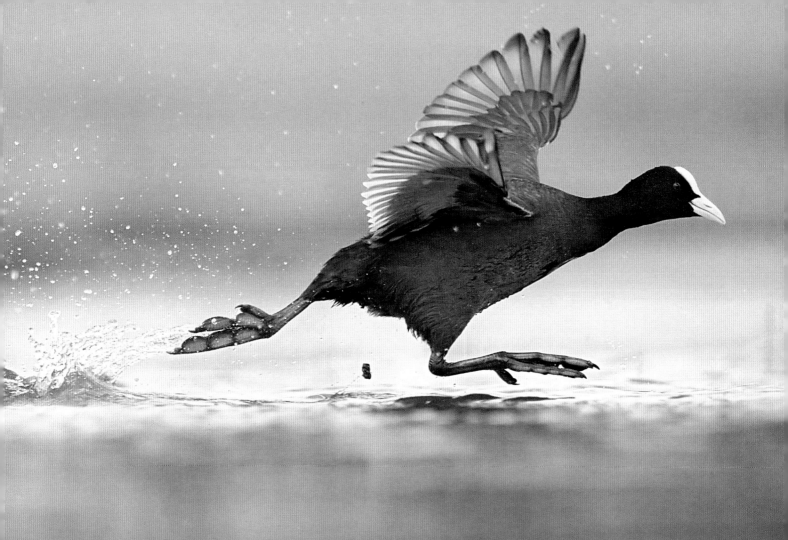

Bearded reedling

The great reed bed seems truly empty on this late fall day. There is not a sound, except for the trilling alarm of an invisible wren. All of a sudden, a series of nasal notes breaks the semi-silence: *ping…ping…ping!* It is some bearded reedlings, strolling from reed to reed. For the moment, you can hardly sees them, for they travel between the stalks and are well hidden amid the thickness of the vegetation. Then, for some unknown reason, the little flock take off over the tops of the reeds, and, with an undulating and vibrant flight, cover several dozen yards before plunging back into the thicket.

Later, we are finally able to observe them as they feast on the seeds of the plants. The male is superb, with a gray head, big black mustache, and red back. The females and the juveniles are fawn brown, without a mustache.

The bearded reedlings were for a long time called tits, though they have nothing in common with those birds, aside from a certain physical resemblance. In reality, the reedlings belong to the Timaliidae family, which includes numerous Asian species such as the fulvettas, for example.

The bearded reedling, *Panurus biarmicus*, is found in Europe and in Asia. It is a species with Asian affinities, like the great majority of Timaliidaes, the family to which it belongs and of which it is the only representative in Europe. It is sometimes subject to invasions into Western Europe, and it always lives among the reeds.

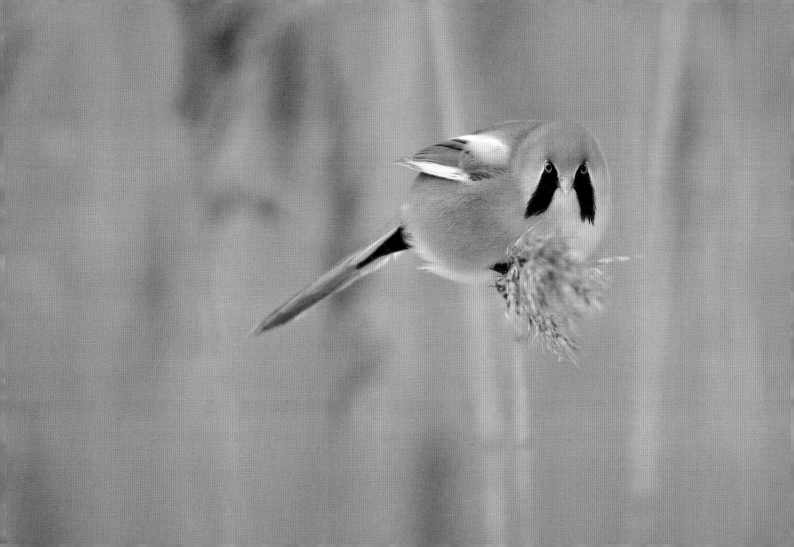

Rose-ringed parakeet

Ask people from London or Brussels if they know that hundreds of parakeets live on the loose in the city, and they will no doubt look at you like you're crazy. But it's true. And it's also true in the case of other major European cities, such as Amsterdam, Paris, or Barcelona. The species is also found in the United States, though rarely—in Florida and California—and is now seen nearly everywhere in the Arabian Peninsula.

This traveler from the tropics has acclimated perfectly to temperate regions, and the frost does not seem to trouble it. It has learned perfectly to take advantage of the bird feeders people put out in the winter, which allow it to survive the cold weather. And it has now settled in the cities alongside the blackbirds and pigeons.

But for those who are not aware of this, it is always surprising to see a squalling flight of bright green parakeets, with their long tails, come to land at the top of a tree—against a city skyline that features the tall silhouette of Big Ben or the Eiffel Tower.

The rose-ringed parakeet, *Psittacula krameri*, is originally from Africa and tropical Asia. Escaped from aviaries or brought over on boats, the birds have adapted to numerous places in the world and are today favored by the warming climate. What the impact of this species might be on indigenous bird life is still unknown.

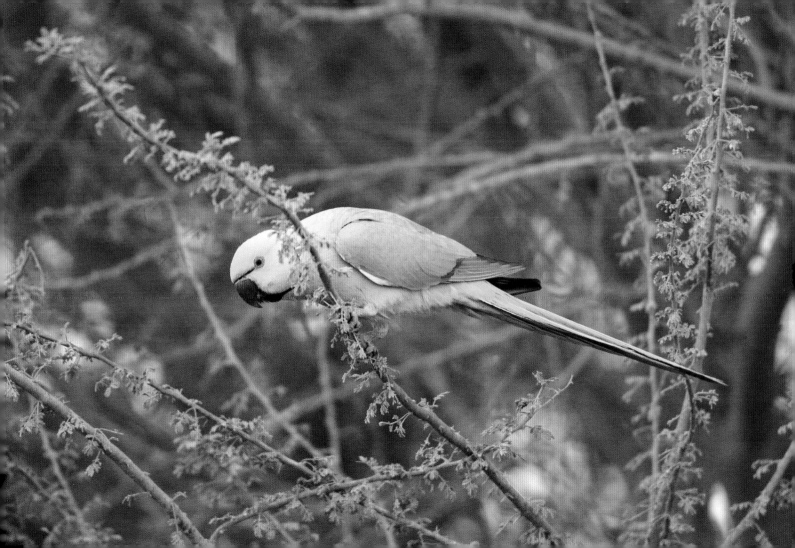

Hybrid gull

It is notoriously hard to distinguish between species of gulls. The problem is especially pronounced in the case of young birds, which look nearly identical except for subtle variations in color, shape, and the structure and molting patterns of their feathers. Not content with the headaches this gives the ornithologists who observe them, gulls like to up the ante by interbreeding among species, creating hybrids that defy any attempt at classification. In Europe, one regularly encounters these hybrid birds, which provoke much debate among specialists.

In the United States, one place that is very likely to dissuade you from studying gulls—or, indeed, birds in general—is the city of Petaluma in California. Each winter, hundreds of gulls come to bathe in the large basin of a public park there. A good third of the flock is made up of hybrid birds, and it is nearly impossible to put a name on them.

So, if you love birds, never go observe the gulls in Petaluma. There is a serious risk that it will cause you to sell your binoculars and start a stamp collection instead.

A good number of bird species are known for interbreeding in nature. Among ducks, for instance, it is fairly easy to deduce the birds' origins, for the males of the various species have very distinctive plumages. Among gulls, on the other hand, where the plumage of the various species is already very similar, guessing the identity of the hybrids is much more difficult.

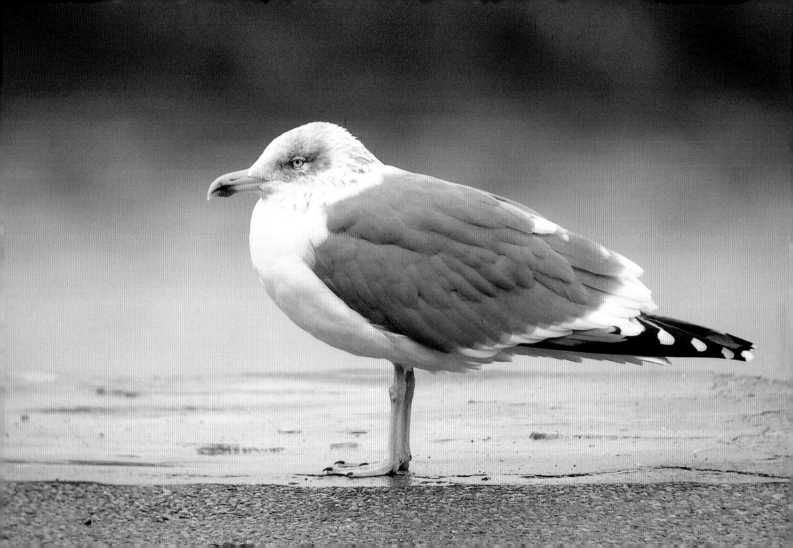

Eurasian golden plover

Above the plain, a flock of birds with fine wings and a rapid flight traces patterns in the sky, giving little sweet and whistling cries. They are Eurasian golden plovers, who have arrived from the tundra and are stopping here to replenish their strength. If the weather stays good, they will remain in the neighborhood, feeding on earthworms and seeds. On the other hand, if it freezes or snows, the birds will abandon the place and head farther south, in search of more propitious territory where the ground is still soft.

So go the lives of golden plovers in winter. Depending on the caprices of the weather, they may spend one winter in the Netherlands and another in southwest France.

This flock passes by again and again, searching for the best place to land. The birds talk among themselves through simple vocalizations, fluting and a little melancholy, as if exchanging suggestions about what to do. "Should we land here? Over there?" they seem to be saying.

The Eurasian golden plover, *Pluvialis apricaria*, is a nesting bird of the tundra whose range spans from Iceland to central Siberia. In the winter, golden plovers are found on the prairies, swamps, and crop fields of Europe, North Africa, and the Middle East. In the course of migration, they sometimes also stop along the seashore.

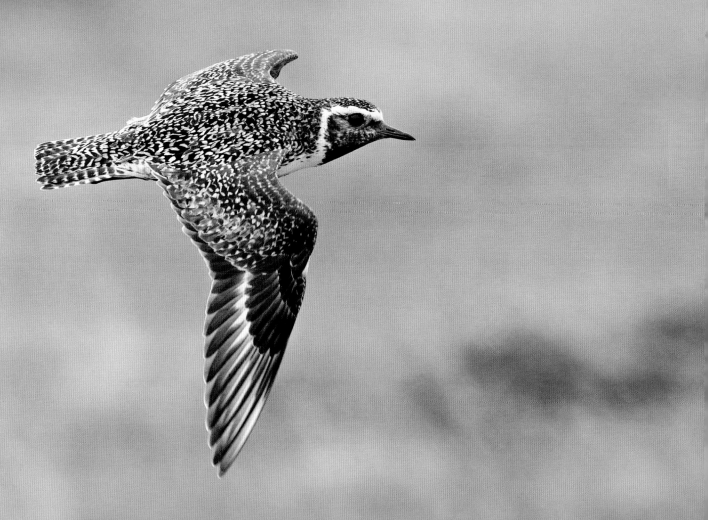

Eurasian wigeon

This great bay, somewhere in Wales, is temporarily drained of its water. It is low tide, and the shorebirds are seizing the moment to feed busily in the silt and the salt marsh. At the back of the bay, ducks wade in the soft mud, and you can regularly hear their whistling cries echoing across the open space. The males have a red head and a black cap; the females are uniformly red-brown. They are Eurasian wigeons.

They remind me of their cousin the American wigeon, which I have seen in a similar habitat on the Pacific coast. The two species differ only in a few details of their plumage. And besides, in winter one often sees a Eurasian wigeon among the American birds, just as one may find an American wigeon in a flock of the Old World ducks. In the ordinary life of the wigeon, the birds not only fly and stroll, but sometimes stray very far from their territory—to the great pleasure of those who observe them.

The Eurasian wigeon, *Anas penelope*, nests principally in Northern Europe and in all of Arctic Siberia. To the west, it is replaced by the American wigeon, *Anas americana*, which is found in North America. Both are migrators and spend the winter in temperate regions.

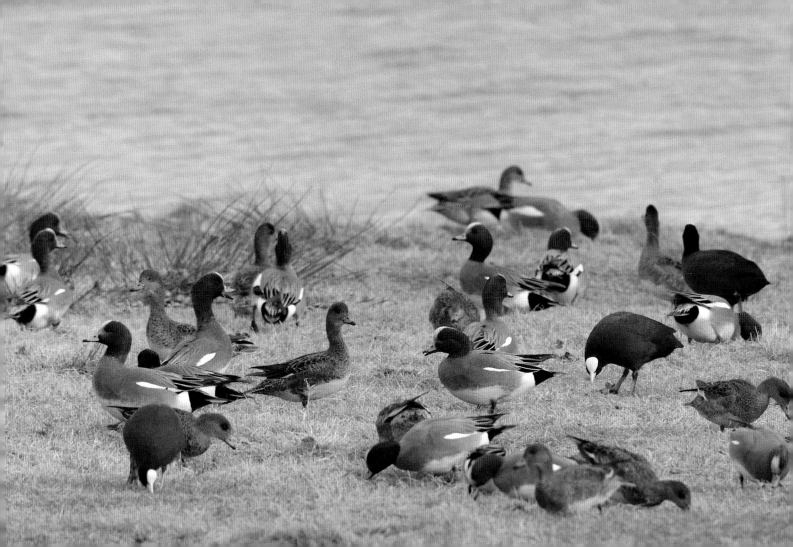

Shore lark

This lark comes to us from the Great North—at least in our temperate regions, for it is also found in the mountainous areas of western Asia. But the group that is walking toward us on the shore with rapid steps, searching for seeds, is from the northern population. If its body resembles any lark's—mostly beige, and streaked with brown and black—it is on the head that you see the signature of the shore lark. It is yellow, with a black cap and two black "horns" (indeed, in North America, it is also known as the horned lark) to set off its finery. A handsome little devil, and a feast for the eyes!

While the frozen ground offers up little nourishment, you can see the birds pacing with tiny steps along the beach, which is swept by a glacial wind. These larks are tenacious in their quest for a meal. Facing into the north wind, they advance boldly, forced back a few steps only when a particularly strong gust moves them against their will. Occasionally, they take off and let themselves be carried a few hundred yards until they find a more sheltered spot. Then they resume their search.

The shore lark, *Eremophila alpestris*, nests principally throughout the tundra that surrounds the Arctic. In Europe, it winters at high latitudes, extending no farther south than northern France, but it reaches as far as Mexico in North America. Other populations inhabit the Carpathian Mountains, the Middle East, and central Asia, especially in mountainous areas.

Purple sandpiper

The purple sandpiper is an expert at blending into its habitat. At least this is true in winter, when, having left its native tundra, it comes to spend the harsh weather on the shores of more temperate regions. It particularly likes the rocky coast. There, it spends its days on stony crags swept by sea spray and waves, searching for food among the seaweed which, like the sandpiper itself, is clinging to the rocks. With its dark gray winter plumage, against the deep green of the seaweed, it does not stand out. One can thus easily miss an isolated bird, even in scrupulously scanning each large rock on the coastline. Fortunately, this bird is often seen in the company of turnstones (see December 19), which, with their white bellies, are much more visible. So when you find a group of turnstones foraging through the seaweed, it is wise to cast an attentive eye around the flock to see if you can spot the purple sandpiper. In examining it close up, you can see that it has yellow feet, which are unusual in sandpipers. Along with the base of its beak, which is the same color, this is the brightest part of its anatomy.

Closely tied to the tundra in summer, the purple sandpiper, *Calidris maritima*, nests on the Arctic perimeter. In winter, it comes to stay in more southern coastal latitudes. The Eurasian birds go no farther south than the French Atlantic coast, and the American birds of the East Coast no farther than Maryland.

Common kingfisher

itit! A strident cry ruffles the calm of the pond. A blue fleck skims over the water and goes to settle farther off, on a big dead branch on the bank. A common kingfisher has just flown by. In general, the bird likes to lie in wait over the water, in search of a small passing fish. As soon as it spots one, the kingfisher will dive in quickly—and it rarely misses its prey. It will then go sit on its branch, swallow the still wriggling small fish, and preen its feathers. When it stands still, you're unlikely to see the bright rust and blue of its plumage. It is in flight, when the kingfisher displays its azure blue back and rump, that you can spot it most easily. But it is quick to bolt, flying off to perch in the low branches, always a little hidden and perfectly still.

The pond must freeze solid for the kingfisher to leave this place—and it is the same when the streams that it likes are overtaken by ice. Then it will leave, for a few days or weeks, to pass its days along the banks of large rivers, or even on the coast among other wintering birds.

The common kingfisher, *Alcedo atthis,* lives in Europe, but also in Siberia, Southeast Asia, and beyond as far as Bali, Timor, the Sunda Islands, and eastern New Guinea. Only the northern populations are migratory. The rest of the European populations are sedentary, but may move in the case of severe cold.

DECEMBER

7

Reed bunting

This evening, in the cold of December, just two of us have come to witness the reed buntings arriving to sleep in the big reed bed that borders the pond. It is bone-chillingly cold, and despite our layers of clothes, we are shivering. Our goal is simply to count the number of birds that come to spend the night here. In terms of actual observation, we will have to return later. Aside from the cold, the twilight is falling quickly, and the birds coming to spend the night seem to turn up out of nowhere. They arrive in groups of two to five birds as if fallen out of the sky, and melt into the thick reeds without even landing on top of the stalks. They hardly even spare us a soft, high *tsiie!* as a sign of their identity. The noise seems to come from everywhere, but we search in vain to catch a glimpse of a little group of birds coming in from afar: nothing. No, they come straight out of the dark gray sky and conceal themselves immediately. To observe them any better, to gain any details such as how many juveniles there are compared to adults, and so forth, we would have to set out nets, capture the birds, and tag them.

This evening, the counter shows that several hundred birds have dropped from the night sky. With shivering hands, we inscribe in our notebook the number of these furtive evening buntings.

The distribution of the reed bunting, *Emberiza schoeniclus*, is vast. It runs from Western Europe to China and Japan, by way of Siberia. Many populations of buntings are migratory, but they tend to winter in the temperate regions of Eurasia or in North Africa, and the Middle East.

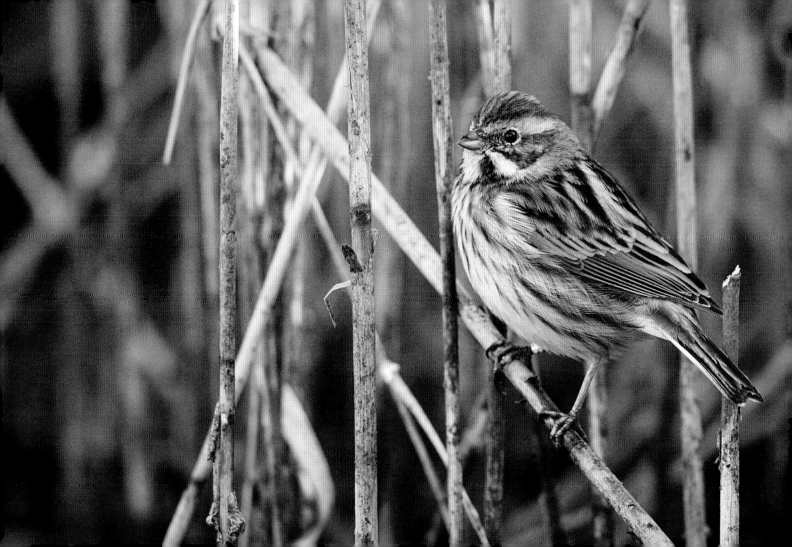

Ring-necked duck

Among the birds of the *Aythya* genus—a group of slender diving ducks that includes pochards and scaups as well as the ring-necked duck—it takes a certain amount of experience to differentiate among the various species, especially the females, which tend to resemble one another. To make things worse, birds of this genus sometimes have an unfortunate tendency to hybridize. The males, which are more colorful than the females, are more identifiable, but one still hesitates before putting a name on any of these birds.

The ring-necked duck is a Nearctic bird, found in small numbers throughout North America. It likes to nest in prairie potholes, which are pools of water in the Great Plains where many ducks reproduce. In the fall, the birds flock together, then head down to spend the winter in the southern United States or Mexico. Often, in winter, you can see thousands of *Aythya* ducks crowded together on large lakes or reservoirs. Lost in the crowd of other species, the ring-necked duck is rarely the most common. You have to scan the flock carefully to spot the presence of these birds, whose otherwise black beak displays a clear band of white.

DECEMBER

9

The ring-necked duck, *Aythya collaris*, nests principally in the Great Plains region of the North America. Among all the species of North American ducks, it is one that strays the most often into Europe—where it is regularly seen in very small numbers along the countries of the Atlantic coast.

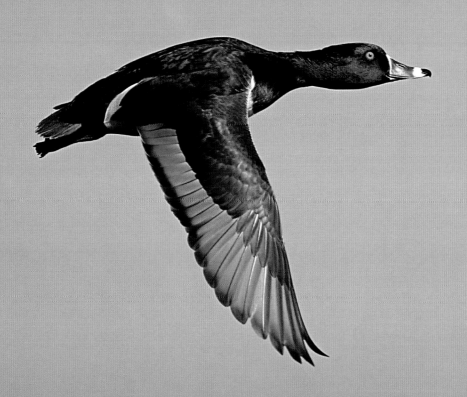

Long-tailed tit

One … two … three … ten … twenty … twenty-one long-tailed tits have just passed in front of me, in single file, wandering from tree to tree. As they make little calls of contact, high and trilling, the birds advance like this without ever really stopping. Where are they going, and where will they rest? Already, the first have passed the trees of the garden and have arrived in the yard next door. The last birds follow, distinctive in silhouette with their long tail and their undulating, slightly jerky flight. Soon, there is not a single long-tailed tit left in my garden, but I still hear the calls of the group, continuing their expedition toward who knows where.

This is typical behavior for the long-tailed tit. Once the nesting period is over, the birds form little groups—sometimes mixed with other species of tits—and move from place to place in long, noisy streams. Human observers may not be able to join the flock themselves, but they can watch and be amazed by the spectacle of these little feathered creatures. One by one, the birds fly over the branches and twigs, on a mysterious quest that seems as if will never end.

The long-tailed tit, *Aegithalos caudatus,* reproduces all over Europe, in Siberia, and into Asia. Only the northern populations within its distribution range are more or less migratory, the others being resident.

DECEMBER

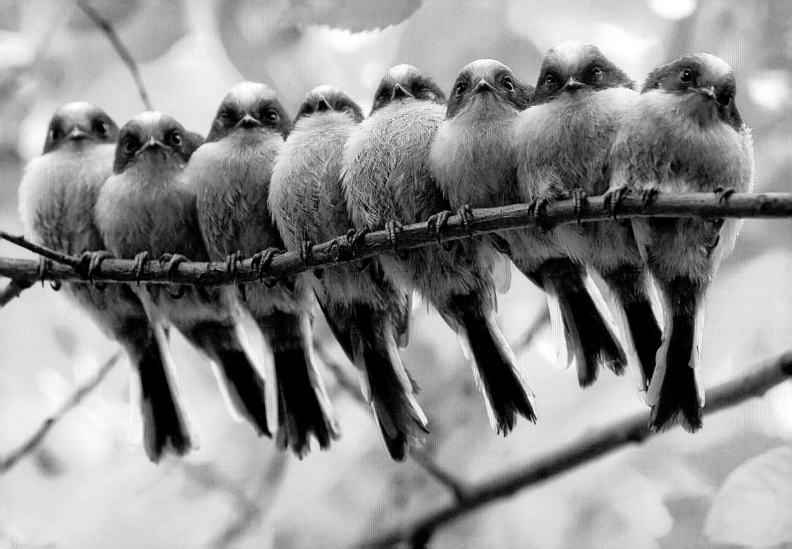

Glaucous gull

In the mass of gulls flying around the trawler now hauling up its nets, I have spotted a large bird of a uniform cream color. I have an idea of its identity, but take a little peek with the binoculars just to be sure. And I'm right: it's an immature glaucous gull, which, along with the herring gulls and great black-backed gulls, is coming to snitch the fish entrails tossed into the sea by fishermen. It stands out singularly with its pale feathers.

The glaucous gull comes from far away. It nests in the High Arctic, far from human beings, boats, and even other gulls. It is accustomed to the cold. When the winter comes, it heads south, almost regretfully, toward places that are barely any warmer. At least here, the sea is not iced over. This is why, if you want to see the glaucous gull in large numbers, you must often travel north even in winter, to Scandinavia or to Labrador in Canada.

However, some birds do venture farther south, notably the young ones, who may follow their beaks toward temperate latitudes. To find one of these birds in the state of Delaware or in a port in Brittany is always a true pleasure: a little winter glimpse of the Great North.

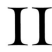

DECEMBER

II

Loyal to the Arctic, the glaucous gull, *Larus hyperboreus*, nests in the high cliffs on the edge of the Arctic Ocean. In winter, it heads down to the limits of the ice cap, though the birds may also venture farther south in limited numbers.

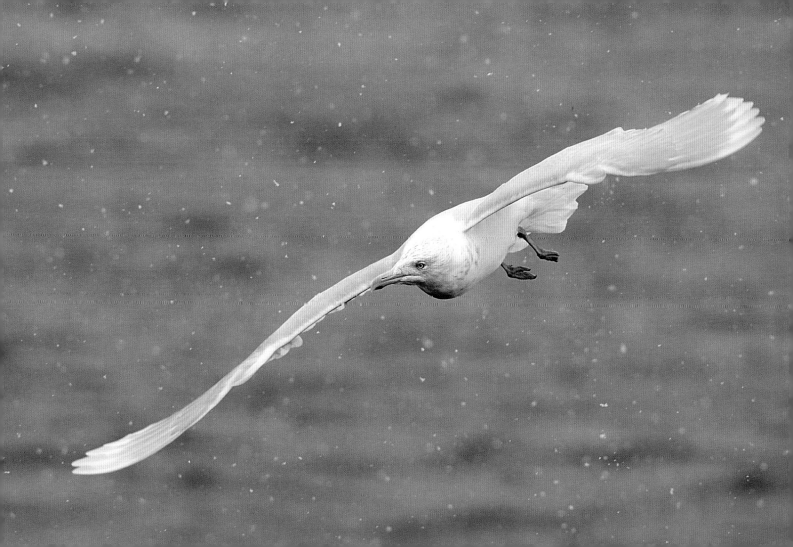

Flock of geese in the Netherlands

For us French ornithologists, a winter visit to the Netherlands is considered a holy pilgrimage. This is where we go to observe hundreds of thousands of wild geese descending in large, chattering flocks on the grassy polders, seashores, or freshly plowed crop fields.

At this time of the year, in this small country, it is hard to drive more than a dozen miles without encountering a flock of geese standing in a meadow or flying over the highway. At home in France, where the geese are so rare (because we are farther south but also because they are mercilessly hunted), such a vision would make us stop every few miles. Indeed, that is what we do toward the beginning of our journey…and then, quickly, we realize that we are never going to arrive at our destination if we stop for every goose. So we stop only for the largest flocks. This is a chance to search for the barnacle goose among the graylag geese, for greater white-fronted geese, or for perhaps pink-footed geese arrived from Spitsbergen. Sometimes, a lesser white-fronted goose or a red-breasted goose, species that are much rarer, reward our long hours of observation through the telescope. One never tires of this wonderful spectacle in the country of the geese.

The Netherlands, along with Germany, the United Kingdom, and Romania, is a good place to go in Europe if you want to encounter large numbers of geese in winter. In the United States, Texas and California are the states to visit if you want to see immense gatherings of geese from the Canadian Great North.

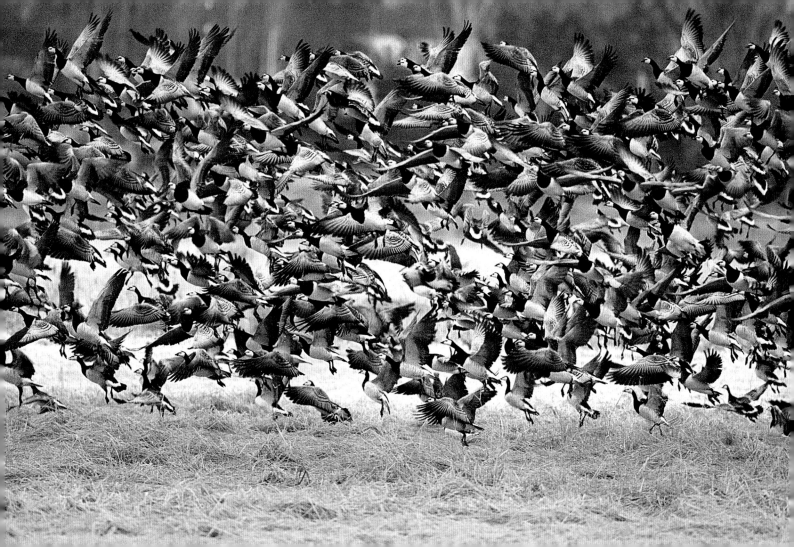

Eurasian tree sparrow

Its chirp, higher and more staccato than that of its cousin the house sparrow, attracts the ear of the ornithologist. With its brown cap and the little black patch on its white cheek, it is readily identified. The Eurasian tree sparrow is a companion to villages, green hedges, and hollow trees. In short, it is at home in a natural world that is disappearing with each day—and the tree sparrow along with it. In Western Europe, where it was once very common, scientists have been distressed to see its numbers dropping before their eyes. Invasive agriculture, the use of pesticides, the razing of the hedges, and the switch to metal and cinder-block as building materials are all undercutting the health of the species. Thus it is disappearing here and withdrawing to Eastern Europe, where the "modernization" of agricultural techniques is not yet so advanced. In the coming years, however, that region is likely to be touched by these modifications as well, perhaps leading to the disappearance of the tree sparrow there also.

In Asia, the species is still very much present. Perhaps, in a few decades, we will have to travel there to observe this bird who, so little time ago, was squabbling over its food with the house sparrow.

The Eurasian tree sparrow, *Passer montanus*, is found from Western Europe to eastern Asia, reaching even into Java, Sumatra, and Bali. It was introduced around Saint Louis, Missouri, in 1870 and established itself in that area. This sparrow was once a migratory bird to temperate Europe, but the near disappearance of the populations in the northern part of the continent has caused these migrators to vanish as well.

Gyrfalcon

This sturdy falcon with a powerful flight is a solitary bird, and hardly ever lives in groups. Dwelling in the cliffs that overlook the tundra, the gyrfalcon is an extremely efficient hunter. It is amazing to watch it suddenly appear in a large colony of kittiwakes, swoop down on a bird, seize it firmly in its talons, and fly off again. With its rapid and unhesitating flight, it can inspire incredible panic among the thousands of nesting birds in no more than an instant.

The gyrfalcon does not leave its Arctic territory unless the cold is extremely severe. In that case, it will make irruptions into the Great Plains of North America, sometimes even as far as the coast, without flying very far south. In Europe, it is a rarity. The birds of Greenland are in general the whitest and most beautiful of the gyrfalcons. In Labrador, the birds are dark brown, while they are gray in northern Europe. In each region, they are masters of the great polar desert.

The gyrfalcon, *Falco rusticolus*, nests in the Arctic, Canada, and Siberia. In Europe, it is found in Iceland and in northern Scandinavia. It is fairly sedentary but may change locations in the fall, depending on the harshness of the climate and the food resources that are locally available.

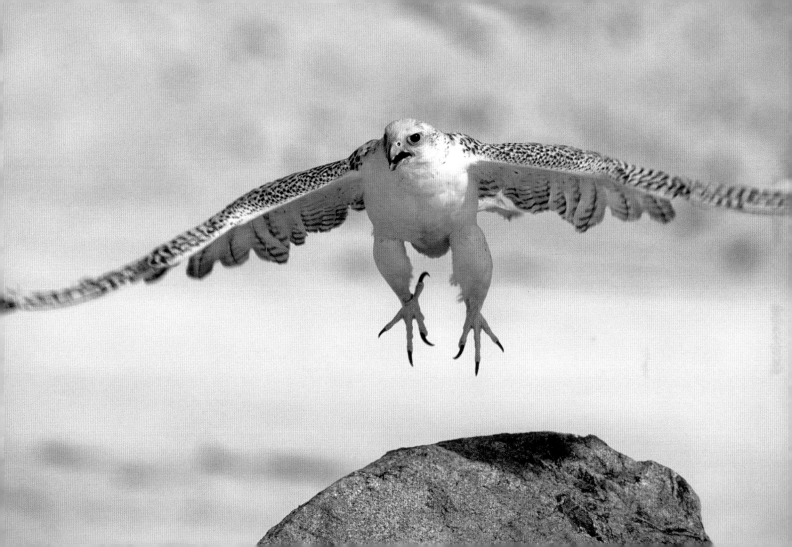

Yellow-rumped warbler

In the south of the United States and along the coasts, the yellow-rumped warbler spends the winter. A number of these birds remain in North America, unlike the majority of warbler species, which fly down to the tropical forests of Mexico and South America in winter. So it is not surprising to see one of them looking for food at the edge of the road, giving its soft but carrying cry of *twick!*

At this time of year, the yellow-rumped warblers have put back on a drabber plumage than in the spring, but when one bird flutters from branch to branch the bright yellow rump is always visible, like a little flower constantly on the move. In choosing to stay up north, it must accept a diet of fruits or berries, including bayberries, that can sustain it all year long, rather than being restricted to the insects of summer. And it must be ready to brave the cold and snow. Certain brave yellow-rumped warblers make exactly this choice, remaining at latitudes as far north as New York. Other birds in the species, meanwhile, decide they'd just as soon go take in the sun in Mexico.

Very common in North America, the yellow-rumped warbler, *Dendroica coronata*, nests as far north as Alaska. It is one of the warbler species that leaves last in the fall and returns earliest in the spring. The species also winters in fairly significant numbers in the southern half of the United States.

DECEMBER

15

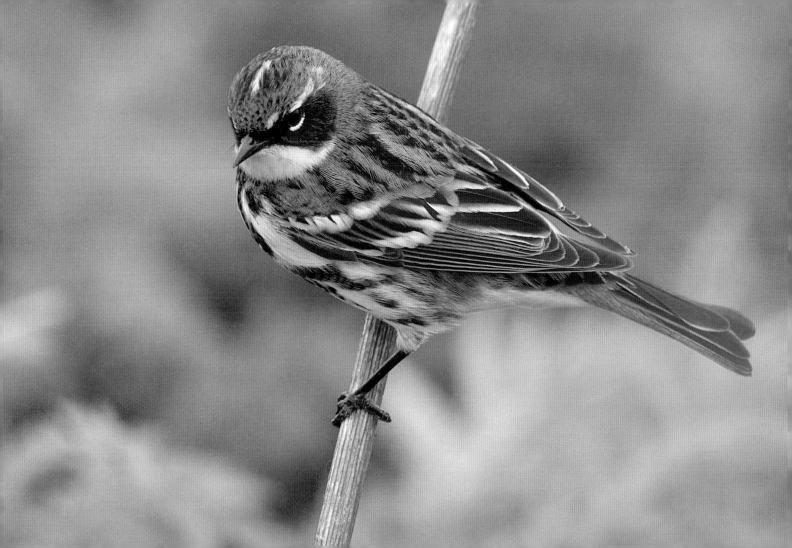

Herring gull

In the Atlantic ports of Europe, this gull holds first place, just like its cousin on the east coast of North America across the water. Perched on a lamppost, a jetty, or the mast of a boat, or simply sitting on the dock, it keeps watch. With its severe and piercing gaze, it is on the lookout for the smallest scrap of fish or bread, and at the first sight of food will swoop down on it immediately. The trouble is that it will not be the only one. At least ten other gulls will swoop down with identical speed. And just like that, the gulls will be suddenly transformed into rugby players at the center of the scrum. The result, too, is as in rugby: an aggressive exchange, a few knocks, but no blood. That said, if a sickly pigeon or a passerine exhausted by a long migratory journey happens to pass by, they gulls will show no mercy. But a seeming code of honor dictates that they will share the scraps of this unlucky bird and thus all emerge with dignity from the killing.

In the spring, the battles between the males will not be settled except by some well-aimed blows of the beak. Which, when you see the power of the gull's beak, is no laughing matter.

The European herring gull, *Larus argenta-tus*, nests throughout northern and central Europe. On the Mediterranean and the Black Sea, it is replaced by two closely related species. In North America, the extremely similar American herring gull, *Larus smithso-nianus*, occupies the whole continent.

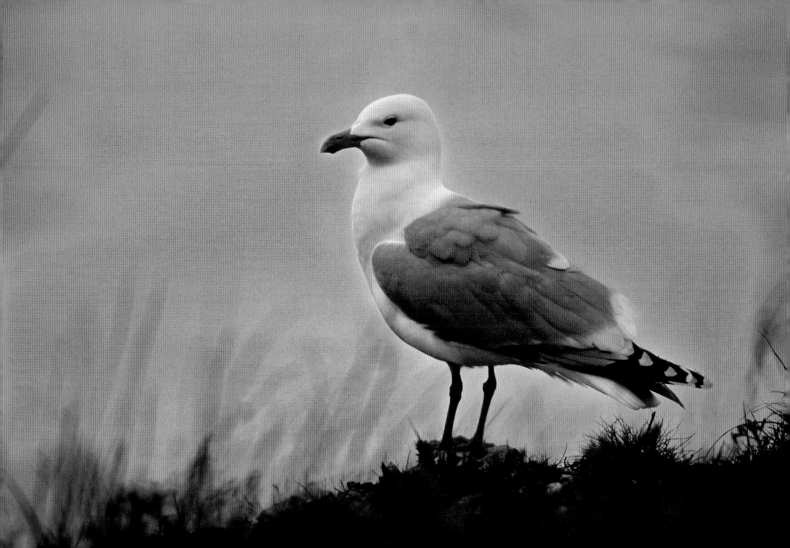

Great gray shrike

At the top of a bush, now barren of leaves, a gray, black, and white bird with a long tail is balancing in the blast of cold wind from the north. It is a great gray shrike on the lookout. If you watch it closely, you will discover that behind what looks like a friendly passerine is the soul of a raptor. You need only see its strong hooked beak to guess that the shrike does not eat seeds. Instead, it prefers mice and voles. In winter, it will not disdain to pursue a passerine, while in the summer, it will not hesitate to attack butterflies or beetles. By reducing these populations of smaller animals, the great gray shrike has served as a valuable assistant to agriculture.

But is it still? Given the sudden and recent decline of its numbers in Europe, one can reasonably ask the question. A collateral victim of pesticides of every kind, which are much more effective than the shrike at killing the small fauna seen as "pests," the great gray shrike is losing its prey and risks disappearing forever from the agricultural landscape. Certainly, this bird gives a signal that our much discussed biodiversity has difficult days ahead.

The great gray shrike, *Lanius excubitor*, has a wide range that extends from Western Europe into Siberia, while it also nests in the northern half of North America. A partial migrator, it does not cover great distances between its nesting quarters and winter quarters. The populations of Western Europe are in great danger of extinction.

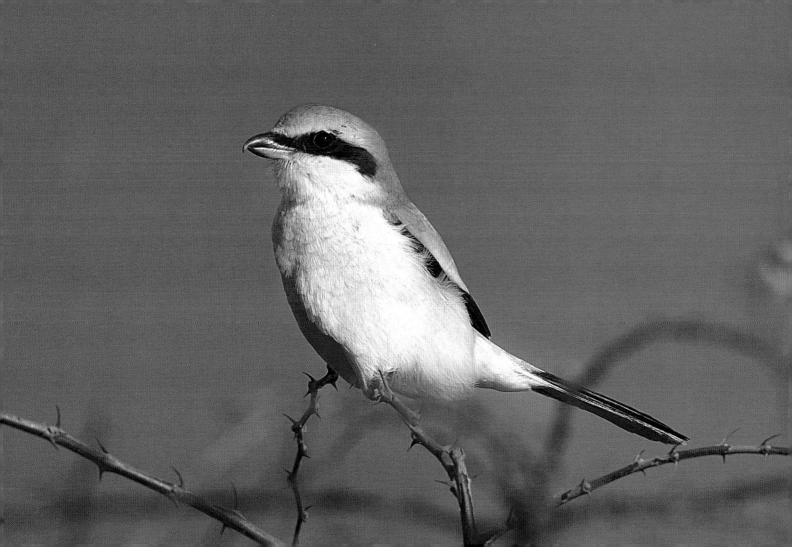

Red kite

In the blue winter sky, a red kite circles. The snowy landscape of the Auvergne Mountains reflects sunlight up at the bird, and it seems almost as if lit up by a spotlight. This throws into relief its long forked tail, which is an intense red-brown, and the white marks on its wings.

Without a single flap, just by slightly moving its tail, which works like a rudder to maintain its equilibrium, it glides for long moments, searching for little rodents that dart into their tunnels under the snow. In French it is known as the "royal" kite, and that is the right word for this majestic animal when it sails through the air. When it stands still, on the other hand, it is fairly inconspicuous, dressed all in brown and tan. The red kite is a bird of the air. It is impossible to imagine it doing anything other than flying over the countryside, gliding along until it touches the clouds. It is the bird of blue skies, which beautifully set off its elegant silhouette.

In the long procession of endangered species, this raptor, alas, holds an important place. Like many birds, the red kite is a victim of pesticides, which, as with DDT fifty years ago, are decimating its populations.

The red kite, *Milvus milvus*, is a species endemic to Europe. The most northern populations migrate toward southern Europe. Its numbers have fallen sharply in the course of these last decades (despite the fact that it is completely protected), because of high mortality linked to pesticides, which are used to kill the rodents that it eats.

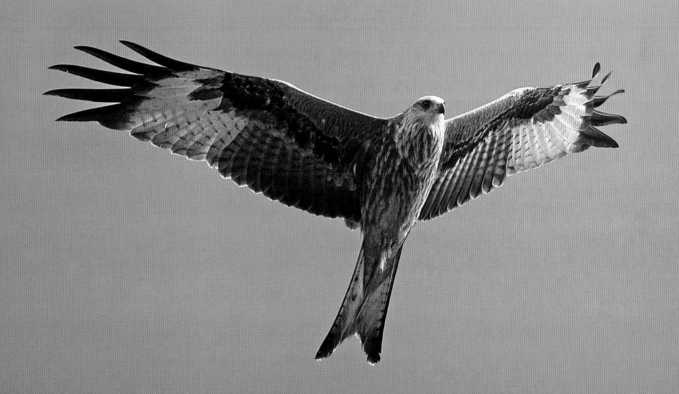

Ruddy turnstone

When the sea comes in, the little shorebirds flock onto the rocks that poke out of the water. From the coast, you can watch them, huddled together, waiting patiently for the water to retreat. There are oystercatchers, curlews, and then smaller birds: sandpipers of all species and, among them, birds with a dark plumage and a short beak. These are turnstones.

It's a funny name for a bird. But in fact, when it feeds, the turnstone uses its beak to turn over clumps of seaweed, shells, or small stones to flush out the tiny invertebrates hiding there, which it eagerly devours.

At this time of year, like many other small wading birds, or limicolines, it has put back on a fairly drab plumage, which is brown and white in the ruddy turnstone's case. But as soon as spring comes, it undergoes a metamorphosis, and our bird then displays beautiful colors of black, red, and white. For the moment, this winter apparel permits the bird to blend marvelously with the algae and lichen that cover the rocks.

The ruddy turnstone, *Arenaria interpres*, nests all over the Arctic, and it is found in winter on all the shores of the great oceans. Some birds fly no farther than Europe or North America in winter, while others venture as far as Australia or South Africa.

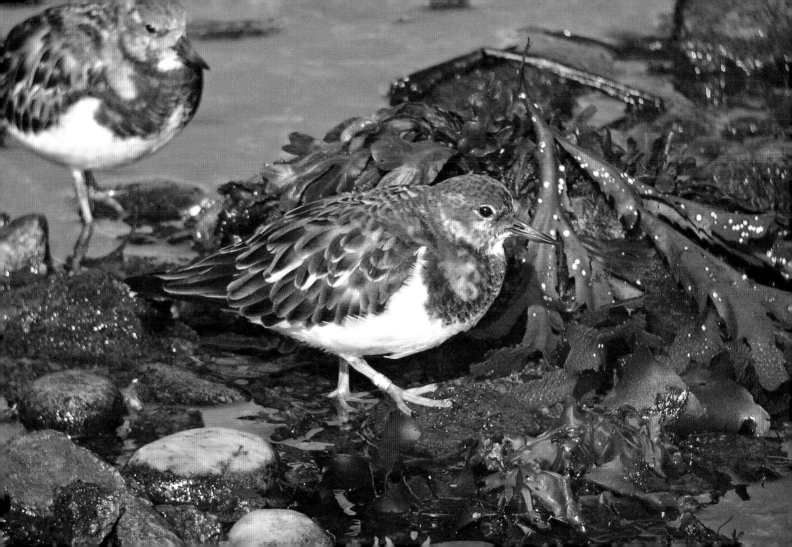

Sardinian warbler

The *garrigue*, or low-lying scrubland of the Mediterranean basin, is very quiet at this time of year. No bird sings, and there are not even the usual scents that make the garrigue so incomparably appealing. A few robins that have come to spend the winter here take off as someone walks by. From a large strawberry tree suddenly comes a rasping call of alarm: *trr…trr…trr!* It is a Sardinian warbler signaling, reminding us that there is still a little life yet in the dormant garrigue.

The bird bursts out of the thick foliage, displaying its red eyes, which contrast brightly with the black background of its cap. Barely has it emerged than it has already dived back into the thick bushes. It just wanted to check on this intruder who had come treading onto its territory. Even if he is quiet, the male remains on his turf. And as soon as warmer weather returns, he will be quick to proclaim his rights. For the moment, he is content to shower his entourage regularly with his rattling cry. After this little demonstration of life, the winter silence resumes its reign over the garrigue.

The Sardinian warbler, *Sylvia melanocephala*, nests almost entirely on the Mediterranean coast. Most of the birds are resident, but some (perhaps the younger birds?) migrate to Africa, sometimes reaching even the Sahel.

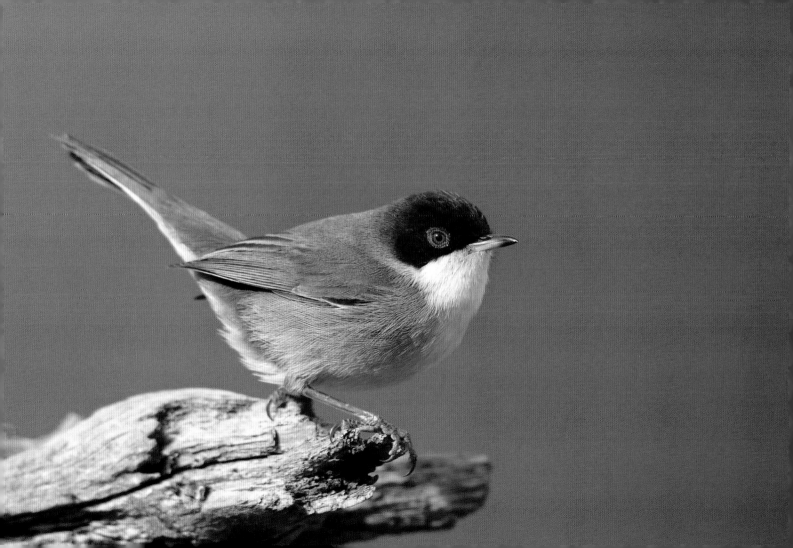

Laughing dove

Amid the palm grove, people are busily working their crops. In the trees, bulbuls and warblers sing, even at this time of year. In the middle of this chorus, one also hears a low and insistent cooing. It is the song of the laughing dove, and one has the impression that this bird sings for itself alone. The sound is not loud or showy; the dove's song is simply a soft cooing over five notes, which it delivers with its head hunched slightly into its shoulders.

This species is neither rare nor shy in its area of origin. It likes the company of people and stays close to them, in the fields, the palm groves, and even right in town. With a hurried little step, it trots in the neat furrows under the palms or along the little walls between fields. Curious, it inspects its surroundings for seeds. But it is quick to fly off when a dog or cat, or playing children, come along. It is surprising, then, to see the bird's rather dark silhouette suddenly set off by bright white patches at the corners of its tail.

The distribution ground of the laughing dove, *Streptopelia senegalensis*, covers the Middle East, a large part of tropical Africa, and, to the east, the southern part of central Asia and the Indian subcontinent. The species is sedentary, but it seems to be gradually colonizing North Africa.

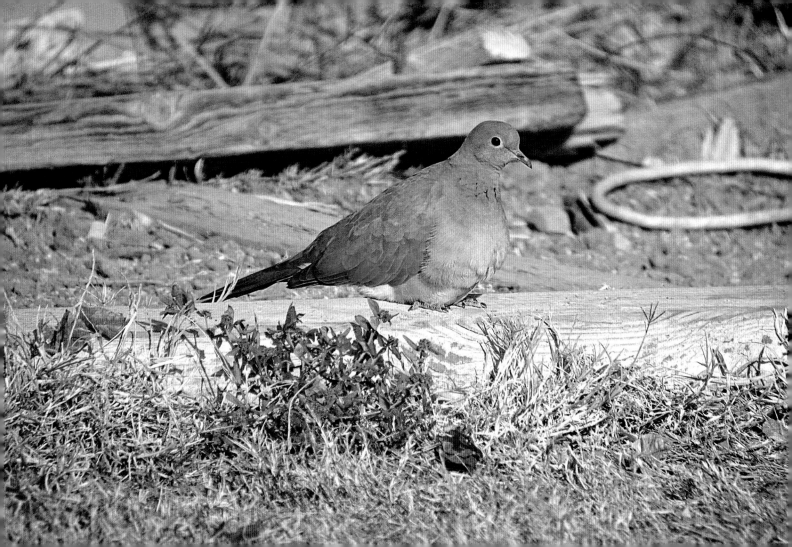

Brant goose

At first, all we hear is a distant hubbub of soft and slightly trilling sounds. We advance slowly, hidden behind the seawall. There must be many birds here, for the flock is noisy. Having arrived at a little dip in the dike, we climb up slowly so that only our heads poke over. We see them before us, on the salt meadow, grazing peacefully. There appear to be more than a thousand. These brant geese, small sea geese that come to visit in winter, splash in the silt between earth and sea. The birds regularly extend their necks and survey their surroundings, then go back to grazing. The whole group is quacking, and the chorus of their sounds is like a distant rumble.

The brant geese come to us from the High Arctic, and, after having flown thousands of miles along the coasts, they arrive at the edge of the ocean to spend the winter. The adults can be distinguished from the juveniles by the white borders on their wings. This year, given the number of young birds in the flock, we can conclude that their reproductive season has gone well.

The brant goose, *Branta bernicla*, nests throughout the Arctic. Three subspecies can be distinguished, all fairly different from one another, and each wintering in a separate temperate region along the coasts of the northern Atlantic and Pacific oceans.

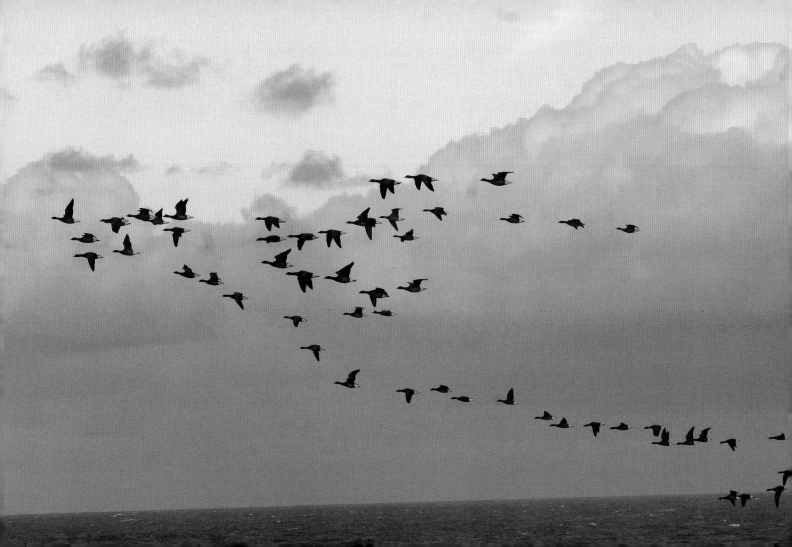

Bohemian waxwing

At the temperate latitudes, there are some winters with bohemian waxwings and many winters without. This beautiful bird, with its lustrous plumage, specializes in irruptive migrations. Most often, we do not see them here, because they have remained quartered in the north, around the boreal forest where they nest. But if seeds and fruit become scarce, they make "invasive" migrations that can carry them far from their normal distribution area. We may then see them here, even in cities, yards, and public parks, gorging themselves with small red fruit.

The Dutch name for the bohemian waxwing means "plague bird." In ancient times, it was believed that the sudden arrivals of these birds correlated with outbreaks of the plague. The connection built between the two events was as erroneous as it was hasty. In fact it was mere coincidence; these unfortunate birds have never been carriers for the plague germ.

These days, we can enjoy the sight of the waxwings when a little flock chooses a mistletoe bush to embrace in the search for food.

The bohemian waxwing, *Bombycilla garrulus*, is found in the American, European, and Siberian boreal forest. The birds may make invasions south and west, and then can sometimes be observed in the British Isles, northern Spain, or the central United States.

Northern cardinal

Among all the birds to be seen in winter, the northern cardinal perhaps best encapsulates the spirit of Christmas Eve—even if it has traded the white beard of Santa Claus for a little black mask and a lovely crest the same color as its feathers. It is snowing today, near Boston, where I observe two cardinals hopping from bush to bush in search of food. These two red imps, in this silent and immaculate scene, draw almost no attention to themselves despite their distinctive coats. They make no more than the occasional high, crisp *tik!* to indicate their presence.

Seeing the cardinal, with its bright plumage, you may easily think it is a tropical species that has strayed into the frigid winter of North America. But the species is at home here, even in the snow and cold. The two birds move into the distance as the snow doubles in intensity, and it becomes hard to follow them through my binoculars. Soon, these two little Santa Clauses are no more than distant gray silhouettes.

DECEMBER

24

The red cardinal, *Cardinalis cardinalis*, is found in the extreme southeast of Canada, throughout the eastern United States, and to the south as far as Mexico and Belize. It is sedentary. It is often seen around bird feeders in winter, and is not shy. This bird is the mascot for a number of American sports teams.

European robin

What better bird to illustrate Christmas day than the robin? In England, it shows up everywhere at this time of the year: as an ornament on Christmas trees, as a decoration on plates or cups, as an image on postage stamps. It's as if the robin, that cheeky bird of our gardens, comes right into our houses to celebrate this holiday. Maybe the revelers will even scatter a few scraps of their holiday feast out on the balcony or the terrace…

This bird is the European robin. On the other side of the Atlantic, there is another kind of robin, whose scientific name is *Turdus migratorius* (see December 26). That bird is quite different—a more colorful relation of our European blackbird, but with a red belly like the European robin's. And the French have their own robin as well, another species— *Tarsiger cyanurus*—which is similar to the European robin but nests instead in the Siberian forest.

The European robin is said to be the friend of gardeners. In warmer weather, it is indeed never far from them, ready to pounce on the first earthworm that their spades bring up from the dirt. It is the first to arrive at the bird feeder in the morning, when light is still scarce, and the last to leave it in the twilight, when the tits have long since departed for the evening. Then, you can see its furtive silhouette weaving away through the branches.

The European robin, *Erithacus rubecula*, nests in a large portion of Europe, North Africa, the Middle East, and as far east as central Siberia. The northern and eastern populations winter particularly around the Mediterranean, but they may also be found among the palm trees, at the gates of the desert.

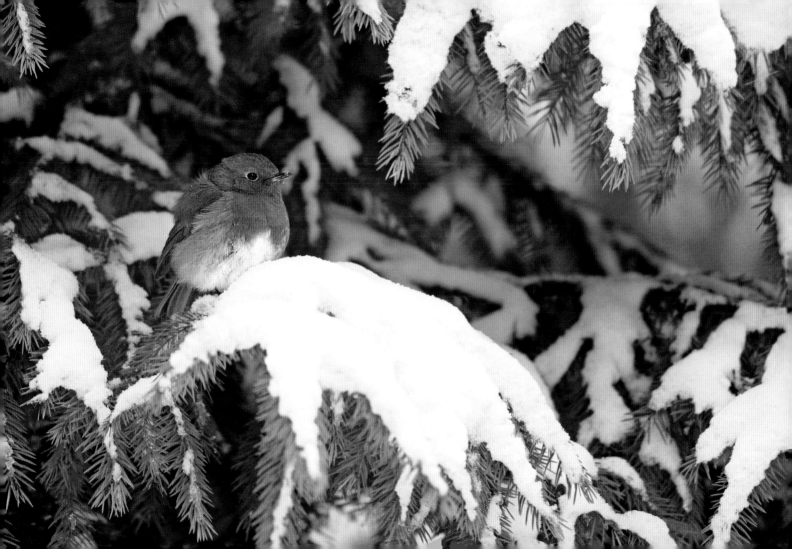

American robin

While the Europeans contemplate their friend to gardeners (see December 25—European robin), the Americans can observe their own. This cousin of the Old World blackbird is also a staple of yards and gardens, especially at this time of the year, when food grows scarcer in the forests and countryside. In the suburbs of large cities, and around small villages, one can sometimes see beautiful flocks of these robins hopping along the ground, looking for food. On the frozen ground where only a few scrawny blades of grass poke out, the robin displays its red, black, and gray plumage as well as its yellow beak, adding bright accents to the winter monotony. The birds advance with little hops, then freeze, peck something on the ground—a seed, an insect—and continue with their little hopping gait. Despite the biting cold, they manage to find nourishment: sometimes by scratching the snowy ground with their feet, sometimes—and this is certainly easiest—by coming to share a meal with other passerines at a bird feeder.

For the inhabitants of more northern regions, the return of the robin is a synonym for spring. They await it impatiently, for they know that when it arrives, winter will at last be gone.

The American robin, *Turdus migratorius*, is widely distributed on the North American continent. In nearly all of Canada, it is a migrator; it leaves to spend the winter in the United States and as far south as Mexico. It is, by contrast, sedentary in most of the United States. The American robin is the state bird of Connecticut, Michigan, and Wisconsin.

26

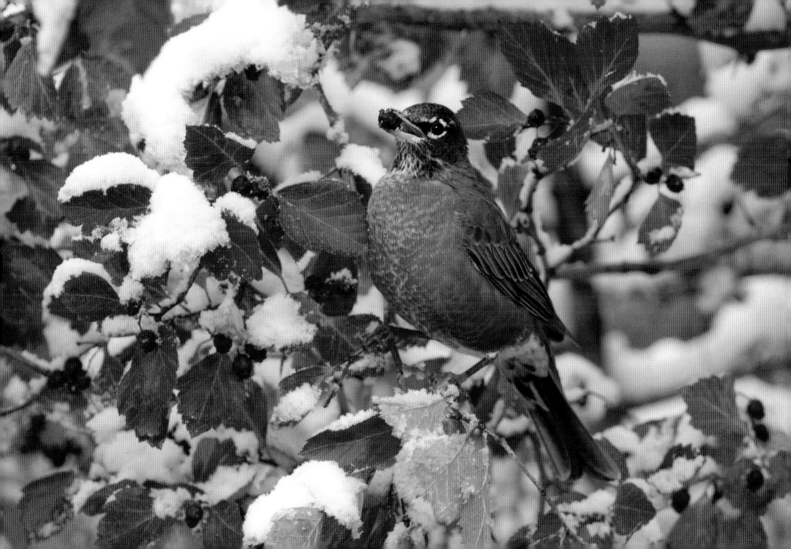

South polar skua

It is in the South Shetland Islands, off the coast of the Antarctic Peninsula, that I saw this species for the first time. We had just crossed through the Drake Passage, which links both Antarctica to South America and the Pacific to the Atlantic. After being thoroughly tossed around there, we now found ourselves in calmer waters, more propitious for the tranquil observation of birds.

Like all skuas, the south polar skua is a shameless pirate and thief. Because of its powerful flight and sharp beak, it thinks no laws apply to it. And the female sea lion who has, with difficulty, borne a pup had better watch out. The skuas are not far off, and will rapidly come to attack the newborn if she is not extremely vigilant. The female may well bark in protest; her objections will mean nothing to the half dozen skuas who have already fallen on the young animal.

Above the boat we saw some skuas, with their piercing gaze, who seemed to be challenging us to an aerial duel. We contented ourselves with simply watching and admiring their flight, which, as with all the seabirds, is a constant dance amid the wind, air, and waves.

Faithful to the southern seas, the south polar skua, *Stercorarius maccormicki*, nests on the Antarctic coasts. After reproducing, the birds disperse through the oceans. They generally do not cross the equator, but a fraction of the population reach as far as the northern Pacific, the east coast of North America, and, most likely, also the African coast as far south as Senegal.

Bewick's swan

The snow-covered meadow on the side of the highway is strewn with white masses. Stopping the car on the shoulder to get a closer look, I realize quickly that these masses are actually birds—swans, to be precise. Side by side, here are the three species that one can see in winter in northern Europe: the mute swan, most common of all; the large whooper swan, which dominates all over the world, with its long neck; and the slender Bewick's swan, smaller than its cousins.

This whole little society is grazing away without any concern for the cars speeding by just a few dozen yards away. Regularly, the birds raise their heads, stretch out their necks to survey their surroundings, then go back to grazing. The Bewick's swan is distinguished from the whooper swan not only by its size but also by the extent of the yellow mark on its beak, approximately equal in size to the black section. In the whooper swan, the yellow part is larger.

In North America, the Bewick's swan has a cousin—the whistling swan—that has little or no yellow at the base of its beak. The two forms of the bird are considered part of the same species.

The Bewick's swan, *Cygnus columbianus bewickii*, nests in the Siberian High Arctic. It winters in northern Europe (and hardly goes farther south than France) and on the Pacific coast of temperate Asia. The whistling swan reproduces in Canada's Far North and in Alaska, and winters in the western United States.

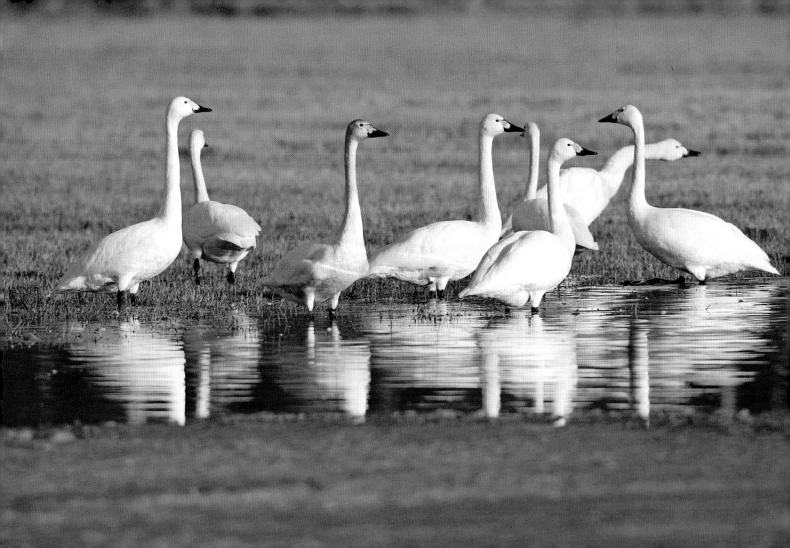

Black-capped chickadee

The Midwest is numbed by the cold and snow. Driving is difficult on the secondary roads, and so I prefer to stay in the house and watch through a large bay window, with a hot cup of tea in my hands and my binoculars at my elbow, as birds come and go around the bird feeder. My hosts are not stingy with their sunflower seeds and balls of suet. So the birds throng around the feeder avidly, seeking to make up their caloric losses as quickly as possible. Among the visitors, the black-capped chickadee is far from the most timid. Sounding their call of *chickadee dee dee!*, which gives them their name, these American tits attract other species, announcing that they have found a good source of food. The chickadees are known for forming flocks in the fall, and for leading with them other species that benefit from their ability to find the seeds, berries, and insects necessary to survival. For the moment, as the end of the afternoon approaches and activity at the feeder wanes, two chickadees feverishly crack open their sunflower seeds.

The black-capped chickadee, *Poecile atricapilla*, is found in a large portion of North America, although it is absent in northern Canada and the southern United States. It is a sedentary bird; certain populations may nevertheless move short distances in winter.

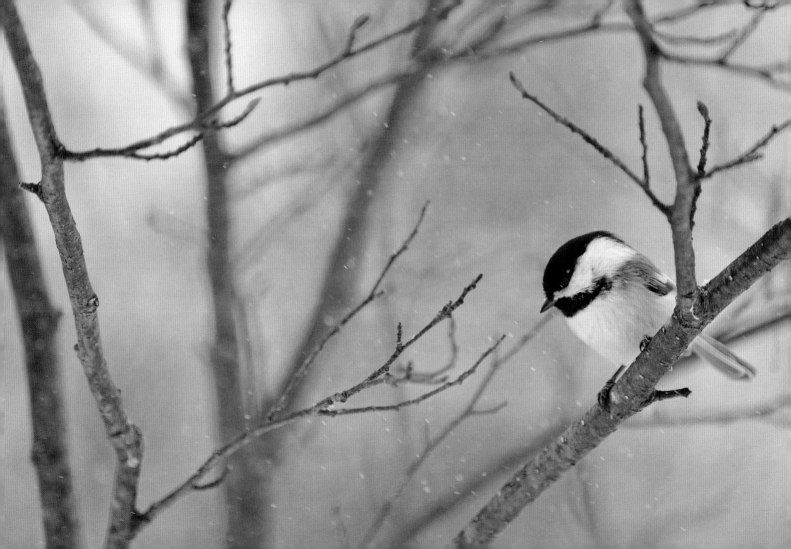

Sandhill crane

On this next-to-last day of the year, we are walking in the Merced National Wildlife Refuge in California's Central Valley. In a field of corn stubble, tens of thousands of snow geese and Ross's geese (see October 22 and January 16) make up a thick snow-white coat, from which some large gray geese emerge. They are sandhill cranes that have chosen to spend the winter here in the company of these white geese. Curiously, despite their superior size, they blend in better to the environment than the snowy geese. Their gray feathers provide good camouflage, and we have to look at them through the telescope to distinguish the little red crown on top of their heads. With slow steps, they pace through the fields, bending down nonchalantly to retrieve kernels of corn. Their calm contrasts with the bustle of the geese, who pick through the stubble anxiously.

Suddenly, for some inexplicable reason, a large number of birds take off—perhaps there is a raptor in the vicinity, or a prowling coyote. White birds dominate over gray, but the cranes have a much larger wingspan and a slower flight, which distinguishes them immediately from the geese. Their trumpeting cries and chattering intermingle, as do their wings and bodies. Soon, the birds settle back to earth, like an infinite number of white and gray snowflakes.

The sandhill crane, *Grus canadensis*, nests in a large part of Canada, in Alaska, and in the Midwest of the United States. The majority winter in the southern and southwestern United States or in Mexico. A small isolated population spends the winter in Florida.

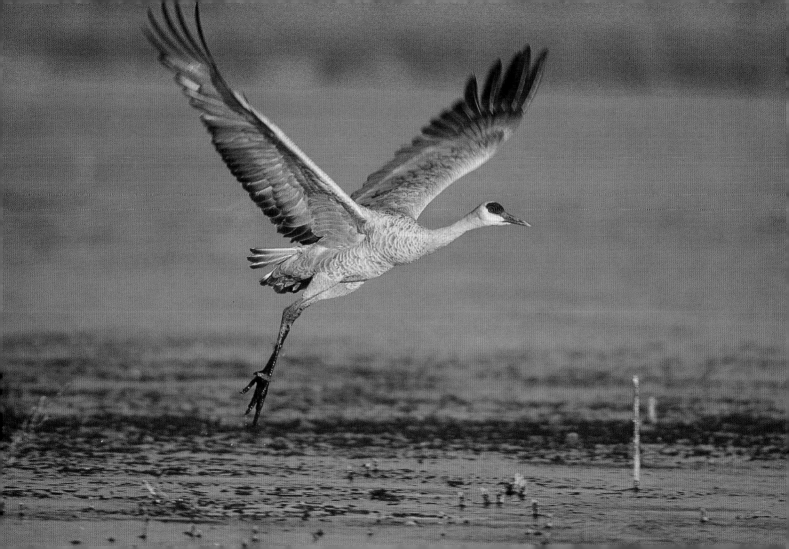

CONTEMPLATING BIRDS

It is six o'clock in the evening, and I am relaxing in the bathtub. In a few hours, my friends and I will celebrate the end of the old year and beginning of the new. With my eyes closed, my thoughts drift away in the hot water. What returns to me is a crowd of images recalling past moments in the company of birds. Stolen instants, unbearable suspense, simple pleasures, a vast quantity of feathers, beaks, feet, and glorious flights—this whole world living and beating through the rhythm of my days and nights suddenly passes before me, a great and varied parade of life on earth. Here or there, sometimes very far away, these chance encounters or long-sought meetings have given me the lasting joy of contact with nature. For birds, when you take the time to study and understand them, are a pretext to escape: to find yourself alone with them, and thus alone with yourself. Tomorrow will be another day, and the year that begins will be another year, with its moments of joy, its moments of disappointment. But the quest for birds unfolds across many days, months, and years, as it plays out across borders, countries, and oceans. Because birds are free and fly where they please, they enchant me daily and make each day more beautiful.

And as I open my eyes, I notice that the little yellow rubber duck that has been sitting for ages on the edge of the tub has come to join me in the bathwater.

ENGLISH INDEX

LATIN INDEX

Emberiza schoeniclus DECEMBER 8
Empidonax alnorum AUGUST 5
Eremophila alpestris DECEMBER 5
Erithacus rubecula DECEMBER 25
Eurynorhynchus pygmeus AUGUST 11
Eurypyga helias SEPTEMBER 10

F

Falco columbarius NOVEMBER 4
Falco naumanni JULY 30
Falco peregrinus JUNE 14
Falco rusticolus DECEMBER 14
Falco sparverius OCTOBER 17
Falco vespertinus MAY 23
Ficedula hypoleuca APRIL 15
Ficedula parva OCTOBER 12
Fratercula arctica MAY 18
Fratercula cirrhata APRIL 27
Fringilla coelebs OCTOBER 23
Fringilla montifringilla NOVEMBER 26
Fulica atra NOVEMBER 29

G

Galerida cristata FEBRUARY 11
Gallinula chloropus MARCH 20
Gallus gallus JULY 14
Garrulus glandarius SEPTEMBER 26
Gavia artica JANUARY 11
Gavia immer JUNE 23
Gavia pacifica JANUARY 11
Gavia stellata NOVEMBER 23
Geococcyx californianus AUGUST 29
Geothlypis trichas JUNE 2
Geronticus eremita APRIL 12
Glareola pratincola AUGUST 16
Glaucidium passerinum JUNE 3

Goura victoria SEPTEMBER 2
Grus canadenis DECEMBER 30
Grus grus NOVEMBER 8
Grus leucogeranus MARCH 8
Gymnogyps californicus MARCH 6
Gypaetus barbatus JULY 4

H

Haematopus bachmani AUGUST 31
Haematopus ostralegus JANUARY 28
Haliaeetus leucocephalus FEBRUARY 14
Himantopus himantopus MAY 11
Hirundo rustica MARCH 15, SEPTEMBER 18
Histrionicus histrionicus JUNE 19
Hydrobates pelagicus AUGUST 7
Hydrocoleus minutus APRIL 24
Hydrophasianus chirurgus OCTOBER 18

I

Irania gutturalis MAY 26
Ixobrychus minutus AUGUST 28

J

Junco hyemalis AUGUST 1

L

Lacus michahellis JULY 28
Lagopus muta APRIL 23
Lanius collurio MAY 16
Lanius excubitor DECEMBER 17
Larus argentatus DECEMBER 16
Larus audouinii MAY 12
Larus delawarensis MARCH 26
Larus fuscus JULY 3
Larus glaucoide FEBRUARY 18
Larus hemprichii APRIL 19

Larus hyperboreus DECEMBER 11
Larus marinus NOVEMBER 20
Larus melanocephalus AUGUST 20
Larus pipixcan NOVEMBER 1
Larus ridibundus JANUARY 18
Larus smithsonianus DECEMBER 16
Leptopoecile sophiae MAY 21
Leptoptilos crumeniferus SEPTEMBER 28
Limosa lapponica SEPTEMBER 23
Limosa limosa MARCH 25
Lophodytes cucullatus NOVEMBER 2
Loxia curvirostra JULY 19
Luscinia megarhynchos MAY 7
Luscinia svecica APRIL 4
Lymnocryptes minimus NOVEMBER 27

M

Megalaima FEBRUARY 27
Melanitta nigra JULY 31
Melanochlora sultanea SEPTEMBER 1
Melanocorypha calandra APRIL 29
Melanocorypha yeltoniensis MAY 24
Melospiza melodia MARCH 21
Merops apiaster AUGUST 14
Milvus migrans AUGUST 2
Milvus milvus DECEMBER 18
Monticola saxatilis JULY 22
Montifringilla nivalis JULY 6
Morus bassanus AUGUST 15
Motacilla alba JANUARY 27
Motacilla cinerea FEBRUARY 3
Motacilla flava APRIL 13
Muscicapa striata MAY 19

N

Nucifraga caryocatactes SEPTEMBER 8

Nucifraga columbiana JUNE 5
Numenicus phaeopus APRIL 26
Numenius americanus AUGUST 21
Numida meleagris AUGUST 19
Nycticorax nycticorax JUNE 10

O

Oceanites oceanicus SEPTEMBER 3
Oenanthe hispanica JUNE 15
Oenanthe oenanthe JULY 13
Onychoprion fuscata MAY 4
Oriolus oriolus MAY 5
Orthotomus MARCH 7
Otis tarda APRIL 14
Otus scops APRIL 3
Oxyura leucocephala MARCH 29

P

Pagophila eburnea JANUARY 21
Pandion haliaetus JUNE 8
Panurus biarmicus NOVEMBER 30
Parus major JANUARY 1
Passer domesticus JANUARY 14
Passer montanus DECEMBER 13
Passer simplex MARCH 2
Passerculus sandwichensis AUGUST 30
Pavo cristatus FEBRUARY 12
Pelecanus occidentalis JULY 23
Pelecanus onocrotalus MAY 22
Perdix perdix SEPTEMBER 20
Periparus ater OCTOBER 3
Pernis apivorus MAY 6
Phalacrocorax carbo OCTOBER 4
Phalaropus fulicarius NOVEMBER 12
Phasianus colchicus AUGUST 22
Philloscopus sibilatrix MAY 13

PHOTOGRAPH CREDITS

Front cover: © Jari Peltomäki
Back cover:
Top row, from left: © Markus Varesvuo, © Markus Varesvuo, © Tomi Muukonen,
© Markus Varesvuo
Middle row, from left: © Jari Peltomäki, © Markus Varesvuo, © Tomi Muukonen
Bottom row, from left: © Markus Varesvuo, © Markus Varesvuo, © Markus Varesvuo,
© Arto Juvonen

BIRDPHOTO

© Arto Juvonen: JANUARY 1, 11, 19, 28; MARCH 18, 25, 27, 28; APRIL 5, 10, 16, 25; MAY 13, 20; JUNE 3, 8, 20, 24, 28; JULY 8, 12, 26, 27, 29; AUGUST 10; SEPTEMBER 18, 20, 26; OCTOBER 2, 12, 26; NOVEMBER 11, 15, 19, 20, 29; DECEMBER 6, 9, 10, 12, 23; © Tomi Muukonen: JANUARY 2, 3, 10, 21, 23, 25, 26, 29, 30; FEBRUARY 6, 22, 26, 28; MARCH 4; APRIL 4, 7, 15, 29; MAY 1, 9, 19, 22, 28; JUNE 10, 12, 16; JULY 2, 9, 10, 17, 19; AUGUST 6, 8, 12, 17, 20, 22, 28; SEPTEMBER 6, 12; OCTOBER 4, 11, 15, 16, 20, 21, 28; NOVEMBER 3, 8, 23, 28; © Jari Peltomäki: JANUARY 4, 8, 9, 12, 15, 22; FEBRUARY 2, 11, 16, 24; MARCH 1, 12, 19, 20, 22, 24; APRIL 20, 22, 24, 26, 28; MAY 2, 5, 8, 23, 29; JUNE 4, 13, 14, 26; JULY 5, 13, 22; AUGUST 16, 27; SEPTEMBER 4, 8, 19, 24, 25; OCTOBER 10, 30; NOVEMBER 9, 21, 25; DECEMBER 7, 8, 11, 17; © Markus Varesvuo: JANUARY 6, 7, 18, 24, 27, 31; FEBRUARY 3, 5, 7, 8, 17, 20, 25; MARCH 3, 5, 9, 11, 13, 15, 31; APRIL 2, 6, 9, 21, 23, 30; MAY 6, 7, 11, 18; JUNE 7, 9, 15, 18, 19, 23, 25; JULY 1, 31; AUGUST 2, 3, 14, 15, 23; SEPTEMBER 5, 23; OCTOBER 3, 23; NOVEMBER 4, 10, 12, 13, 14, 24, 30; DECEMBER 1, 3, 4, 18, 20, 25, 28

BIOSPHOTO

© Emile Barbelette: MAY 16, DECEMBER 5; © Glenn Bartley/NHPA/Photoshot: OCTOBER 9; © Samuel Blanc : DECEMBER 27; © Denis Bringard: OCTOBER 1; © Fabrice Cahez: JANUARY 5; © Mark Carwadine: OCTOBER 17; © Fabrice Chanson: AUGUST 21; © Sylvain Cordier: JANUARY 13, FEBRUARY 14, AUGUST 7, OCTOBER 18; © Patrice Correia: NOVEMBER 18; © Michel & Christine Denis-Huot: JULY 18; © Frédéric Desmette/Wildlife Pictures: JANUARY 14; © Berndt Fischer: MAY 27; © Michel Gunther: FEBRUARY 4, JULY 7; © Muriel Hazan: AUGUST 29; © Robert Henno/Wildlife Pictures: APRIL 3; © Pierre Huguet: JANUARY 20, FEBRUARY 12; © Koshy Johnson/OSF: FEBRUARY 9; © J.-L. Klein & M.-L. Hubert: JULY 14, AUGUST 4; © Mike Lane: OCTOBER 19, NOVEMBER 16; © L.Marbaix/Wildlife Pictures: JULY 21; © Marie Read/Photoshot: AUGUST 5; © Johann Schumacher/Peter Arnold: JULY 11; © Christophe Sidamon-Pesson and David Allemand: DECEMBER 29; © Chris Schenk/FotoNatura: APRIL 18; © Cyril Ruoso: OCTOBER 7; © Thierry Van Baelinghem: FEBRUARY 10; © Markus Varesvuo: APRIL 11; © Tom Vezo/Peter Arnold: JULY 16; © Carl Vornberger/Peter Arnold: NOVEMBER 2; © Peter Weirmann: DECEMBER 14

EYEDEA

© Delphine Aures/Jacana: SEPTEMBER 3, OCTOBER 6; © Hermann Brehm/NPL/Jacana: SEPTEMBER 10; © John Cancalosi/Age/Hoa-qui: MARCH 6, JULY 20, AUGUST 9; © John Cancalosi/NPL/Jacana: SEPTEMBER 22; © Bernard Castelein/NPL/Jacana: MARCH 8; © Sylvain Cordier/Jacana: JULY 4, 23; © Cornélia and Ramon Dorr/Jacana: DECEMBER 16; © Thomas Dressler/Jacana: AUGUST 18; © Dinodia/Age photostock/Age/Hoa-qui: MARCH 7; © Hanne and Jens Eriksen/NPL/Jacana: AUGUST 11; © Patrick Forget/Explorer: SEPTEMBER 2; © Grambo/Firstlight: NOVEMBER 22; © Catherine Jouan and Jeanne Rius/Jacana: APRIL 1; © Stephen J. Kraseman/Jacana: SEPTEMBER 16; © Danegger Manfred/Jacana: OCTOBER 27; © Tom Mangelsen/Jacana: DECEMBER 24; © Gilles Martin/Jacana: SEPTEMBER 7; © Chris Mattison/Age/Hoa-qui: MARCH 21; © George McCarthy/NPL/Jacana: JUNE 15; © Mary McDonald/NPL/Jacana: MARCH 23; © Steven David Miller/NPL/Jacana: SEPTEMBER 27; © Rolf Nussbaumer/NPL/Jacana: JUNE 21, AUGUST 25, OCTOBER 8, DECEMBER 26; © Fredric Petters/Firstlight: DECEMBER 31; © Roger Puillandre/Hoa-qui: MARCH 16; © Paul Andrew Sandford/Explorer: OCTOBER 31; © Anup Shah/ Jacana: AUGUST 26, SEPTEMBER 28; © Shattil and Rozinski/NPL/Jacana: MAY 14, AUGUST 1; © Phil Savoie/NPL/Jacana: OCTOBER 14; © Etienne Sipp/Jacana: APRIL 14; © Lynn M. Stone/NPL/Jacana: AUGUST 31; © Tom Vezo/NPL/Jacana: AUGUST 30, SEPTEMBER 11; © Winfried Wisniewski/Jacana: APRIL 27, MAY 4, AUGUST 13, DECEMBER 30; © Gunter Ziesler/Jacana: APRIL 8.

VIREO

© G. Armistead: MAY 30; © A. Morris: SEPTEMBER 29; © M. Strange: SEPTEMBER 1

OTHER SOURCES

© Aurélien Audevard: FEBRUARY 18; MARCH 10, 21; MAY 15, 21, 26; JUNE 17, 30; NOVEMBER 1; © John James Audubon, F.RS. F,LS/Bibliothèque de Besançon: NOVEMBER 6; © Christian Aussaguel: APRIL 17; © Julien Boulanger: FEBRUARY 15; © Geneviève Brosselin: FEBRUARY 15; © Edouard Dansette: SEPTEMBER 17; © Frank Dhermain: FEBRUARY 1; © Philippe Jacques Dubois: APRIL 13, 19; MAY 3, 10, 12, 24, 25, 31; JUNE 1, 6, 11, 22, 29; JULY 3, 6, 25, 28; SEPTEMBER 30; OCTOBER 13, 22, 29; NOVEMBER 27; DECEMBER 2, 13, 19, 21; © Yves Dubois: FEBRUARY 19; © Marc Duquet: FEBRUARY 23; © Findnature/Michel Lamarche: JUNE 2, JULY 24, DECEMBER 15; © Guy Flohart: SEPTEMBER 21; © Julien Gernigon: SEPTEMBER 9; © Andreas Guyot: OCTOBER 24; © iStockphoto.com/Brent Paull: MARCH 14; © Lazlo Novak/GreenEye Ecotours & Images: NOVEMBER 26; © Daniele Occhiato: MARCH 17, APRIL 12, JUNE 27, JULY 30, AUGUST 24, SEPTEMBER 14, NOVEMBER 17; © Georges Olioso: MARCH 2; © Elise Rousseau: MAY 17, JULY 15, AUGUST 19, SEPTEMBER 15, OCTOBER 25, NOVEMBER 5, DECEMBER 22; © Llyod Spitalnik: OCTOBER 5; © Alex Vargas: NOVEMBER 7; © Michelle and Peter Wong: FEBRUARY 27

Translated from the French by AMANDA KATZ

For the English-language edition

Editor: AIAH RACHEL WIEDER
Designer: SHAWN DAHL
Production Manager: JACQUIE POIRIER

Cataloging-in-Publication Data has been applied for and
may be obtained from the Library of Congress.
ISBN 978-0-8109-9613-7

Originally published in French in 2010 under the title *365
Jours avec les Oiseaux* by Éditions de La Martinière, Paris.

Printed and bound in China
10 9 8 7 6 5 4 3 2

Abrams books are available at special discounts when
purchased in quantity for premiums and promotions as
well as fundraising or educational use. Special editions
can also be created to specification. For details, contact
specialmarkets@abramsbooks.com or the address below.

THE ART OF BOOKS SINCE 1949

115 West 18th Street
New York, NY 10011
www.abramsbooks.com